The Photographer's Dictionary

A RotoVision Book

Published and distributed by RotoVision SA
Route Suisse 9
CH-1295 Mies
Switzerland

RotoVision SA
Sales and Editorial Office
Sheridan House, 114 Western Road
Hove BN3 1DD, UK

Tel: +44 (0)1273 72 72 68
Fax: +44 (0)1273 72 72 69
www.rotovision.com

10 9 8 7 6 5 4 3 2 1

ISBN: 978-2-940378-43-2

Art Director for RotoVision: Tony Seddon
Design by Fineline Studios

Reprographics in Singapore by ProVision Pte.
Tel: +65 6334 7720
Fax: +65 6334 7721

Printing and binding in Singapore by Star Standard Industries Pte.

The Photographer's Dictionary

An A to Z of Technical Terms Explained

NK Guy

RotoVision

For Jennifer

Contents

Index

Index

A note on the text:
Entries in this book are
arranged thematically,
rather than alphabetically.
Text in italics indicates
cross references
between entries.

Technical Basics

Light

Electromagnetic radiation of wavelength that can be detected by the human eye.

What we perceive as light is actually just a tiny band of what physicists refer to as the electromagnetic spectrum. Seemingly disparate physical phenomena—light, radio waves, X-rays, microwaves, *ultraviolet* and *infrared*, gamma rays—are actually all forms of the same thing: electromagnetic radiation (EMR). The difference between these various forms comes from the wavelength.

Extremely short wavelengths of EMR take on the form of gamma rays and X-rays, which can be harmful to living tissue. Longer wavelengths are microwaves and radio waves. Falling in between are rays of visible light, which have wavelengths of roughly 400nm (nanometers: 10^{-9} or one billionth of a meter) to 700nm and which

are the only type of EMR detectable by unaided human vision. The wavelength of light also determines its color. Blue light falls around 475nm, green is around 510nm, red is around 650nm, and so on.

In addition to wavelength, light has two other important properties of interest to photographers: intensity and polarization. Intensity is simply the brightness of the light. Polarization refers to the plane in which the light wave oscillates or vibrates: think of the way jump ropes move up and down in waves.

It's possible to be a good photographer without understanding the underlying science of optics and quantum physics, because the art of photography is about the practical use and manipulation of light sources to create a two-dimensional image based on light reflecting back from surfaces.

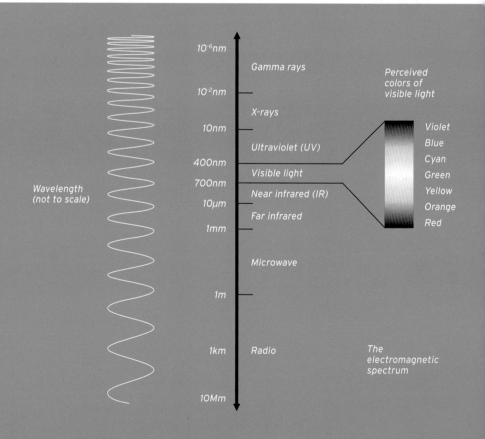

Wavelength (not to scale)

10^{-6}nm	
	Gamma rays
10^{-2}nm	
	X-rays
10nm	
	Ultraviolet (UV)
400nm	
	Visible light
700nm	
	Near infrared (IR)
10µm	
	Far infrared
1mm	
	Microwave
1m	
1km	Radio
10Mm	

Perceived colors of visible light

Violet
Blue
Cyan
Green
Yellow
Orange
Red

The electromagnetic spectrum

Exposure

Determining the correct amount of light which must hit the surface of film or an *image sensor* in order to record a scene.

Too much light striking the film or sensor will result in an image that's overexposed and too bright. Too little, on the other hand, will result in a dark and underexposed image.

There are two basic means through which the amount of light can be controlled by the camera: lens *aperture* and camera *shutter speed*. These two factors combine with the sensitivity of the film or sensor, and of course the amount of light illuminating the scene, to determine the final exposure.

Most cameras sold today contain light meters, which measure the amount of ambient light reflected back from a scene, and computers which can use this information to calculate correct aperture and shutter speed settings. Exceptions include *disposable film cameras* and old-style *view cameras* and *pinhole cameras*, which usually lack light *metering* systems altogether.

However, photography is as much an art as it is a science. Most cameras' *automatic exposure* systems try to get the majority of the scene to record as a neutral medium-gray color. And this may not achieve the mood or feeling required. Consider the three images below. The darker shot is moody and evocative, but loses a great deal of detail. The brighter shot shows much of this detail, but looks too bright. The middle exposure balances the two, but perhaps lacks the emotional impact of the darker image. Which photo is correctly exposed is a judgment call based on the priorities of the photographer.

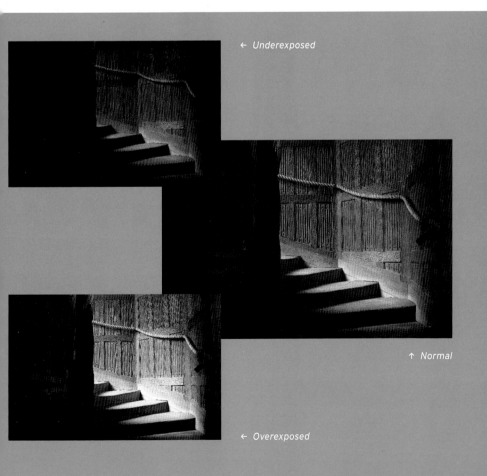

← *Underexposed*

↑ *Normal*

← *Overexposed*

Positive and negative

A positive image is one in which the colors or brightnesses accurately reflect real life, e.g.: white appears as white, black as black, and so on. A negative image inverts the brightness values and, in the case of color, the color information.

Some of the earliest photographic processes produced positive images only. For example, daguerreotypes were metal plates bearing positive images. This meant they appeared in an easy to read and view form, but also meant that they could not be duplicated. A daguerreotype was a single-use process.

The invention of processes which created transparent negative images on glass plates and film made quick reproduction of photos possible. The negative is the first-generation image, but also an intermediate one, since it would then be used to create the final positive image. This required two steps, but rendered photographic duplication possible. This model holds true today for most chemical-based prints.

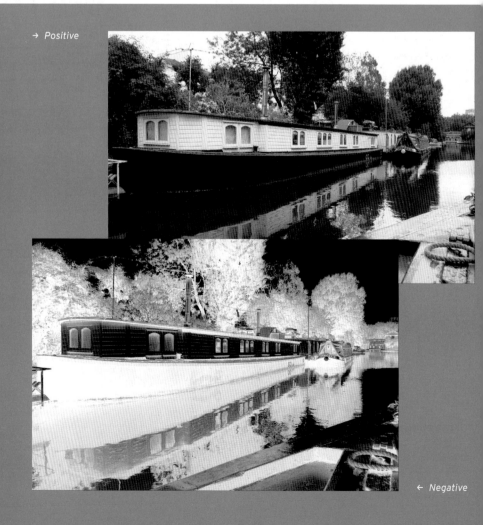

→ Positive

← Negative

Aperture

The small hole or opening through which light enters a camera; analogous to the pupil of the human eye.

The aperture, along with *shutter speed* and film/sensor sensitivity, is one of the three fundamental tools available to the photographer for setting correct *exposure*.

Most camera lenses contain adjustable mechanisms called *diaphragms*, analogous to the iris of an eye, which can expand or contract to create apertures of different sizes. Changing the size of the aperture lets in more or less light, thereby altering the exposure of the image. Some cameras, such as *disposable film cameras* and inexpensive *digital cameras*, have lenses with fixed apertures which cannot be altered. →

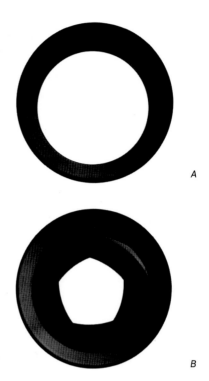

A

B

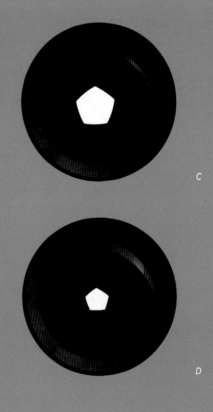

→ *An aperture diaphragm with five blades.*
A: Wide open, which on this lens is f/4.5.
B: Stopped down to f/8.
C: Stopped further to f/16.
D: Stopped down to f/22.

C

D

Aperture

The aperture of a lens is measured by a number known as an f-stop. Each aperture size setting has a different f-stop value, premarked by the lens manufacturer. The f-stop is calculated by dividing the *focal length* of the lens by the physical diameter of the aperture. Since the result is a ratio it is sometimes written as 1:1.8 and so on.

A confusing consequence of f-stops being ratios is that the smaller the f-stop value, the larger the aperture, and the larger the value, the smaller the aperture. Thus f/1.4, for example, lets more light into the camera than f/22.

Adjusting a lens aperture also alters certain optical characteristics of the lens. For example, using a large aperture decreases the *depth of field* but increases the amount of spherical *aberration*. At the other end, a small aperture increases the depth of field but increases the amount of *diffraction*.

Note that the aperture function of a lens is almost always different from the camera's shutter mechanism, though both are light-admitting openings. Very few cameras combine the aperture and shutter functions into one mechanism.

A large aperture lets a large amount of light strike the film or sensor.

A small aperture restricts the light reaching the film or sensor.

Shutter speed

The length of time that a piece of film or an *image sensor* is exposed to light.

The shutter speed or, more accurately, shutter time is one of the basic methods of determining correct *exposure*, along with *aperture* and *film speed* or image sensor sensitivity.

Cameras have traditionally contained light-blocking mechanical shutters. These mechanisms open up to admit light and then close again after the required period of time. This time may be determined by an automated *metering* system built into the camera, may be a fixed period of time in the case of simple cameras such as *disposables*, or may be set manually by the photographer if the camera allows for it. Some *digital cameras* simulate mechanical shutters simply by turning on the image sensor for the time required.

Shutter times are usually extremely brief. For example, it might take only 1/125 of a second to record a photo on a bright sunny day. But the time required depends on the sensitivity of the film or sensor, the aperture setting of the lens, and the amount of light available. A photo of a moonless night sky might require many hours, whereas a midday desert might need a thousandth of a second.

Somewhat misleadingly, a long shutter time is called a "slow" shutter setting and a brief shutter time is called a "fast" shutter setting. These terms do not refer to the speed at which the shutter opens and closes, since that speed is constant regardless of the open duration. →

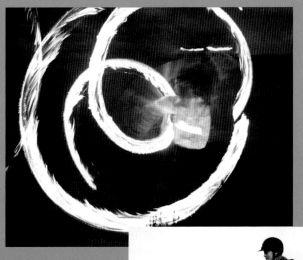

←↓ *A very high shutter speed of 1/2,000 second was required to freeze the horse mid-leap, whereas the fire performer was photographed with a 3-second exposure, resulting in whirling streaks of flame.*

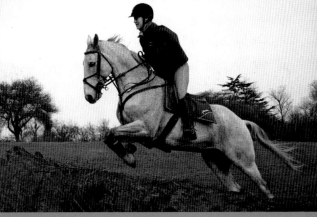

Shutter speed

Creative use of shutter times is a useful way of showing or halting motion in a picture. For example, a photo of a galloping race horse might deliberately use a slow shutter time which blurs the motion of the animal's legs, suggesting speed. Conversely a photo of a tennis player might use a fast shutter time to freeze the moment the ball hits the racket.

By convention, shutter times are displayed in seconds and fractions of a second. Cameras with digital readouts usually use the " symbol to indicate whole seconds and no unit for the fractions. Confusingly, different manufacturers adopt different schemes for displaying time values between 1/4 second and 1 second. Below are two digital shutter time scales used by Canon and Nikon respectively for 1/10 second through to $2\frac{1}{2}$ seconds, using 1/3 stop between exposure increments.

Seconds	$\frac{1}{10}$	$\frac{1}{8}$	$\frac{1}{6}$	$\frac{1}{5}$	$\frac{1}{4}$	$\frac{1}{3}$	$\frac{2}{5}$	$\frac{1}{2}$	$\frac{2}{3}$	$\frac{3}{4}$	1	$1\frac{1}{3}$	2	$2\frac{1}{2}$
Canon	10	8	6	5	4	0"3	0"4	0"5	0"6	0"8	1"	1"3	2"	2"5
Nikon	10	8	6	5	4	3	2.5	2	1.6	1.3	1"	1.3"	2"	2.5"

Thus a Canon camera will display 0"6 (i.e.: 0.6 seconds) to mean $\frac{2}{3}$ second, whereas a Nikon camera will display 1.6 (i.e. $\frac{1}{1.6}$ seconds, or 0.625 seconds). Canon cameras show half a second as 0"5, whereas Nikon cameras show the same time value as 2.

Exposure value (EV)

A numeric value, based on a combination of *shutter speed* and *apertures*, used to describe *exposure*.

The notion of an exposure value derives from the law of *reciprocity*, which states that exposure = intensity x time. Intensity is represented by the aperture setting and time by the shutter speed.

Exposure value tables are useful as educational tools and for determining correct exposure settings for given lighting conditions without a light meter.

	f/1.0	1.4	2.0	2.8	4.0	5.6	8.0	11	16	22	32	45	64
1 sec	0	1	2	3	4	5	6	7	8	9	10	11	12
1/2	1	2	3	4	5	6	7	8	9	10	11	12	13
1/4	2	3	4	5	6	7	8	9	10	11	12	13	14
1/8	3	4	5	6	7	8	9	10	11	12	13	14	15
1/15	4	5	6	7	8	9	10	11	12	13	14	15	16
1/30	5	6	7	8	9	10	11	12	13	14	15	16	17
1/60	6	7	8	9	10	11	12	13	14	15	16	17	18
1/125	7	8	9	10	11	12	13	14	15	16	17	18	19
1/250	8	9	10	11	12	13	14	15	16	17	18	19	20
1/500	9	10	11	12	13	14	15	16	17	18	19	20	21
1/1,000	10	11	12	13	14	15	16	17	18	19	20	21	22
1/2,000	11	12	13	14	15	16	17	18	19	20	21	22	23
1/4,000	12	13	14	15	16	17	18	19	20	21	22	23	24

↑ *Exposure value table. Shutter speed in seconds is on the vertical axis and lens aperture in f/stops is on the horizontal axis.*

Latitude

Exposure latitude is an approximate measure of how forgiving a photographic medium or *image sensor* is of correct *exposure*.

In other words, a film or image sensor with low latitude must be exposed correctly or else it will be noticeably over- or underexposed. A film or sensor with wide latitude can be more tolerant of exposure *metering* and may still produce acceptable results even if metering is not spot-on.

There is clearly something of a subjective element to latitude, since the acceptability of given exposure is dependent on the photographer or viewer.

However, color negative films are generally held as having a few stops of latitude for a typical midrange subject. Color slide films, however, have a very narrow latitude of only a stop or two.

Digital sensors vary, but are typically closer to the narrower latitude of slides than they are of color negatives. Digital sensors in particular are subject to blow-out highlights. An overexposed area captured by a digital sensor may simply contain pure 100 percent white values. Since there is no detail there to be had, recovery from such a blown-out area is not possible.

Optics

The branches of physical science and engineering which deal with the properties of visible light and near-visible electromagnetic radiation (*ultraviolet* and *infrared*).

Light is a very complex phenomenon, and many theories have been developed over the years to explain and predict its behavior. Most aspects of light that matter to photographers can be described by thinking of light as waves traveling through spaces rather than as tiny particles known as photons, though both are accepted scientific models. Geometric optics deals mainly with refractive phenomena, and its

ray-based model is important for classical lens designs. Wave-based optics deals with phenomena such as *diffraction* and polarization of light.

The term "optical" is also used to describe certain camera functions. For example, an optical *viewfinder* in a camera relies purely on lenses. This is in contrast to an *electronic viewfinder* which, while including optical components also relies heavily on electronic circuitry. Likewise an optical *zoom lens* is one which functions purely through light-altering devices, as opposed to *digital zoom* which is based around digital alteration of captured data.

Refraction

A fundamental optical principle, upon which nearly all photography is based, whereby the direction of light changes upon moving from one medium to another.

A classic example is the appearance of a pencil immersed in a glass of water. The pencil will seem to be broken–even though it clearly is not–because of the refractive properties of water and light.

The principle of refraction is used to create lenses for cameras, telescopes, eyeglasses, and the like. Through careful selection of different lenses with different refractive strengths it's possible to construct a compound lens for a camera which images a picture onto a flat image plane. Light entering the lens is bent and focused upon the surface of the film or an *image sensor*. With the exception of *catadioptric (mirror)* and diffractive optics lenses, all camera lenses are purely refractive in nature.

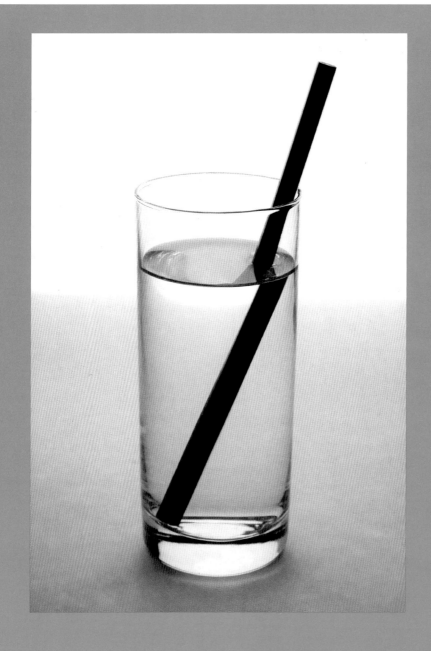

Field of view, angle of view

The amount of a scene visible in a photo. The photo on the right was taken using a 17mm lens on a 35mm camera, and takes in a tremendous sweep of the scene. Diagonally about 103 degrees of the scene are visible.

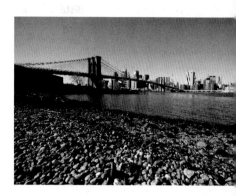

By contrast, the photo below right is of the same scene and was taken from the same location but, by isolating one small area, it has a very restricted field of view. This is because a telephoto lens of 280mm was used, yielding a diagonal angle of 8.5 degrees. Different lenses were used to take the two photos, but similar shots might be taken with a *zoom lens*, which has an adjustable field of view.

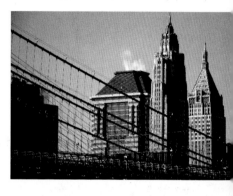

Field of view can be measured in degrees as the angle of view. And, since photos are usually rectangular, the horizontal, vertical, or diagonal angles can be measured.

While the angle of view is a useful concept, traditionally the *focal length* is used to indicate how much of a scene is taken in by a camera lens.

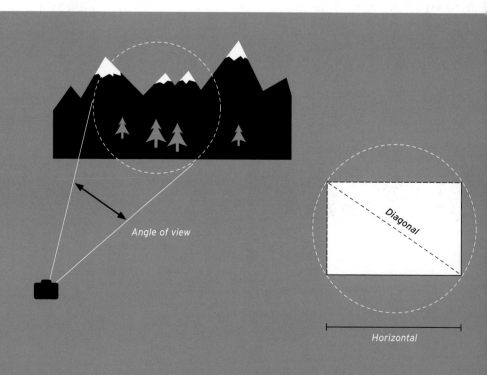

Angle of view

Diagonal

Horizontal

Focal length

The most important optical property of a lens; technically the distance from the rear nodal point of the lens to the *focal plane* when the lens is focused to *infinity*.

From the point of view of the average photographer, the focal length is a numeric value, expressed in millimeters, which describes how much of a scene can be photographed.

While this is useful as far as it goes, thinking in these terms is actually the cause of a lot of confusion. This is because focal length is but one of two factors which determine the *field of view* of a photograph. The size of the camera's *imaging area* is equally important.

This matters because a *35mm film camera* with a lens of a given focal length will not have the same field of view as a *sub-frame* digital *SLR* or a small *point and shoot* camera with lenses of the same focal length (see *cropping factor*). However, since 35mm cameras have been so dominant for so long, the focal lengths associated with 35mm have become something of a shorthand for field of view. People often say a landscape requires a 28mm lens, for example. Or a portrait needs an 85mm lens. But these particular values are meaningful only for cameras with the same imaging size as 35mm film.

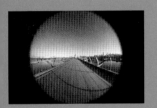
↑ *8mm fisheye*

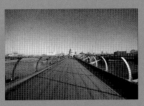
↑ *17mm*

↑ *24mm*

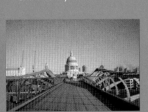
↑ *50mm*

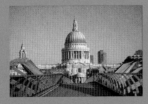
↑ *105mm*

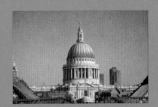
↑ *135mm*

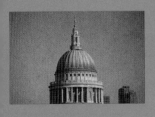
↑ *200mm*

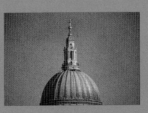
↑ *300mm*

↑ *420mm*

↑ *A series of focal lengths used on a 35mm camera. The camera was stationary; only the focal length and thus the field of view changed.*

Aspect ratio

The ratio of height to width of a rectangular photo.

It can be quite a shock to get custom prints back from the lab, only to find that things that were clearly visible through the *viewfinder* are completely missing from the edges of the finished print. This is usually caused by differing aspect ratios.

The aspect ratio is simply the shape of a rectangle, or the ratio between the width and the height. For example, a square photograph taken with a medium-format camera will have a ratio of 1:1, but a rectangular photograph taken with a typical *35mm camera* will have a ratio of 3:2, since it will be three units tall and two wide, regardless of size.

Different devices and output media use different aspect ratios; there is no single standard. This means that a photo taken on one device may not conveniently fit the output of another. It may be necessary to slice off (crop) the edges of a photo to make it fit. Or the whole photo may fit only if empty strips are added to two sides— much like the "letterboxing" used to adapt wide-screen movies to regular TV.

On the right is a table of some common aspect ratios. *Digital cameras* use a wide variety of ratios, depending on the particular *image sensor* used in the given model.

↑ *This picture demonstrates some of the hazards of choosing the wrong aspect ratio. It was carefully framed on a 2:3 SLR to emphasize its height.*

↑ *If printed at 8x10in, quite a lot of the image is lost by the change to a 4:5 ratio.*

Device/paper size	Aspect ratio	Width / height
35mm camera	3:2	1.5
Most digital point and shoots	4:3	1.33
Most digital SLRs	3:2	1.5
645 medium-format	6:4.5	1.33
6x6 medium-format	1:1	1.0
APS C mode	3:2	1.5
APS H mode	16:9	1.78
APS P mode	3:1	3.0
4x5 sheet film	4:5	1.25
8x10 sheet film	4:5	1.25
4x6in print	3:2	1.5
5x7in print	7:5	1.4
6x8in print	4:3	1.33
8x10in print	4:5	1.25
8x12in print	3:2	1.5
16x20in print	4:5	1.25
8$\frac{1}{2}$x11in (US letter)	11:8.5	1.29
8$\frac{1}{2}$x14in (US legal)	14:8.5	1.65
11x17in (US tabloid)	17:11	1.55
US business card	3.5:2	1.75
International business card	55:86	1.59
A5 paper	1:1.41	1.41
A4 paper	1:1.41	1.41
Most regular TVs	4:3	1.33
Most wide-screen and HD TVs	16:9	1.78

 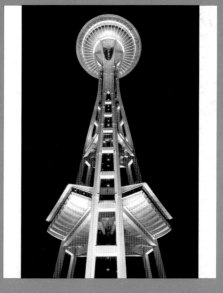

↑ One solution: move the crop to preserve more of the top of the tower at the expense of the lower section. This has the drawback of disrupting the balance of the image.

↑ Another solution: print the entire image to fit the paper, which unfortunately results in blank strips on two edges.

Focus

The point at which rays of light entering a camera converge.

The areas of an image which are in focus should be sharply and crisply defined, accurately reflecting the object that the photo records. Objects which are not in focus will be blurred and soft, as the light will be spread out across an area rather than being brought together at one point. There are a number of important facts to note.

First, in a mathematical model the rays of incoming light will meet at a single point known as the "focal point." If this focal point coincides with the image plane (the surface of film or an *image sensor*) inside a camera then the picture will be sharp and in focus.

In real life this kind of precision is impossible. Instead the rays will converge to a very small circle or disc, known as the *circle of confusion*. Sharper lenses will image smaller circles than poorer lenses. Other factors governing the sharpness of focus include *aperture* size (small apertures cause *diffraction*, which results in blurring) and lens *aberrations*.

Second, focus is not an on or off situation. Instead, each photograph will have a range of acceptable focus, as described in *depth of field*.

Third, focus has a subjective component. Accurate focus is as much a matter of perception of the observer.

Fourth, blurring of an image can be caused by factors other than focus. For example, *motion blur* is a common source of blur that does not stem from focus error. Soft *filters* can also blur an image even though correct focus is maintained.

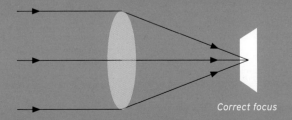

Correct focus

Image area

In varying contexts, the area which contains or records an actual image.

The size of the imaging area is one of the key factors determining the quality or *resolution* of a captured image.

In the case of film a percentage of the surface area is not used to record a picture. For example, with *35mm* film the edges are occupied by the sprocket holes used in the film transport mechanism, and are thus unavailable for imaging. There is also a tiny strip between each frame to separate them. Accordingly each 35mm film frame is only 24mm by 36mm in size.

Digital cameras also have different image areas, depending on the physical size of the sensor chip used to capture the photo, and the surface area of the chip dedicated to recording image information.

Image circle

The circular image projected by a lens onto an *imaging area*.

While almost all digital or film imaging areas are rectangular or square, lenses themselves are typically cylinders containing round lens elements. And the images they project onto the film or sensor are also circles, cast onto a black ground.

There are a number of consequences to this difference in shape. First, the circle cast by the lens must be larger than the image area in use, or else dark triangles will appear in the corners of the final image. Second, since the sharpness of the image typically worsens the further one gets from the optical center, corner sharpness can be a problem with some lenses.

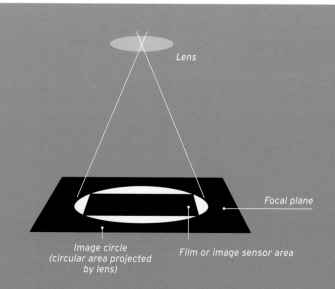

Lens

Focal plane

Image circle
(circular area projected
by lens)

Film or image sensor area

Portrait and landscape

In the case of nonsquare photos, the orientation of a rectangular image or frame.

A picture in portrait orientation has the long dimension vertical, whereas a picture in landscape has its long dimension horizontal.

Of course, the pictures do not have to be of portraits or landscapes necessarily. The terms simply arose because the orientations are usually appropriate for their respective types of photography. The same terms are also used to describe the orientation of paper in a printer.

Perspective

The appearance of a scene, based on factors such as the position of the camera, lens type and *focal length* used, angle, and so on.

The closer an object appears to the observer, the larger it appears to be. The further away it is, the smaller it appears. These and other visual clues help an observer determine the relative distances and positions of objects.

When the focal length changes it is often necessary to change camera positions to take advantage of the change in the scene. A common example is portraiture. People often say that different lens focal lengths result in different perspectives in a portrait. This is not, strictly speaking, true. If a camera stays put but the focal length changes, then the *field of view* will be different but the perspective of given areas remains the same. However, the camera needs to move when using different focal lengths in order to get the person's face appearing the same size in the final picture. This change in physical position is what causes the shift in perspective, not the focal length per se.

It is often said that focal lengths of, say, 85mm to 135mm are ideal for portraits on *35mm cameras* because they tend to flatten features in a flattering fashion. This is because of the distance the camera needs to be from the subject for such lenses to be useful in portraiture.

More flattering ◄ ► Flattering ◄

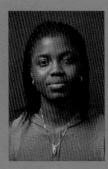
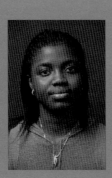

200mm 135mm 105mm 85mm

10ft/3m

↑ *Photographs of the same model taken at varying distances. In order that the model's face fills the frame to the same amount, lenses of different focal lengths were used. As can be seen here the model should receive some sort of bravery award for allowing the highly unflattering extreme wide-angle photos to be taken.*

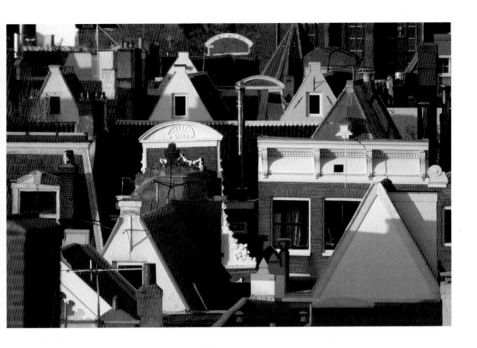

Magnification of a portion of a scene can also cause perspective effects, such as the compressed perspective apparent in the long focal length photograph above. The use of the *telephoto lens* results in a picture in which the buildings appear to be very closely spaced.

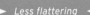

► Less flattering ◄ ► Deeply embarrassing

50mm 28mm 24mm 17mm

 5ft/1.5m 6in/15cm

Parallax

Apparent changes in position of an object caused by different viewing positions.

The basic principle of parallax is very easy to demonstrate by holding a finger a close distance in front of one's face, then viewing the finger first through one eye and then the other. The finger appears to jump, but of course this occurs purely because it's being seen from a different viewpoint. But notice that objects much further away do not appear to jump. This is because the distance between one's eyes is significant compared to the finger but not compared to the distant objects.

Parallax is one phenomenon which makes depth perception possible, and stereo photographs exploit this principle. However, parallax error can be an issue when using a camera in which the *viewfinder* lens and *taking lens* are separate. In the case of such cameras, close focusing can be a problem since a near object may not be framed correctly to the taking lens even if it looks correct to the viewfinder lens. *SLRs*, which use the same taking lens as the viewfinder, do not suffer from this problem. *Digital cameras* with *live view* capabilities are also free of parallax.

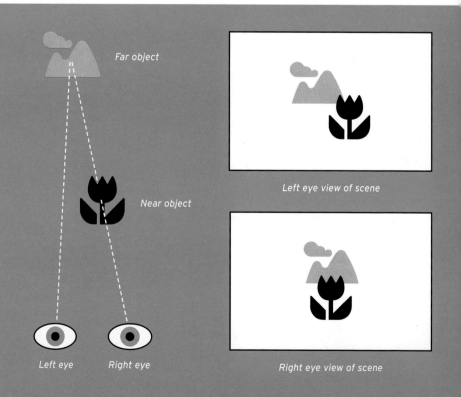

Far object

Near object

Left eye Right eye

Left eye view of scene

Right eye view of scene

Hyperfocal distance

The nearest point upon which a lens can be focused while maintaining acceptable *focus* for objects at *infinity*.

It is often desirable to have as much of an image in focus as possible. For example, landscape photographers often want to maximize the area of the scene that is in focus, from the *foreground* to the *background*. The "hyperfocal distance" is one way of determining useful *depth of field*. It is essentially a distance setting to which a photographer will focus, normally using a lens equipped with a distance scale which indicates how far away objects in correct focus are located. Everything in the *field of view* that is located from halfway to this point out to infinity, as a rough rule of thumb, will be in acceptable focus.

As with depth of field, the subjective concept of acceptable focus arises, and thus the *circle of confusion* value is required. When the lens *aperture*, the circle of confusion, and the lens *focal length* are all known, the hyperfocal distance can be calculated. Since it can be onerous to be performing arithmetic in the field, before digital it was common for photographers to carry precalculated hyperfocal distance tables or rely on the depth of field scales on older manual-focus lenses. Today a photographer could simply use a web-enabled phone to access one of many online hyperfocal distance calculators.

It is also common for digital photographers to bracket focus (take photos at different focus settings) and perhaps even combine these images in a computer for greater depth of field. This technique avoids the biggest flaw with relying on the hyperfocal distance: that objects at infinity are typically at the outer range of acceptable focus and thus may actually be somewhat softly focused in the final photo.

Camera focus is set to this point

Hyperfocal distance

1/2 hyperfocal distance

Depth of field

Depth of field (DoF)

The range of distance in a photograph in which objects are considered to be acceptably in *focus*.

When a lens is focused on a subject, the precise point at which focus is achieved is (or at least should be) perfectly sharp. The further one moves, distance-wise, from that point, the less sharp objects become. If there is great depth of field then much of the photograph will be acceptably sharp. If there is narrow depth of field then much of the rest of the photograph will be blurry. There is no arbitrary sharpness cutoff point—focus will decrease gradually as one looks away from the point in focus.

Depth of field is a surprisingly complicated subject, and discussions of DoF tend to involve a lot of mathematics. Here are a few of the key points.

First, depth of field is dependent on the lens *aperture* used. When a lens is used wide open (e.g.: f/1.8), depth of field is considerably less than when a lens is used stopped down (e.g.: f/22). For that reason photos taken under low-lighting conditions may not seem as acceptably sharp, because low-light photos tend to be taken with larger apertures to let in more light.

Second, the size of the photo is important. A photo displayed as a tiny picture on a website may seem acceptably sharp, yet the same image may seem disappointingly and unacceptably soft when enlarged as a photographic print.

Third, viewing distance matters. A large print may look quite soft when examined closely. Yet it may seem acceptably sharp when observed from a normal viewing distance.

Fourth, depth of field is dependent on the size of the image capture area. Photos taken with *point and shoot* digital cameras tend to be pretty sharp all over. This is because they have tiny image capture chips and correspondingly deep depth of field. Photos taken with medium-format or large-format film cameras may have very narrow depth of field.

Fifth, the distance from the subject in focus affects depth of field. For example,

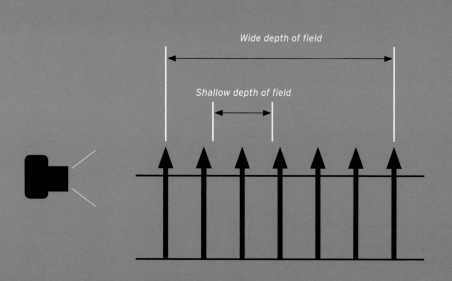

Wide depth of field

Shallow depth of field

at *macro* (closeup) distances the depth of field is notoriously razor-thin.

Sixth, it is often said that *wide-angle lenses* have great depth of field and *telephoto lenses* have narrow depth of field. To be strictly technically accurate, the *focal length* itself has almost no effect on depth of field. However, at subject distances at which they are normally used, wide-angle lenses end up having more of a scene in acceptable focus than telephoto lenses.

Finally, there is an element of subjectivity: what seems acceptably sharp to one person may seem unacceptably blurry to another person. Focus decreases gradually, and "acceptable" focus will differ from one person to another.

It is possible to calculate the depth of field based on a number of pieces of information. These calculations rely on the *circle of confusion*.

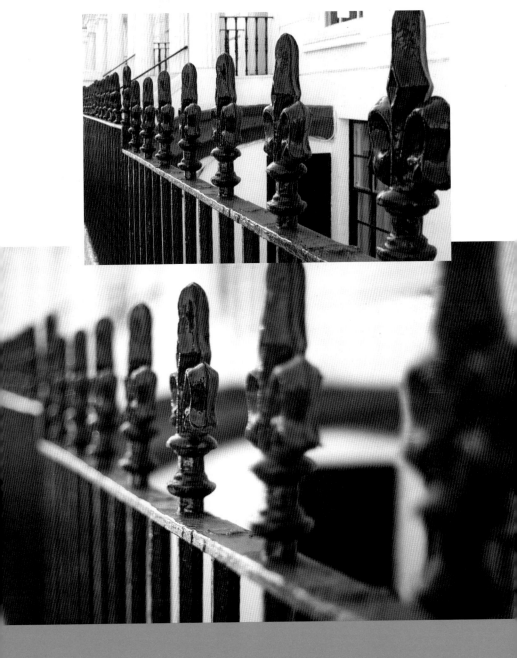

Circle of confusion (CoC)

A bundle of rays of light that records as a circle on film or on an *image sensor* rather than a point.

Mathematical calculations of *depth of field* rely on a concept known as the circle of confusion, which is essentially a way of quantifying the subjective notion of acceptable *focus*.

Lenses can be said to cast cone-shaped bundles of light rays onto the surface of the film or image sensor (the image plane). If an object is precisely in focus then the very tip of the cone will touch the image plane, resulting in a perfect point of light being recorded. (At least in theory— no lens in real life is ever this precise.) If the lens is not in focus then the tip of the cone will no longer coincide with the image plane. A cross-section of the cone will cut through the plane, resulting in a circle being recorded.

If the circle is really tiny then the human eye will be unable to distinguish it from a true point: the two can be confused. There is thus a maximum size to the circle of confusion, which is the size when a circle no longer resembles a point.

This is a subjective concept. The CoC depends on many factors, such as the visual acuity of the observer and the viewing distance. Accordingly, there are certain conventional notions of an acceptable circle of confusion which have arisen. In the case of *35mm* film, a CoC of 0.025mm or 0.030mm is often used. Small digital sensors will have smaller circles, and medium- and large-format film will have larger.

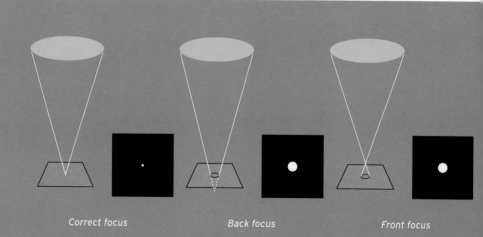

Correct focus Back focus Front focus

Background

Very simply, anything situated behind the subject of a photograph.

The term is contextual, and can refer to a canvas or seamless paper studio backdrop, or to anything that appears behind the subject, such as a landscape or a building. Because artificial light falls off quite rapidly, according to the *inverse square law*, a background will often be lit separately from the subject. The background may also not be in *focus*, assuming that the focus is set to a *foreground* subject and *depth of field* is inadequate to provide acceptable focus.

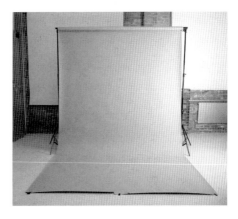

↑ *A pair of stands supporting a horizontal crossbar. This type of backdrop stand is often used for location work. Shown here with a roll of gray seamless paper draped in a smooth sweep or scoop.*

Foreground

Those items located toward the front of a scene, particularly those closer to the camera than the subject in *focus*.

Because of *perspective*, foreground objects may appear to be relatively large. They may also be in or out of focus, depending on the *depth of field* and the distance from the (presumably in-focus) subject.

The presence of foreground objects can help convey a sense of depth to the image by providing another plane of focus.

Distortion

Curvilinear distortion is an *aberration* which causes straight lines to appear as curves in an image.

Distortion is a problem typically seen in lenses, *CRT* monitors, and *projectors*. Three common forms are barrel, pincushion, and moustache.

Barrel distortion

Barrel distortion results in a square grid appearing to have a bulge in the middle, as shown below. It's commonly seen on *wide-angle lenses*, but fortunately can be corrected fairly simply using image-editing software, since the bulging occurs in a simple, predictable fashion.

Pincushion distortion

Pincushioning results in square grids appearing to sink inwards, as shown below right. Like barrel distortion, a pincushion is easily fixed using software. The effect can sometimes be seen on *telephoto lenses*.

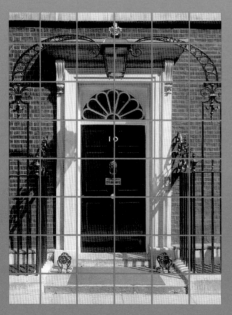

↑ *The scene as an ideal lens would see it. Straight lines are straight and parallel.*

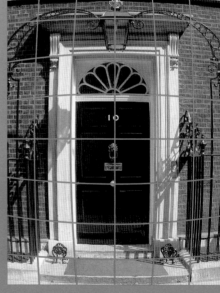

↑ *The scene as viewed by a lens with extreme barrel distortion, exaggerated here for effect. Straight lines appear to bulge forward. Barrel distortion is common with wide-angle zoom lenses, particularly those used by inexpensive cameras. Note how the effect is more pronounced toward the edges of the frame.*

Moustache distortion

A more complex form of distortion combines both barrel and pincushioning, and is colloquially known as moustache, wave, or gullwing distortion. Such distortion is more difficult to correct for in software.

Lens distortion

Distortion is commonly seen on consumer *zoom lenses*, because it's one of the less obvious and objectionable optical problems a lens can have. It's also challenging to design an affordable zoom lens, which is why it's common for zooms to have noticeable barrel distortion at the wide end and pincushion at the long end.

While distortion is particularly problematic for architectural photographers, where the rendering of straight lines is of paramount importance, the average photographer is probably more concerned with sharpness and *contrast*. If distortion is an issue it's generally best to use *prime lenses*, particularly *macro lenses* which are usually optimized for geometrical accuracy.

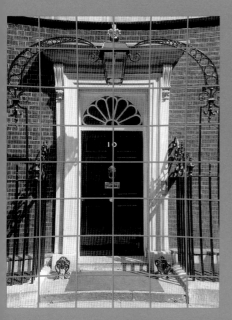

↑ *The scene with extreme pincushion distortion, again exaggerated for effect. Straight lines appear to sag inward.*

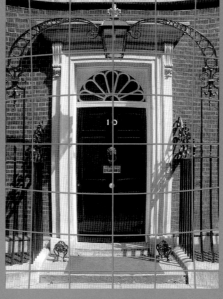

↑ *A complex form of distortion. This example appears as barrel distortion toward the center of the frame, becoming pincushion toward the edges of the frame. Straight lines resemble the large handlebar moustaches sported by nineteenth-century men.*

Aerial perspective

The appearance of distant objects; namely a loss of *contrast* and shift in color toward blue, caused by the atmosphere.

The Earth's atmosphere is not completely transparent. It consists of different types of gases and suspended particles, all of which can absorb and scatter light. The further an object is from the observer, the more the atmosphere's effects become apparent.

A classic example of aerial or atmospheric perspective is that of a range of hills or mountains. Each wedge of landscape appears as a separate flat plane with increasingly less detail and a muted bluer hue.

Leonardo da Vinci was a pioneer in using aerial perspective to demonstrate distance in paintings. The Mona Lisa, for example, employs aerial perspective in its background landscape.

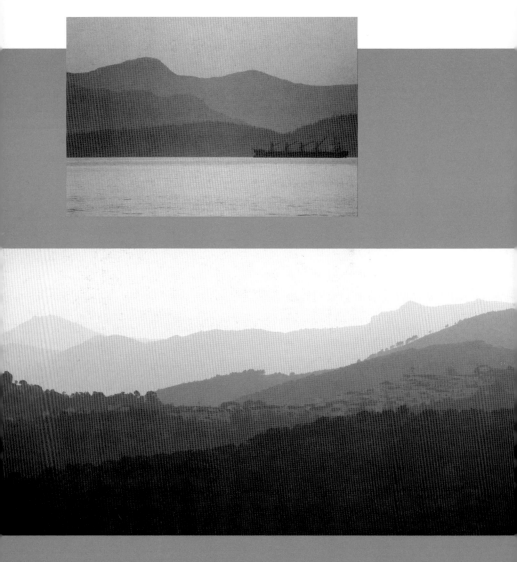

Focal plane

A flat plane, perpendicular to the optical axis of the lens, onto which the image is cast.

Normally the focal plane coincides exactly with the film or *image sensor* plane. In other words, the surface of the film or image sensor is located precisely at the point at which correctly focused rays of light converge. Any unintended deviation of the film or image plane from the focal plane will result in *focus* errors.

Note that there are instances when the film or image plane does not coincide with the focal plane. In the case of *view cameras* or cameras with tilt lenses, the film or image plane may be tilted at an angle relative to the focal plane to achieve specific results.

The position of the film or image plane is often marked on the outside of the camera body by the ⊖ symbol to assist with precise *macro* measurements.

← *Since this SLR cannot support lens movements, and since its lens has no tilt capabilities, the light rays entering the camera are at the center of the lens, perpendicular to the focal point.*

90°

Keystoning

A *perspective* issue whereby a rectangular object images as a trapezoid.

Converging verticals can be a problem when photographing tall buildings from the ground. The effect is that of a building tilting backward or falling back. This is an example of keystoning, where the camera is tilted so that it is not parallel to the ground, and the distance from the camera to the base of the building is less than the distance from the camera to the top of the building. This perspective means that the building records in a characteristic trapezoidal shape.

Keystoning is not an optical flaw but the result of simple optical geometry. It can be corrected by moving the camera position relative to the building. Or, if that isn't possible, it can be corrected optically by using a perspective-correction (shift) lens, or digitally using software.

Keystoning is also seen in *CRT* displays and *projectors*. In the case of CRTs it results from timing issues of the electron beam inside the tube, which must be adjusted electronically. In the case of projectors it occurs when the screen upon which the image is being shown is not parallel to the projector.

The term likely derives from the architectural keystone, the wedge-shaped stone at the top of an arch.

↑ *This photo was taken with the lens tilting upward. As a result the top portion of the building was further away from the camera than the lower portion, resulting in the classic converging verticals illusion that makes the building look like it is falling away backwards.*

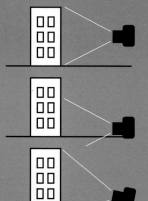

Dispersion

A change in *refraction* based on wavelength; a phenomenon we see as the breaking up of white light to reveal its constituent colors.

As Isaac Newton demonstrated in the 1670s, what we see as white light actually consists of many different colors or wavelengths of light. A *prism* can be used to break up or disperse white light into a rainbow.

Dispersion is a problem for photographic imaging, since it can result in color fringing around high-contrast objects. The issue is particularly acute for lens designers when making long *telephotos* and *retrofocus wide-angle lenses*.

For this reason many lenses contain special glass that has very low dispersion (higher refractive index) properties. Such glass is known by a variety of marketing names, such as low dispersion (LD), extra-low dispersion (ED), super-low dispersion (SD), ultra-low dispersion (UD), and so on. When used to make eyeglasses this type of glass is usually known as high-index glass.

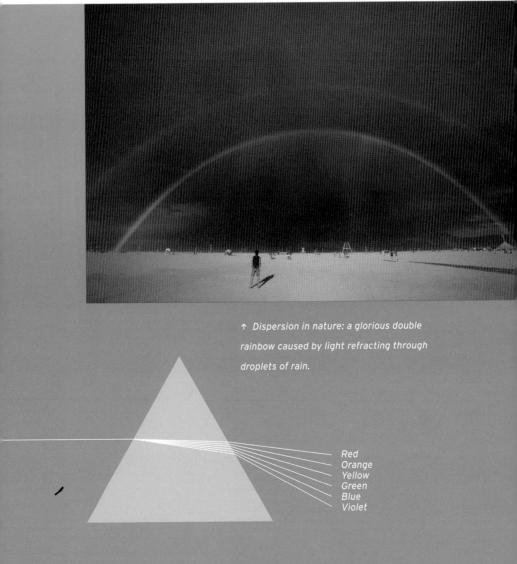

↑ *Dispersion in nature: a glorious double rainbow caused by light refracting through droplets of rain.*

Red
Orange
Yellow
Green
Blue
Violet

Aberration

Any of a number of different optical imperfections in a lens that result in a deviation in actual imaging results from a theoretical ideal.

The ideal goal of camera lens designers is a lens which projects a perfect image. Each ray of light entering the lens would image to the same expected point on the film or sensor. Straight lines would record as straight lines, *contrast* and sharpness would be high, and no fringing would be evident.

Unfortunately, such a lens is just a dream, since real life imposes compromises between what is desirable, what is technically feasible, and what is affordable. There are many different types of flaws or optical aberrations, all inherent to the design and manufacture of the lens, of which some are listed here.

Spherical aberration

This classic form of aberration usually shows itself as blurring, particularly away from the center of the image. It can be corrected by using "aspherical" lenses, which are lens elements not a cross-section of a sphere. Spherical aberration affects all colors of light equally, and can be reduced by stopping down the lens. Some lenses deliberately use spherical aberration to induce a *soft focus* look.

Chromatic aberration

This color aberration is due to *dispersion*, which causes white light to be split into its constituent colors. It manifests itself as color fringing to objects, often in purples and greens, and comes in two forms: lateral and longitudinal. Transverse or lateral chromatic aberration (LCA) causes

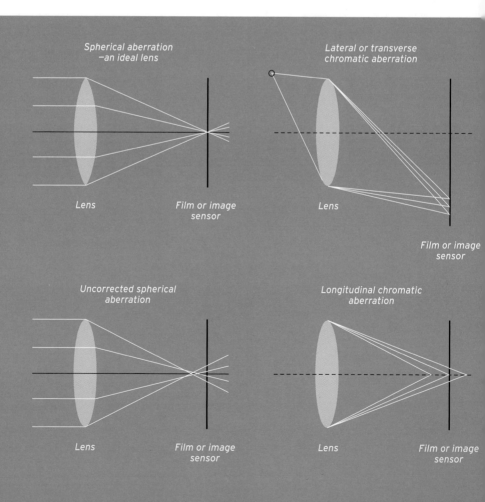

Spherical aberration
–an ideal lens

Lens

Film or image sensor

Lateral or transverse chromatic aberration

Lens

Film or image sensor

Uncorrected spherical aberration

Lens

Film or image sensor

Longitudinal chromatic aberration

Lens

Film or image sensor

color fringes around high-contrast lines toward the edges of the frame, and cannot be reduced by changing *aperture*. Longitudinal or axial CA, on the other hand, affects high-contrast edges across the frame, and can be minimized by stopping down.

Distortion

Distortion is a common enough aberration to warrant its own discussion elsewhere in this book. It involves alterations in the shape of the projected image.

Coma

An aberration that causes points to image as teardrop or comet shapes toward the edges of the frame, hence the name. Coma can be reduced by stopping down the lens.

Curvature of field

An aberration that images a flat plane as a curved surface, resulting in *focus* errors toward the edges of the frame. True *macro lenses*, designed in part for copy work, tend to be well-corrected against this problem.

Astigmatism

An aberration that causes blurring of subjects depending on their orientation. A lens with noticeable astigmatism will cause more blurring for lines radiating out from the center of the lens, or for lines perpendicular to those lines (sagittal and tangential). The problem is more pronounced away from the center of the frame.

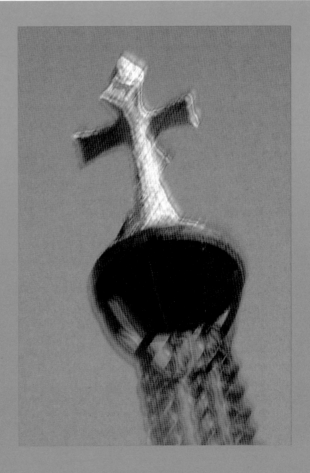

→ An image taken normally, and with a prism-style multiple-image filter. The filter suffers from extreme chromatic aberration, leading to bright color fringes appearing around objects. In this case the red and blue fringes can be seen as shadows on either side.

Diffraction

An optical phenomenon whereby light waves form interference patterns when passing through narrow openings or past obstructions.

Light bends when it passes an obstacle. This is normally not a particularly noticeable effect except when very small *apertures* (openings) are used.

Sharpness loss at small apertures

Diffractive effects can cause loss of image sharpness in camera lenses. The most common example is that of a photographic lens stopped down in aperture. When lens apertures are very small, diffraction around the opening takes a heavy toll on image sharpness.

Diffraction limits with digital cameras

Diffraction is also one of the causes of *image quality* loss with *digital cameras* with very small sensors. Tiny photosites or light sensors on such chips are greatly affected by the diffractive effects of a lens. This is one reason why increasing the number of megapixels on a sensor chip actually does little to improve actual image quality in the case of *point and shoots* once the diffractive limit is reached: the resolution is actually "diffraction-limited."

Diffractive lenses

A handful of lenses exploit diffractive optics as part of their design. Such lenses contain carefully constructed diffraction gratings along with normal lens elements. The diffraction gratings allow for lighter and shorter lenses than otherwise might be possible. The diffractive elements are immune to chromatic *aberration* but can be vulnerable to flare.

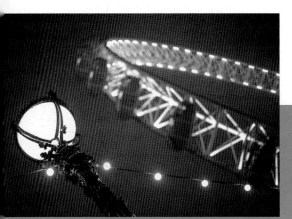

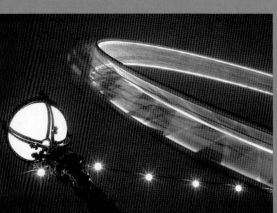

← *Diffraction at small apertures softens focus and can also result in star patterns appearing around point sources. The first photo was taken at f/1.8 for 1/4 second and the second at f/22 for 25 seconds. The exposure values are the same, but the second image shows starbursts because of diffraction as well as blurring the motion of the Ferris wheel because of exposure.*

Infinity

I n a photographic context, simply a long way away.

In practical terms, when a lens is focused to infinity it doesn't necessarily mean a literal infinite distance away. After all, an object an infinite distance away from us wouldn't be visible at all since its light would take an infinite amount of time to reach us and the universe has a finite age. The term just means that any object a great distance away will be in *focus*. In real-life photography that usually means objects in the sky such as clouds or the moon.

Not all lenses are capable of infinity focus. For example, some specialized *macro lenses* have a limited range of focus. A lens adapted from another camera system may fail to attain infinity focus if the lens registers are incompatible.

Other lenses are also capable of having their focus adjusted past the infinity mark. Such lenses can't actually travel to infinity and beyond but are simply designed to accommodate changes in focus owing to mechanical wear or thermal expansion.

The position for infinity focus is usually marked on a lens with the infinity symbol (∞).

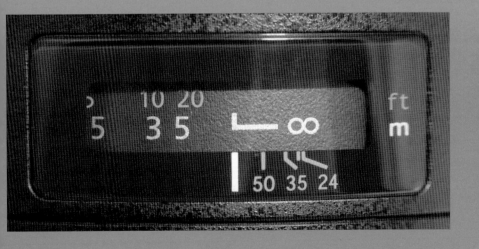

Lens flare

Light which is reflected inside a lens or camera in an unwanted fashion, resulting in bright areas appearing in the photo.

The classic example of lens flare occurs when the sun is visible in the frame. In addition to bright lines radiating from the sun there will be one or more ghost images of the sun, or curved bright areas, appearing elsewhere in the image. This is caused by light reflecting inside the lens itself. The problem can be worsened by poor quality or dirty lens filters.

The sun doesn't even have to be in the frame for this to occur. Nonimage-forming light entering the lens obliquely can also cause lens flare. This is the primary cause of mysterious ghostly dots or "orbs" appearing in photographs. *Lens hoods* are one way of reducing this problem, because they effectively put the lens at the bottom of a short tunnel, thereby blocking this stray light. Sometimes it may be necessary to shield the lens from the sun or a bright light. *Studio* photographers often use small movable panels, known as flags, for this purpose.

Poorly designed or badly coated lenses can also have an overall loss of *contrast* to them because of lens flare.

Lens flare can be reduced by using high-quality multicoated lenses, by using *prime lenses* rather than *zooms* (zooms tend to have more lens elements and can sometimes be more vulnerable to flare), by using lens hoods, by keeping the glass scrupulously clean, by using clean multicoated filters or no filters at all, and by using lenses with flare-reducing internal baffles.

Of course, flare can also be used for creative effect. In fact, computer graphics artists often add simulated lens flare to games and movies to make them seem more realistic.

Bokeh

The subjective quality of out-of-focus areas (background blurring) in an image.

Lenses have many optical qualities: sharpness, color rendition, *contrast*, and so on. One of the less obvious ones has long been known in Japan, but wasn't really discussed in the West until the 1990s: bokeh.

Bokeh or boké is a Japanese loan word pronounced with two short vowels and no diphthongs, and refers to the quality or softness of those areas of a photo which are not in *focus*. For example, a portrait might be taken of a person standing in front of a tree. If *depth of field* is narrow, the tree may be very much out of focus. But how that tree appears in the final photo depends on the lens design used. Some lenses render out-of-focus objects in a soft and smooth way, but others render them in a noisy and jumbled fashion. Portraiture is just one type of photography where smooth, uncluttered, and nondistracting *backgrounds* are usually considered highly pleasing.

The shape of the aperture diaphragm is one factor influencing the look of bokeh, since circular *diaphragms* sometimes produce smooth bokeh. Mirror lenses or other lenses with central obstructions are notorious for poor quality bokeh. Such lenses render small, bright areas as tiny rings, or annular bokeh. They may also render single lines as double lines, a phenomenon known as "cross-eyed" or "ni-sen" ("two line" in Japanese) bokeh.

Aspects of bokeh can be manipulated in a simple fashion for creative or amusing effect. For example, a piece of paper can be installed over a camera lens with a shape cut out of it. Bright out-of-focus areas will then take on that shape.

Bokeh is generally not a consideration with small *point and shoot* digicams. Such cameras have small *image sensors*, resulting in very wide depth of field, so relatively little of a given photo will be out of focus anyway.

→ *Putting bokeh to creative use. This photograph is nothing more complicated than a model sitting in front of a string of Christmas lights taped to the wall. A cardboard disc with a moon shape cut out of it was installed in front of a 50mm f/1.8 lens on a 35mm camera. The bright highlights take on the moon shape accordingly.*

Inverse square law

The quartering of light intensity as distance from the light source doubles.

It is intuitive and obvious that light seems dimmer the farther one stands from its source. What is less obvious is the rate at which light decreases in brightness as one moves away from the source. It actually falls off surprisingly rapidly because, unless concentrated into a focused beam, light spreads out through space. So if the distance is doubled then light has to cover four times the same area. And the light is only a quarter of the strength with a doubling of the distance from the source.

Physicists call this the "inverse square law." More formally, the brightness of light radiating from a point source is inversely proportional to the square of the distance from that source.

This has real consequences for lighting and photography. Since light drops off in brightness so rapidly it can sometimes take more light than expected to illuminate a subject. A snapshot of a group of friends in a restaurant is a classic example. The light from the camera's *flash* will illuminate the people quite well, but unless it's a powerful flash the rest of the scene will be quite dark.

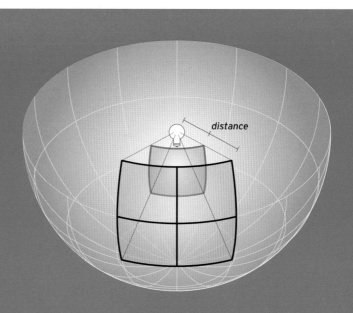

↑ *Light shining on the interior surface of an imaginary sphere from a light source positioned at its center. With a doubling of the distance from the light source comes a quadrupling of the surface area of the sphere covered by the same amount of light.*

Peripheral darkening

Uneven illumination of field; a decrease in brightness toward the edges of the image.

There are a number of different conditions which can result in the periphery of a picture appearing darker than the center, an effect also known as "vignetting."

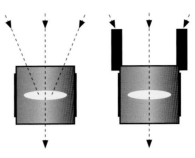

↑ *Light entering a lens (left). Light obstructed by an incorrectly sized lens hood (right).*

Mechanical

Very simply, something is blocking the light around the edges of the lens. This can be a *lens hood* of the wrong size, or too many or too thickly framed add-on *filters*, and so on.

Optical

Lenses are generally built inside opaque tubes. When the aperture diaphragm is wide open, light entering at an angle may be blocked by the sides of the lens itself. The problem decreases if the aperture is stopped down since the cone of light projecting out from the back of the lens is narrower and thus less likely to be obstructed.

Natural

Also known as \cos^4 vignetting, for the "cosine to 4th power" mathematical law. The more of an angle at which light has to be bent, the more light falloff there is. Thus the edges of a photo, where light rays are at an oblique angle, may be darker.

This can be a particular problem with *wide-angle* rangefinder lenses, which have rear elements very close to the film or *image sensor*. In fact, some classic *rangefinder* lenses came with add-on filters which were dark towards the center to counteract the effect.

Pixel

Digital camera sensor photosites are located at the bottom of shallow wells or holes in the surface of the sensor material. Pixel darkening is thus optical vignetting in miniature, as the walls of the photosite can obstruct light entering at an angle other than 90 degrees.

Intentional

Vignetting can be deliberately created in order to draw the viewer's attention to the middle of the picture, or to give the impression of an old photo. This effect is easily performed in a *darkroom* by burning in the periphery, or through digital editing.

↑ *Darkened corners have been deliberately added to this photo for a vignetting effect.*

Image quality (IQ)

In a colloquial sense, the subjective technical quality of a photo or, more commonly, the capabilities of an image-gathering system.

An analysis of image quality considers factors such as the sharpness, *contrast*, color fidelity, and other technical qualities of the photo rather than artistic considerations such as *composition* or informational content. However, image quality is nonetheless typically a subjective determination and not necessarily reliant on detailed comparative measurements.

The term is also used informally to describe the abilities of a camera or lens. For example, "my six megapixel *SLR* has way better image quality than my 10 megapixel *point and shoot*."

→ *The obligatory snapshot of the family pet is, in fact, an effective way to get a rough sense of a camera's image quality. Fur has extremely fine high-contrast detail which a camera has difficulty in resolving.*

← *This image was taken with a pro-level 12 megapixel digital SLR, handheld at ISO 800. Some noise is apparent at this high ISO setting, but fine details in the iris can be made out.*

← *This image was taken with a consumer 12 megapixel point and shoot, also handheld at ISO 800. Even though this camera has the same output resolution and the same ISO settings were used, the drawbacks of its tiny sensor are apparent: there is considerable noise. The camera has attempted to reduce this through noise reduction algorithms, but the result is a smudged loss of detail.*

Color

Different wavelengths of light and, equally important for photographers, the subjective human experience of sensing that light.

From the point of view of a physicist, light consists of electromagnetic radiation with different wavelengths and intensities. Measured in nanometers (nm), light ranges in wavelength from around 400nm to about 700nm. Light at the shorter end of the electromagnetic spectrum appears blue to humans, and light at the longer end appears red. Other colors fall in a rainbow spectrum between those two extremes.

From the point of view of a biologist, the retina of the human eye is lined with millions of photoreceptor cells. These light-sensing cells come in four basic types. One type, the rods, can't sense color and is used only in low-light situations. The other three types, known as cones, respond to light across a range of frequencies but only under fairly well-lit conditions. (This is why things look less colorful at night: there isn't enough light to trigger the color-sensitive cells.) At the risk of oversimplifying matters, one cone type responds primarily to red light, one to blue, and one to green. The brain takes in the signals produced by these cone cells and interprets the sensation as color. We then use learned, arbitrary, and culturally-specific labels to describe certain colors: red, blue, green, and so on.

From the point of view of an artist there are countless emotional triggers associated with color. Red, the color of blood, is very noticeable to the eye and is typically associated with warnings or strong emotions. Yellow light and blue light have associations with the warmth of a fire and the coolness of late evening respectively.

From a photographic point of view, therefore, color is a very complex subject since it combines all of the above. In some respects it's a matter of physics and engineering. But perception of color is also highly subjective, psychological, and emotional.

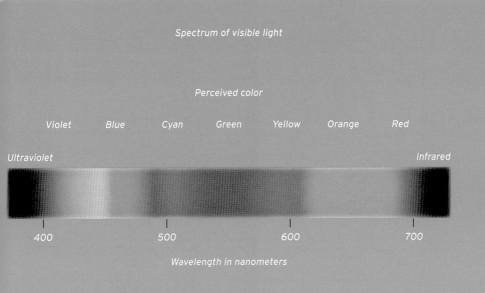

Spectrum of visible light

Perceived color

Violet Blue Cyan Green Yellow Orange Red

Ultraviolet Infrared

400 500 600 700

Wavelength in nanometers

Trichromatic vision

A theoretical model for human color vision, described by Thomas Young and Hermann von Helmholtz in the nineteenth century, which states that the eye has three types of color-sensitive receptors.

Trichromacy, which has been backed by considerable physiological research in the twentieth century, explains the way that three colors of light can be mixed in various proportions to simulate all the colors which we can see.

The eyes of most human beings contain four different types of light-sensitive cells, or photoreceptors. One type, known as rod cells, is used for low-light and motion sensitivity and cannot really sense any color. The other three types are known as cone cells. Each type is sensitive to slightly different wavelengths of light. Signals from these three cone cell types are sent to the brain, where they are interpreted and a color view of the world is constructed.

Trichromatic color vision is not universal. "Color blind" individuals lack certain types of functioning color-detecting cells, restricting the range of wavelengths they can distinguish. They can confuse colors which appear very different to a person equipped with trichromatic vision (see *metamerism*). Other species of animal are capable of detecting a different range of colors than humans. Most birds, for example, can see more colors than people can, sometimes even sensing *ultraviolet*. Dogs and cats, however, have far worse color perception than humans.

Trichromacy is used to our benefit in the construction of video screens and in color printing. Only three colors of light or printed ink are required to simulate the color range we can detect.

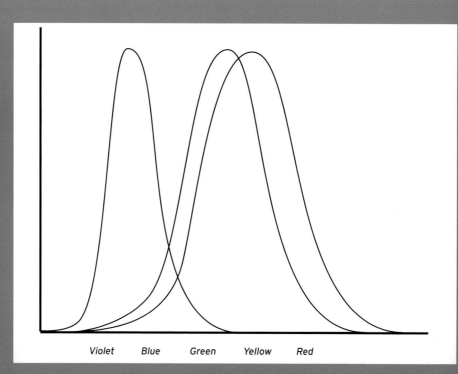

Violet Blue Green Yellow Red

↑ *Approximate spectral response of the three types of cone cells in the human eye. Note how there is considerable overlap in color response between the three types.*

Color opponent model

A model of human color vision which states that color is interpreted in three pairs of opposing color types.

While the Young-Helmholtz tristimulus (*trichromatic*) model of human color vision is very effective, it fails to explain certain phenomena. For example, the notion of a mixture of red and green is simply unimaginable to us. Accordingly, the color opponent process theory was devised in 1878 by Ewald Hering, who argued that human color vision involves three "opponent pairs" of color information.

These opponent pairs are bright-dark, yellow-blue, and red-green. Further research in the 1950s and 60s established that, while color receptor cells do indeed follow the traditional tristimulus model, the information they send to the brain is processed by another group of neurons in a manner explained by the opponent pair model. Thus both models are accurate and are not contradictory.

Color opponency explains why, for instance, the afterimage of a bright red light source is green. The Lab color model is one practical application of the theory.

Opponent pairs

Metamerism

A phenomenon whereby two different objects, which reflect light of very different wavelengths, appear to a human to be of the same color.

The classic example of metamerism is the color-matching problem when shopping for clothes. Two items of clothing may seem to be the same color when viewed under the artificial lights in a store, but are revealed to be completely different colors when taken outside and viewed under daylight conditions. The two clothing samples are said to be "metamers." Colors can also look very different if illuminated by tungsten versus fluorescent lights.

People sometimes say that the color mismatch issue is metamerism, implying that metamerism is itself a problem. Other people refer to the mismatch issue as "metameric failure" caused by different illuminants. To be strictly accurate, metamerism refers to the entire situation of two material samples, two light sources, and human vision. It can be a problem or it can be an advantage.

Metamerism is used to our benefit in the case of color reproduction. The RGB and CMYK *color models* work by simulating a wide range of possible colors even though only three actual colors are used. (CMYK adds a black ink for improved black quality, but this is not required for reproducing the sensation of color.) The three colors are chosen to stimulate cone cells in the human eye in a way that simulates full color. Thanks to metamerism we can print out a color portrait without having to use skin-colored ink.

Metamerism is thus a consequence of human *trichromatic* color vision, whereby most people have three types of color-sensing visual cells. We thus cannot detect specific or absolute color values the way a machine might. Instead, combinations of signals from the three types of color-sensing cells allow the brain to build up a picture of the world illustrated with color information. And certain combinations coincide, causing metamerism.

A related problem can occur with pigment-based ink-jet prints, which can appear color-shifted when viewed under different lighting conditions. Technically this is not actually metamerism, since it involves apparent shifts in color for one print viewed with different illuminants. It does not involve a comparison of two materials.

Color temperature

The color of light emitted by a theoretical black body object that has been heated to a certain temperature, described in Kelvin units.

Color temperature is a confusing concept because it is both a theoretical model and, in a simplified form, a practical tool for photographers who work with color.

Color temperature and physics

From the point of view of a physicist, black body radiators are imaginary objects that absorb all energy (or to be technically accurate, all electromagnetic radiation or EMR) shone upon them. However, when heated, a black body object itself radiates energy outward.

The closest thing to a black body object in real life is something like a lump of iron which appears dull black when cold. However, when heated the iron will start to glow: red, yellow, then white. The color of the light (i.e.: the frequency of visible EMR) is directly related to the temperature.

Note two potentially confusing and counterintuitive points. First, light that we traditionally consider to be yellowish and "warm" is actually cooler by the color temperature model. By contrast, light that we consider to be bluish and "cool" is actually hotter in terms of its color temperature. Second, color temperature does not necessarily refer to actual physical temperatures experienced by a person. →

↑ A true black body object, if one were to exist, would absorb all forms of electromagnetic radiation, including light. It would thus appear completely black to the eye, since nothing would be reflected off its surface.

↑ However, if the black body object became hot enough it would start to send electromagnetic radiation outward. If the wavelengths corresponded to visible light then we would be able to see the object glowing.

Color temperature

Color temperature is measured using the standard physicists' temperature unit, the Kelvin, abbreviated as K. Kelvin units are similar to degrees Celsius but start at absolute zero rather than the freezing point of water. Zero degrees Celsius is equal to 273.15 Kelvin or 32 degrees Fahrenheit.

Color temperature and photography

How does this relate to photography? Well, many sources of light approximate a black body model. Sunlight and artificial lights which work by heating metallic elements, such as incandescent tungsten bulbs, both come close to the black body ideal. Light from a tungsten bulb has a color temperature of about 3,200 K. Light from noonday sun in a temperate region is about 5,500 K.

It is also critical to note that human perception of white light is extremely subjective and contextual. Take, for example, the light from an ordinary tungsten bulb, which seems white to us. Yet if we were to go outside at dusk, when the evening light is very blue, then suddenly that light spilling from the living room window looks extremely yellow.

Color film is not capable of adjusting to light conditions the way our brains can. The chemistry of its emulsion is set permanently at time of manufacture. Film thus has a predefined white point, which is the color temperature of light that records as white and not orange or blue. Most films are daylight balanced, and assume "white" means 5,500 K. Such films, when used indoors under tungsten lighting, end up recording very orange-looking scenes. Tungsten-balanced film usually assumes "white" is 3,200 K, and will record bluish scenes if used outdoors. The only way to correct for this is to use colored *filters* to adjust the balance of light entering the lens.

Digital cameras are considerably more flexible, since they can examine incoming light, determine its color temperature, and adjust *white balance* accordingly. This is known as automatic white balance.

Light sources which do not follow the black body model, such as fluorescent lamps and other gas vapor lights, have "correlated color temperatures."

8,000 K	Shade
6,500 K	Cloudy
5,500 K	Flash
	Sun
3,200 K	Tungsten
1,500 K	Flame

Color cast

An overall color tinge to a color photograph. Color casts are generally unwanted, and may represent a mismatch between the light source and the color balance of the imaging device. In the case of film, color casts often occur when using certain emulsions under light sources not designed for them. A classic problem is the yellow-orange cast that daylight-balanced film takes on when used with tungsten light. Tungsten-balanced film will take on a blue cast when used with *flash* or sunlight.

Color casts can also be introduced by other light source issues. For example, *bounce flash* can give a wall or ceiling-colored cast. Rooms lit by fluorescents can lend a greenish cast without a light magenta color correction filter.

Color casts, particularly those caused by mixed lighting situations, can be challenging to resolve with film, but digital is more flexible. *White balance* settings may be set inside the camera, or the color balance can be adjusted selectively in an image-editing program later on.

Color model

Mathematical models, built on both biological theory and empirical testing of human subjects, which quantify the human response to color.

One of the first color models, still in use today, is the CIE XYZ model. It was published in 1931 by the CIE (Commission Internationale de l'Éclairage, or International Commission on Illumination, an international standardization body for lighting), and was based on human color perception research from the 1920s. Scientific research into color, the measurement of color data, and the practical application of color models is known as "colorimetry."

The XYZ model can be illustrated by a two-dimensional chart containing a roughly horseshoe-shaped curve. The area inside this curve represents the full range of colors of which the typical human (the "standard observer") is capable of seeing. It thus is a model for the subjective human experience of vision rather than a model for all the possible colors that may exist.

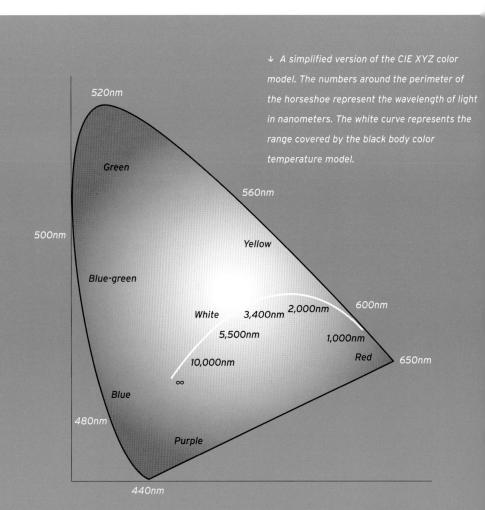

↓ A simplified version of the CIE XYZ color model. The numbers around the perimeter of the horseshoe represent the wavelength of light in nanometers. The white curve represents the range covered by the black body color temperature model.

Additive color

A *color model* for combined light projected by multiple light sources.

TV sets and computer monitors are common examples of additive devices which produce red, green, and blue light. When these three colors are mixed in different proportions, other colors appear to form thanks to our *trichromatic* vision. For example, red light mixed with green light appears yellow to human vision, even though true yellow light is actually of a different wavelength. When all three colors are mixed equally, white light results.

Additive color is thus the reverse of the *subtractive color* model used for inks, paints, and dyes. It may seem counterintuitive, but can easily be proven by examining an *LCD* monitor in operation. A screen displaying a white object appears to be solid white to the eye, but a magnifying glass will show that white areas actually consist of separate red, green, and blue light sources.

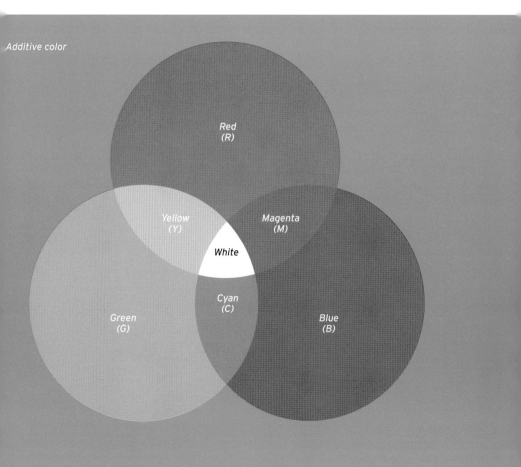

Additive color

Red
(R)

Yellow
(Y)

Magenta
(M)

White

Cyan
(C)

Green
(G)

Blue
(B)

Subtractive color

A *color model* for reflected light, whereby white light shines on an opaque surface and is reflected back to the eye.

The most common subtractive color model is CMYK, which is the model used for color printing onto an opaque material such as paper. It assumes a number of things. First, it assumes that the light hitting the paper is essentially pure white, that the paper itself is as white as possible (i.e.: it reflects all colors equally), and that four basic dyes or pigments are available: cyan (C), magenta (M), yellow (Y), and black (K). These colors are why CMYK is also known as a four-color process. Black is "K" because the letter "B" is reserved for the blue of the RGB color model.

With CMYK the three colored inks are used in varying proportions to create a range of different colors. Each blend of colors subtracts (hence the name) wavelengths of light from the pure white of the paper. For example, a yellow and blue blend removes those two wavelength ranges from the white, resulting in a color we interpret as green. Similarly magenta and yellow produces red. This subtractive color model is essentially the model we learned when mixing paints as children, though offset printing uses color *halftones* rather than a mixing of the colors as such.

The fourth ink, black, is required because color dyes and pigments are not pure enough to produce true black when cyan, magenta, and yellow are used. This usually results in a sort of muddy brown color, just as mixing all our paints together did when we were kids. Accordingly jet black inks are normally used for printing true black areas, such as black type on a page.

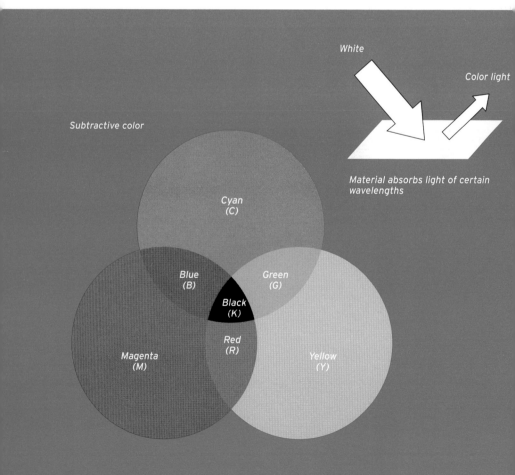

White

Color light

Subtractive color

Material absorbs light of certain wavelengths

Cyan (C)

Blue (B)

Green (G)

Black (K)

Red (R)

Magenta (M)

Yellow (Y)

Monochrome, monochromatic

Involving varying shades of one color only.

Black-and-white photographs are a traditional type of monochrome image, in which a scene is recorded as shades of gray. However, monochromatic images can involve other colors. For example, cyanotype photographs record images as shades of blue, and so are not literally "black and white" though they are monochrome.

Black-and-white photography

Photography in which the brightness of a scene is recorded, but color information is not.

The term frequently implies traditional monochrome *silver gelatin* film technology. However, it's possible to take black-and-white photographs through a wide variety of means. For example, *chromogenic* dye cloud film can be used, as can digital technology. All record the amplitude of the light waveform but not the wavelength.

Black-and-white photography is no longer popular owing to the low cost and ubiquity of color photography. However, it's still very common in the fine art world, where tonality of form and subtlety of expression is valued over more literal recordings of a scene.

Color photography

Photography in which both the brightness and color information of a scene are recorded.

Most people are capable of detecting colors, which result from varying wavelengths of light energy. Color photography attempts to reproduce the human experience of color in the form of a two-dimensional photograph.

Many different technologies have been developed over the years to record color photographically, from combining the output of three colored glass plates in a slide projector, to multilayer chemical film, to digital devices which divide a scene into *pixels* recording varying proportions of red, blue, and green light.

Photograph

A two-dimensional still representation of a scene, created by means of an optical process.

Traditional definitions have focused on the need for chemical processes, simply because that was the only workable way to produce an optically-derived image before the advent of digital technology. Today electronic *image sensor chips*, sensitive to light, are the more common tool to create photographic images.

The first forms of photography were black and white, in that they could record the brightness of light. Later forms allowed for the recording of color, or light wavelength. The term derives from the two Greek words for "light" and "writing," respectively, and was coined by John Herschel in 1839.

Photosensitive

A material which reacts to the presence of light. Light-sensitive material is the fundamental basis for all photography, and takes two forms.

Photochemical sensitivity

Traditional chemical-based photography usually relies on silver halides. These are chemical compounds containing silver and one of three halogen elements: bromine, chlorine, or iodine. (Fluorine and astatine are not used photographically.) When a silver halide is exposed to light, some of the halide is converted into a tiny speck of metallic silver. This forms the invisible *latent image*, which is then rendered visible through a process of chemical development.

Photodetectors

Digital cameras (and solar power cells, for that matter) rely on a very different principle. The photoelectric effect causes certain materials to eject electrons when struck by electromagnetic radiation such as light. *Image sensors* are a type of photovoltaic device, where these electrons pass into the semiconductor material, allowing an electrical current to be captured. This current can be amplified and recorded by a computer.

Electronic image sensors will produce electricity so long as light shines upon them, making them suitable for both video and still-image capturing applications.

Frame

In the context of film, the area of a piece of film associated with an *exposure* or an image.

Most of the surface area of a piece of film is used for exposing the image, and thus constitutes the "frame." The size and shape of the frame depends on the type of camera being used. For example, virtually all *35mm still cameras* use a frame 36x24mm in size, with the long dimension parallel to the edge of the film.

In the context of digital, the size of an *image sensor* is sometimes described in relation to the concept of the "frame." Ultimately this is more for historical reasons than anything else, though it can be useful when comparing two cameras with different sensor sizes which are both compatible with the same type of lens.

Continuous tone

An image consisting of continuous shades of gray, as opposed to an image divided into a finite number of separate shades of gray.

A photograph is a continuous tone image, in that any arbitrary shade or color can be represented, at least within the range of grays and colors supported by the medium in question. A *halftone* image, on the other hand, is made up of a series of groups of dots. From a distance the halftone image may simulate a continuous tone image, but closer examination reveals this is not the case. Ink-jet printers also produce images made up of countless dots rather than continuous tones.

Contrast

The overall difference in brightness between a light area and a dark area in an image.

An image with a large range between the two is said to have high contrast. Take this crane silhouetted against the sky, for example. There are very few tonal values, and those that exist are widely separated in brightness: near-white for the sky and near-black for the crane and the building. This is a high-contrast photograph.

On the other hand, a grayish image with very little range between the two is said to be "flat," with low contrast. A photo taken on a foggy day is a good example of a low-contrast image. A brightly lit *high-key* image can also be low contrast.

The aerial photograph of a high desert region (below right) also has a limited tonal range, with the shades of gray quite close together. There are no blacks or whites in the image. This is a low-contrast photograph.

Cropping

Reducing the physical size of a given photographic print or negative, or altering the area of a negative or digital file source while optionally preserving the same output size.

At its simplest, cropping simply refers to taking a print or negative and cutting off unwanted areas of the image with a pair of scissors or a paper cutter. Similar effects can be achieved in an *enlarger* by

masking off areas of an image. Digitally, a cropping tool can remove unwanted portions of a photo. Having been trimmed, the cropped image may then be enlarged as required to fill the necessary space.

Cropping is usually done for aesthetic reasons, since it can involve the removal of distracting peripheral elements. It may also serve an editorial function in terms of focusing attention onto a given subject. This has often been taken to extremes in certain political and social arenas by removing key elements of a photo in order to mislead the viewer.

From a technical point of view, excessive cropping and subsequent enlarging of the image can worsen *image quality* by magnifying film *grain* or digital *pixels*.

↑ *Before*

↑ *During cropping*

← *After*

Exposure range

Available range of brightnesses between pure white and pure black.

Essentially, exposure range is the general concept of dynamic range applied to imaging, as it refers to the difference in brightness between the darkest area of an image and the brightest area. It does not refer to the number of tones or brightnesses between those high and low values.

Tonal range

The number of individual tones available to describe the full range of colors in an image.

In the case of a *digital camera*, the more bits of data are assigned to a *pixel* the most possible colors or shades that pixel can be. Accordingly there is greater flexibility available when manipulating images with high pixel depth than low pixel depth. If few shades are available then *banding* can occur if brightness or contrast, or particularly curves, are changed.

Halftone

A method for simulating shades of gray or color through the use of patterned dots.

The offset printing technology used for books and newspapers is not capable of reproducing shades of gray or color: it can only print solid colors. This means that photographs and other images with *continuous tones* can't be printed directly.

The solution is to convert a continuous tone image, such as a photograph, into a series of tiny solid dots; a process known as halftoning. These dots, which are equally spaced but are of different sizes, are so small that from a distance the halftoned image looks like it is made up of continuous shades. Color halftoning is also possible through careful positioning of groups of colored dots.

Traditionally halftoning was done photographically using fine screens. Today most photos are scanned into computers, and imagesetting machines are used to produce the halftoned images required by printing presses.

↑→ *A picture printed with a fine halftone and a coarse halftone.*

Moiré patterns

An interference pattern which appears when sets of evenly spaced lines, grids, or dots are superimposed. Moiré (pronounced "mwah-RAY") patterns can be an interesting optical illusion. For example, in the image to the left two sets of concentric circles are drawn over each other. Curved wavelike patterns seem to appear where the circles meet. Moiré interference is one of the tools exploited by op art artists in the 1960s to create their illusions.

In the fields of graphic design and digital photography, however, moiré can be a frustrating problem. Moiré is a frequent unwanted *artifact* with misaligned *halftone* patterns used in printing, with digital scans of halftoned images and with *image sensors* used in *digital cameras*.

Unwanted patterns also appear when a digital camera is used to photograph a subject with a higher frequency than the *resolution* of the camera's sensor. A phenomenon known as frequency aliasing results in the shimmering moiré artifacts. Take the concentric circles again. When drawn at a low resolution, such as on a computer screen, moiré appears.

A similar problem occurs when photographing patterned objects. Most cameras have *anti-aliasing* filters to minimize this effect, at the cost of some sharpness.

↓ *Moiré in an actual photograph. The bridge decking is made of metal with an antislip tread consisting of grooves on a regular grid. At certain magnifications a pronounced curved moiré pattern appears.*

Digital

Digital

Camera Storage

Camera Features

Computers

Software

Digital

Technology that stores information in a discontinuous form.

While technically many systems have been developed over the years that store information in a discontinuous format, such as Braille and Morse code, the term "digital" generally refers to electronic computers which store information in a binary format. That is to say, all information in the system can ultimately be reduced to one of two values: zero (off) or one (on). Modern computers then string together millions or billions of these binary *"bits"* together to produce a representation of continuous information, such as music, video, or photographs.

Analog and digital

Analog refers to information in a continuous form. In theory there is an infinite range in an analog signal, which can be seen as taking on a series of shades of gray.

Digital refers to information that has been divided into a series of discrete steps. Most digital devices store information in a binary form, where information is either on or off; black or white.

For example, nondigital audio equipment, such as cassettes and record players are all analog devices. They all record or play back real-world sounds that have been converted into continuously variable electrical currents.

By comparison, digital audio devices, such as CD and DVD players, store sound as a huge collection of on/off values. This is done through a process known as sampling, whereby a device records a continuously variable real-world sound and records its values as a representative sequence of samples. If the sampling rate is high enough, then the human ear is fooled into thinking that the discrete series of steps is continuous sound.

Digital photography is somewhat similar. A *digital camera* records each scene as a two-dimensional grid of tiny dots, or *pixels*. If enough pixels are recorded, and if each pixel has sufficient color values, then the resultant photograph is interpreted by the human eye as an image with *continuous tones* rather than separate and discrete values.

In an ideal world an analog signal should be of higher quality than a digital signal, since analog information has not been sliced up into discrete chunks. However, in reality analog signals are very vulnerable to degradation owing to *noise*. Think of an audio cassette which has been copied repeatedly: the music starts getting drowned out by the random hiss of analog noise. Digital systems, by contrast, usually have the ability to detect and correct errors introduced by noise.

Traditional film cameras are sometimes called "analog" cameras, although they rely on photochemical processes rather than electrical image-capturing systems. Technically the first electronic still cameras introduced in the 1980s were true analog cameras, since they used analog video electronics instead of digital. Such electronic analog cameras are largely a historical footnote today.

Analog waveform

Digital (sampled) approximation

Pixel

F rom "picture element." A single sampling point in a digital photo or other image.

Digital photos are often thought of as chessboard grids of tiny points. From a distance the eye can't make out each individual point, and sees instead a picture made of shades and colors. Each point is known in computing jargon as a pixel. A million pixels are known as a "megapixel." Images made up of pixels are often known as raster or bitmapped images.

Pixels are typically considered the smallest elements which compose a picture. But this is actually an oversimplification and depends on context. For example, *LCD* screens employ "subpixels." Each pixel on a color LCD is made up of three subpixels—one red, one green, and one blue. The varying brightnesses of each color combine to make a single color value for the pixel as a whole. Most *digital cameras* are even more complicated in that each image sensing point can typically only detect one color, resulting in a mosaic image (see *color filter array*).

Pixels are also considered to be one measure of *image quality*, in that a picture made up of many pixels is of higher quality (higher *resolution*) than a picture made up

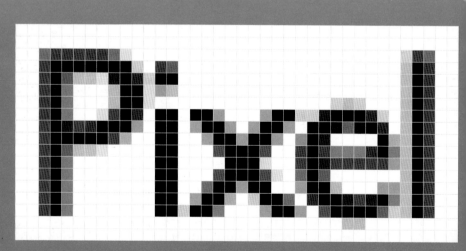

↑ *Digital images are usually made up of tiny dots on a grid. A grayscale grid looks like this.*

of fewer pixels. While this is true in the most general sense, other factors such as *bit depth* come into play. And in the case of digital cameras, various other factors such as *noise* and *compression* also determine the final quality of a captured image. For this reason a camera's megapixel specification isn't necessarily the best way to determine its output quality.

Most cameras and computers use square pixels, to avoid the problem of the image changing shape when rotated. However, some products do use rectangular pixels, such as the Nikon D1X digital camera and many PC graphics cards in the 1990s.

Sometimes a camera's megapixel and effective megapixel ratings are both listed. The latter is more meaningful since it indicates the true number of pixels which makes up the image. Digital cameras generally mask off a few pixels along the outer edges of the *image sensor* and use these blacked-out pixels to establish baseline black values. Since these masked pixels do not get included in the picture it's rather misleading to count them as part of the megapixel rating.

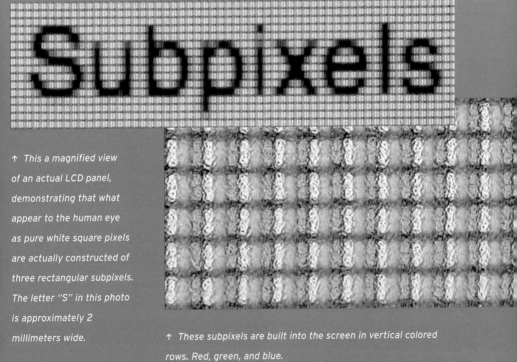

↑ This a magnified view of an actual LCD panel, demonstrating that what appear to the human eye as pure white square pixels are actually constructed of three rectangular subpixels. The letter "S" in this photo is approximately 2 millimeters wide.

↑ These subpixels are built into the screen in vertical colored rows. Red, green, and blue.

Image sensor, image sensor chip

An electronic component which is sensitive to light and which can record a picture projected onto it by an optical system such as a lens; the key component of a *digital camera*.

Image sensors serve a similar function to film in a film camera, in that they are both surfaces which record an image. Sensors differ from film in that their sensitivity to light is an electronic process, not a single-use chemical process.

Image sensors consist of millions of tiny photodetectors embedded into the surface of a flat piece of silicon, known as a chip. Each detector or "photosite" sends out electrical signals when light falls upon it. These analog signals are transformed into digital data which can then be displayed on a screen or printed out.

Image sensors are of one of two types at present—CCD (charge coupled device) and CMOS (complementary metal oxide semiconductor). CCDs are analog devices and output electrical signals to be digitized. CMOS sensors have amplifying circuits on-chip and perform the digitizing stage within the chip itself. Manufacturers tout the benefits of each chip type, but final *image quality* generally has more to do with the overall design of the camera than just the specific sensor type used. Most image sensors use *color filter arrays* to record color data.

Microlens

A tiny lens over a photosite which improves light capture.

Unlike film, where the entire surface of the *photosensitive* material is able to capture light, *image sensors* can only record light at specific points known as photosites. These are the locations where the light-sensitive photodiodes are physically located. The rest of the image sensor surface is taken up by other electronic components which are essential but which do not sense light. Thus a lot of light striking such a sensor is essentially wasted: it's either absorbed by the surface of the sensor or reflected.

One way to minimize this wastage is to install tiny little lenses over each photosite. These lenses capture light that would otherwise miss the photosite and funnel it accordingly, improving the device's sensitivity.

Microlenses can serve another useful function. Image sensor photosites are recessed into the surface of the sensor. This is often likened to viewing the sky from the bottom of a well: it's possible to see straight up but not to the sides. As a result, *digital cameras* often suffer from light falloff toward the edges, because most lenses send light at more oblique angles toward the edges. Carefully positioned microlenses can help compensate for this problem.

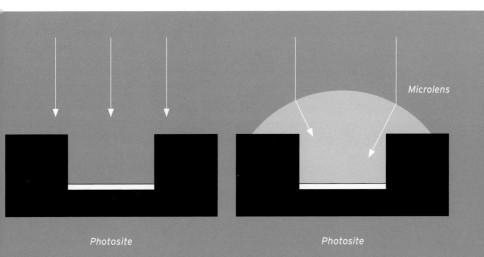

Microlens

Photosite

Photosite

Sensor dust

Dust particles which adhere to a digital *image sensor* (or to the protective filters which cover the sensor chip), and the resultant small dark marks which mar a finished photo.

Every time a photograph is taken with a film camera, a fresh clean piece of *photosensitive* material is exposed. However, *digital cameras* employ the same image sensor for each picture. *Point and shoots* have lenses and bodies carefully sealed against dust entry, but this is clearly not possible in the case of cameras with interchangeable lenses such as most *SLRs*. Accordingly, dust particles can build up on the surface of the sensor of any

interchangeable lens camera, resulting in visible dark spots and shadows.

These spots are most visible when a small *aperture* is used and when a large blank area, such as sky or a wall, is in the frame. Dust is less apparent at wider apertures because the light striking the film or sensor surface is less directional than when small apertures are used.

The image below was taken under conditions ideal for these problems, since it was shot in a desert during a dust storm. The image is also backlit with a reasonably small aperture (f/11), making dust more apparent. The closeup section reveals a large number of individual specks of dust.

Sensor cleaning

Methods for removing dust from the surface of an *image sensor*.

As noted opposite, dust and other foreign particles are an ongoing problem for digital imaging devices, particularly those with interchangeable lenses. There are two strategies for dealing with dust.

Manual sensor cleaning

Most *digital cameras* with interchangeable lenses support a sensor cleaning mode which simply flips up the *mirror* and opens the *shutter*, exposing the sensor so it can be cleaned. This mode does not actually do any cleaning—it simply permits manual cleaning to be performed.

There are three techniques used for cleaning sensors by hand: dry, wet, and adhesive.

All three involve objects physically touching the delicate surface of the glass filters installed over the top of the sensors themselves. As such they must be used with extreme care, since a scratch to the filter will permanently affect *image quality*. Most camera manufacturers, in fact, do not officially sanction any of these cleaning methods.

Automatic sensor cleaning

Many cameras contain vibrating mechanisms which can shake the sensor at a high frequency, dislodging some of this dust and thus minimizing the problem. They may contain sticky pads inside the mirror box to collect the dislodged dust.

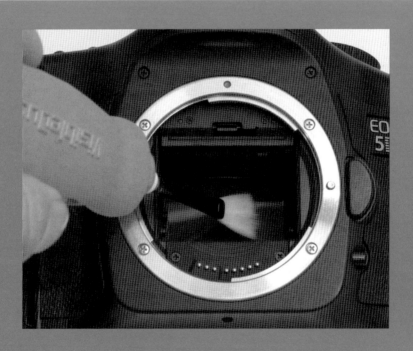

↑ *A special sensor cleaning brush being used to gingerly clean a digital SLR sensor. This particular brush is designed to build up a static charge in order to attract dust particles. Note that only brushes specifically intended for cleaning sensors should be allowed to come into contact with the delicate sensor surface.*

Resolution

A measure of the ability of an optical system to resolve visual details.

Traditionally the resolution of an optical system has been measured by photographing a series of finely spaced lines, or line pairs. The lines are printed on a "test chart" and are of decreasing size. Sometimes they are parallel, and sometimes they radiate outward in "wedges." Analysis of the photograph is used to determine the point at which the optical system can no longer distinguish adjacent lines as separate. The result may be described as the number of line pairs per millimeter which can be resolved.

Because subjective observation of the testing results is involved, this traditional form of resolution testing has generally

been replaced by the *modulation transfer function (MTF)*.

The *pixel* counts or pixel dimensions of *digital cameras* are sometimes described as the camera's "resolution," but this is not really accurate since *image sensors* come in different sizes.

Image-editing programs also refer to the resolution of an image. This is the number of pixels displayed per unit of measurement, such as pixels per inch or pixels per centimeter. The resolution of an image is something of a notional setting which is related to the output size of the finished picture. The pixel dimensions of a photo are the absolute values which determine the amount of information in an image.

Full-frame and sub-frame

A digital *image sensor* that covers the same *imaging area* (full-frame) or less than the same imaging area (sub-frame) as an analogous film size.

In most contexts today, a full-frame sensor is a digital sensor that is the same size as a *35mm* film frame, or 36 by 24mm. A sub-frame sensor is smaller than a 35mm frame; typically about 24 by 16mm. Since the *field of view* is governed by both *focal length* and imaging area size, cameras with sub-frame sensors involve a *cropping factor* relative to full-frame sensors.

Digital backs designed for medium-format cameras also refer to full- and sub-frame sensor sizes, but relative to medium-format film (6cm wide) and not to 35mm film.

Note that the terms have other meanings in other contexts. For example, some older 35mm still film cameras actually recorded an image to an area of film equal to half the size of modern 35mm cameras. Such cameras were usually called "half-frame" and were able to fit twice as many photos onto a single roll of film, but at the cost of *image quality*.

↑ *A digital sensor equivalent in size to a 35mm film frame, or "full frame."*

→ *A digital sensor equivalent in size to an APS C film frame, or "1.6x sub-frame."*

Cropping factor

A comparative reduction in *field of view* caused by a decrease in *imaging area*.

The most confusing aspect of *digital cameras* with interchangeable lenses is the effect of *image sensor* size. This confusion arises from the belief that the *focal length* of a lens determines the coverage of a scene, whereas two factors are actually involved with the field of view of a rectilinear lens: the focal length and the imaging size.

Virtually all *35mm film cameras* use a 36x24mm frame, which means a piece of film of that size is exposed to form the image. Since these cameras have been popular for decades it's common shorthand to describe a certain field of view by the focal length required to achieve it on a 35mm camera. People might say a landscape requires a 28mm lens, for example. Or a portrait needs an 85mm lens. But these particular values are meaningful only for cameras with the same imaging size as 35mm film.

So a complication arises with digital or *APS* film cameras which are compatible with the same lenses as 35mm cameras. Since it's currently quite expensive to produce image sensors that are 36x24mm in size, most DSLRs contain *sub-frame* sensors that are typically about 24x16mm in size.

Unfortunately a small sensor can't capture as much of a scene as a *full-frame*, given the same lens. Using a sub-frame sensor is like taking a full-frame photo and snipping off the edges. This is the "cropping factor" or, more accurately, "format factor."

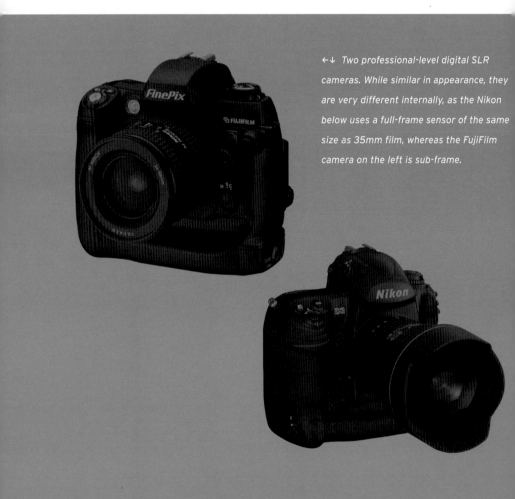

←↓ *Two professional-level digital SLR cameras. While similar in appearance, they are very different internally, as the Nikon below uses a full-frame sensor of the same size as 35mm film, whereas the FujiFilm camera on the left is sub-frame.*

It's also known popularly but misleadingly as the "focal length multiplier," because, for example, a 50mm lens on a sub-frame might have the same field of view as a 75mm lens on a full-frame. Such a camera would be advertised as having a 1.5x sensor. The reason this is misleading is that, while the field of view goes down as the sensor size decreases, the actual optical properties of the lens remain unchanged. This can have an effect on *perspective* and *depth of field*, depending on usage.

However, when using an *SLR*, what you see in the *viewfinder* is what you get. The confusion mostly arises when comparing cameras with different sensor sizes, or when using a lens designed for one image size on another camera. Note also that some lenses, such as Nikon DX and Canon EF-S, are designed to be compatible solely with sub-frame DSLRs.

Sub-frame cameras have the drawback of limiting the field of view, which particularly affects the usefulness of *wide-angle lenses*. They do have advantages aside from affordability, however. First, *telephoto lenses* have a much longer apparent reach, which can be useful for sports and wildlife photographers. And second, lower-cost lenses tend to be blurrier toward the edges. A sub-frame camera crops those areas, hiding some of the limitations of the lens.

Finally, although this discussion has centered around 35mm cameras, similar issues arise around medium-format lenses—only the specific numbers differ.

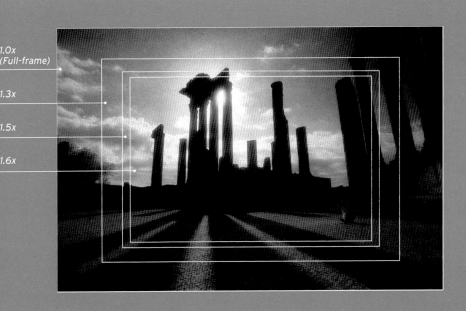

1.0x
(Full-frame)

1.3x

1.5x

1.6x

↑ *This photo, taken with a 17mm lens on a 35mm film camera, compares three popular digital SLR formats. It demonstrates how the same lens would look at 1.3x for some Canon professional DSLRs, 1.5x for most Nikon, Pentax, and Sony DSLRs (Nikon DX, Sony Alpha, Pentax DA) and 1.6x for APS-C film cameras and most Canon consumer/midrange DSLRs (Canon EF-S).*

Bit

A binary digit; the fundamental and indivisible unit used to represent information in a digital computer.

A bit can be thought of as a simple light switch that is either on or off. When on, the bit represents the number one, and when off, zero. Virtually all contemporary computers ultimately use this "binary" system to store data.

One or zero is fairly limiting, so computers store information as groups of bits. A byte is a group of 8 bits. Since each bit can be either on or off there are 2^8 different combinations of bits, and so one byte can represent up to 256 different numbers. By stringing vast numbers of bits and bytes together a computer can store a representation of human-readable information such as text, photos, sound, or video.

In the world of computers, large groups of bytes are measured in units of 1,024, which is 2^{10}. However, *hard drive* manufacturers advertise their products using units of 1,000 instead, which leads to some confusing inconsistencies of how much capacity a hard drive actually has.

1,024 bytes = 1 kilobyte

1,024 kilobytes = 1 megabyte

1,024 megabytes = 1 gigabyte

1,024 gigabytes = 1 terabyte

1,024 terabytes = 1 petabyte

In terms of size, a simple word processing file might take up a few tens of kilobytes, whereas a *JPEG* image from a camera might take up a few megabytes.

A floppy might store 1.4 megabytes, a CD 650 megabytes, a DVD 4.7 gigabytes, and a BluRay disc 25 or 50 gigabytes.

Bit depth

The number of bits of computer data assigned to each *pixel* in a digital photo.

At its simplest, a grid of pixels might have a single binary digit (bit) of computer data assigned for the storage of each point. Each bit can have two possible values: one or zero. This is like a chessboard, in that each pixel is either black or white.

However, if two bits of data are used per pixel, then 2^2 or four different color values can be stored. The more bits used, the greater the bit depth and thus the greater the number of colors possible.

The following table shows the number of colors possible at different bit depths.

Bits	Possible values
1	2
2	4
4	16
8	256
12	4,096
14	16,384
16	65,536
24	16,777,216
32	4,294,967,296

→

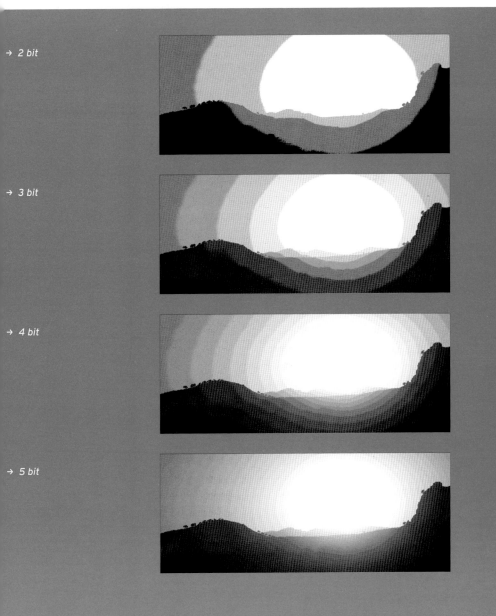

→ 2 bit

→ 3 bit

→ 4 bit

→ 5 bit

Bit depth

All other things being equal, the greater the number of colors, the smoother and higher quality the image. GIF pictures can only store 8 bits of color data per pixel, which limits the total number of colors to 256. *JPEG* stores 24 bits per pixel, allowing slightly over 16 million different colors.

16 million colors may sound like a lot, but it actually has visible limits. Since each pixel can be one of three different colors (red, green, or blue) the 24 bits of data must be divided by three. This means only 8 bits are available per color channel, so only 256 shades of each color can be

achieved. With 256 shades, *banding* can sometimes appear in large areas with smooth transitions, such as the sky.

Most good cameras can capture and store 36 or 48 bits of color information per pixel, allowing for far more subtle color rendering. Such files are usually output as *RAW*.

Note one area of confusion. 24-bit color is sometimes called 8 bit, since 8 bits of data are used for each color channel. Cameras which record 36 bits of data per pixel are sometimes called 12 bit accordingly.

→ *6 bit*

→ *7 bit*

→ *8 bit*

→ *16 bit*

Sensor clipping

Image overexposure in a *digital camera*.

One key similarity between slide film and digital is that overexposed highlights will "blow out" completely and turn pure white. No matter how much additional light shines on these areas, nothing more will be recorded; a problem known as "clipping." This differs from negative film, which is more forgiving to overexposure.

Most digital cameras have highlight warnings which blink bright areas or show them as bright red to help photographers avoid the problem. They, with *histograms*, are an important tool for managing *exposure*. For example, when shooting *RAW* many photographers advocate "exposing to the right," which means ensuring that the bulk of the histogram appears toward the right side of the chart, thus improving shadow detail. This technique must be done carefully to avoid the risk of clipping.

Excessive light hitting a sensor can also cause "sensor blooming" whereby excess current from an overexposed photosite (think of an overflowing bucket) spills over to nearby photosites. This can result in nearby darker pixels becoming bright.

Artifact

From an end user's point of view, an artifact is any undesirable change in the appearance of a photograph following image *compression* or some other technique.

Artifacts are a by-product of a process, and involve alterations to an image which essentially add information that was not there before. Compression and *sharpening algorithms* are two common processes which can involve the creation of artifacts. Take this small section of an image below.

Digital image sharpening is a technique for increasing the *contrast* between the sides of a line, thereby making a photo appear to be sharper. However, the most common sharpening technique, unsharp mask, tends to result in faint light-colored ghost lines appearing parallel to the sharpened edge. Here, an image is severely oversharpened to demonstrate the effect.

Aggressive use of a lossy compression system can also result in the appearance of artifacts. The most common artifacts caused by aggressive *JPEG* compression are jagged ghost lines and a smudged blurring pattern appearing in the form of squares. The squares appear because JPEG compression divides each image into 8x8 pixel blocks. Normally these are not visible, but when heavy compression is used, the block boundaries become apparent as compression artifacts.

The only way to eliminate compression artifacts completely is to use a lossless compression method, though reducing the amount of compression applied when using a lossy method can minimize the problem.

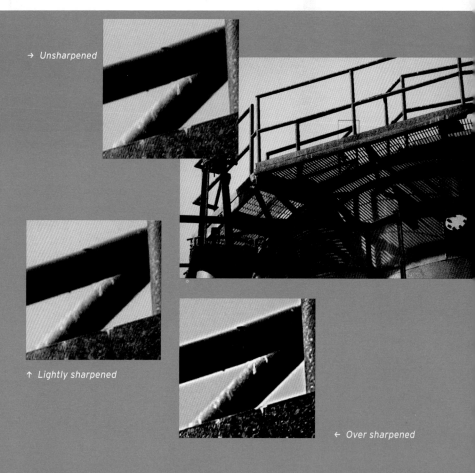

→ *Unsharpened*

↑ *Lightly sharpened*

← *Over sharpened*

Banding

A visual *artifact*, caused by a limited range of available colors, in which bands or stripes of solid color appear in areas that should have *continuous tone*.

All output devices, such as printers and monitors, have a finite range of possible colors, or a "color palette." If that range is very limited, then visible bands or stripes can appear in areas of smooth color; a problem known as "banding" or "posterizing."

The original photo below left is a 16-bit image, and so has millions of different colors available. The image below right has had its color palette reduced to just 16 colors. This reduction in possible colors has caused bands of solid colors to replace subtle graded tones.

This definition deals primarily with unwanted forms of banding, which result from what are known mathematically as color "quantizing errors." But of course the effect can be applied deliberately to an image. The term posterizing derives from the deliberate restriction of colors to a limited palette as seen in a graphic poster.

Dithering

A digital image-processing technique which simulates a wider range of colors or shades of gray than would otherwise be available.

Dithering is a method of minimizing posterization of an image. Instead of displaying a smooth gradient as a series of discrete bands on a limited color palette device, for example, the gradient is broken up into a series of dots of different colors. If the dots are small enough then a visual illusion of smooth gradients or intermediate colors is created.

Ordered or pattern dithering

One way to implement dithering is to use simple dot patterns on a grid. Pattern dithering, such as the Bayer dithering shown below left, tends to look obtrusive as it results in an obvious 8x8 pixel pattern matrix and considerable loss of detail.

Diffusion dithering

There are many variants on this type of dithering, with the venerable Floyd-Steinberg model being the most common. Dithering techniques such as the Atkinson diffusion dithering shown below right, do not use patterns.

The drawback to all forms of dithering is that a dithered image will often appear to have an objectionable speckled appearance, particularly when the dots are fairly large or the color palette is extremely restricted. Poorly dithered images are common on the web, particularly when *continuous tone* photographs have been reduced to GIF files containing only 256 colors or fewer.

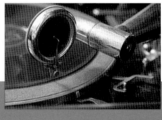

↑ *Original grayscale image*

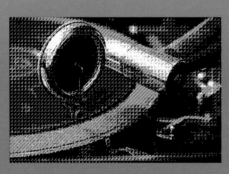

↑ *Bayer pattern dithering*

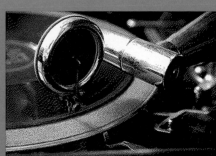

↑ *Atkinson diffusion dithering*

↑ *If a chessboard pattern is sufficiently small, as shown here in decreasing sizes, then it appears as a smooth gray to the eye.*

Color filter array

The color filters used in most digital *image sensors* which permit them to detect color information.

Counterintuitively, the individual light sensors (photosites) used by most digital cameras can record brightness but not color. So how can these cameras produce color photos?

Color is possible because each image sensor, a tiny chessboard of photosites, is covered with a layer of colored filters, known as a Bayer filter after its inventor. This simple technique allows each photosite to detect just one color of light— usually red, green, or blue. For each red and blue filter there are two green in the Bayer model, because the human eye is more sensitive to green light.

However, each *pixel* in the final photo should really be any arbitrary color, not just a shade of a primary color. So the camera laboriously examines every pixel and determines mathematically what color it should be, based on the colors of its neighbors. This process, known as demosaicing or interpolation, inevitably results in a slight degradation of *image quality*, particularly if *moiré patterns* appear. Fortunately most cameras have enough pixels, and the interpolation software is usually sufficiently advanced, so this degradation isn't too noticeable.

Not all cameras follow this design. Some employ different filter colors, such as cyan, yellow, green, and magenta. And the Foveon sensors used in some Sigma cameras avoid color filters altogether by using a sensor built of three color-sensitive layers.

↓ *A Bayer filter array, the most common type used in modern digital cameras. Each tiny image sensor on the chip is covered by a color filter in an RGGB pattern.*

Anti-aliasing

In a photographic context, optical or mathematical reduction of aliasing *artifacts* which can occur in a digitally encoded image.

Aliasing is an artifact of a discontinuous system being used to encode continuous information. Under certain circumstances these artifacts can be very distracting and apparent.

A classic visual example is that of a line drawn on a screen with a *bit depth* of 1 bit. When the line is horizontal or vertical it appears as a straight continuous line. But when drawn at an angle, the high contrast between each *pixel* (which in the case of a 1-bit image is either black or white) becomes a very obvious stairstep or jagged line.

One way of reducing these "jaggies" is to fill in the intermediate pixels with mathematically calculated in-between values; a process known as "interpolation." The resultant lines appear smoother to the eye, though at the cost of a loss of sharpness and contrast. This technique is commonly used to improve the appearance of text on a computer screen. Most modern operating systems include proprietary anti-aliasing algorithms (software, in this case) to ensure that type is as smooth as possible.

Aliasing can also cause *moiré patterns* or odd sparkling effects: a high-resolution signal creates the artifacts in a lower-resolution sensor. Most *digital cameras* contain anti-aliasing filters, which are thin sheets of transparent material over the sensor. These filters blur the image slightly, but a softer image is generally considered a lesser evil than aliasing artifacts.

This is also why a digital photograph should be properly aligned (to the horizon, for example) at the time the photo is taken. Rotating it in a computer afterward can result in aliasing artifacts.

Digital ISO

The sensitivity to light of a digital *image sensor*, as rated on a scale that emulates the film-based ISO index.

Digital sensors can be more or less sensitive to light. And, just as film offers trade-offs in quality between grainy fast film and higher-quality slow films, digital sensors generally produce higher quality results when they require more light to expose correctly.

Because the traditional *film speed* index defined by the International Organization for Standardization (ISO) is so commonly used and understood, *digital cameras* simulate ISO settings. Accordingly, "ISO" has become shorthand for "sensor sensitivity" on most digital cameras produced today.

All sensors have a base or normal level of sensitivity that provides the optimal *image quality* and lowest *noise* levels. This "base ISO" can range from ISO 50 to 200, depending on the camera.

Noise

Unwanted random information in an electronic system.

An old-style TV set, when tuned to a blank spot on the dial, would display a random flickering pattern of dots accompanied by an annoying hiss. This is an example of what the engineering world calls "noise."

Noise, in this context, refers not just to sound but to any unwanted information that enters a system as a by-product of its design, since all electronic devices are subject to a certain degree of noise. In the case of digital photography, noise refers to random speckling that can appear in a photograph.

Digital camera noise worsens in two common cases: long *exposures* and high ISO settings. Better digicams, in fact, produce virtually noiseless photos when shooting at speeds of under a second at ISO 100 or 200. Increasing the ISO is a definite way of increasing noise, since cameras generally increase sensitivity by amplifying the signal from the *image sensor chip*.

Digital noise comes in two basic forms: chrominance noise and luminance noise. Chrominance or color noise affects each color channel independently whereas luminance affects the overall brightness of each *pixel*. Of the two, chrominance noise is usually more obtrusive and objectionable

Noise is usually random in nature, but it can sometimes take on a structured form. For example, noise resulting from radio interference can sometimes result in textured striping or *banding* noise appearing in an image. Long exposure noise can also take on blotchy patterns reflecting the internal design of the image sensor.

Noise is sometimes likened to film *grain* but the two phenomena look very different and have very different underlying causes.

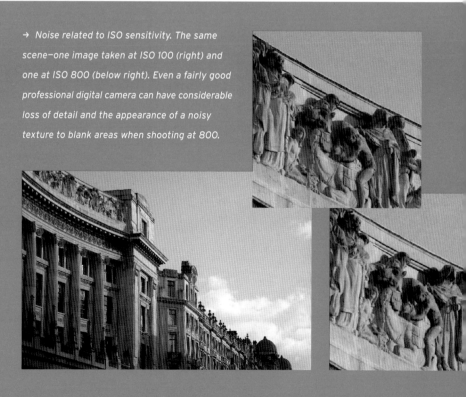

→ *Noise related to ISO sensitivity. The same scene—one image taken at ISO 100 (right) and one at ISO 800 (below right). Even a fairly good professional digital camera can have considerable loss of detail and the appearance of a noisy texture to blank areas when shooting at 800.*

Noise reduction

Hardware and software techniques for reducing *noise*.

Digital noise is a generally undesirable phenomenon. The random dots that can show up in a photo will weaken detail and, unlike film *grain*, are rarely considered to be aesthetically pleasing. As a result, camera makers have put a tremendous amount of effort into developing noise reduction systems. These are technological improvements to *image sensors* and computer circuitry which can detect, and compensate for, the presence of noise. For that reason it's quite common for a new model *digital camera* to have lower noise levels than an equivalent earlier model.

Cameras with small photosites are also more vulnerable to noise than cameras with larger photosites, all other things being equal. This is because the smaller photosites record fewer photons and thus may need to amplify the signal more, making the signal more vulnerable to noise. Since most *point and shoots* have extremely small sensors they thus tend to be noisier than cameras with larger sensors, such as digital *SLRs*.

One way around this problem is to combine *pixels*; a technique known as "pixel binning." For example, if a camera treats four adjacent photosites as a single pixel the *resolution* of the image drops by half, but the sensitivity of each pixel increases.

Another noise-related problem is that of hot pixels during long *exposure* times, which result in bright speckling in dark areas. This is caused by photosites erroneously returning image data during very long (greater than a few seconds) time periods. Some cameras address this issue by taking two frames when long exposures are shot. The first is taken normally and the second is taken with the shutter closed. Any photosites which return spurious image data are thus recorded by this dark frame as white pixels on a black background. The camera then subtracts the spurious noise from the final image. This technique of "darkframe" noise reduction doubles the exposure time required, but can result in a much cleaner image.

Noise can also be reduced, out of the camera, after the photo has been taken. Software tools can process noisy images and mitigate the worst effects. However, while noise can be reduced it cannot be entirely eliminated. Noise reduction techniques also result in some blurring and loss of detail.

A

B

← *Image A is a 30-second exposure magnified to pixel level. It shows some noisy texture, but the main problem is that it's blighted by numerous hot pixels. Image B uses darkframe noise reduction. This eliminates the hot pixels at the cost of doubled exposure time. However, most modern RAW decoding programs automatically map out individual hot pixels like this without the user ever being aware of them.*

Infrared-blocking filter

A *filter*, such as that installed over a digital *image sensor*, which blocks *infrared*.

The image sensors used on *digital cameras* are generally very sensitive to energy in the infrared portion of the spectrum. This energy, invisible to our eyes, radiates from the sun, from light bulbs, and from many other sources. Unfortunately if a camera picks up this kind of energy then it records as red in the final image, and this red cast interferes with ordinary visible light photography. A camera which records IR can demonstrate color shifts with certain materials. For example, dark synthetic clothing may have a magenta tint to it.

Accordingly most image sensors have a glass filter installed which blocks infrared through reflection. These filters are normally not removable, and also serve as a protective glass layer over the sensitive sensor surface.

These filters may absorb or reflect infrared energy, depending on the specific material used. IR-reflecting filters are sometimes known as "hot mirrors" since they can reflect wavelengths of energy associated with heat. However, this should not be confused with actual warmth or temperatures.

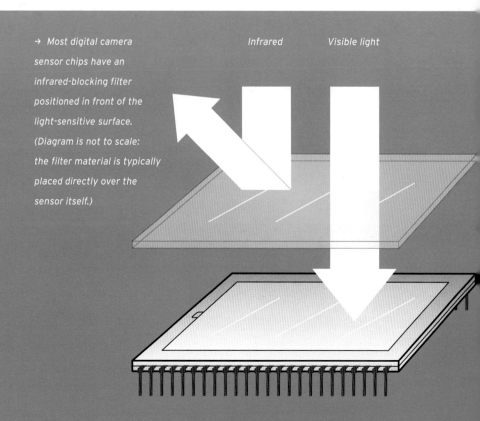

→ Most digital camera sensor chips have an infrared-blocking filter positioned in front of the light-sensitive surface. (Diagram is not to scale: the filter material is typically placed directly over the sensor itself.)

Infrared Visible light

Buffer memory

A temporary holding space in computer memory, which can retain information until a computer or process, is ready to accept it.

Digital cameras commonly rely on memory buffers to improve responsiveness. For example, a camera might be used to shoot a rapid sequence of photos. The camera's computer has to process each image and save it ("write" it) onto a *memory card*, which takes time for each shot. A camera without a holding tank would stop responding while it was writing, limiting its usefulness.

But by transferring each photo to a memory buffer, the camera can queue up all the files to be saved, permitting shooting to continue while the write operations carry on. Of course, once the buffer is full it will be necessary to wait until the camera has cleared out the buffer and saved the images.

The number of photos that can be stored in this buffer is often referred to as the "burst depth" of the camera. The burst depth will vary depending on the quality setting of a camera, since a group of low-quality images will take up less room than a group of high-quality images.

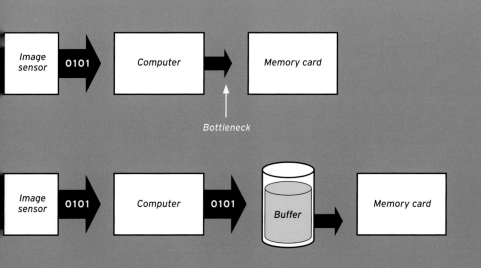

Memory card

A tiny electronic device, typically smaller than a matchbook, used to store digital information.

Most *digital cameras* use removable memory cards to store photos, just as a film camera would store pictures on film. When the card fills up, the photographer just removes it and puts in another.

Most cards use flash memory, which can retain information indefinitely without a power source. Unlike film, the cards are reusable. It's possible to erase the files from a card and load it with a fresh batch of pictures. Flash memory does wear out, but it takes hundreds of thousands of rewrites to do it.

Memory cards range dramatically in capacity, from as small as 8 megabytes or so to tens of gigabytes and beyond. The number of photos they can hold depends on the size of the photos produced by the camera.

Most compact digital cameras today use SDHC (Secure Digital High Capacity) memory cards, with many digital *SLR* cameras using the older CF (CompactFlash) card standard. Other formats include SD (SecureDigital, the predecessor to SDHC), microSD, Memory Stick and variants (Sony products only), xD, SmartMedia and Multimedia Card (MMC).

Note that CompactFlash type II cards use very tiny mechanical *hard drives* containing rotating magnetic discs instead of flash memory, but such microdrives are becoming less common as flash prices drop.

↑ *Four popular types of memory card. From left to right, a CompactFlash card, an SDHC card, an xD card, and a Memory Stick Pro Duo card.*

Memory card format or file system

The formatting system used to store files on a *memory card*.

Memory cards require preparation before they can be used. This preparation, known as formatting, is akin to painting the lines in a parking lot before cars can park. There are different formats or file systems in use, depending mainly on the size of the card.

Most cameras format their memory cards using the FAT16 and FAT32 systems designed by Microsoft for use with the DOS and Windows operating systems. (FAT stands for "file allocation table"). These file systems can be used with memory cards up to 2 gigabytes and 8 terabytes in size, respectively. Most *digital cameras* can use the FAT16 format, and most digicams made since 2005 or so can also use the FAT32 format which is needed to support larger capacity memory cards.

Memory cards can, like *hard drives*, be formatted using other systems such as the Mac's HFS+, Windows NTFS, Linux ext2/ext3, and Sun ZFS. However, few if any camera products use these particular file systems, in part because support for FAT16 and FAT32 is pretty well universal across operating systems and thus they serve as a useful common denominator.

As a verb, "format" means to prepare a memory card or hard drive or other storage device by erasing it. Many cameras use the word "format" synonymously with "erase."

Card readers

Devices which can read information from *memory cards* and transfer them to a computer.

Direct transfer of photos from a camera to a computer via a USB cable is often rather slow. A faster method is to remove the card from the camera and put it into a card reader attached to a computer. The card should appear to the computer as if it were a removable *hard drive*, and files can then be copied off the card onto the computer.

Most card readers connect to computers through USB, though FireWire is also popular with Apple Macintosh users. Laptop users often use PC card (formerly PCMCIA) or ExpressCard readers which fit into slots on the side of the portable.

Some readers accept only one type of card, such as CompactFlash. Others have a number of slots which accommodate many different types of card. Card readers aren't always stand-alone devices. Card reading functionality is often built into printers, computers, and even monitor screens.

↑ *Two card readers. The reader on the left is a multipurpose USB reader which can accept 12 different card types, including CompactFlash, SD, Memory Stick, xD, and others. The reader on the right is a professional high-speed model. It uses FireWire 800 and can only read CompactFlash cards.*

Compression

Software techniques for reducing the size of digital files. Digital photos are often compressed so that they occupy less storage space, using one of two techniques.

Lossless

Lossless compression involves no alteration to the image when it's decompressed. The file is none the worse for the compression experience, and information is neither lost nor discarded. Lossless techniques rely on finding repeated patterns in a file, and are of limited efficiency for complex files such as photos.

LZW (Lempel-Ziv-Welch) and ZIP are common forms, and TIFF files can use either type. PNG and GIF files are also lossless.

Lossy

Lossy compression is more efficient but also more ruthless. Lossy techniques such as *JPEG* take information easily missed by the human eye and throw it away. Depending on the compression level, the result may be nearly indistinguishable from the original, or may be marred by block-shaped blurry *artifacts*.

Lossy compression is always a matter of trade-offs: aggressive compression will sacrifice *image quality* for smaller file sizes. Better cameras have adjustable compression levels.

Consider image A below. The original file takes up about 36 MB. By applying lossless compression (TIFF LZW) the file size is decreased to 9 MB without any loss of picture quality (image B).

Lossy compression (JPEG, high quality) reduces the file quite dramatically to 1.1 MB (image C). There is some loss of quality, particularly ghost lines around high contrast areas, but the image quality is quite reasonable.

Lossy compression aggressively applied (JPEG, lowest quality) reduces the file to an amazing 400K (less than half a MB). However, the quality of image D is now very poor. Compression artifacts dominate.

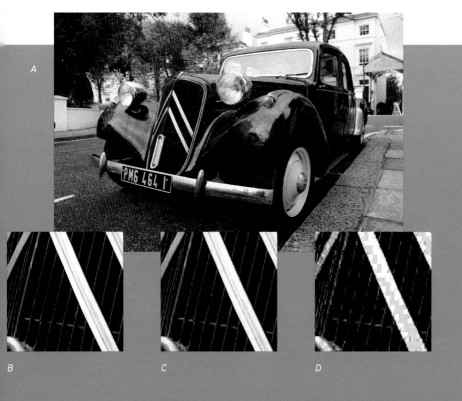

A

B C D

File format

The internal structure used to store information in a digital form.

Since digital files are simply large masses of ones and zeroes it is vitally important that the files be structured in a well-documented and easily understood fashion. Otherwise it would not be possible to transfer information reliably from one software application to another. These formats come in two basic forms: open and proprietary.

Open or publicly licensed formats are based on readily available and publicly documented standards. They may be completely free and open for anyone to use, such as the PNG format. Or they may be controlled by a manufacturer or committee but nonetheless popular and widely used or licensed, such as *JPEG*, DNG, TIFF, and GIF.

Proprietary closed formats, on the other hand, are designed by a given company for their sole use. Some of these formats may be licensed to other companies, others have been decoded and their formats understood, but some are locked down and encrypted and cannot be read except by the maker's own software. *RAW* files are a typical example of a closed format.

File types are frequently identified by filename extensions, which are brief alphanumeric codes appended to the file's name. For example, flower.jpg indicates that the file named "flower" is stored in JPEG format.

JPEG	Joint Photographic Experts Group	**.jpg, .jpeg**
TIFF	Tagged Image File Format	**.tif, .tiff**
GIF	Graphics Interchange Format	**.gif**
PNG	Portable Network Graphics	**.png**
DNG	Digital Negative	**.dng**
NEF	Nikon-proprietary RAW format	**.nef**
CRW	Canon-proprietary RAW format	**.CRW, .CR2**
PSD	Adobe-proprietary Photoshop format	**.psd**

JPEG

A popular format used for compressing and storing digital pictures.

The odd name, pronounced "jay-peg," is an acronym for the Joint Photographic Experts Group, the international committee which created the standard in the early 1990s. Virtually all *digital cameras* today can produce JPEG photographs. JPEG is so popular because it is extremely good at reducing the storage requirements of large digital photographs through lossy *compression*. (It is possible to apply lossless compression in some forms of JPEG, but it's rarely used.)

While JPEG is ubiquitous it does have some drawbacks. The primary problem is it can normally only store 8 *bits* of information per *channel* (24 bits per pixel in the case of RGB pictures), which limits the total number of colors which can be stored in an image. The second drawback is that lossy image compression invariably results in some degradation of the picture. For that reason more advanced cameras tend to support *file formats* which can store higher quality images–usually proprietary *RAW* formats, TIFF, or DNG.

In addition to the regular JPEG format, the committee has created other standards. These include JPEG 2000, which uses highly efficient "wavelet" compression, and JPEG XR, which supports up to 32-bit images.

Note: to be technically correct, JPEG refers to a compression method published by the JPEG committee under the memorable name ISO/IEC IS 10918-1 | ITU-T Recommendation T.81, and does not refer to an actual file format for documents. JFIF (JPEG Interchange Format) is the proper name for the file format. However, most people refer to both as JPEG.

RAW

Unprocessed "raw" data extracted from a camera's *image sensor* and stored in a manufacturer-proprietary form.

To begin, there are two things that RAW is not. First, it is not an acronym and really should not be written in uppercase, though by convention it usually is. Second, it is not an actual *file format* but rather an umbrella category of proprietary file formats.

RAW files are simply raw, unprocessed, or minimally processed collections of data read directly off a camera's image sensor, packaged into a file with camera *metadata*. And since each camera model tends to have a slightly different internal design or image sensor chip, the raw data from a given camera is typically structured in a form unique to that camera model. There is no universal format governing how raw data should be arranged.

The raw data from a sensor is valuable because it represents the highest *image quality* of which the camera is capable. RAW also avoids the limitations of some popular file formats, such as *JPEG*, since it's neither compressed nor restricted to just 8 *bits* of data. Most cameras can record 12 bits of data per color and up. However, since the data is not compressed, RAW files can be quite large and cumbersome to use. Each photographer must decide if the improved quality and flexibility provided by RAW offset the file storage requirements.

In an attempt to ward off the "abandoned file format" problem, which all proprietary formats can face, software maker Adobe has created a universal data format for cameras. This documented file format, called "DNG" for "digital negative," would eliminate the problem, were it to be adopted universally.

Nikon's RAW files are known as NEF, for "Nikon Electronic Format." Canon simply calls them "Canon RAW" or "CRW" or "CR2."

Metadata

A supplementary set of data that further describes a primary set of data.

Consider an ordinary printed photograph or a *35mm* slide mounted in a cardboard frame. It may be useful to write a few notes about the subject of the photo on the back of the print or on the edges of the slide mount—perhaps the date or people's names or a location. This supplementary information does not form part of the image itself, but is useful for sorting and categorizing and so on.

Digital metadata is similar, in that it is optional and supplementary information which is attached to a digital file but which does not form part of the visible photograph itself. Most *digital cameras* generate such metadata automatically,

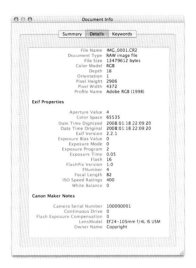

and embed it into each digital photo. The metadata may contain the *aperture* used, the *shutter speed*, the *focal length*, whether *flash* was on or off, the shooting date, the camera's serial number, and countless other pieces of data.

Watermark

A dditional information added to a photo, either as a visible overlay on the image or encoded within the digital data of the file.

Just as paper currency can have faint images marked into it, digital photos can contain faint impressions of an image as a visual overlay. Such watermarks are typically used to identify copyright ownership for a photo displayed as a sample on the internet. They can be subtle, small boxes in the corner for instance, or obtrusive, such as large overlays covering the whole picture, as in the example above right.

Digital watermarks can also be invisible. Some software tools can build specially formatted digital information into the data of the file itself. Such data is not visible to the human eye, since it doesn't form part of the image as such. It requires a special

software tool to read. However, since it is embedded into the very data of the visible image it can't simply be cropped off, as a visible watermark could be. Nor can it be overwritten, such as *metadata* stored elsewhere in the file. Such invisible watermarks are a form of steganography, or the art and science of concealing messages within documents.

Most image files can also contain metadata, though this is not usually considered a watermark as such.

Data transfer (wired)

In general terms, the copying of data from one digital device to another over a physical wire.

There are a variety of connection methods which allow digital devices such as cameras, printers, and computers to communicate, involving specific types of plugs and cables. Most of these connection technologies use different ways of transmitting data down the wires, and so different connection methods normally use different plug shapes to avoid the risk of connecting a device incorrectly.

Serial

RS-232 and RS-422 are data transfer technologies that were popular in the 1980s and 1990s, but are now uncommon. Serial ports were traditionally used for linking printers, modems, and other peripheral devices to computers. Some early *digital cameras* used serial ports, and suffered from slow picture transfer rates accordingly.

Parallel

Another older "legacy" technology, parallel ports were primarily used for linking printers to personal computers.

SCSI

Small Computer Systems Interface, usually pronounced "scuzzy." A popular means for attaching external *hard drives* and scanners in the late 1980s and 1990s. Now largely superseded by USB and FireWire.

USB

Universal Serial Bus, the most popular way to connect a peripheral device to a computer since the late 1990s. Virtually all digital cameras use USB to transfer pictures to a computer and, sometimes, a printer. External hard drives are also mostly USB compatible. In fact, all manner of devices from keyboards, mice, scanners, cellphones, music players, and even cup warmers have been produced with USB connections.

USB comes in two speeds. USB 1.1 can reach 12 Mbit/sec (megabits of data transferred per second) and USB 2.0 can hit 480 Mbit/sec, though these are peak rates and not sustained transfer rates. Note that the version number is not a guarantee of speed: slower devices are sometimes sold misleadingly under the USB 2.0 label owing to a technicality in

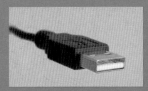

↑ *USB A connector to a computer.*

↑ *USB B connector to a peripheral such as a printer or scanner.*

↑ *USB mini-B connector for a small peripheral such as a phone or a camera.*

↑ *RJ-45 ethernet connector.*

↑ *eSATA connector.*

the standard. USB cables work with both 1.1 and 2.0 but have different plugs at each end, which prevents USB from being used to link one computer to another. Some cameras use regular cables but others have manufacturer-proprietary plugs with a standard USB connector on the other end. Unlike most of its predecessors, USB is "hot pluggable," meaning that it isn't necessary to turn everything off before plugging in or unplugging a USB device.

FireWire/IEEE 1394/iLink

FireWire is used primarily for hard drives and digital video cameras, though some high-end still cameras and scanners support it. It comes in two versions: FireWire 400 and FireWire 800, referring to the maximum speed in Mbit/sec. Both flavors have higher sustained transfer rates than the more popular USB. FireWire plugs can be the same at each end, so FireWire can be used to link computers together as well as linking computers to peripherals. FireWire is Apple's marketing name for the technology, IEEE 1394 is the official technical standard, and iLink is Sony's name for a small FireWire 400 connector.

Ethernet

Ethernet is used for local (typically building-sized) networks and comes in a variety of speeds: 10 Mbit/sec, 100 Mbit/sec, and 1,000 Mbit/sec. The latter is known as "gigabit Ethernet." Ethernet employed a couple of different cable types in the past, though unshielded twisted pair (UTP; similar to indoor telephone wire) is the most common variety today.

Ethernet cables are normally used for local area networks (LANs) within homes and offices. Such networks are also commonly linked to the internet.

eSATA

External serial ATA, used for very high speed connections (3 Gbit/sec) to external storage devices; mainly hard drives. eSATA is a tougher variant of the SATA connectors used to link internal storage devices inside most personal computers.

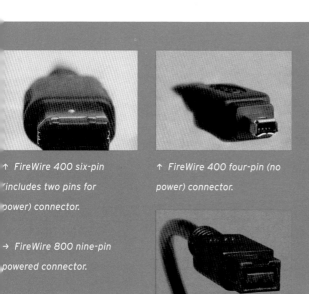

↑ FireWire 400 six-pin (includes two pins for power) connector.

↑ FireWire 400 four-pin (no power) connector.

→ FireWire 800 nine-pin powered connector.

↑ The back panel of a computer, showing some of these connection types.

Data transfer (wireless)

Systems for transferring digital data over radio waves.

Generally digital devices connect together using wires, but wireless connections for portability and convenience are also available.

Wireless Ethernet/WiFi/ 802.11x

Wireless Ethernet is a technology that simulates a wired Ethernet connection over radio waves. Most portable computers contain wireless hardware that allows them to access the internet without any cabling. Some cameras support wireless connections to printers and file storage devices. Photojournalists can use wireless to send images directly to a newsdesk or editor.

The technology, sometimes marketed under the name "WiFi" for "wireless fidelity," is used for local area access. That is, unlike mobile/cellular phone technology, wireless Ethernet can only be used within a short distance of a base station or access point. These base stations are then typically connected to the worldwide internet by physical cables.

Wireless Ethernet comes in a variety of speeds or data transfer rates. The oldest standard is known technically as IEEE 802.11a, though it is rarely seen today.

The first popular wireless standard was 802.11b with peak rates of 11 Mbit/sec, with its successor 802.11g supporting higher peak rates at 54 Mbit/sec. 802.11n is the most recent version, peaking at 248 Mbit/ sec. Note that these rates are highly optimistic, and typical sustained throughput is actually anywhere from half to a quarter of the advertised rate.

Bluetooth

Bluetooth is a wireless technology used for short-distance and low data rate transfers, and is typically used by cellphones. Mobile phone accessories such as wireless earpieces commonly use Bluetooth, and the technology is also used to synchronize address books and other information between phones and computers. It can be thought of as filling the role of USB in a wireless context.

Because of the slow data transfer rates (1 Mbit/sec for version 1 or 3 Mbit/sec for version 2 EDR), Bluetooth is not very useful for most photographic applications. Some phone cameras use Bluetooth to transfer pictures to computers, however. The technology's unusual name is a reference to tenth-century king Harald Bluetooth, who united Denmark and Norway.

Remote capture

The technique of using a personal computer to control a *digital camera*.

Remote capture usually involves a physical connection between camera and computer; typically a USB cable. It can also be done over wireless Ethernet in some cases.

The technique requires a custom software program written for the personal computer in question. It sends commands to the camera, and receives data back from it.

There are a number of ways in which remote capture is useful. First, it can be used to capture images from a remote camera on a timed basis. This combination serves as a sophisticated *intervalometer*. Photos can be stored on the computer's *hard drive*, making long sequences possible. This is valuable for scientific data gathering or documenting a time-dependent event. It is even possible to fire a camera through custom software for particularly complex actions in response to external stimuli. Motion-sensing software which takes a photo only upon a change in the scene, such as a person walking by, is one example.

Second, particularly in wireless situations, the technique allows for a high level of control over a remote camera: ideal for sports photography or situations where the camera is in a dangerous or inaccessible location. Sports shooters commonly set up cameras in unusual locations, such as the rafters of a sports arena, the bottom of a swimming pool, or under the starting gate of a horse racing track, in order to record unusual views of the action.

Third, it allows for images to be viewed on a computer monitor within moments of capture (see *tethered shooting*).

Tethered shooting

The practice of connecting a camera directly to a computer via a data cable.

In many situations a cable can be an annoying encumbrance. But in *studio* situations, such as fashion, still life, and portraiture where cabling and fixed camera positions are common, tethered shooting is very popular.

Most of the studio portraits in this book were taken using a tethered setup. This allowed for the instant examination of photos on a full-sized display rather than the tiny preview screen on the camera back. It also made it possible to check for proper *exposure*, *pixel*-level focusing, and so on.

In the setup shown below, the camera on the right transmitted photos to the computer on the left via USB. Photographs were transferred immediately to a cataloging program without any need to import the photos separately.

Tethered shooting is also commonly used by some digital backs for medium-format cameras, which produce such huge quantities of data that *memory cards* are not practical. Accordingly, such backs may require an external *hard drive* pack or computer connection to handle the amount of information generated.

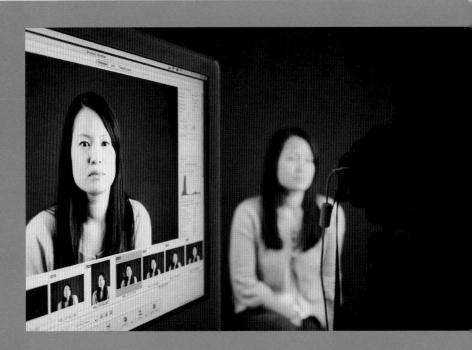

↑ *A tethered studio photo shoot.*

Histogram

A chart plotting the frequency of grouped categories of brightness, used to analyze *exposure* metering.

Histograms come in two varieties: brightness/luminance and color/RGB. The horizontal axis of a simple brightness histogram indicates brightness level, from dark to bright. The vertical axis indicates how much of the photo is of that particular brightness level. Color histograms are similar but break up the chart into three separate graphs for the red, green, and blue *channels*.

While seemingly arcane, histograms are an invaluable tool for determining if a photograph was metered and recorded correctly. Most *digital cameras* display histograms next to a captured image on a preview screen, making it possible to analyze the effects of a given exposure setting immediately after taking a picture.

↑ *This image has a fairly well-balanced exposure, with most tones in the middle ranges, as its histogram indicates. It could have benefited from a little more exposure to the right.*

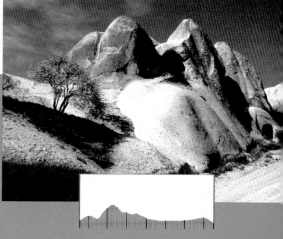

↑ *This image has extremely high contrast between the black of the night sky and the bright white of the fireworks. The histogram is a sort of U-shape accordingly.*

↑ *If the contrast is deliberately increased using an image-editing program the histogram becomes very different. First, the brightness values are stretched across the full range available. And second, gaps now appear in the histogram, where certain brightness values are missing. This is sometimes called a "combed histogram" and happens when software is used to stretch out a set of tonal values. Essentially it indicates posterization is occurring.*

Firmware

Computer software built permanently or semi-permanently into a device.

Digital cameras and automated computerized film cameras both use firmware to control the electronics and mechanisms that make up the physical hardware. The firmware is inseparable from the hardware in terms of the device's basic functionality.

Sometimes firmware is encoded onto read-only (ROM) chips which cannot be modified. Better cameras and computers store firmware in flash memory, which means that updated versions of the firmware can be installed by an update procedure. Manufacturers can thus fix *bugs* or, less commonly, introduce new features by releasing updated firmware for a given product.

Occasionally hobbyists create their own unauthorized modified versions of a product's firmware in order to alter or expand its capabilities. This is commonly known as "hacking" the firmware.

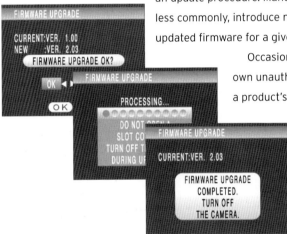

Startup time

The time required by a camera or similar device to start up and be fully ready to the user.

Traditional fully manual cameras do not have any startup time to speak of. *Digital cameras*, however, are a different story. Inexpensive *point and shoot* cameras are notorious for quite long startup delays involved with preparing a camera for use from initial power-on.

In the case of such point and shoots, there are generally two factors. First, there are mechanical requirements. Most such cameras have motorized retractable lenses which must be extended from the camera body in order to have an adequate focal length. Second, the computer circuitry inside the camera must startup, much as a computer must be booted up before it can be used.

Startup time, along with shutter lag, is a frustrating problem for many users, and so camera developers have expended considerable effort over the years in reducing these wait times in their products. As always, the less expensive products tend to be more compromised in this area.

Protocol

A set of rules controlling computer communication between devices or software programs.

When two computer-controlled devices are used together there must obviously be some form of shared common language between them. The internet, for example, would simply not be possible if not for a shared set of communication rules.

The same applies for contemporary photographic tools. Most cameras, lenses, and flash units sold today (film and digital) contain computers, and of course *digital cameras* need to be able to communicate with personal computers. Accordingly there are different protocols, or communication rules, governing these interactions.

Camera/accessory protocols

In the case of the interactions between cameras and camera accessories, these protocols are largely manufacturer-specific or proprietary. For example, Canon EF lenses are only designed to communicate electronically with Canon EOS bodies. Nikon F lenses containing chips can only communicate with Nikon and compatible bodies. And so on. An item designed to work with a given camera system is referred to as being "dedicated" to that product line.

While such camera-lens protocols are not public and open standard, *third party* lenses and flash units do exist. This is because the manufacturers of these products have studied the proprietary products and learned how they work. This "reverse engineering" of communications protocols allows for a third-party market.

Digital camera protocols

In the case of communications involving digital cameras, there are some cross-manufacturer protocols available from industry groups. Although not open to everyone, these standards are nonetheless not proprietary to any one manufacturer, simplifying compatibility issues considerably. Without such standards, special software programs known as "drivers" are required to ensure that each camera model can communicate with a given personal computer or printer.

PTP (Picture Transfer Protocol) and PictBridge are two common protocols. PTP defines how communication should occur between compatible USB cameras and computers. PictBridge supports communication between compatible cameras and printers and allows for a camera to print directly to a printer without using a personal computer.

White balance

Processes and techniques for ensuring that the representation of color in a finished photograph is accurate and reflects the color of the original scene.

Color accuracy is a complex field, involving both the physics of light and human perception of that light. Our minds automatically adjust to the color of light illuminating a space, and interpret white objects as white. However, film and *image sensors* are not so flexible. Film in particular is locked to the assumptions about "white" made when the emulsion was created at the factory. Digital is fortunately much more flexible, but nonetheless certain assumptions must be made about what color is "white." If incorrect assumptions are made then an image may take on a wrong *color cast*, such as yellowish or blue.

White balance is intimately tied to the concept of *color temperature*. At its most basic, white balance is a matter of telling the camera what color temperature "white" is. At noon under sunlight, that setting may be 5,500 K, for example. In a room lit by tungsten lights that setting may be 3,200 K.

Most cameras can also determine white balance through examination of an image; a process known as "automatic white balance." Generally AWB works fairly well, though it can be thrown off by certain conditions. For example, say a photo is taken at dawn. The subject is bathed in lovely yellow light, giving a warm cast. Unfortunately the camera thinks this is a mistake. Surely things shouldn't be so yellow! Therefore it may erroneously set white balance to a bluish setting, resulting in a disappointing photo.

In such cases the white balance can be adjusted manually to reflect the desired effect. This may be done by photographing a *gray card* and *metering* the white balance setting from that. It can also be done, quickly and somewhat crudely, by tricking the camera. Setting a camera to assume the scene is actually a cloudy day can fool the camera into warming up the image.

In addition to yellow-blue color temperature settings, white balance in more advanced cameras can also take magenta-green settings into account. This is particularly useful for dealing with fluorescent light sources.

Orientation sensor

A position sensor used to determine which way is up when a photo is taken.

If a camera does not know which way is up then it will have no way to specify which way is up in a photo. Accordingly portrait orientation images may be displayed incorrectly as landscape orientation images when transferred to a computer (i.e.: they will be shown rotated 90 degrees from the orientation in which they were taken).

An orientation sensor uses gravity to determine which way is up, and the camera uses this information to mark the photo's EXIF *metadata* so that it will be displayed correctly. Some cameras use simple mechanical orientation sensors, and it's possible to hear a faint clicking sound from within the camera body when it's rotated. Other cameras use purely electronic sensors which are silent in operation.

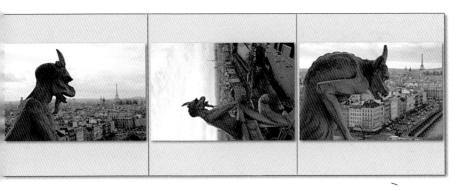

↑ *The three photos here were taken with a camera which lacks an orientation sensor. The left and right images display correctly, since they were taken in landscape orientation.*

However the middle image was taken in portrait orientation and is thus displayed incorrectly. A graphics program must be used to rotate the picture 90 degrees.

DPOF

D igital Print Order Format, a method of specifying in-camera which pictures are to be printed out, and in what order.

DPOF involves the creation of a special *metadata* folder on a *memory card*. The camera will have a user interface of some type which allows the photographer to go through the pictures on the card, marking

which pictures are to be printed. The card can then be taken to a photo lab or the camera connected to a printer for immediate output. DPOF is a consumer system and is not typically used by the advanced amateur or professional photographer.

Digital zoom

A simulated zoom effect which crops *pixels* from an image and interpolates the remaining data.

True *zoom lenses* are purely optical in nature: they widen or narrow the *field of view* by changing the *focal length*, which is an optical property of the lens. But some *point and shoot* digital cameras have a fake zoom-in mode which simulates narrowing the field of view. This simulated zoom works by cropping out the edges of a picture, throwing those pixels away, and enlarging the cropped file.

This so-called "digital zoom" is fake because it adds no further information to the file. In fact, it degrades the picture quality by discarding information and enlarging it. A photographer is better off cropping an image in an image-editing program if this effect is desired. Digital zoom also can't simulate zooming out or enlarging the field of view. This can only be done optically.

When shopping for a point and shoot digital camera, be sure to ignore any references to "digital zoom" and look solely at the true "optical zoom" specifications.

Original

Cropped

Enlarged

Live view

An *electronic viewfinder* which displays a picture in real time.

Traditional film cameras cannot show the user precisely what the captured image will look like, for the simple reason that film is a single-use chemical medium. *Digital cameras*, however, can output captured results to a screen within milliseconds. For this reason most *point and shoot* cameras are capable of displaying live video fed directly from the image sensor itself.

Confusingly for people moving to digital SLRs from digital point and shoots, some SLRs cannot display such live video from the sensor. This is because these SLRs are structured around the same basic design as their film counterparts. Light entering the camera either strikes a *mirror* and is deflected up into an optical viewfinder system or, if the mirror has been raised, directly strikes the *image sensor*. Normally the image sensor itself is not involved in the viewfinder system simply because moving mirrors can only be in one of two separate positions.

Other digital SLRs do, however, support live video from the sensor. For this to work the mirror must be raised, any mechanical *shutter* opened, and the image sensor exposed. At this point the optical viewfinder is cut out of the system and the camera's *LCD* becomes the only way to see the image. The complication with SLRs of this type is that the phase detection *autofocus* sensor is physically housed in the viewfinder section of the camera. It therefore isn't possible to autofocus normally with live view enabled.

To resolve this problem without a fixed pellicle mirror, point-and-shoot-style contrast detection focusing must be performed, using data from the image sensor. Alternatively the photographer can focus the lens manually, using the display's zoom or magnify function to check for correct *focus*.

Audio annotation

The ability to record and attach a sound file to a digital photograph in-camera.

Some cameras, particularly those aimed at professional photojournalists, have the ability to attach short sound clips. These can be used by the photographer as a sort of audio notepad for recording locations, subjects, and so on. The function differs from the ability to record video clips, commonly seen among consumer-level digital *point and shoot* cameras.

Global Positioning System (GPS)

A worldwide satellite-based navigation system.

Operated by the US government and originally designed for military applications, GPS is commonly used for civilian purposes today. The system requires small portable receivers which pick up radio signals from a constellation of GPS satellites orbiting the globe. The signals, once decoded, can provide latitude, longitude, altitude, and time information to the user on the ground.

Some *digital cameras* support GPS receivers, allowing for precise location information to be stored in each photograph's EXIF *metadata*. A location record of this sort can be extremely valuable to news, wildlife, and nature photographers, who can refer back to this information to determine where a photo was taken.

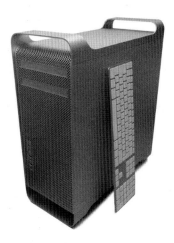

→ *The world is encircled by a constellation of over two dozen GPS satellites.*

Computer

A digital device for performing calculations; often short for "personal computer."

While the term "computer" is technically a very general one, encompassing all digital devices which contain a *CPU*, the word normally refers to a self-contained unit containing most or all of the components required to make a useful computing device. In summary, when people talk about "computers" they normally mean a personal computer.

Personal computers have become the primary tool used by photographers for *postprocessing* digitally-acquired or captured images. They are also used for sorting and archiving photo collections. Portable or laptop computers are very valuable in the field for accurate previews of recently acquired images, and for cataloging and editing on the road.

Microchip

A small rectangular piece of silicon upon which circuitry is built; an essential component in constructing modern electronic equipment.

Modern computers and electronic devices are built around such chips, which are complex electronic circuits constructed upon tiny slivers of silicon often smaller than a fingernail. These chips, also known as integrated circuits or ICs, are encased in plastic or ceramic housings. Metal pins or contacts protrude from the casings, allowing the circuits within to be connected to other devices.

Chips can be constructed which contain billions of tiny interlinked transistors. This advanced level of component miniaturization has made the modern digital camera possible. Chips are used for every function of a digital camera, from the actual image sensors that make up the heart of the modern digital camera, to the computing chips that perform

mathematical calculations and data processing, to the memory devices which store digital photos.

Cameras often contain highly specialized and custom-designed microchips created for specific purposes, such as processing data from an imaging chip. These custom chips are sometimes known as application-specific integrated circuits, or ASICs. They are in contrast to the general purpose computing chips used in personal computers.

IC chips are soldered onto or plugged into laminated surfaces known as printed circuit boards (PCBs, not to be confused with the toxic chemical with the same acronym). Circuit boards in personal computers are usually flat and inflexible, and typically made of glass fiber and plastic resin. Other devices, such as cameras, use flexible plastic sheets that can be folded to fit into oddly shaped internal spaces.

↑ A closeup photograph of a newly minted batch of computer chips with a pencil for scale. Each tiny rectangle is a complete microprocessor. The next stage in manufacturing is for a fine-tipped saw to slice the silicon into individual chips, which will then be encased within a protective housing.

Central processing unit (CPU)

An electronic component which rapidly performs mathematical calculations and, by extension, the ability of a device to perform such calculations.

Most modern CPUs are "microprocessors" consisting of millions or even billions of transistors and other microscopic subcomponents built onto tiny rectangles of silicon. They perform endless calculations, process instructions and data, and control the devices attached to them. CPUs are thus the brains that drive all digital devices, from personal computers to *digital cameras* to talking toy teddy bears.

Personal computers usually contain CPUs built by a handful of major manufacturers: Intel, AMD, IBM, and Motorola. These CPUs are general-purpose devices which can run the computer's operating system software. By contrast the CPUs in specialized devices such as cameras are mostly custom-built chips built by or for the camera maker itself, and are tailored to the specific needs of the product. Such special-purpose chips are marketed under a variety of names: DIGIC (Canon), Venus Engine (Panasonic), Bionz (Sony), PRIME (Pentax), and so on.

Some digital devices contain single CPUs and others contain multiple processors operating in parallel. Some contain single CPUs which in turn contain multiple cores. Such multiple-core CPUs offer many of the performance benefits of multiple processors. Most personal computers also contain a supplementary computer chip that rapidly performs the numeric calculations required to draw graphics. Such chips are known as GPUs, for graphics processing units.

Although the term CPU normally refers to a specific component, it has other meanings as well. Sometimes the enclosure containing the computer hardware is referred to colloquially as a CPU, as opposed to its peripherals (keyboard, screen, mouse). CPU is also commonly used as a loose description of computing ability or calculating horsepower. For example, a person might say "my new computer has more CPU than my old one," or "that image-editing software I'm using is taking up a lot of CPU!" In this slang sense, the term is actually short for "CPU cycles" or "CPU time."

Clock rate (MHz, GHz)

The operating rate of a microprocessor's internal timing system.

The microprocessor chips that serve as the brains or processing centers of any personal computer contain timers which govern and coordinate their operation. All the calculations march in step with these "clocks." Not to be confused with a date and time clock, these internal clocks control only the universe of the computer in question and are not related directly to anything in the outside world.

Clock rates are measured in terms of Hertz, or cycles per second. Computers perform calculations at a very rapid rate, and so clocks are commonly measured in terms of millions of cycles per second (MHz) or billions (GHz). The computers aboard the Apollo lunar spacecraft of the late 1960s operated at about 2 MHz as did home computers of a decade later. At the time of writing, computers operating at several GHz are common.

The clock rate is one of the factors determining the overall performance of the machine. However, despite advertising suggesting the contrary, it's definitely not the only factor. In particular it's rarely meaningful to compare the clock speed of one computer chip type to another, or indeed one computer design to another.

Moore's law

The observation that the number of transistors on a chip has been doubling approximately every two years.

This notion, which strictly speaking is not a law at all but a prediction based on extrapolating present trends, was put forward in 1965 by Gordon Moore, cofounder of computer chip manufacturer Intel. And it is ultimately the reason why the capabilities of computer equipment have been increasing so rapidly. It also explains why computer equipment, such as *digital cameras*, depreciates in value so quickly over time.

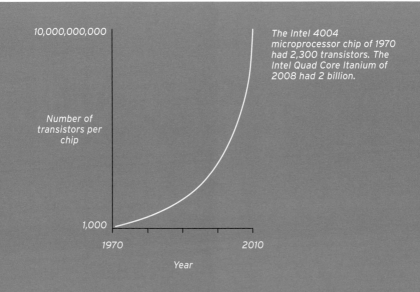

10,000,000,000

The Intel 4004 microprocessor chip of 1970 had 2,300 transistors. The Intel Quad Core Itanium of 2008 had 2 billion.

Number of transistors per chip

1,000

1970 2010

Year

Memory

Electronic components used for storing digital information.

Memory generally falls into three basic categories: ROM, RAM, and flash. All types of true memory used today are solid state, which means they are transistor based and have no moving parts. *Virtual memory* is a simulated form of memory and is defined elsewhere.

ROM

Read-only memory (ROM) has data encoded into it upon manufacturing and cannot be altered thereafter. ROM cannot function as user-modifiable storage and is used for storing software that needs to be fixed permanently.

A typical example is *firmware*: the software that controls a digital device such as a camera. Firmware is often encoded into ROM so that it cannot be erased. Game cartridges used by classic game consoles (and some portable game players) frequently employ ROM chips. Note, however, that most advanced devices today now use flash memory for firmware so that they can be upgraded if necessary.

RAM

Random access memory (RAM), which is "volatile" electronic storage since it requires a continuous supply of electricity to maintain information. RAM is used for temporary information storage on computers.

If a computer is being used to type up a document in a word processor, for example, that information is stored in RAM for rapid access. If the document is not saved to permanent storage (such as a *hard drive*) then it will be lost if the computer is turned off. Likewise if a camera shoots a rapid sequence of images it may store those photos temporarily in RAM (a memory buffer) until it can write those photographs to a *memory card*. If the camera loses power before writing is complete, those photos will be lost.

Personal computer RAM typically takes the form of electronic chips soldered onto small flat plug-in modules, known as SIMMs (single inline memory modules) or DIMMs (dual inline memory modules). Laptops typically use SO-DIMMs (small outline DIMM). Memory modules are available in a huge range of sizes (megabytes and gigabytes) and operating speeds.

↑ *Three memory modules.*
From left to right: a SODIMM
(small outline dual inline
memory module) from a
laptop, a regular DIMM (dual
inline memory module) from a
desktop computer, and an FB-
DIMM (fully buffered DIMM)
with huge metal heat sinks
(cooling fins), intended for
use on a high-end server
computer. Each flat board has
a number of black rectangles
soldered onto it. These are the
memory chips themselves.

Computer memory is sometimes referred to as DRAM, for dynamic RAM, in contrast to far less common static RAM. The distinction reflects internal design differences that do not affect the end user.

Flash memory

Memory which can retain information even when no power is applied, unlike RAM. And, unlike ROM, flash memory can be altered and updated. It is technically a type of EEPROM, or "electrically erasable permanent read-only memory."

Like ROM but unlike RAM, flash memory is "nonvolatile" memory. This makes flash memory ideal for file storage, particularly for devices such as *digital cameras*. Most camera memory cards are built around flash memory chips. Flash memory is also used for storing camera firmware, custom settings, and the like. Flash is also being used increasingly as a form of mass storage, though its cost per megabyte means hard drives are still far more common.

Flash memory is often described with a speed rating, typically using the baseline of 150 kilobytes per second used by CD-ROM drives. Thus a card advertised as 8x would be able to transfer data at a speed of 1.2 megabytes per second. Unfortunately these speed ratings aren't always comparable between manufacturers, since there is no universal standard for measuring the speed of a card.

Unlike other forms of computer memory, flash memory can wear out with use. After hundreds of thousands of erase and rewrite cycles, a flash memory cell can fail. This problem rarely strikes casual users, but can be a significant issue for professionals.

Virtual memory

Virtual memory is *hard drive* space used as a form of temporary memory (RAM).

Computer RAM is, on a per-megabyte basis, more expensive than hard disk space. For that reason it is common practice for personal computers to use a portion of a hard drive as simulated RAM.

The main drawback is that hard drive mechanisms are much slower than genuine RAM, and so virtual memory brings a performance penalty. If a computer gets caught up moving data back and forth from real memory to virtual memory, it can get even slower. This is known as "thrashing," and causes hard drives to whir continuously for long periods during which the computer is fairly unresponsive.

For this reason, adding more real RAM to a computer is one of the better ways to increase performance, particularly when working on large files such as photographs.

Hard drive

An electromechanical device, consisting of a rotating disc mechanism sealed inside a metal case, which is used to store digital information.

Hard drives are the components that most personal computers use to retain files when the machines are turned off. They are mass storage devices, ubiquitous because they're fast, capacious, and inexpensive. However, since they are mechanical devices with moving parts they have one serious drawback—they are vulnerable to shock, vibration, and wear. And, as anyone who has had a hard drive fail knows, the mechanisms can fail catastrophically with little or no warning. Such failure can result in partial or complete loss of information. Since hard drives store information as magnetized points on a surface they can also be affected by strong magnets.

The physical size of hard drives is determined by the diameter of the disc platters. They range in size from tiny 1in drives used in CompactFlash type II

↑ Three hard drives, clockwise from left. A parallel (EIDE or ATA) 3¹/₂in hard drive for use in older desktop computers, which has been opened to expose the delicate internal mechanism. (Note that this is for illustration purposes only, since opening hard drives will cause them to fail permanently.) A 2¹/₂in hard serial ATA (SATA) hard drive for use in most laptop computers. And a tiny 1in hard drive used as a type II CF card.

← Two external hard drives. The large one contains a 3¹/₂in mechanism, the small a 2¹/₂in mechanism.

cards and some music players, to the 2¹/₂in drives used in most laptops, to the 3¹/₂in drives used in most desktop computers.

Hard drives are considered to be "internal" when they are built inside computer cases, or "external" when they are housed in separate portable enclosures. Internal hard drives typically use serial ATA (SATA) connectors, though parallel ATA or IDE/EIDE connectors were popular in the past. External drives typically use USB, with FireWire and eSATA used for higher transfer speeds, though SCSI was popular in the 1990s.

In the past professional photographers often relied on CompactFlash hard drives because they offered more affordable storage than similarly sized flash-based cards. However, flash is more resistant to impact and shock, and flash prices have fallen. CompactFlash hard drives are thus becoming rare. In fact, flash memory is encroaching on the hard drive market. Storage devices built around flash chips are known as solid-state devices (SSDs) and are becoming increasingly popular.

Digital workflow

The techniques, steps, and methods used in capturing, importing, cataloging, editing, outputting, and archiving a digital image.

In the days of film, most processing work was farmed out to a laboratory. The photographer would deliver exposed and undeveloped negatives to the lab, then pick up completed prints later on. The arrival of digital means that much of this work can now be done by the photographer him or herself. This affords considerable flexibility, but also requires additional time and the development of a new set of skills.

Importing

Sometimes humorously referred to as "ingesting," this is simply the matter of transferring the image files from the camera to a personal computer's *hard drive*. This may be done by a direct cable or through means of a *card reader*.

Cataloging

Once on the computer, various programs are commonly used to sort and organize the images so they can be searched and retrieved at a later date. Such programs are sometimes known as digital asset management (DAM) programs, and frequently support image annotation through *metadata*. Photos may be assigned numerical ratings to aid in the process of winnowing out results, may have keywords added to them to simplify future searches, and may be grouped according to location, date, shoot, and topic. The most successful photos in a shoot are often known as "picks" and are highlighted or marked accordingly.

Editing

Successful images are usually altered in some form prior to printing. This may be relatively modest in scope: perhaps the color balance or *contrast* levels will be adjusted, much as one might have done in a *darkroom*. Or they could be quite elaborate, involving complex alterations to the image. This work is usually done in an image-editing program, though some asset management tools have basic editing functions built in.

Outputting

If a print is desired, the image is then prepared for outputting in hard (printed) form. This may be outsourced to a lab, or may be done through a printer connected to the computer.

Backing up

Also known as archiving, the process of creating redundant copies of all images so that nothing is lost in the event of a mistake or system failure. This may involve transferring copies of the photos to another hard drive mechanism, to optical discs, or to off-site storage facilities.

Digitizing

The conversion of an analog source into a digital representation.

Digitizing is thus a process of sampling continuous analog information and storing a representation of that information in a discrete, discontinuous form. Any digitizing device is an analog to digital (A/D) converter. The quality of a given piece of digital information that derives from an analog source is dependent on the quality, *resolution*, and accuracy of the A/D conversion.

Digital cameras are digitizing devices for capturing real-world scenes as still digital images. *Scanners* are another specialized form of digitizing device, designed for recording two-dimensional images only.

The process of analyzing continuous analog data and converting it to a digital form is known as "sampling," since representative samples of information are taken. Once information has been digitized it is said to be in the "digital domain" and can be copied or duplicated without any further loss of quality.

Color management

The digital tools and techniques used to reproduce color accurately across different devices.

Every device records and displays color differently. Without color management, the colors in a photo may look great on-screen but completely wrong when printed out. This is because of fundamental differences between the color-producing capabilities of the devices. Color management can't change those differences, but can make color conversion between devices match more closely.

No camera, computer display, printer, *scanner*, or other device is capable of reproducing the entire range of colors visible to the human eye. Instead it can reproduce only a certain range, known as its "gamut." This gamut can be represented numerically by a "color profile."

Each device in the chain should be calibrated, or measured against a known standard. It will then be possible to move an image from one device to another (e.g.: from a computer to a printer) without unexpected surprises in terms of color quality and accuracy if color-management software is used with all the devices.

→ *This colorimeter or color calibration tool sticks to the surface of a monitor with tiny suction cups. In conjunction with color management software it can be used to adjust a screen for correct color output.*

Backup

Creating a duplicate copy of a digital file for archival purposes.

Digital information, while easily created, is also easily lost. Just as it is easy to fill up a digital camera's *memory card* with photos, a single errant keystroke or failed *hard drive* can destroy that information permanently. And longer-term strategies are also problematic. Film is a more durable long-term medium than digital.

Backup strategies are methods for creating exact duplicate copies of digital files in order to lower the risk of data loss and make it possible to recover from disasters. There are a number of common ways in which information can be lost.

User error

As computer aficionados like to say, "error exists between chair and keyboard." This is probably one of the most common problems. Replacing a folder of new data with a folder of old data, for example, is an easily made mistake.

Media failure

Memory cards and other forms of solid state storage are generally fairly reliable, but mechanical devices such as hard drives are susceptible to cataclysmic failure. A single failed hard drive can take down a massive amount of information.

Soft errors

Storage systems such as hard drives use catalogs to keep track of their files. Just as destroying the card catalog in a library can make it massively time-consuming or even impractical to locate a given book, corruption of a file system's catalog can render a storage device useless even if it still works physically. Data recovery software is an important tool for any digital photographer, since such programs can frequently rescue photos from memory cards and hard drives with corrupt catalogs.

Theft, damage, fire

Any of these situations can easily result in permanent loss of equipment and thus information.

Backup methods

There are a number of backup strategies commonly used, all of which revolve around duplicating data.

↑ *A spindle of optical discs, used for backing up computer data.*

Optical backups

Recordable (single use) or rewritable (multiple use) CD DVD, and Blu-ray discs are a popular way of backing up files. The discs are generally fairly reliable once created (a process known as "burning") and can easily be locked away in a fireproof media safe or taken to an off-site location. However the capacity of optical discs is limited and the drives are typically very slow.

Hard drives

Data is easily and quickly copied to additional hard drives. Special backup software can be used to automate the process, freeing the user from having to remember to copy documents on a regular basis. Many backup programs also support "incremental" backups whereby only those files which have been altered are backed up, saving time and storage space. Some programs can also create snapshots in

me, recording the state of a hard drive at ny given moment, making it possible to ewind in time to before a file was deleted y mistake. External hard drives are useful ackup media, since they can easily be hysically secured when not in use.

RAIDs

edundant Array of Independent or nexpensive Drives. A device or system vhich records information to multiple hard rives. RAID covers a range of storage trategies, including "fault tolerant" rrangements which preserve data ntegrity. However, even fault tolerant RAIDs are susceptible to catalog damage r user error: they mainly protect against ard drive failure.

RAID level 0, or "striping," is not fault olerant. It splits information across more han one drive mechanism for enhanced peed. It is rarely used by photographers ince the failure of one drive results in otal data loss.

RAID level 1, or "mirroring," is the implest fault tolerant level. Data is written o two hard drives simultaneously.

RAID level 5 stores information edundantly using multiple hard drives so hat information is preserved even if a drive fails; this is very useful for photographers and others who need massive amounts of protected storage.

Network backups

It is becoming increasingly popular to back up files across the internet to dedicated storage facilities operated by backup companies. This essentially offloads the drudgery of backup to a paid service. While useful, the primary limitation for photographers is the speed of the network. Large picture files may simply take too long to transfer over a typical home or office internet connection.

Tape

Digital data can easily be copied to special backup tapes. Tape is not a common backup medium as it once was, however. Tape technology has not kept up with advances in drive capacity, and the mechanisms are slower than hard drives, particularly when searching for arbitrary files.

Portable card readers

Many traveling photographers use small self-contained card readers containing small screens and hard drives. These devices can read memory cards and transfer their contents to small internal drives. Often these are used as primary storage so that the card can be erased and reused out in the field. This is an unwise strategy from the point of view of data integrity, since mechanical drives are far less stable than memory cards. However, it can be useful to use a pair of such card readers as backups to the memory cards.

← An enclosure capable of containing multiple 3^1/$_2$in hard drives in a RAID configuration. The third drive down is partially ejected, showing how the mechanisms can easily be removed.

Display

An electronic device capable of displaying two-dimensional images that can change in real time.

The two types most commonly used by photographers are *CRTs* and *LCDs*. Other technologies, such as rear-projection, plasma, and OLED, are mainly used for televisions.

CRT (cathode ray tube)

A display device, of the kind used by traditional TV sets, constructed around a bottle-shaped vacuum tube made of glass.

CRTs are large and heavy because of the glass tube. They are also deep, owing to the need for the protruding neck which houses the electron gun. CRTs are thus only useful for desktop applications.

For many years they were the primary display technology used with personal computers. Today they are still seen in some prepress applications, owing to their superior off-axis viewing, consistency of illumination, and color accuracy. However, their size, energy consumption, bulk, and environmental toxicity (the glass typically contains lead) mean that they are very much a fading "sunset" technology, being rapidly replaced by flat panel technology.

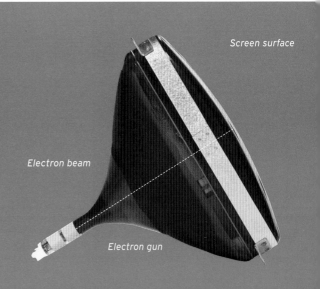

Screen surface

Electron beam

Electron gun

LCD

Liquid crystal display; a common type of flat computer screen.

LCDs are flat and thin displays used with digital devices. They rely on the principles of polarization and come in two basic varieties: monochrome and color.

Monochrome LCDs

Monochrome LCDs are used in the display readouts in many cameras and digital watches. They typically have a light gray surface above which black letters and symbols seem to float. They can easily be viewed in daylight since they reflect ambient light, but require small backlights to be readable in the dark.

Color LCDs

Color LCDs are used as camera screens, computer monitors, and flat-screen TV sets, and can display full-color images. In a sense they're a bit like photographic slides, in that they display transparent images that require a light shining through from behind to be visible. They can thus be difficult to view under bright lighting conditions such as direct sunlight. Some use fluorescent panels for the backlighting, and some use white LEDs.

LCDs are popular because they are very thin and use very little power, though some varieties have slow response times and poor viewing angles. There have been many types of color LCD technology over the years, though most today are TFT (thin film transistor) panels. Generally speaking, most affordable displays use dithered 6-bit TN (twisted nematic) panels, while more expensive displays often employ 8-bit IPS (in-plane switching) and variants (S-IPS, H-IPS).

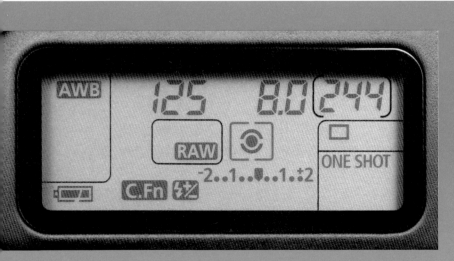

↑ *A monochrome LCD on a camera's top deck.*

Television

Electronic devices for displaying moving images; sometimes used to preview photos taken on *digital cameras*.

While TV technology is not an immediately obvious adjunct to still photography, most digital cameras today do support some sort of video-out option. This is because a TV set can act as a simple, albeit generally low quality, preview screen. A casual photographer might take a camera over to Grandma's house and plug it into her TV for an immediate slideshow of the children, for example. Or a *studio* photographer might use a high-definition video monitor to preview studio shots. There are a number of different types of television technology, both analog and digital.

→ *A high-definition flat-panel LCD TV. This digital unit has a wide-screen aspect ratio of 16:9. Most high-definition TVs use HDMI connectors.*

NTSC, PAL, SECAM

There are three forms of traditional analog television used in the world today. This technology, generally developed in the 1950s and 1960s, is slowly being phased out in favor of digital, but is still ubiquitous.

The oldest analog standard seen today is the NTSC system developed by the National Television System Committee of the US, and used in the US, Canada, Mexico, Japan, and a few other countries. PAL, or "phase alternating line," is used in most parts of Western Europe, Asia, South America, and Africa. SECAM, or "Séquentiel Couleur à Mémoire," is used in France, parts of Africa, and parts of the former Soviet Union. Few digital cameras support SECAM video-out. All three standards have screens with an aspect ratio of 4:3.

Composite video

Most cameras support either NTSC or PAL video-out using simple composite video connectors. Composite carries all video information through a single connector, typically an RCA plug color-coded yellow, and offers fairly low quality.

High-definition (HD) television

Some cameras, generally high-end models, also support digital video-out in HD form using an HDMI (High Definition Multimedia Interface) plug. The most common types are 720p, 1,080i, and 1,080p, with the number referring to the number of horizontal lines supported. The "p" refers to progressive scan, which means that the picture is not displayed using alternating lines, and "i" refers to "interlaced" scan, which is. HD television uses wide-screen displays with an aspect ratio of 16:9.

Native resolution

The highest and optimal *resolution* which a *pixel*-based monitor can achieve.

Line-based monitors such as *CRTs* can easily be adjusted to different resolutions. This is because the image they display is essentially analog in nature, is projected onto a glass surface, and can easily be moved on that surface. However, pixel-based monitors such as *LCDs* and plasma displays have fixed grids of pixels built into the display itself. These are rows of light-producing elements which are laid down during manufacturing and cannot be moved.

Since it is not possible to alter the spacing of the dots of such fixed grid monitors, they are forever locked at a certain resolution. However, these screens usually allow for simulated changes in resolution through interpolation. This is a process whereby a computer calculates what the image would look like at a lower resolution and redraws it on the fixed grid of the screen.

Interpolation of this type allows for fixed-grid monitors to support different resolution levels, but the drawback is that the image is always softer and blurrier at any interpolated resolution except for the case of exact multiples (e.g.: if four native pixels are used to represent one pixel).

A fixed-grid monitor that is displaying its maximum resolution is said to be running at native resolution. Sometimes this is referred to as "pixel perfect" since this is the optimal resolution for which the monitor is designed.

↳ The first line of text was correctly sized for the pixel grid in use. The second, however, was drawn onto a smaller grid and then enlarged to fit. Since pixel size is fixed, the result is a jagged mess.

Defective pixel

A malfunctioning *pixel* or subpixel on an *image sensor* or *LCD* screen.

Image sensors and LCD panels contain millions of individual transistors, diodes, and other electronic components. Sometimes a product ships from the factory with one or more failed pixels, and sometimes a pixel fails at a later date. There are three basic categories of such defects.

Dead pixel

An individual element which never works at all. This will appear as a black dot.

Hot pixel

An individual element in an array which erroneously sends a continuous output signal. Such pixels are always lit up white in the case of LCDs or record white dots in the case of image sensors.

Stuck pixel

A subpixel in a group that is permanently on or off. This will result in a red, green, or blue dot appearing. Products which ship from the factory containing failed pixels are frustrating from a consumer point of view, but exist for economic reasons. Panel prices are set in "classes" by the manufacturer based on the number of defective pixels, with zero-defect screens commanding the highest prices. Many vendors do not guarantee flawless screens and have instead a pixel policy stating their limit of acceptable failure.

← *A magnified view of a hot pixel which appeared during a long time exposure.*

Printer

Hard copy output devices, capable of imaging directly onto paper or similar materials, controlled by a personal computer or camera over a digital connection.

Ink-jet

Ink-jet printers use liquid inks, which are squirted out in tiny microscopic droplets onto the paper. They range in price and complexity from inexpensive printers that are virtually given away with new computer purchases, to high-end printers capable of photographic-quality prints. Most use four-color inks, but some improve color reproduction by using as many as eight different colors of ink. Ink-jets are popular printing devices, but do have some drawbacks, such as drying times when prints are complete. They cannot produce *continuous tones* but simulate them by laying down patterns of tiny dots.

Dye sublimation

Dye-sublimation printers are capable of continuous-tone reproduction. They use cartridges containing films of colored dyes. When heated, the dyes turn into a gas that is transferred onto the page. The gas then sublimates back to a solid state. Dye subs were once very costly printers, but inexpensive photo printers based on the technology are readily available. Unlike ink-jet prints, photos produced using this process do not need to dry.

Laser

Laser printers use the same principles of "xerography" as photocopiers. A dry powder known as toner is directed on to a paper surface through static electricity controlled by a laser beam. It is then melted onto the paper by application of heat. Laser printers are mainly used as high-speed office printers capable of high *image quality*, though full-color laser printers are available.

Phase change

Solid ink printers which use waxy crayon-like sticks. The inks are melted and applied to the pages in tiny dots.

Imagesetters

Strictly speaking imagesetters aren't printers as such. They are high-resolution output devices used by graphic designers in prepress work for magazines, books, and newspapers. Typesetting is commonly performed on these machines.

PostScript

Not a type of printer, but a computer language used for generating printed pages. Devices designed for typesetting applications, such as laser printers and imagesetters, frequently use this language.

Giclée

An image created with an ink-jet printer, though by implication an expensive high-quality printer using archival paper, rather than a home or office ink-jet.

Giclée (pronounced jee-CLAY) is sometimes used in gallery contexts to avoid the "ink-jet" appellation. It's derived from a French verb meaning to spray or squirt. Unfortunately the photographic usage was not coined by a French speaker, as the word has vulgar slang connotations in France.

Scanner

An imaging device used to digitize film, photographs, and other nominally two-dimensional material.

Scanners differ from cameras in that they are special purpose devices optimized for capturing static two-dimensional items and digitizing them accurately. There are three common types used today: flatbed scanners, film scanners, and drum scanners. They typically connect to computers using either USB or FireWire/IEEE 1394 cables.

In addition to sharpness and resolution, scanners differ in terms of their dynamic range. The best scanners are able to extract both shadow detail and highlight detail from source material, where poorer scanners can see solid blocks of dark or light. The ability of a scanner to detect detail in shadows is referred to as its "Dmin" value and highlight detail as its "Dmax" value.

Flatbed scanners

The most common type seen today, flatbeds can scan any item placed on their glass tops, much like a conventional photocopier. They can thus be used for scanning photographic prints, books, large-format film negatives, and other flat items of an arbitrary size. However, since objects can fit on their scanning platforms as well, they are sometimes used for artistic scans of shallow objects.

Film scanners

These devices transfer film-based content to the digital domain. They typically have slots which can accept one or two different types of film and nothing else. For example, a *35mm* film scanner might be able to accept 35mm negatives, 35mm slides, and possibly, via an add-on adapter, *APS* canisters. High-end scanners may also support medium-format film. Some contain motorized feeding mechanisms.

Drum scanners

Large commercial devices which offer extremely high *image quality*, but which are expensive to purchase and operate. They require the source material to be wrapped around a rotating cylindrical drum, which limits the kind of materials which can be scanned.

Scanner dust and scratch correction

The ability of some film scanners to scan film with an *infrared* scan to detect and correct for the presence of dust.

Painting out or "spotting" dust and scratches from a film scan is an extremely labor-intensive and tedious task. It can be reduced somewhat through scrupulous care during the scans and careful cleaning of the film. But a more time-efficient approach is automated detection and elimination of dust shadows.

Many film scanners use infrared light scans in addition to regular visible light scans. Since most films are transparent to infrared energy, opaque flaws such as dust and scratches show up much more clearly. The scanner can then simply eliminate the flawed areas by comparing the visible light and infrared scans.

Kodak's Digital ICE and Canon's FARE are two common systems for reducing scratch and dust. Note that these systems often do not work well with traditional silver-based (non-*chromogenic*) black-and-white negatives and Kodachrome slides since those films can contain materials opaque to IR.

→ Image A is a straight scan of a very dusty and dirty 35mm slide.

→ To correct the problem, the scanner performs an IR-only scan, revealing the specks of material (image B).

→ The scanner's software then mathematically removes the dirt from the image, resulting in the final clean scan (C). Note that slight smudging is visible in areas where particularly heavy lumps of dirt were present, but on the whole far less work is required to clean up the negative.

A

B

C

Software

In an abstract sense, the instructions which control a computer. In a practical sense, the packages which allow the computer to perform different functions.

While hardware consists of physical components that can be touched, software is essentially intangible. Of course, software is stored on a variety of devices (*hard drives*, CDs, etc.) to be useful.

Software can be divided into two basic forms. System or "operating system" software is like the engine of a car, and is the fundamental software that the computer needs to run. Windows, Mac OS, and Linux are three popular operating systems. "Application software" is software that a user runs to perform various tasks, such as word processing or image editing. In other words, applications can be thought of as tools wielded to do a job.

↑ *Adobe Photoshop, a popular image-editing software application.*

→ *Image cataloging software such as Expression Media will help you stay organized.*

Image editor

A software application used to alter a digital photograph, particularly modifications at a *pixel* level.

Digital photographs are simply large collections of colored dots represented by numbers inside a computer. Since these numbers are easily modified, it makes digital photography a very malleable medium.

Photochemically-produced pictures require considerable *darkroom* work to alter tone or color, and substantive changes typically involve painstaking retouching work. By contrast it is extremely simple to make a global alteration to a digital picture, and image-editor applications allow for easy brightness, contrast, tonal curve, and color/*white balance* changes.

Image editors also work at a per-pixel level, meaning that arbitrary areas of an image can be selected and modified independently of the photo as a whole. This may replicate traditional darkroom techniques, such as dodging and burning for darkening or brightening selective areas, or may involve complete *retouching*

Most image editors generally work on a "destructive" basis, which means that they can permanently alter the actual file being edited, depending on the nature of the operation performed. It is thus wise to create a backup copy of a photo before working on it.

Original

Edited

Thumbnail

A very small preview image, typically used by cataloging programs and the like.

A simple textual list of file names is not a very useful way to sort through a collection of photographs, particularly if the pictures have camera-generated sequential numbers for names. A much more useful approach is to show a collection of digital photographs as tiny scaled-down versions of each picture. These miniature copies of the full-size photo are known as thumbnails.

Pregenerated thumbnails are quite common, as they permit graphics programs to display previews of large numbers of pictures quickly and efficiently. Without thumbnails the programs would have to load each entire photo one by one each time, which is very time-consuming.

Nondestructive editing

Of an image-editing program, the ability to record editing changes without actually altering the original image in any way.

In a traditional image-editing program the *pixels* that make up a photograph are loaded into memory and then altered. Any changes to the photo, once saved to disc, are not reversible.

By contrast, nondestructive editors load an image into *memory* and then record changes to the image as a series of instructions. For example, a user might note that a photo needs a 10 percent increase in *contrast* and a 5 percent lowering in brightness. These instructions are applied to a temporary copy of the loaded image, but are not applied to the original saved file.

The final image is produced through a process known as rendering, during which the recorded instructions are applied to a copy of the original data. The result is a second image containing all the requested changes.

The advantage of nondestructive editing is obvious: the original picture isn't changed at all, and thus alterations can be reversed instantly by reloading the original. However, the distinction between destructive and nondestructive editing is becoming blurred, with more programs taking aspects of both. Many traditional image editors are capable of applying various nondestructive forms of editing, such as layers and channel masks. Nondestructive editors can also support localized editing, such as burning and dodging.

↑ *Apple Aperture, a nondestructive editing program. The changes to the second version of the photo are merely instructions or "recipes" which are applied to the image on the fly and which can be altered at any time without affecting the original file.*

Color space

A digital map which delineates the colors available to a given application or process, and which assigns absolute numeric values to them.

Human eyes see color in a continuous form. A computer, however, does not handle continuous information but requires a sampled set of data, represented by its color space. The range of colors contained in a given color space is its "gamut."

The most common color spaces used in digital photography are Adobe RGB 1998 and Microsoft and HP's sRGB. Both are based on the RGB color model, but record a different range of colors. Adobe RGB was intended for color reproduction to printers and handles a fairly wide range of colors. sRGB, by contrast, has a smaller gamut, being weaker primarily in the greens. However, sRGB is fairly universally supported by a wide range of devices and is thus a safe choice for use on the internet. A third, less popular, color space is Kodak's ProPhoto RGB, which covers a huge range of colors—including ones we can't see.

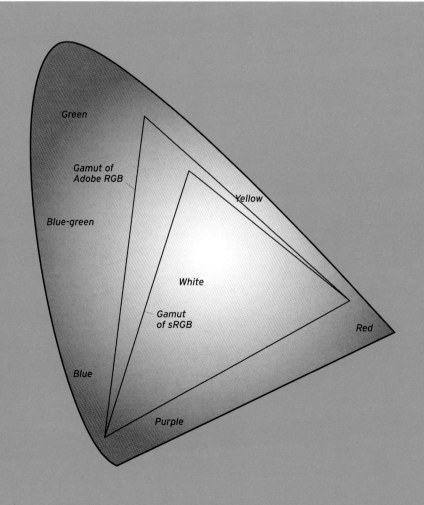

Channel

A layer of digital information consisting of brightness (luminance) information for one specific discrete entity, such as a color.

Computers can treat the three *additive colors*—red, green, and blue—as separate layers. Each channel, is essentially a grayscale picture for that one color, recording the brightnesses of greens or reds or blues. All three channels constitute a full-color picture. *Subtractive color* using CMYK has four channels: cyan, magenta, yellow, and black.

Channels can be used for other purposes, such as "alpha channel transparency," whereby a single channel stores a "mask." This is a grayscale image indicating which areas of the picture are visible (black in the mask) and which areas are transparent (white in the mask); very useful for layering multiple images.

Selective use of channels can also be employed when converting color images to black and white. Much like different colored *filters* can be used with *black-and-white photography*, selective channel use create very different *monochrome* photos.

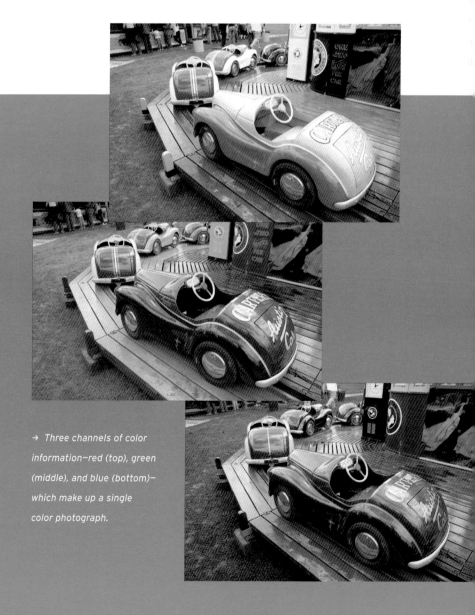

→ *Three channels of color information—red (top), green (middle), and blue (bottom)— which make up a single color photograph.*

Sharpening algorithm

A software function which improves local *contrast* in order to make an image appear sharper.

Sharpening algorithms are computer programs which take an image and apply a series of mathematical transformations to the data. They are designed to increase the contrast on either side of an edge, thereby making a picture seem sharper. The degree to which the algorithm increases the contrast affects the sharpness of the final image.

One of the most common sharpening algorithms is known as "unsharp mask" or "USM." Modeled after the classic sharpening technique of the same name used in printing film enlargements, unsharp mask first creates a blurry version of the image. It then mathematically subtracts the normal version of the image from the blurry version, allowing the program to distinguish edges. Localized contrast enhancement is then applied to edge areas.

Like any software tool, sharpening can be overdone. A classic *artifact* of excessive image sharpening is the appearance of bright lines running parallel to edges.

Most *digital cameras* produce fairly soft images at a sensor level, because of their use of Bayer color masks and the need to interpolate color data. Most *point and shoots* automatically presharpen images in-camera, but photos from *SLRs* often benefit from the application of a little image sharpening.

Unsharpened image from camera

Sharpening applied

Oversharpened

Bug

An error in a computer program which causes unexpected or undesired results.

Personal computers and their associated software can fail or "crash" because of bugs.

But, less obviously, modern cameras are computer-controlled devices containing complex software programs which can also suffer from software bugs. Sometimes such bugs can be quite subtle, perhaps resulting in slight metering inconsistencies. Sometimes they're odd problems triggered only by an unusual set of circumstances. Or in some rare instances they can actually cause the camera to lock up and fail to respond altogether, a condition known as "freezing."

Most cameras contain *firmware* stored in flash *memory*, which can be updated. Serious bugs can be fixed this way, though minor or obscure bugs may never be fixed by the manufacturer.

Plug-in

Supplementary software which can extend the functionality of a key piece of software.

Many image-editing programs support plug-ins, which allow the application to apply different filter transformations and other features not included in a default installation. Such filter libraries, often available from *third party* software companies, support a wide range of features, from emulating film to overlaying three-dimensional models to adding simulated *lens flare* effects.

The creators of the *image editor* themselves usually publish details of how the plug-ins must be written in order to talk correctly to the host program. The rules governing such interactions are known as APIs, or "application program interfaces."

Multimedia

Digital information which includes more than one media type, such as text, audio, still images, and video.

Multimedia was quite a buzzword in the early 1990s, when it was heralded as a new way of using computer technology. Today nearly all commonly used computer information is multimedia in some form. Web pages, for example, typically include both text and graphics. Video and animated graphics are also commonly seen.

It is even possible to build a complete image cataloging and editing application that works within a web browser, as shown here.

Tonal curve

Mathematical compensation applied to an image, often in order to match the response curve of another medium.

Different devices, objects, and substances respond to light in different ways. For example, digital *image sensors* have a mostly linear response curve. This means that if the amount of light falling on the surface of a sensor doubles, then the sensor's output will also double. The result is a straight, or linear, response.

Human vision, on the other hand, does not have a linear response to light. In fact, it's mostly logarithmic: our eyes are much more sensitive to changes in light level at low-light conditions. A doubling of light at low levels makes a big difference, whereas a doubling of light at high levels makes much less of one. Film, incidentally also has a nonlinear response, described by its *characteristic curve*.

To minimize this mismatch, compensation is applied to digital images so that the image captured by the sensor more closely approximates the response of the human eye. This kind of compensation is known as a tonal curve. Some cameras allow for changes in tonal curves to be set internally.

Another area where tonal curves are used is when using a device such as a printer. Printers have a limited dynamic range, and tonal curves may be applied to compress the range of brightnesses so that it looks good on the final print.

Linear Logarithmic

Film

Film

Light-sensitive material, consisting of a photochemical emulsion on a flexible transparent substrate, used for recording two-dimensional images of a scene.

For most of the twentieth century, film was the primary means for recording visual information photographically. From everyday snapshots to the most important historical events, silver-based film was used.

The earliest photographic images were recorded using metal or glass plates. The development of flexible film, particularly the invention of roll film in sealed canisters, transformed photography from a specialized *studio* business to something within the reach of the average consumer. Over that time countless *film formats* were employed, from large 8x10in sheets to long rolls of *35mm* film to tiny squares of film housed on plastic discs.

All commercial film relies on the same fundamental principle: that silver halides react to the presence of light, becoming metallic silver. This photochemical transformation can be controlled and manipulated to produce a finished image. *Silver gelatin* and *chromogenic* dye films are the most common types used today.

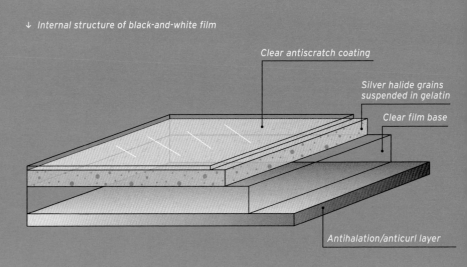

↓ *Internal structure of black-and-white film*

Clear antiscratch coating

Silver halide grains suspended in gelatin

Clear film base

Antihalation/anticurl layer

Photogram

Alensless and contact-based method for forming images by placing objects on a *photosensitive* surface and exposing the material to light.

The simplest way to produce a photographic image is to rely on shadows cast by objects on photosensitive material. Leaves, lace, feathers, glass bottles: all have been used in this fashion. The final result following development is a high-contrast and *monochrome* silhouette of the objects.

Since photograms, also known as photogenic drawings, shadowgraphs, Rayographs, and sunprints (photogram cyanotypes), do not require lenses or cameras they were frequently made in the early days of photography. William Fox Talbot produced the first permanent photograms in 1839, and in the 1920s and 30s artists such as Man Ray and László Moholy-Nagy produced photograms as part of their extensive experimental work. Today photograms are a popular educational tool for children. They can be made using traditional black-and-white chemistry or, alternatively, presensitized cyanotype papers can be exposed to the sun to create permanent images once fixed with water.

A simple photogram of a peacock feather.

Alternative processes

One of many different types of photochemical processes not reliant on *silver gelatin* and mainly developed during the early days of photography.

The early history of photography, from the pioneering work of Nicéphore Niépce in the late 1820s through to the rise of the silver gelatin process toward the 1900s, was marked by constant technological change. Countless chemical techniques were developed and discarded as scientists, inventors, and experimenters relentlessly pursued the holy grail of photography: affordable, permanent, and easily reproducible images. The widespread use of silver gelatin photography effectively brought this era of change to an end.

Compared with contemporary photochemical methods, antique or alternative processes are often slow, cumbersome, and sometimes quite toxic. They may no longer be in general use, but all have unique styles and looks. Some artists and hobbyists keep these old methods alive to create photographs that are unachievable in any other way.

Daguerreotype

A process which creates a unique image on a polished metal plate. Developed by French inventor Louis Daguerre and based on the work of Niépce, daguerreotypes were the first useful form of photography. While a remarkable technological breakthrough for the time, they had several drawbacks: the images were laterally reversed (mirror images), could not be reproduced, and used toxic mercury vapor.

Another drawback of daguerreotypes, as with most photographic processes of the nineteenth century, is shown below in the portrait of a mother and child taken in the late 1850s. The long exposure period required by the process has resulted in noticeable blurring. Also apparent is the glass-fronted case used to protect the delicate image.

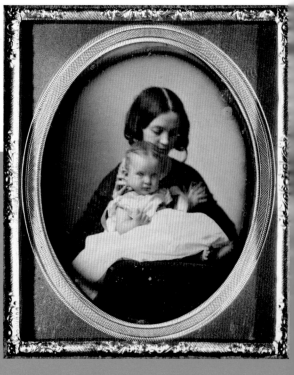

Calotype

Invented by Daguerre's photographic rival, William Fox Talbot, the calotype process created negative images on ordinary paper which could then be used to make a positive image through a contact process. It was the first photographic process to employ intermediate negatives to create final positive images.

Cyanotype

An iron-based process invented by John Herschel in 1842. Cyanotypes are one of the simpler antique processes for hobbyists to use today, but their popularity is limited because prints are blue. In fact, cyanotype chemistry formed the basis for traditional blueprints.

Wet collodion

Developed in the 1850s, wet collodion involved a transparent emulsion formed over a glass sheet. It was affordable and, since it involved the formation of a clear photographic negative, could be used to create multiple positive images on paper. However, the image had to be exposed while the glass plate was still wet, making the process rather cumbersome.

Ambrotype

A wet collodion process that created a negative image on a glass plate. The back of the glass was painted black, so that the image looked positive from certain angles.

Albumen

Albumen prints were made from modest ingredients: egg white and table salt, treated with silver nitrate. The invention of the albumen print led to the nineteenth-century fad known as "cartes de visite," which were small prints of friends, acquaintances, and celebrities of the day.

Tintype/ferrotype

A process that recorded images to iron, not actually tin, sheets. Extremely popular in the USA from the 1850s until the turn of the century. Many US Civil War portraits were taken using the tintype process.

Gum bichromate

A process that sensitizes gum arabic with potassium dichromate. Gum bichromate can yield very interesting painter-like results and is thus still popular with hobbyists and artists today. It can also be printed in multiple layers to support color images.

Film format

The physical size and packaging of a given type of film.

There have been dozens of different film types over the years. The formats are generally divided into three rough categories based on size.

Small-format film has frames smaller than about 4x4cm in size, and usually comes in long rolls of film, sealed in canisters or cartridges. The most popular small format in history is the ubiquitous *35mm* film. Other small formats include Instamatic *110* from the 1970s, disc from the 1980s, and *APS* from the 1990s. The emphasis on such film formats is generally convenience and portability, though 35mm film can achieve reasonably high-quality results.

Medium-format film is also roll based. The only types commonly available today are 6cm-wide 120 and 220 film, which differ primarily in length. Both types offer excellent quality because of the large size of the negative, hence their popularity in commercial work.

Large-format film is sheet based and is quite expensive and inconvenient to use owing to the large sizes involved. For this reason, large-format photography is generally the province of artists and high-end commercial photographers. The massive area of the negatives, from 4x5in to 8x10in, means that extremely high-quality images can be taken.

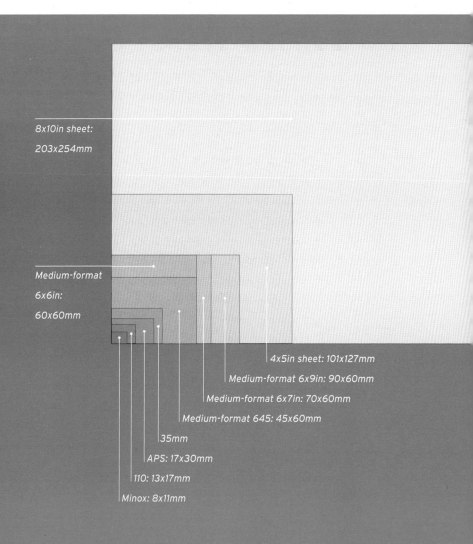

8x10in sheet: 203x254mm

Medium-format 6x6in: 60x60mm

4x5in sheet: 101x127mm
Medium-format 6x9in: 90x60mm
Medium-format 6x7in: 70x60mm
Medium-format 645: 45x60mm
35mm
APS: 17x30mm
110: 13x17mm
Minox: 8x11mm

35mm

A small-format roll film 1³⁄₈in (35mm) wide, sealed in daylight-loading canisters.

35mm film is the most popular film format in history. It had its beginnings as motion picture film in 1892, but was not widely used as a still film format until the introduction of standardized daylight-loading canisters ("135" format) in the 1930s. These small light-tight metal cans, with film protruding through a felt-lined slot, allowed for compact cameras that could be loaded in subdued lighting conditions ("daylight") rather than pitch dark.

While 35mm images cannot compete with the quality produced by cameras with larger negatives such as medium- and large-format film, the portability, convenience, affordability, and universal compatibility of 35mm film have proven to be key advantages over the years.

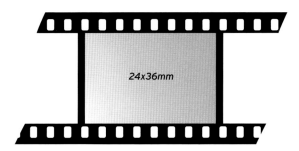

24x36mm

35mm wide

Leader

The portion of film, unusable for imaging, which is used to attach roll film to a camera spool.

In the case of *35mm* film, the leader is the segment of film which protrudes from the canister. This segment is usually cut down in width to simplify the process of loading film into the camera.

Some cameras with automatic winding have an optional feature known as "leader-out" which leaves the leader protruding slightly when the film is rewound back into the canister, rather than winding it all the way back in as normal. Leader-out allows the roll to be partly shot and then reloaded, but also increases the risk of accidental double-exposure.

APS (Advanced Photo System)

Film format released in 1996 and sold by Kodak and several other companies. APS was intended as a simple consumer format, and consisted of roll film stored within permanently enclosed plastic cartridges. Unlike *35mm* film, which is removed from the canister prior to development, APS film was always protected from the outside world. Other APS advantages included a transparent magnetic strip laid over the film itself. This strip could record shooting data from the camera's computer.

APS was not a commercial success, and has the dubious honor of being probably the last film format ever made. Conspiring against APS were the facts that 35mm was too dominant, the *image quality* of APS prints was always lower because of the small size of the negative (only 16.7 by 30.2mm), and the printing costs were often higher than 35mm film. The arrival of digital erased any convenience advantages and sounded the death knell for the format.

110

A cartridge film popular in the 1970s for use with simple *point and shoots*. 110 cameras used tiny drop-in film cartridges and were extremely easy to use and highly portable. They suffered from poor *image quality* primarily because of the small size of the negative (a mere 13 by 17mm) and because most cameras had low-quality fixed focus lenses.

110 products were often synonymous with the Kodak brand name "Pocket Instamatic," though other manufacturers sold 110-compatible cameras. Pentax even marketed a tiny 110 *SLR* camera.

Enlarger

A device used to produce an enlarged copy of a film-based negative by projecting an image onto a flat surface upon which *photosensitive* paper can be placed.

The typical enlarger is an open unit which must be used in a *darkroom*, though enclosed commercial enlargers exist. Most consist of a head assembly mounted on a post or frame which allows for vertical travel, typically using a rack and pinion mechanism. The head contains a light source, a carrier for the negative, an adjustable *aperture* enlarger lens, a focus mechanism for the lens, and a holder for *filters*.

The light source may be an incandescent bulb or a fluorescent tube. The light may be modified by a series of lenses (a condenser enlarger) or by frosted material (diffuser enlarger). Condenser enlargers tend to produce detailed higher *contrast* images, but reveal scratches and other flaws in the negative. Diffusion enlargers tend to offer lower contrast images, are suitable for scratched or retouched negatives, and are also used with color printing. Black-and-white enlargers may have filters for multigrade paper, and color enlargers often use dichroic filters. The *exposure* is controlled by a darkroom or process timer, a simple electromechanical or electronic countdown device which switches on the enlarger's lamp for the required period of time.

The image from the negative is projected down to a flat baseboard upon which photographic paper is placed, often held down by a metal easel. Enlargers designed for extremely big prints may also project an image onto wall-mounted paper.

The invention of the enlarger transformed photography by making it possible to print big photos from small or medium-format negatives. This in turn meant that very small and portable cameras became feasible. Before the enlarger, photos were either one-off images such as daguerreotypes, or could only be used to make *contact prints* the same size as the original negative.

↑ *A large color-capable photographic enlarger. The head has three dichroic filters which allow a narrow range of light wavelengths (colors) to pass through. These can be adjusted to support accurate color balance in the final color print.*

Push and pull processing

Changing development time to compensate for under- or overexposure.

Film is sometimes shot at an ISO setting (*exposure index*) that differs from the expected setting published by the manufacturer. This may be by mistake, if a manual camera has its *film speed* set wrong. Or it may be intentional, if a film is being deliberately used in a certain way to achieve a certain effect. For example, in low-light conditions a photographer may intentionally shoot a roll of film at a higher film speed setting.

Say a roll of ISO 100 film is shot at ISO 200. This is one-stop underexposure, and can be compensated for by "push" processing, or letting the film stay longer in the developer. The less common reverse situation is "pull" processing, whereby the film spends less time in the *developer* to make up for increased *exposure*.

Push and pull processing tend to increase the *contrast* and *grain* in film, so these adjustments come at a price.

Latent image

The unrevealed picture on an exposed but undeveloped piece of film.

When film is exposed to light it immediately undergoes an internal change in chemical composition. But there is no way for the human eye to see this change. Even if it were possible, looking at the film at this point would require illumination, which would destroy the undeveloped image.

Development is thus the chemical process of converting this latent image into a permanent image that will survive having light shone upon it. Once this is done the image will become visible to us.

Light exposes film or paper, creating an invisible "latent" image.

Chemical development makes the image visible.

Characteristic curve

A chart graphing the sensitivity to light of a photochemical material.

Like human vision and unlike digital sensors, *photosensitive* material responds to light in a nonlinear fashion. In other words, a doubling of light does not necessarily result in a doubling of opacity or density. Instead each type of film or paper has a unique nonproportional response curve which can be plotted out on a graph.

Traditional black-and-white materials often have an S-shaped logarithmic response curve. This characteristic curve, "density curve" or "H&D curve," (after nineteenth-century scientists Hurter and Driffield) plots the *exposure* on the horizontal axis and the density of the material on the vertical.

The lower left portion of the curve is known as the "toe" and typically has a shallow slope, indicating that the film is relatively unresponsive at low exposures. The section to the upper right is known as the "shoulder." The bulk of the curve is a fairly linear response curve to light. The slope of the line is known as the "gamma."

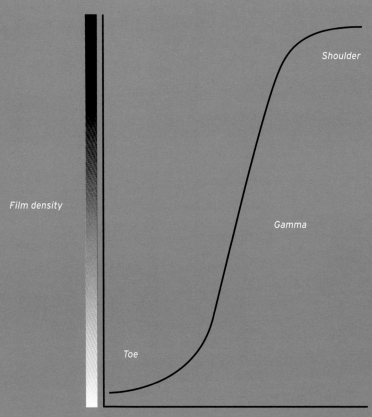

Zone system

A classic technique for assuring correct *exposure* metering.

The zone system was devised by photographers Ansel Adams and Fred Archer in the late 1930s, and places considerable emphasis on the ability of the photographer to "visualize" what the desired photo will look like. It was created for *black-and-white photography*, and so assumes that the photographer is working purely with brightness values, but can be used for color photography as well.

In the zone system a scene is divided into 11 different zones, arranged in increasing order of brightness and assigned Roman numeral designations. The darkest zone is 0, representing the purest black value attainable. Zone X, on the other hand, is paper white, or the brightest white possible. Zone V is a midtone value. A change from one zone to another represents one stop.

The photographer then meters the scene and chooses a zone in which to "place" the primary subject of interest. A light-colored human face, for example, might need a Zone VI exposure. The rest of the scene will then fall where it will in terms of *exposure values*.

Pure black Mid gray Pure white

0 I II III IV V VI VII VIII IX X

Zone system

Silver gelatin

Conventional black-and-white photographic chemistry, which uses silver halides in gelatin.

Traditional black-and-white film is made of a flexible transparent base, usually made of cellulose acetate or polyester, coated by a light-sensitive "emulsion." The emulsion is animal-derived gelatin in which crystals of silver halide are suspended. Silver halides are metallic silver made *photosensitive* by being combined with halogens—bromine, iodine, and chlorine. The film is completed by a few other coatings: an *antihalation* layer, an antiscratch overcoat layer, and an anticurl layer.

Photographic paper is similar, except the emulsion is supported by a paper or white polyester base instead of transparent film.

Fine art photographers and galleries often use the term "silver gelatin," partly to distinguish it from other *monochrome* photographic processes and partly because it sounds better than "ordinary *black-and-white photography*."

↑ *Silver halide crystals take on hexagonal or triangular shapes.*

Chromogenic

Ordinary color film, in which visible dyes are generated at the time of development.

Some films contain dyes at time of manufacture, and the processing of the film involves bleaching out unwanted dyes. Chromogenic films take the reverse approach. They are "color coupled" or "dye coupled." They contain silver-containing emulsions, but they are used to create dyes where silver is located. The silver is then removed at the end of development through a bleach which leaves dyes intact.

Most chromogenic films are color, using C-41 negative or E-6 slide processes, but the technology can also be used to create black-and-white films. Chromogenic black-and-white emulsions can be developed using ordinary C-41 color processes rather than traditional black-and-white processes. Chromogenic black-and-white films thus have "clouds" of black dyes rather than actual silver grains.

Dye-coupled prints made from chromogenic films are sometimes known as "C-prints."

Transparency

A color film transparency, normally using *35mm* reversal film.

Color prints are shot with negative film, since the end result (the photographic print) is positive. Color slides, however, are themselves the end product and are thus a positive image. The process is known as "reversal" since the silver halides in slide film are exposed in much the same way as they would be in a black-and-white negative, but the slide development process results in dyes forming a positive image.

There have been a number of different chemical processes for producing transparencies. Kodachrome K-14 is one of the oldest, yet is also unsurpassed in its color saturation and resistance to fading. However the process is extremely complex and expensive, and very few facilities can still handle Kodachrome film. E-6, a *chromogenic* process, is the most common 35mm slide process used today. Slides are sometimes called "chromes" since many slide trademark names end in "-chrome," meaning "color." It has nothing to do with the metal chromium.

35mm transparencies are usually mounted in card or plastic frames, known as slide mounts. These holders are used to protect the slide from damage, and to make it easier to use slides with *projectors*.

Cibachrome/Ilfochrome is a high-end transparency process in which dyes are present in the film prior to development, then bleached out or destroyed as required. It uses large polyester sheets often mounted in backlit frames, and is known for very stable dye colors.

Grain

The characteristic fine texture of film-based photography, caused by individual particles of silver in the film or paper.

Traditional black-and-white film contains tiny light-sensitive particles suspended in transparent gelatin. These silver halides turn into metallic silver when exposed to light and processed chemically. The density of silver grains determines the darkness or lightness of the image.

There is a direct relationship between grain size and the speed of the film. Large silver grains react rapidly to light, and therefore fast film tends to be noticeably grainier. Small grains take longer to react, which is why slow film tends to be smoother and less grainy.

Technically, modern *chromogenic* color films do not have grains of silver in the final negative or print, but instead "clouds" of color dyes formed during the development process.

Film speed

A measure of a given film medium's sensitivity to light described by numeric values.

There are different types of film in common use. Some, known as fast films, react extremely rapidly to light and can thus be used under low-lighting conditions or with brief *shutter* times. Others, known as slow films, react much more slowly to light and require brighter lit scenes or longer shutter times.

This sensitivity to light is known colloquially as the "speed" of the film, and is described by a numeric standard defined by the International Organization for Standardization. The organization has the short name "ISO," which is not an acronym but derives from the Greek word for "equal." The film speed is often referred to as its "ISO setting" accordingly, though *exposure index* is a more accurate term.

↑ *The film speed dial on a classic camera that predates the ISO name.*

Technically the ISO rating of film inherits and combines two very different technical standards used before the 1980s: the linear system developed by the ASA (American Standards Association, now known as ANSI) and the logarithmic system developed by the DIN (Deutsches Institut für Normung, or German Institute for Standardization). The official ISO value thus contains two numeric values describing the same thing. The most common film speeds are:

50/18°
100/21°
200/24°
400/27°
800/30°
1,600/33°

The DIN-derived logarithmic film speed value is denoted with a degree ° symbol, which does not refer to temperature. In fact, in everyday usage the logarithmic portion of the film speed value is typically omitted, and people just talk about film having a speed of ISO 100 or ISO 800.

DX encoding

An encoding system for marking *film speed* and other information on film canisters and film edges, used by film cameras and automated film processers.

Before the introduction of DX (Digital indeX) in the early 1980s it was very easy for photographers to set a camera's ISO setting incorrectly and end up with badly exposed film. Similarly an inattentive film processing operator could accidentally *cross process* a roll of film by developing it using the wrong process. DX coding solves these problems, at least for *35mm* and *APS* users, by means of two optical bar codes and an electrical contact system.

Camera auto sensing

Film speed is read automatically through a system of electrical contacts which exploits the fact that most 35mm film canisters are made of metal. A compatible camera's film chamber contains a row of small contacts. The film canister has a grid of squares printed on it. If the grid is bare then it conducts electricity, and if it's painted black then it's insulated.

This system allows for a camera to detect the correct film speed. DX also allows for the encoding of film *latitude*

and film length in frames, though in practice few cameras can detect this extra information.

Adhesive stickers are available to allow plastic-bodied film canisters (such as those used by hobbyists who load their own film in reusable canisters) in automatic cameras. Such stickers can also be used to fool automatic cameras which lack ISO override controls into using different ISO settings.

Film canister bar code
Next to the electrical DX code is an optical bar code which contains information about the film manufacturer and film type. This can be read by automatic film processing machines.

Latent image bar code
Finally the film itself has a tiny bar code system printed on it using a *latent image* process (i.e.: the bar code is created by exposing the edge of the film to light during manufacture and before development). This bar code is used by automated film processors. It cannot be read by cameras since it's invisible prior to film development.

→ A roll of 35mm film, showing the painted black squares of the DX code. Below it is a printed black-and-white bar code.

→ A view of the film chamber from a 35mm camera. The row of metal pins is used to read the DX data from the film canister.

Exposure index (EI)

The sensitivity setting at which film has actually been shot versus the recommended sensitivity setting published by the manufacturer.

Normally people shoot film using the same ISO value on the camera as printed on the box of film. However, there are times when a different camera ISO setting may be desired.

For example, a photographer may choose to shoot film rated at ISO 100 at 400 instead, and *push process* it. Or a photographer might shoot film with a camera setting of ISO 125 rather than the film's published ISO rating of 160 in order to achieve specific effects of *grain* and saturation In this latter case the photographer is "rating" the film with an EI of 125 even though it will still be developed as if it were an ISO 160 film (i.e.: it isn't push processed).

Density

The opacity of a film or print.

An underexposed or underdeveloped negative will have low density and will be considered "thin." Photographic film that is overexposed or overdeveloped will contain a large amount of silver or dye and will have high density. Digital prints made with too much ink can also be considered high density.

Low density

High density

Orange mask

An orange cast to color negative film which compensates for dye impurities.

One of the great mysteries of film cameras: why is it that color slides clearly show the colors of the original image, that black-and-white negatives are indeed black and white and shades of gray, but C-41 color negatives are dyed a strange orange color?

Color negative film uses a *chromogenic* process. When a film is undeveloped it contains no dyes; the dye colors (cyan, magenta, and yellow) are generated during the development process itself. However, they are not completely pure. In particular, there is a little too much yellow and magenta to them.

One way to eliminate the problem is to color the entire film an orange color. Then, during printing, a light with a blue-green cast is used to compensate for the excess orange. The result is a fairly accurate color print.

Solarization and the Sabattier effect

An effect whereby portions of an image are rendered in reverse (i.e.: bright areas appear dark and vice-versa).

If photosensitive material is heavily overexposed or exposed to light ("flashed") during the process of development then the reversal effect can occur. Technically the former is solarizing and the latter is the Sabattier effect, but both are commonly called solarizing.

While many photographers have used the technique over the years, Man Ray's Sabattier photos of the 1930s are classic examples.

Antihalation layer

An opaque coating applied to the back surface of film in order to reduce or eliminate an unwanted glow caused by reflections from the interior of the camera.

The antihalation layer is easily seen when comparing undeveloped and developed *35mm* film. The undeveloped film protruding from a 35mm film canister is typically a solid brown or gray color. But the same film, once developed, is transparent. This is because the antihalation layer is a water-soluble dye, washed off during processing.

Light enters film, exposes emulsion, passes through to the pressure plate where it is reflected. It then passes back through the film, exposing it a second time.

Nearly all films have this layer. When a photo is taken, light will pass through the surface of the film and trigger chemical changes, resulting in a *latent image*. But most of the light continues on through the film. Without an antihalation layer at the back to absorb and block it, the light would exit the film and hit the pressure plate on the inside of the camera back. This plate is typically shiny black metal or plastic, and so some light can be reflected off it. The reflected light would then make a return journey back through the film layer, essentially exposing it a second time.

Antihalation light absorbing backing to film

Film that lacks an antihalation layer has a glow, or halo, around bright objects as a result of all this light bouncing around inside the film. This can be useful for creative effects, and some older films lacked antihalation layers, which contributed to their unique look. The photograph below was taken using an *infrared* film with no such layer, and has a characteristic glow. But generally speaking it is not a desirable effect and so most films have an antihalation dye.

Bulk film loader

A manual device which allows a photographer to wind lengths of *35mm* film into reusable film canisters. Bulk film is available at reasonable cost savings over buying preloaded film canisters. It also permits any number of frames to be loaded into the canister, up to 36 frames. Most film is too thick to fit more in a single canister, and many automated cameras rewind automatically after 36 frames.

Metal and plastic reloadable canisters are available from camera shops, as are optional *DX-encoding* stickers.

Liquid emulsion

A light-sensitive emulsion which comes in a liquid or gel form.

Liquid emulsions can be painted on various surfaces: glass, wood, paper, etc. They transform those materials into *photosensitive* surfaces upon which black-and-white photographs can be printed. Certain surfaces, particularly smooth ones such as glass, may require pretreatment known as "subbing" so the emulsion can adhere properly.

Silverprint Emulsion SE1

This product is light sensitive. Open under red or orange safelight conditions only.

Store below 10°C, do not freeze.

Caution Harmful if swallowed. Irritates eyes and skin. In case of contact with eyes, rinse immediately with water and seek medical advice. Keep out of reach of children.

Reciprocity

A model that states that increasing the lens *aperture* by one stop has the same effect on *exposure* as decreasing the *shutter* time by one stop.

All film and *digital cameras* are built around the basic assumption that reciprocity (sometimes referred to as a "law") always holds true for common shooting situations. The length of time that film or a sensor is exposed (the *shutter speed*) is inversely proportional to the amount of light entering the camera (the lens aperture).

exposure = intensity x time

Of course, although two different shutter/aperture combinations may happen to have the same *exposure value*, or *EV*, that does not mean they are equivalent in ways other than exposure. A short shutter time with a wide aperture may freeze motion at a narrow *depth of field*. A long shutter time with a small aperture may result in *motion blur* with a wide depth of field.

Reciprocity failure

Failure of the *reciprocity* model in outlying time situations.

Digital cameras do not suffer from a failure of reciprocity in a significant fashion. However, film is vulnerable to reciprocity failure at extremely brief and extremely long *exposures*, which means that the exposure times predicted using the reciprocity model are not always correct.

The brief exposure issue is rarely a problem for most photographers, since it only comes into play at incredibly short exposure times at high intensities. However, long exposure times (low intensity reciprocity failure, or LIRF) can be a problem for night photographers and astrophotographers. The problem manifests itself in two important ways. First, the different color layers of color film experience reciprocity failure at different points, and so long (multiple second or multiple minute) exposures can result in strange color shifts. Second, the multiple-hour exposure times required by *astrophotography* can take even longer because of reciprocity failure.

Printing

The process of making photographic prints from an intermediate negative stage.

Most contemporary film processes, not counting processes such as slides, create a negative image straight out of the camera. This negative is then used to create as many positive images, usually to photographic paper, as are desired. This process is known as printing.

Black-and-white printing is generally performed in a *darkroom* with an *enlarger*. The enlarger allows for a small negative to be printed to a larger sheet of photographic paper.

Since most enlargers are open to the air, it's possible to perform localized control over the *exposure* of the image by positioning masks in the path of the light. A mask with a hole cut out will block light except for one area, allowing for "burning" effects. A stick or wand holding a small mask can allow exposure to be decreased for certain areas, allowing for "dodging" effects. The tools are waved around over the print during the exposure to minimize the edges of the mask becoming apparent.

Photofinishing

The business of developing film and producing prints.

Typically a photofinishing facility operates one or more "minilabs," which are self-contained machines that process film (usually C-41 type) and produce prints. Such machines are partly or fully automated, and are typically used to provide one-hour developing services in drugstores, small camera shops, and so on. A photograph produced by a minilab is known as a "machine print."

Traditionally these have been large photochemical machines, but as the bulk of consumer photography switches to digital, such minilabs are now digital output devices. Such digital finishing stations consist of a screen, a computer, a *card reader*, and a printer. They may also contain a *scanner* for reproducing preexisting photographic prints.

Paper

Flexible, opaque material used as a substrate for photographic prints.

There are many different types and categories of paper which are designed for different applications. The main split is between traditional light-sensitive papers used for chemical photography, and papers designed for use with digital printers.

Photosensitivity

Photosensitive

Traditional photographic papers are coated with a layer of emulsion that responds to light. Except in a few rare cases such as Cibachrome/Ilfochrome reversal materials, papers are designed for use with photographic negatives. In other

words, they will produce a finished positive photograph when exposed using light from a negative image. Paper for color prints contains three emulsion layers: cyan, magenta, and yellow.

Nonphotosensitive

A response to the burgeoning digital sales in the 1990s, digital "photo papers" do not have an emulsion. Instead they are usually coated so that they will easily carry the inks, dyes, or toners used in a digital printing process. Papers for ink-jets in particular must not be absorbent, to avoid the problem of ink soaking into the paper and spreading. Some papers for digital printing are designed to emulate the look and feel of classic photographic papers, containing fiber materials and baryta (barium sulfate) coatings.

Paper materials

Fiber-based

A traditional type of paper stock for chemical-based black-and-white printing, usually made from wood pulp or a similar natural material such as hemp or fabric rags. Very labor-intensive to use, since its high absorbency means long drying times, but valued for its rich classic appearance and, in some cases, greater archival properties. Many fiber papers are coated with baryta for improved richness of tone.

esin-coated (RC)

C paper is coated on both sides with a plastic material.
t can be dried very rapidly since it's less absorbent than
ber-based paper. It also has greater dimensional stability
ian fiber, meaning it's less likely to stretch or shrink as it
ries. Machine prints are always made on RC paper.

Paper finishes

hotographic paper in general comes in a number of
ifferent finishes, though which is best is typically a
latter of taste.

Glossy

hiny surface which offers very high *contrast*, but which
asily shows fingerprints.

Matte

lonreflective paper. Slightly lower contrast, but more
esistant to fingerprints.

Pearl or semi-gloss

lightly textured paper that represents something of
a compromise between matte and glossy. The pattern
exture can be distracting. Probably the most common
>aper finish for consumer prints.

Variable grade

Variable *contrast* black-and-white photographic paper.

Determining the overall contrast of a photo is a basic task in black-and-white printing, and can be achieved by choosing a numeric paper grade. Papers are sold in a series of contrast levels, represented by grades. 0 is typically the softest/lowest contrast, 2 is normal, and 5 the hardest/highest contrast. A printer chooses a specific grade to match the negative or to achieve the desired look.

Alternatively, variable grade papers (also known as VC, multigrade, or polygrade) containing both a high contrast and a low contrast emulsion can be used. The two emulsions are designed to respond to different colors of light. A colored filter, yellowish or orange or pinkish, is inserted into the enlarger head, and the filter color determines the final contrast level of the print.

Darkroom

An enclosed and lightproof room or chamber used for photographic processing, development, and printing.

Darkrooms are laboratories for performing photochemical work, particularly traditional *black-and-white photography*. They range in size and complexity, but ideally they are divided into two halves: a wet side and a dry side.

Wet side

The wet side of the room is used for all of the water-based chemical processes related to developing. It requires plumbing, space for the storage of photochemicals and development tanks, an area for hanging wet negatives to dry, and a table or bench for the print trays used to contain the chemical baths and prints used in the development process. A wash tray or sink for flooding the developed prints with flowing water is also required.

Dry side

The dry side of the room is used for all the aspects of printing that should not involve water. This side usually contains a good working area, an *enlarger* and timer, space for storing unused photographic paper, paper cutters, and cleaning equipment. It may also include a print dryer.

Lighting

Darkrooms should be sealed against the intrusion of light to avoid inadvertent fogging of *photosensitive* materials, unless they are to be used solely at night. However, they do not need to be pitch black if black-and-white printing is performed. Such darkrooms can be lit by low levels of red or amber light from a *safelight*.

Color

Color chemical photography, owing to the complexities involved, is more commonly done by automated processing machines such as minilabs.

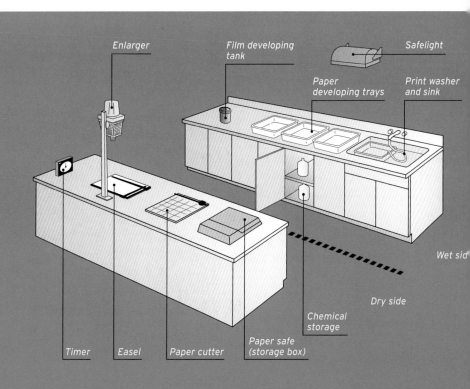

Enlarger · Film developing tank · Safelight · Paper developing trays · Print washer and sink · Wet side · Dry side · Chemical storage · Paper safe (storage box) · Timer · Easel · Paper cutter

Safelight

A red or yellow-amber lamp used for providing low-level working light in a *darkroom*.

Black-and-white photographic papers are usually orthochromatic, which means they're sensitive to blue or green light but not to red or orange light. Darkrooms for black-and-white printing can thus be illuminated by safelights. They allow for enough dim light to see by, but shouldn't fog undeveloped paper.

Film, on the other hand, is rarely orthochromatic except for some special-purpose emulsions typically used for medical imaging and graphic design. Most black-and-white film is panchromatic, hence the word "pan" in many traditional film brand names, and can respond to light of any color. For that reason undeveloped film should not be exposed to a safelight.

↑ *Safelights come in a range of shapes and sizes. This one is a low wattage lamp intended for small home darkrooms.*

Test strip

A series of test exposures performed on *photosensitive* material.

The most common use of test strips is in the *darkroom*, where the easiest way to determine correct exposure of a photographic print is a simple empirical test. A representative sample of a negative is projected using an *enlarger*. A piece of card or something similar is placed over the paper as a simple mask, and is moved across the paper at preset time intervals of a few seconds each. The strip is then developed and inspected to determine the best exposure time to achieve the desired results. Special frames with fold-out finger-like masks are available to simplify the process of making a test strip, though it is still a fundamentally manual procedure.

Developer

A chemical solution used to develop *photosensitive* materials.

When film or other photosensitive material is exposed to light, a change occurs in the silver halides suspended in the emulsion. A tiny number of halides are transformed into a few atoms of silver. At this stage the photo is still invisible and is known as the *latent image*.

Developers are usually liquid baths that transform the latent exposed image into something the human eye can see, through a chemical process which converts silver halides into metallic silver. In the case of black-and-white photographic papers viewed under a *safelight*, this is the time the image emerges in ghostly form from the blank surface of the paper as it sits in its tray of photographic solution. The longer the material is left in the developer, the darker it becomes.

↓ *A plastic tank for developing roll film. The developer is supplied as a dry powder to be mixed with water.*

Once the image is correctly developed the development process must be arrested via a *stop bath* before the photo turns totally black.

Stop bath

A chemical solution which halts the development process.

Once an image has been properly developed the chemical reactions occurring inside the film or paper must be stopped. If not, the developing process will continue unabated until the image is completely black.

Stop baths are the second stage of classic black-and-white printing, and are a mildly acidic chemical solution which halts development. The stop bath is normally used in a shallow pan between the *developer* and *fixer*, and is generally the strongest smelling of traditional photographic chemicals. It is of course vitally important that no stop solution gets splashed into the developer pan at any time. The image must then be fixed.

↑ *An "indicator" stop bath solution which changes color when exhausted, reminding the printer to refresh the supply. Traditional black-and-white photographic prints are developed in shallow plastic trays such as the one shown here. A darkroom will have at least three separate trays—one for developer, one for stop and one for fixer. Tongs, made from bamboo, plastic, or stainless steel, are used to handle the prints.*

Fixer

A chemical solution which renders a developed image permanent and lightfast.

Fixer is a chemical solution into which developed and stopped photographic films and prints must be immersed. It removes any remaining silver halides, preventing the image from darkening to black when exposed to light.

Thiosulfate chemicals are usually used. Sodium thiosulfate, often called "hypo," was popular for many years, and was synonymous with fixer.

Once the three stages of the development process are complete the image must be carefully washed in water to remove any residual chemicals. Leftover fixer in particular can cause staining of photos. This rinse procedure can be quite time-consuming in the case of traditional fiber-based papers.

A bottle of fixer and a washing tray. Leftover fixer can stain a print, so thorough washing is vitally important, especially for more absorbent fiber-based papers. A tray such as this, hooked up to a water supply via a flexible hose, is a popular tool for rinsing prints. The device resting on the tray is a double-sided squeegee for removing excess water from a washed print.

Photochemistry

The chemical compounds used to create permanent photographic images.

For a century and a half, photochemical processes were the only means available to record optically-captured photographic images. Many chemical systems, from the earliest simple processes of the 1820s through to the complex multistage dye processes of modern color emulsions, have been created over the years. All involve a light-sensitive chemical medium and a process to develop, then "fix" or lock down the image so that further *exposure* to light does not alter its appearance.

The traditional *silver gelatin* black-and-white process is one of the simplest, and still commonly used by artists and hobbyists who enjoy the complete control the process lends to the creation of photographic images. Color processing of chemical films tends to be extremely complex and requires very precise temperature controls, and so is rarely done outside of automated machines today.

The three stages common to photochemical processes are develop, stop, and fix.

Toning

A photochemical process which changes the overall color or cast of a *silver gelatin* black-and-white print for aesthetic or archival purposes.

Different chemical processes have been devised over the years to tint traditional silver gelatin prints. The processes generally involve reactions which replace the silver grains in the prints with other materials. Some of the toning processes also increase the stability of the finished prints, giving them longer lifespans.

Sepia

So named because the brownish prints resemble the natural ink from the sepia cuttlefish, sepia toning is strongly associated with Victorian printing. Cuttlefish are not actually used in the photographic process, which converts silver to silver sulfides. This process is often simulated digitally when people want a photograph to look older.

Selenium

A common archival process which yields a brownish cast to the print. Silver is turned into silver selenide.

Metal replacement

Various other metals can be used in a toning process, such as gold, copper, iron, and platinum. Gold and platinum can help improve the longevity of the image, but iron and copper tend to reduce it.

Split

Combining more than one toning technique.

Cross process

Processing film using a developing process not designed for it.

The term cross process, or "xpro" to the extra-hip, typically refers to developing color slides (E-6) using a color negative film process (C-41) and vice versa. Cross processing results in interesting and generally unpredictable color shifts. It also tends to boost *contrast* and *grain*.

In the 1980s and 1990s it was popular to use cross processing in fashion and editorial photography when an edgy, urban image was desired. Today the flexibility of digital has brought a decline in cross processing, much as film itself has become less popular, since it's generally easier to simulate such effects in a computer. However, the unpredictable serendipity of cross process is difficult to duplicate.

Normal

Cross processed

Spotting

Painting out flaws in an image caused by dust, hairs, scratches, and so on.

Spotting can refer to correcting either photochemical prints or digital images. In the case of film, dust and other foreign material on a negative can cause white areas on a print which can be physically painted over with ink or dyes.

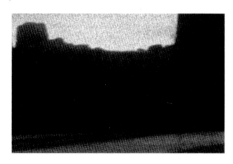

Before

→ *White spots on traditional black-and-white prints can be caused by dust on the negative. Ideally these are avoided through careful handling of the film, but can be spotted out later with dark ink.*

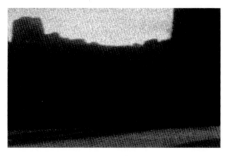

After

Contact print

A photographic print made by placing a negative directly over the surface of photographic paper and exposing it to light.

A contact print can be made without an *enlarger*, though enlargers are often used as light sources out of convenience. A sheet of glass is usually placed over the negative to keep it flat and to prevent the film from curling.

If the negative size is fairly small, as is the case with *35mm* film, then a contact print is primarily useful for generating a sheet of small *thumbnails*. The photographer can then examine the contacts, often with a *loupe*, and determine which negatives are good candidates for enlargement. The contact print may not have enough detail to show if the negative has accurate *focus*, but will show if it was exposed correctly. In commercial environments contact sheets are often produced for ease of categorization and sorting of negatives.

Contact prints of large-format negatives are often used as full-sized prints in and of themselves, particularly 8x10in negatives. However, large contact prints often suffer from Newton's rings, which are concentric patterns of rings in the final print. The rings are caused by constructive and destructive interference in the waves of light reflecting between the glass and the negative surface. Textured anti-Newton glass can be used to reduce the problem, as can some powders and oils. The ring phenomenon is named after physicist Isaac Newton who, although not the first to note the issue, described it in great detail.

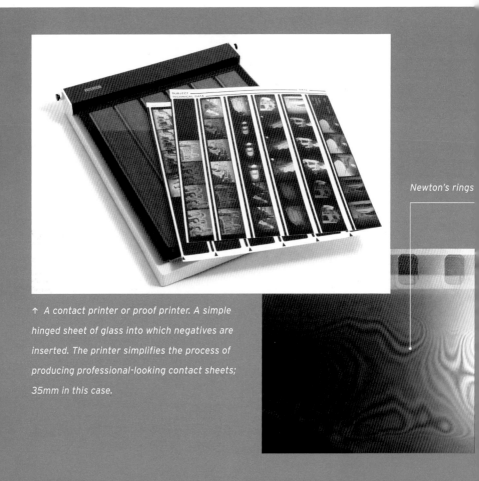

Newton's rings

↑ *A contact printer or proof printer. A simple hinged sheet of glass into which negatives are inserted. The printer simplifies the process of producing professional-looking contact sheets; 35mm in this case.*

Hand-colored

A black-and-white image to which inks, dyes, or transparent paints have been manually applied n order to simulate a full-color image.

Before the invention of color photography, and even for a period after when color photos were extremely expensive, it was popular to hand-color black-and-white images. Today hand-coloring is primarily a hobbyist activity, though some art photographers also use the technique.

Hand-coloring is not the same thing as tinting and *toning*. The latter involves changes in color or tone to the entire photograph in a fairly uniform fashion. Hand-coloring, by contrast, involves the application of color to specific areas of an image.

Light table

A table, box, or frame with a surface of translucent plastic or glass. The frame is illuminated from within, and is used for examining transparent or semi-opaque items such as photographic negatives, slides, and prints.

Light tables and boxes have traditionally used fluorescent tubes because of their low heat output.

A more recent development is flat light panels which use the same backlighting technology as *LCD* computer screens. These thin panels are smaller, battery-powered, and portable.

Equipment

Camera

Adevice which captures light and which is used to record a two-dimensional image of a subject or scene.

The word "camera" derives from the Latin "camera obscura," or "dark chamber." In its basic form, a camera is a light-tight box with either *photosensitive* chemical material or an electronic light sensor positioned at one end. The other end has either an optical lens or, in the case of *pinhole cameras*, a small hole, through which light (or optically modifiable *ultraviolet* or *infrared*) is admitted. The light exposes the film or *image sensor* to record an image.

Except for *instant cameras* which produce finished prints, various processes are then used to turn the *latent image* on film or the electrical impulses captured by a sensor into a printed photograph or an image on a computer screen. Traditionally, cameras have been either still or motion, though many *digital cameras* today blur this distinction by recording both still images and video.

There are many categories of camera, including *35mm cameras*, digital cameras, *SLRs*, *TLRs*, and *view cameras*. In the case of a modular camera with interchangeable lenses, the light-tight box containing the film or image sensor is usually called the camera "body."

↑ *A Hasselblad medium-format camera.*

↑ *A compact 35mm film camera with interchangeable lenses.*

→ *A modern digital SLR camera.*

Film camera

An image-capturing device which uses *photosensitive* film to record two-dimensional representations of a scene.

Cameras are generally categorized by two factors: the *film format* used and the basic optical design employed. Film format includes roll films, such as *35mm*, medium-format, *APS*, and *110*. It also includes sheet films used in larger cameras. Optical designs come in many forms, but include basic *point and shoots*, *SLRs*, *TLRs*, *rangefinders*, and *view cameras*.

> A Graflex Super Graphic view camera from the late 1950s. While seemingly primitive in a digital age, the camera can still be used to take astoundingly sharp photographs since it uses large 4x5in negatives. The camera is also capable of complex lens movements.

35mm camera

A camera that uses *35mm* roll film. Many different camera designs have employed 35mm film over the years, from early *rangefinders* to advanced *SLR* systems to consumer *point and shoots*.

The earliest cameras to use roll film 35mm wide were introduced in the early 1900s by a number of manufacturers, but the Leica rangefinder of the 1920s is the best-known today. The arrival of the Nikon F camera in the late 1950s brought with it a new model for professional photography: a compact SLR system with interchangeable lenses and other accessories. By the 1960s the 35mm camera had become the dominant format; a position it maintained until the arrival of digital. The 1960s and 70s were marked by the rise in amateur 35mm SLR use, and automated 35mm point and shoots became popular in the 1980s.

↑ The Nikon F6, the last of a venerable line of 35mm SLR cameras.

↑ An inexpensive point and shoot camera.

Digital camera

A camera based around an electronic *image sensor* which stores information in an electronic, digital form, rather than employing chemical-based film.

Digital cameras contain a number of essential ingredients

- An image sensor chip which converts light into electrical impulses.
- An optical lens which projects an image onto the image sensor.
- Optional but very common: *autofocus* and automatic *metering* systems.
- Electronic circuitry that takes the signals from the image sensor and converts them into digital information through a process known as sampling or *digitizing*.
- A computer that processes the raw sampled data.
- A storage device, usually a removable flash *memory card*, where the images can be saved.
- Optional but very common: an interface system allowing the photos to be sent to a personal computer or printer.
- A *viewfinder*, either purely optical or electronic via a preview screen.
- Optional but very common: an *LCD* screen used for previewing images and viewing previously shot photos.
- A high-capacity battery to power the whole apparatus.

←↓ *Two digital cameras. The Panasonic Lumix camera on the left, while not an SLR, supports interchangeable lenses compatible with the FourThirds lens system developed by Olympus. The Nikon camera below is an inexpensive point and shoot with a swiveling lens for ease of use.*

Camera phone

A small *digital camera* built into a cellphone.

Camera phones vary dramatically in terms of their feature sets and *image quality*. Rudimentary phones have tiny fixed focus plastic lenses with automatic light *metering*. They offer very low *resolution*, sometimes as low as a third of a megapixel. Better camera phones support much higher resolutions, have improved low-light performance, *autofocus* mechanisms, and *flash*.

Just as important as the image-capturing technology, cellphones also allow near instantaneous image transfer to other phones and computers via the wireless cellular network.

While initially dismissed as mere novelties owing to their low image quality, camera phones have radically transformed the consumer relationship to image-capturing technology. In the past a person would have to make a deliberate decision to carry a camera, but now they have become as everyday as wristwatches.

The phones' ubiquity, inconspicuous size, and ability to transmit photos immediately have all altered social assumptions about photography, particularly regarding such diverse areas as personal privacy, security, news gathering, crime, and performance copyright. For example, many camera phones emit simulated *shutter* click sounds through small speakers, even though they serve no technical requirement, in order to make the cameras more conspicuous and thus less useful for surreptitious voyeur photography. Breaking news stories have been illustrated by photos snapped by amateurs using camera phones.

As digital image-capturing technology continues to improve, the massive growth of camera phones will cause significant erosion in low-end camera sales, rendering such devices redundant to the average consumer. Likewise the ability of camera phones to produce live video will also affect the camcorder market.

Point and shoot

A small, portable, and highly automated camera intended for casual consumer use.

Point and shoot cameras are characterized by a number of features. First, they are built as small as possible to maximize convenience. In fact, "compact" camera is a common synonym. Second, they tend to be highly automated with a fairly simple set of controls. Third, they rely on *autofocus* or fixed focus lenses, thereby minimizing focus error. Fourth, they do not support interchangeable lenses and most other advanced accessories. Finally, they typically have *electronic viewfinders* or separate optical viewfinders: unlike *SLRs,* the photographer does not look through the *taking lens*.

Digital point and shoots have one important technical consideration: they generally have extremely small *image sensors*, much smaller than a frame of *35mm* film. There are certain consequences to this fact. First, the *depth of field* of digital point and shoots tends to be extremely deep. *Selective focus* techniques are not usually possible. Second, the tiny sensors mean that each *pixel* is recorded by a very small photosite, particularly as the number of megapixels per camera increases. Since very little light falls on a tiny photosite it is necessary to amplify the signal considerably for each point, resulting in *noise*. For this reason point and shoot cameras tend to suffer from far more noise than digital SLRs, particularly at low light levels and high ISO settings. Point and shoots can also suffer from performance issues such as *shutter* lag.

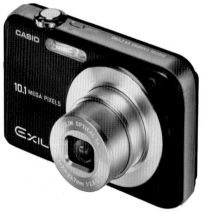

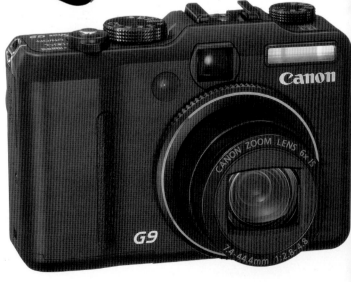

nstant camera

Any camera which is capable of producing a finished photographic print in seconds or minutes.

The best-known instant camera was the Polaroid Land camera and its successors, which contained a complex chemical pack in each photo. When the picture left the camera a chemical reaction was triggered which developed the single-use positive print.

While primarily marketed as a consumer product, instant cameras also quickly found niche markets in law enforcement and identity card production. Polaroid backs were also a common tool for testing studio lighting in the days before digital photography. Very few instant cameras are still made, and instant film is becoming difficult to obtain, as the technology has been supplanted by *digital cameras* and printers.

A Polaroid SX-70 from 1972. This unusual instant camera was a manual-focus SLR which folded down to the size of a paperback book.

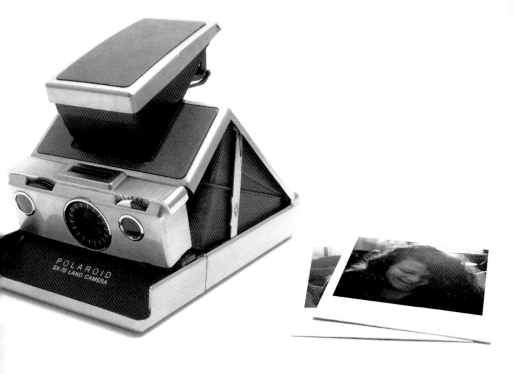

Twin-lens reflex (TLR)

A camera with two lenses of the same *focal length* mounted on the front; one for the *viewfinder* and one which acts as the *taking lens*.

The TLR design was popular in the 1950s and 60s but is not common today. The lower lens directs light to the surface of the film, and the upper lens directs light toward a 45 degree *mirror*. This mirror reflects light up toward a ground-glass viewfinder screen, usually shielded by a popup shade, on the top of the camera body. The viewfinder is used by peering downward at the screen. Very few TLRs support interchangeable lenses.

The TLR viewfinder, although it reverses the image laterally and thus takes some practice to use, has the advantage of not blocking the photographer's face when i use, arguably making it a friendlier design for the subject. Lacking an *SLR's* mirror, the design also does not suffer from *mirror blackout* and is quiet in operation. However, TLRs have tremendous *parallax* error at close focal distances, making the design inappropriate for *macro* photography.

→ *An unusual TLR which supports interchangeable lenses.*

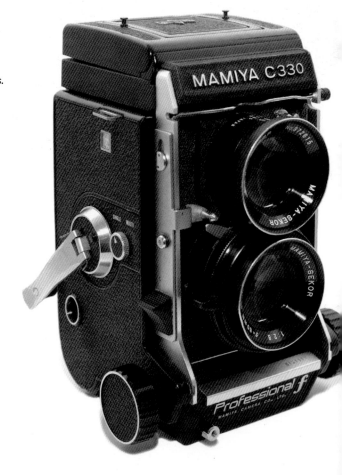

Single-lens reflex (SLR)

A popular camera design in which the taking lens sends light to both the lm or *image sensor* and the *viewfinder*.

Before the advent of the SLR, cameras ither had a viewfinder which was optically eparate from the taking lens (*rangefinders, LRs*), or which showed the scene through he taking lens but upside-down (*view ameras*). The invention of the SLR changed his. Through use of a pentaprism and noving *mirror* assembly, SLRs allowed hotographers to see exactly what the aking lens sees, and correctly oriented. his means that the effects of *filters* and different *focal lengths* are immediately apparent. *Parallax* error, common with TLRs at short distances, is eliminated.

Virtually all SLRs use *focal plane* shutters. Such shutters, located in the camera body and not the lens, mean that it is possible to remove the lens without exposing the film. Indeed, support for interchangeable lenses is a feature of the vast majority of SLR designs. Most film SLRs employ *35mm* roll film, though some are based around medium-format or *APS* film.

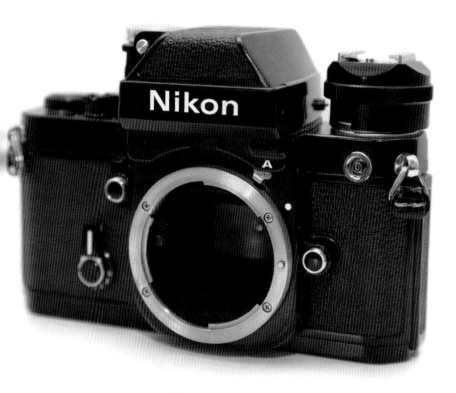

↑ *A Nikon F2 camera; a classic 35mm film SLR from the early 1970s.*

Rangefinder

A camera design in which there are separate taking and *viewfinder* lens systems, and which employs a range-finding device for *focus*.

Rangefinders employ separate viewfinder lenses from the *taking lens*. The photographer looks through the viewfinder and a double image of the subject will be visible. The focus can then be adjusted so that the secondary image is perfectly coincident with the primary, at which time focus has been achieved.

The main drawback of rangefinders is that the photographer cannot look through the taking lens, the way one can through an *SLR*. The fact that the viewing and taking lenses are separate means rangefinders are vulnerable to *parallax* error at close focus distance. It also means that using polarizers can be difficult.

Rangefinders have long been associated with street photography owing to their compact size and quiet operation. Since rangefinders lack *mirrors* they are much quieter and discreet in operation than SLRs. It is also possible to design *wide-angle lenses* more easily (see *lens register distance*).

↓ *Countless classic street photos from the 1920s through to the 1960s were taken using cameras such as this Leica rangefinder.*

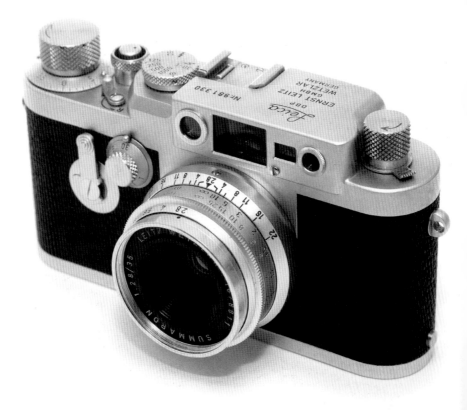

View camera

A very old film camera design which dates back to the middle 1800s, consisting of two flat boards, also known as standards, linked by a bellows. The front board contains a lens and the rear board contains a *viewfinder* screen or a sheet of film.

Basic operation

View cameras are the large and unwieldy boxes seen in period films set in the nineteenth century, and are often equipped with the black cloths under which the photographer ducks to adjust *focus* and other settings. They generally do not have separate viewfinders. Instead, the rear standard typically has a sheet of ground glass installed, and the image from the lens is projected onto this surface. Since the projected image can be fairly dim, the darkcloth helps block ambient light, making it easier for the photographer to see the glass.

Note that the image is projected onto the glass upside down, making camera operation rather challenging for the novice. Indeed, the exacting, time-consuming, and demanding nature of the entire process means that view cameras are really only suitable for contemplative and thoughtful photographic work such as landscapes and portraiture rather than fast-moving or casual situations.

When the lens is correctly focused and adjusted, the ground glass is removed. A light-tight enclosure containing a sheet of film is substituted. A moving panel, known as a dark slide, is lifted, exposing the film surface to the interior of the camera. Finally, the photo is taken by triggering the *shutter*, which is generally located within the lens itself and not near the *focal plane*. →

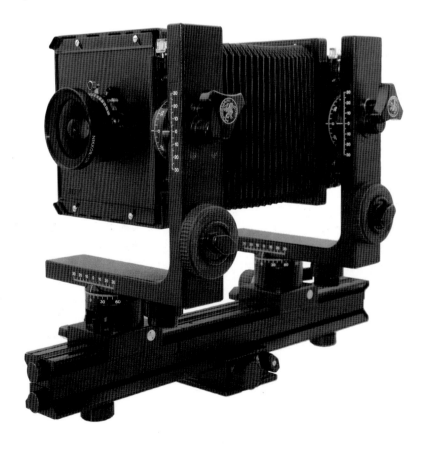

View camera

Image quality

While slow, heavy, and inconvenient to operate, view cameras nonetheless have many advantages over other types of cameras available today. The most obvious is that the film sizes used are huge compared to *35mm* or even medium-format film. In fact, the most common sizes used are 4x5in and 8x10in. Even vast 20x24in cameras have been built. This tremendous film size means that *grain* can be extremely fine and images astoundingly detailed, because the image does not need to be enlarged much from the original negative to form a print. For this reason view cameras are still used by fine art, portrait, and architectural photographers. The large image format also allows for extremely narrow *depth of field*, which can be an advantage or a drawback depending on the type of photography being done.

Lens movements

Another key advantage is less obvious. Most view cameras have very flexible movements possible, owing to the flexible light-tight bellows (either accordion-like pleated bellows or simple bags) between the two boards. These complex movement of the lens position and axis relative to the surface of the film are difficult or impossible to achieve with rigid camera bodies. Movements possible with a typical view camera include shifting, rising/falling, and tilt/swing.

View camera types

"Monorail" cameras have the two vertical standards mounted on a pair of parallel rails. The boards can be moved back and forth independently along these rails, allowing for very precise control over the movements.

"Field" cameras are smaller view cameras which can fold flat for greater portability. They generally support *lens movements*, but to a lesser extent than monorails.

Stereo camera

A twin-lens camera which takes advantage of the principle of *parallax* to create simulated three-dimensional images.

Most of us have binocular vision; we see the world through two eyes. And human eyes are positioned side by side so that we have depth perception. Each eye sees the world from a slightly different angle than the other. Our brains process this information and construct a view that includes depth. Objects that have very different views from our two eyes are close to us, and objects that have a similar perspective from each eye are far away.

Stereo (short for stereoscopic) cameras exploit our ability to perceive depth by taking two separate images simultaneously through two separate optical systems. The two photos are then examined, typically through a viewer device.

Stereo technology for still images dates back to the 1800s, though it reached its peak in the 1950s, when large numbers of affordable *35mm* stereo cameras were sold. Stereo photos are also used for aerial surveys. A similar dual-lens approach is taken by modern 3-D movies, though polarizers are placed over the lenses and the viewer's eyes (3-D glasses) to keep the two views separate.

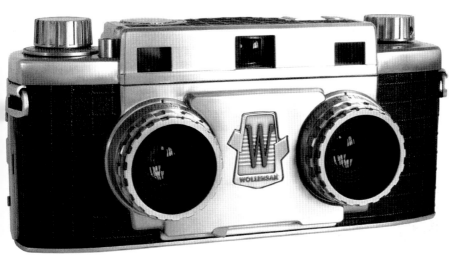

Pinhole camera

A camera which has no glass lens and relies instead on light passing through a tiny hole.

Pinhole cameras exploit optical geometry to accomplish their imaging. Light shining through a tiny circular hole ends up focused on a surface. They vary in sophistication, from oatmeal containers to *35mm cameras* with pierced body caps to large rooms with paper taped to the wall to elegant handcrafted varnished wood and brass masterpieces. They may have hinged caps or scraps of paper held on with tape as a *shutter*. But regardless of design, they are all based around the simplest optical device–a tiny hole, usually in thin sheet metal. The size of the hole can be calculated mathematically, and is created by either an actual pin or, in more contemporary cases, a laser.

The pinhole image is laterally reversed and upside-down. It will also have near-infinite *depth of field*, making everything in the photo equally sharp. However, the image itself will not be particularly sharp as such, since pinhole images are always a bit soft and fuzzy. The tiny size of the *aperture* means that *exposure* times will probably be quite long, often in the minutes. It is not really possible to meter for a pinhole image and so exposure time is always determined through trial and error. Some pinhole photographers use sheet film inside their cameras and others photographic paper. It's even possible to use a *digital camera* to image with a pinhole lens, though the results are generally disappointing since pinholes work best with very large *image areas* and long exposure times.

Pinhole cameras are not practical for casual photography because of the slow exposure times and awkwardness of loading a box with sheets of film or paper. The world of the pinhole is restricted today to artists and hobbyists who appreciate the atmospheric and evocative images that the cameras can create.

← *A pinhole photo taken using a sheet of 4x5in film inside a cardboard box.*

Disposable camera

A single-use camera sold inexpensively to consumers, normally film-based.

Such cameras are usually small plastic boxes containing the film, along with a simple plastic lens prefocused to the *hyperfocal distance* and a very basic optical tunnel *viewfinder*. Winding is via a manual plastic wheel, and the *shutter speed* is generally fixed. Some versions contain small battery-powered electronic *flash* units. Variations include waterproof models, simulated *panoramic* models which mask off the top and bottom of the image, and models preloaded with black-and-white *chromogenic* film.

The cameras are used once, then sent as a whole unit to a lab for processing. Portions of the camera body may then be recycled or reused, and the developed film and prints are returned to the customer.

The low picture quality of disposable cameras can be attributed to three basic factors. First, the lenses are of low quality and the *focus* cannot be adjusted. Second, the cameras generally have a single shutter speed and no *aperture* control, making *metering* impossible. They instead rely on the wide *exposure* latitude of color negative film to get approximate results. Finally, the cameras do not use high-quality film.

Digital single-use cameras also exist, but are generally less cost-effective than their film counterparts.

Build quality

The quality and ruggedness of construction of a given product.

Most camera and lens manufacturers produce products to cover a wide range of markets. It's quite common for a camera builder to produce one inexpensive model for mass-market consumption, a midrange model for more serious amateurs, and a costly top-end model for professionals. The difference in cost is sometimes reflected in terms of the features available, but also in terms of the quality and sturdiness of the physical construction.

Beginner and consumer

These models are optimized for impulse sales at department stores, drugstores, and general sales locations. They tend to be lightweight, low-cost, and with limited feature sets. They are usually highly automated and may offer less manual control over *exposure* or other settings. While by no means poorly built, they may be made from lighter and less rugged materials than more advanced models.

Advanced amateur and prosumer

Advanced amateur and prosumer (a portmanteau word combining "professional" and "consumer") products typically carry advanced feature sets and performance levels approaching professional products. They are aimed at amateurs who take their photography seriously, and frequently permit full manual control. Products in this category tend to differ from professional products primarily in their ruggedness: they are generally less sturdy.

Professional

Professional cameras are those aimed at people who make a living with their gear, and so pro cameras tend to be built with reliability in mind. Rugged, fast, often weather-resistant, and feature-complete, these cameras represent the most advanced products of each manufacturer, and are priced accordingly. Most camera manufacturers produce "flagship" models containing the most sophisticated technology of their product line.

↑ A tiny base model digital SLR designed for mass-market sales.

↑ A midrange model designed for serious amateurs. While larger than its consumer counterpart, it is still relatively compact.

↑ The top of the line model, built from solid magnesium and weatherproofed at all openings.

Shutter

A mechanical barrier which prevents light from entering a camera body, and which can open for a precise period of time in order to expose the film or image sensor.

A shutter can be constructed in many ways. One of the most common types is the focal plane shutter seen in *35mm film cameras* and digital *SLRs*: a pair of horizontal rectangular shutter curtains which slide vertically. Focal plane shutters are so named because they are positioned directly in front of the *focal plane*, within the camera body itself.

Large-format cameras use leaf or diaphragm shutters, which are often built into the lenses. Better leaf shutters often resemble an aperture diaphragm, in that they use curved wedge-shaped blades. Single-leaf shutters are used on cheap *point and shoots*, and have a single moving leaf. A shutter doesn't need to be so complex, however. A homemade *pinhole*

↑ *A 35mm camera's focal plane shutter.*

camera made from a cardboard box might simply use a flap of black paper as a primitive shutter.

Many *digital cameras* don't have mechanical shutters but instead simulate a moving shutter by turning their image sensors on and off to record light for the required time. These are sometimes called "electronic shutters." Some cameras even combine mechanical and electronic shutters, using one to start the *exposure* and the other to end it.

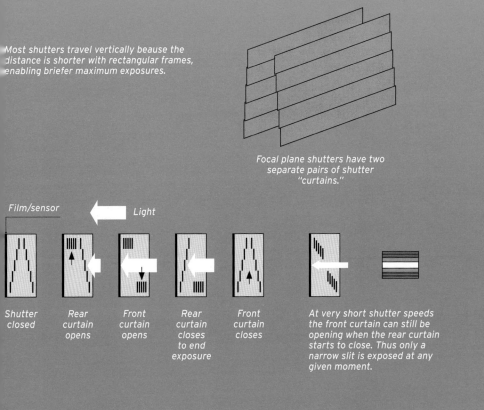

Most shutters travel vertically beause the distance is shorter with rectangular frames, enabling briefer maximum exposures.

Focal plane shutters have two separate pairs of shutter "curtains."

Film/sensor Light

| Shutter closed | Rear curtain opens | Front curtain opens | Rear curtain closes to end exposure | Front curtain closes | At very short shutter speeds the front curtain can still be opening when the rear curtain starts to close. Thus only a narrow slit is exposed at any given moment. |

Automatic exposure

A computer-controlled system built into a camera which meters incoming light, determines the correct *exposure* settings, and adjusts settings such as *aperture* and *shutter speed* accordingly.

Most film and *digital cameras* sold today contain some form of automatic exposure *metering*, which typically has four basic forms.

Fully automatic metering

The only mode available with simpler cameras. In full auto the computer fully controls the shutter speed, aperture, and all other settings; the user has no say in the matter.

This mode is often identified by a green rectangular icon.

"Program" mode

This mode is similar to full auto, but allows for some adjustment. For example, some cameras allow for "shiftable" program mode exposure. This allows the user to change shutter or aperture settings and the camera compensates automatically, maintaining the same exposure (the same *EV*). Some cameras also allow for *exposure compensation*.

This mode is often identified by the letter "P."

"Aperture priority" or "aperture preferred"

An automatic exposure mode in which the photographer specifies the desired lens aperture. The camera then sets the necessary shutter speed to expose the photo correctly, based on readings from the internal light meter.

This mode is indicated on some cameras by the letter "A" and on others by "Av" for "aperture value," depending on the manufacturer.

"Shutter speed priority" or "shutter speed preferred"

The reverse of aperture priority; an automatic exposure mode in which the photographer specifies the desired shutter speed. The camera then sets the necessary lens aperture to expose the photo correctly, based on the light meter.

This mode is indicated on some cameras by the letter "S" and on others by "Tv" for "time value," depending on the manufacturer.

Automatic metering has many other forms. For example, some cameras automatically engage *flash* when light levels are low. Some digital cameras detect faces in an image and attempt to meter correctly for a portrait, and so on.

← *The mode dial from an automated digital camera. The letter modes along the top support advanced forms of automatic exposure. The icon modes along the bottom are intended for beginners.*

Exposure compensation

A control or function which allows a photographer to adjust or override an automatic camera's exposure settings.

Cameras with *automatic exposure* capabilities base their *metering* settings on two things: the results of their internal light meters and either their metering design or calculations by their internal computer programs. And cameras are designed to record the bulk of a scene, or the most important areas as determined by an active *focus* point, as a midlevel gray: about 12 to 18 percent.

For the majority of cases the designer's decisions, embodied by the camera circuitry, are going to be right. But there are instances when automatic metering gets it wrong. For example, many cameras will underexpose the classic example of a white dog sitting in snow, in an attempt to render the entire scene gray. Another common example is a dark scene with a bright light in one section. That one bright area may throw off metering for the entire scene, rendering the rest of the photo completely dark.

Accordingly, many cameras with automatic exposure metering also support exposure compensation. This may be a pair of pushbuttons or a rotary wheel which adjusts the *EV* up or down. Exposure compensation is usually measured in stops, plus or minus.

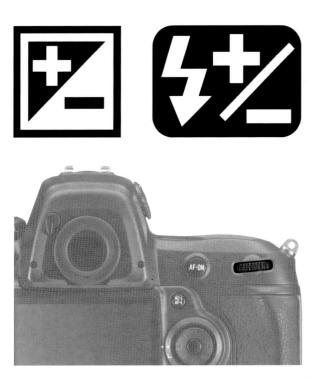

Autofocus

Electromechanical systems which allow cameras to determine and set lens *focus* automatically.

Before the advent of autofocus systems photographers would always adjust lens focus by hand. Manual focus is usually done by peering through a *viewfinder* and rotating the lens until the image appears to be sharp or, in the case of *rangefinders*, until two images appear superimposed over each other. Autofocus automates this process, and comes in two basic forms.

Active autofocus

Active systems send out signals from the camera to the subject. These are usually invisible *infrared* beams, which are reflected back to the camera and recorded by an autofocus sensor that is independent of the lens. The camera then uses reflectance, time, or triangulation data to determine the correct focus distance.

Active technology is generally used by *point and shoot* cameras. It typically does not allow the photographer to specify an autofocus point, is fooled by nearby objects (the bars of a cage, for example), and is limited by the range of the infrared beams.

Surprisingly, one of the earliest consumer cameras to feature an autofocus system used ultrasonic sound to focus. The Polaroid ultrasonic focus system was not very accurate and could not focus through glass but, unlike many optical systems, could focus on blank walls and in complete darkness.

Passive autofocus

Passive systems are often used by more advanced cameras, despite the name. They come in two basic forms: phase detection and contrast detection.

Phase detection

Most film and digital *SLRs* use *through-the-lens (TTL)* autofocus devices based on the principle of phase detection. They take an autofocus sampling area, split the light using *prisms*, and project the sampled image onto two separate line sensors. This is sometimes referred to as "secondary image registration." A computer then measures the distance between the image projected onto the lines. Once this is done the computer instructs the lens motor to adjust focus by the precise amount required to achieve desired focus.

Phase detection is similar to the focus process used by *rangefinder* cameras. These manual focus cameras project a pair of images onto a screen. If the images line up then the picture is in focus. If the images are offset to one side then the image is front-focused and if the images are offset to the other then the image is back-focused.

Phase detection requires a fairly high-contrast subject to focus, which is why focusing on blank walls or the sky is a problem with such cameras. It also explains the difficulty they have focusing in the dark: there simply isn't enough light for the sensors to detect. Finally, such systems work better with fast lenses, not because such lenses let in more light, but because of optical geometry. Wider maximum *apertures* mean there is a physically wider separation of the light angling into the autofocus sensors. This is the same reason split circle/split prism manual focus viewfinders black out when used with longer lenses and extension tubes. Recognizing this issue, some advanced cameras contain multiple types of autofocus sensors: some optimized for greater precision but which require faster lenses, and others with slightly lower precision but which can work with slower lenses.

ontrast detection

ome cameras, typically less expensive
igital cameras, use a contrast detection
ystem instead. Such cameras examine a
ortion of the scene and physically move
he camera lens, measuring changes in
ontrast. When the maximum contrast is
eached the camera assumes the scene is
orrectly focused and halts the lens.

Contrast detection is slow but has a
ost advantage in that it uses the camera's
main *image sensor* for focus detection

rather than a separate autofocus sensor.
Some *SLRs* use contrast detection
autofocus when in *live view* mode, since
live view requires the *mirror* to be raised
and phase detection doesn't work when
the mirror is up since the sensors are
typically in the viewfinder prism.

Servo autofocus

An autofocus system which is capable
of continuous adjustments in order
o keep a moving object in *focus*.

ingle shot autofocus

Many passive autofocus systems can
operate in one of two modes: single shot
and continuous servo. In single shot, the
camera locks focus as soon as it is
achieved. Further subject motion does not
alter the focus, making it ideal for static
subjects. This mode is usually *focus priority*.

Continuous servo autofocus

"Continuous servo" or "full-time AF"
systems continually focus and refocus as
he subject moves, so long as the *shutter
release* button is half-pressed. Many
advanced cameras have a "predictive" or
"focus tracking" autofocus which records
the relative speed of a moving object and
predicts correct focus when the shutter
opens, assuming subject motion is
constant. Continuous modes are usually
release priority.

Professional cameras with such systems
can often track fast-moving objects with

remarkable accuracy. Inexpensive cameras
with such modes tend to be too slow, so it's
usually better to prefocus on a set point
and wait for the subject to hit that point.

Some cameras also have a mode which
defaults to single shot mode but which
switches over to continuous upon
detecting subject motion.

Focus priority and release priority

Internal focus-based rules used by an *autofocus* system which govern whether a camera will take a photograph in response to a *shutter* press.

Focus priority

Pressing the *shutter release* button halfway triggers the autofocus system on most *SLRs*. Pressing the button all the way takes a photograph. However, most autofocus cameras will only take a photograph if *focus* has been successfully acquired and locked first; a mode known as focus priority.

Release priority

More advanced autofocus cameras support automatic focus tracking of moving objects. Since focus tracking is often used for sports and other fast-moving types of photography, such cameras may permit a picture to be taken any time the shutter release is pressed, even if focus has not been acquired. Release priority assumes that a potentially out of focus image is better than no image at all.

Some cameras allow the user to set focus or release priority at their own discretion. Others tie the shooting modes to drive modes, and thus single-shot photography may always be in focus priority but servo or continuous photography may always be in release.

Autofocus features

Focus points

A point in the *viewfinder* representing the area of the image at which *focus* is measured.

The first *autofocus* cameras had just one autofocus point located in the center of the frame. Focusing on an off-center subject meant that the camera had to be pointed at the subject and then moved back, which could cause problems with *metering*. For that reason most *SLRs* sold today contain multiple focus points set across the frame. Some cameras select the active autofocus point automatically, and others permit manual selection via buttons, dials, or eye sensors.

Cross sensors

Many autofocus sensors can only detect contrast in lines, either horizontal or vertical. Others are known as "cross" sensors since they are capable of detecting both horizontal and vertical lines. Cameras with multiple focus points often contain a couple of cross sensors toward the middle of the frame and regular sensors elsewhere.

Autofocus assist

Many cameras equipped with passive autofocus have optional and supplementary lights for low-level autofocusing, often known as "autofocus assist" or "AF illuminator" lights. They are usually red LEDs which project striped patterns, providing some extra illumination and a contrasting edge to help the autofocus mechanism work. Some cameras pulse the main *flash* as a crude and frankly distracting form of AF assist. Note that, since autofocus assist is purely optional, the presence of assist does not turn a passive system into an active autofocus one.

Focus confirmation

Many autofocus cameras indicate successful focus lock by displaying a symbol such as a small dot in the viewfinder. They may also indicate autofocus failure by flashing the dot or displaying an X.

← *Viewfinder with a single autofocus point.*
↓ *Viewfinder with nine autofocus points.*

Split-image focus aid

A *viewfinder* screen, also known as a split-prism *focus aid* and usually on an *SLR* camera, which contains two or more *prisms* to assist the photographer with manual focusing.

These screens, common on cameras sold in the 1970s and 80s, have tiny prisms on the surface. With a standard split-circle screen, there are two semicircular prisms. When a subject is in focus then a line drawn crossing the two halves of the circle will be straight and unbroken. If the subject is not in focus, then the two halves of the image are offset.

There are many kinds of these screens. Some divide the circle into two halves split horizontally, vertically, or diagonally. Others divide the circle into four quarters. Some also surround the circle with a ring of microprisms, which are tiny triangular prisms set into the viewfinder surface. Microprism collars look smooth when an image is in focus, and broken up when an image is not.

Most *autofocus* cameras sold today do not contain such screens, but it is sometimes possible to add one to a contemporary camera to make it easier to use manual focus lenses on an autofocus body.

Split-circle viewfinder

Out of focus

In focus

Prism

A solid block of transparent material which refracts or reflects light.

The most commonly known prisms, triangular in cross-section and which disperse white light into rainbows, do not really serve any photographic applications. However the roof pentaprism is a prism type that serves as a fundamental component in the design of an *SLR* camera.

Roof pentaprisms are valued for their reflective, not refractive, properties, and allow an SLR's *viewfinder* to display the scene through the *taking lens* right side up and oriented correctly from left to right. The pentaprism is responsible for the characteristic hump on the top of an SLR camera. Inexpensive SLRs contain hollow roof *mirror* assemblies which perform the same function as a pentaprism, are conveniently lightweight, but are also dimmer (i.e.: they are less efficient at reflecting light and so less light reaches the photographer's eye).

Small prisms are also used in *autofocus* systems and split-circle manual focus assist aids.

↑ *A roof pentaprism of the type used in most SLRs. Light is reflected upwards into the prism's base by the camera's mirror. The prism reflects the image and sends it to the viewfinder. Note how the image in the viewfinder is correctly oriented.*

Mirror

A flat and highly reflective surface. Mirrors are a basic element of many types of cameras, both film and digital. *Single lens reflex (SLR)* and *twin lens reflex (TLR)* cameras both use mirrors, hence the names—reflex is an archaic word meaning reflection of light.

In most SLRs the mirror is hinged. Normally it is positioned to allow light from the lens into the *viewfinder*, but when a photo is taken the mirror flips up to allow light to expose the film or *image sensor*.

Camera mirrors are front-silvered, meaning that the reflective metal coating is on the front. This differs from ordinary household mirrors, which have coatings on the back or inner surface. This avoids the faint double reflection visible with back-silvered mirrors caused by light reflecting off both sides of the glass. However, front-silvering means that camera mirrors are delicate and easily scratched.

Mirrors in modern cameras are a bit more complex than they may seem,

however. Most are actually partially silvered, which allows some light to reflect up into the viewfinder and some to pass through the mirror to sensors behind.

While virtually all SLRs use moving mirrors, a handful of SLRs have used "pellicle" or half-silvered mirrors which are fixed in place. Such mirrors let light up into the viewfinder and through to the *shutter* simultaneously. The advantage is that there's no blackout period. The drawback is less light reaches the viewfinder and film/ sensor since light transmission to each is decreased by roughly half, depending on the design of the mirror. Cameras with pellicle mirrors are specialized products used mainly by photographers who shoot *high-speed* events, such as sports, and don't want any *mirror blackout* at all.

Some lenses also employ mirrors to fold the light path. These are commonly known as mirror lenses or *catadioptric lenses*.

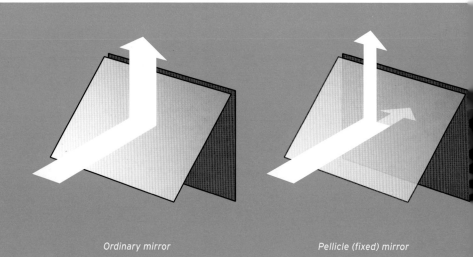

Ordinary mirror Pellicle (fixed) mirror

Mirror blackout

The time required for an *SLR*'s mirror to flip up and back down again, or in other words the brief period of time during which nothing can be seen through the *viewfinder*.

Most SLRs use flip-up mirror mechanisms as part of the viewfinder system. Moving mirrors can either reflect light into the optical viewfinder or move out of the way in order to expose the film or sensor; they can't do both. Accordingly, when the mirror is in its up position, thereby exposing the film or sensor, it's impossible to see through an optical viewfinder.

During long exposures this lack of visibility through the viewfinder can be very noticeable. A 30-second *exposure* will mean 30 seconds of a blank viewfinder. But with brief (split-second) exposures it can be very short indeed, and can be limited by the speed of the mirror mechanism.

This time might vary from around 200 milliseconds (i.e.: 0.2 sec) for an inexpensive consumer camera to 80ms for a professional model. While these times may seem extremely brief, mirror blackout can be quite noticeable for, say, a sports photographer who needs to be able to see as much action as possible.

There are two special cases where mirror blackout does not occur in SLRs. First, cameras with fixed pellicle mirrors have no mirror blackout at all since light is directed to both viewfinder and film simultaneously. And second, most recent digital SLRs have a *live view* mode which permits live video to be sent from the *image sensor* to the preview screen when the mirror is up, replicating the behavior is nearly all non-SLR *digital cameras*.

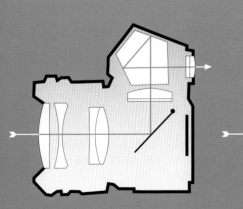

↑ With the mirror down, light entering the lens is deflected up into the prism assembly and then to the viewfinder. This allows the photographer to view the scene through the taking lens.

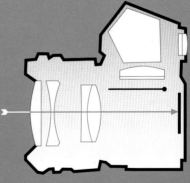

↑ When the mirror swings up to allow light to expose the film or sensor, the light path to the viewfinder is blocked. The viewfinder thus blacks out for the duration of the exposure.

Mirror lockup (MLU)

Moving an *SLR* mirror prior to taking a photo in order to minimize image blurring caused by the mirror's motion.

Most SLR cameras contain mirrors which physically move on rotating hinges when a photo is taken. The mirror allows the same lens to be used by both the *viewfinder* and the image-capturing section of the camera, but it needs to be swung out of the way to snap a photo.

Unfortunately this movement generates vibration inside the camera body, particularly when the mirror slams to a halt. This vibration, while seemingly quite small, can affect picture quality to a minute degree by blurring the recorded image.

Normally mirror slap is so subtle, and *exposure* times are usually so short, that this type of blurring isn't a problem. However, in the case of medium-long exposures, especially with long *telephoto lenses* or *macro* photography, mirror vibration can make a small but noticeable difference.

When shooting with exposure times from about 1/10 second to half a second or so, mirror lockup may be useful, particularly with detail-oriented photography such as nature photography. Better SLR cameras can physically keep their mirrors up in locked position. Some cameras support "mirror prefire" instead, which moves the mirror up before the shot is taken, lets the vibrations die down, takes the photo, then swings the mirror back down.

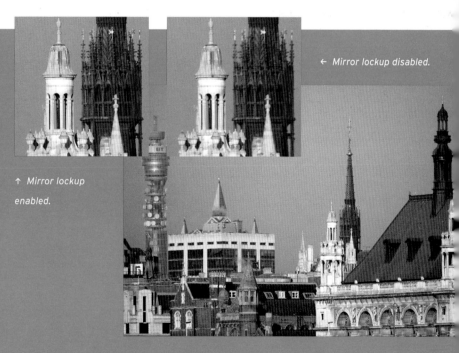

← Mirror lockup disabled.

↑ Mirror lockup enabled.

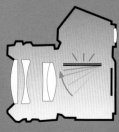

← Moving mirror vibration or "mirror slap"

↑ Motion blur induced by mirror slap is particularly noticeable with extremely long telephoto lenses. This picture was taken with a 300mm lens with a 1.4x extender, for an effective focal length of 420mm. The shot without mirror lockup is noticeably more blurry.

Viewfinder

An optical or electronic device used to preview a photograph that is being taken.

Traditionally a viewfinder has been an optical device used to show how much of a scene will be in the final photograph and to preview other aspects of the image such as *focus* and *depth of field*. It may use a lens separate from the *taking lens*, or it may show what the taking lens sees through a complex optical system, as is the case with *SLRs*.

Most optical viewfinders have small windows on the back of the camera into which the photographer must peer. Some cameras, such as *TLRs*, project an image upward to a flat ground-glass screen occupying the top portion of the camera body. Since such cameras must be used while looking downward they are called waist-level viewfinders. Such viewfinders can be used without pressing the camera against one's face, giving the advantage that the photographer can more easily connect with a human subject. *Digital cameras* may use an *electronic viewfinder (EVF)* consisting of a small video screen.

Not all viewfinders show the same amount of a scene that is actually

↑ *A traditional medium-format camera with a waist-level viewfinder. This is essentially a large ground-glass sheet, upon which an image is reflected from an internal mirror.*

recorded. There may be a small portion around the edge missing from the viewfinder view, which can result in surprises when the photo itself is examined. This viewfinder coverage is normally expressed as a percentage. For example, most amateur and advanced amateur SLR cameras only have a 90 to 95 percent coverage of the total image relative to the finished photo. SLR cameras with 100 percent coverage require larger *prisms*, and so only professional models tend to have full coverage.

← *The bright area around the edges of this photo shows the area that cannot be seen if a viewfinder with 95 percent coverage is used.*

Dioptric compensation

Also "dioptric adjustment" and "diopter correction." Either an add-on *viewfinder* lens attachment or an adjustable optical mechanism inside a viewfinder which compensates or adjusts for the photographer's viewing abilities.

Not everyone has perfect vision. Those who don't often just use a camera normally, looking through the viewfinder while wearing glasses or contact lenses. Unfortunately a lot of camera viewfinders are not designed for glasses wearers, and expect the user to be able to press their face up close to the camera body.

Dioptric compensation assumes that the photographer will remove his or her glasses and look through the viewfinder directly. Additional dioptric lenses may then be clipped to the viewfinder. Some cameras also contain internal dioptric compensation systems accessed by a knob or a slider.

Such internal mechanisms are convenient, but are also a source of consternation when bumped accidentally, sending everything out of focus.

↑ *This tiny dial, located to the upper right of the viewfinder, allows for dioptric compensation to be applied. Other cameras may use sliding mechanisms instead of a dial.*

Electronic viewfinder (EVF)

A camera *viewfinder* which employs an electronic screen in place of, or alongside, an optical system.

Traditional cameras use optical viewfinders, in which the photographer looks through a series of lenses and, in many cases, *mirrors*. Such viewfinders can show what the *taking lens* is seeing in the case of an *SLR*, or can be a separate optical system in the case of *rangefinders*, *TLRs*, and most *point and shoots*.

However, some *digital cameras* eschew an optical system altogether and instead show viewfinder information on a digital display. This screen may be on the back of the camera or may be buried inside the camera body and viewable only when looking through a viewfinder eyepiece. Other cameras, such as the model shown below, use both systems.

Electronic viewfinders have the advantage of showing exactly what the camera is recording, but have the drawback of generally lower *resolution*. Some SLRs support a *live view* mode which is a form of EVF.

Depth of field preview

A button or lever on a camera body which stops down a lens to the *aperture* to which it is set.

All automated *SLRs* perform their *exposure* metering with the lens aperture set to its widest possible setting, regardless of what the aperture is set to on the lens or body. This makes it easier for the user to look through the lens, since the maximum amount of light is shining through. It also makes it easier for *autofocus* systems to work, since they work best when a lot of light is available. Then, when the photo is taken, the camera quickly stops the lens down to the desired aperture setting and takes the photo.

This means that the *depth of field* is always at its shallowest when looking through the *viewfinder*. It is not possible to see the actual depth of field that will be attained when the photo is taken, which may be much deeper if an aperture setting smaller than the widest possible is used.

↑ *Different cameras locate the depth of field button in different places, though the button is generally directly next to the lens mount.*

Angle finder

An attachment which fastens onto a *viewfinder* eyepiece and which reflects light at a right angle. Angle finders allow a photographer to look through the eyepiece of an *SLR* camera even when there is very limited clearance below it. They are useful for *macro* photography and any time the camera is positioned low to the ground.

Most angle finders are purely optical devices, containing a 45-degree mirror and some lenses, fitted into an L-shaped tube. There are also electronic angle finders which consist of a tiny video camera and small *LCD* screen. These may have a variety of sophisticated features, such as *intervalometer* timing, motion sensing, detachable LCDs, and so on.

Battery

An electrochemical pack which can retain an electrical charge for a period of time and supply it to a device.

Batteries and cells are sealed chemical packs used by portable electrical devices. Technically a "cell" is an individual electrochemical unit, whereas "batteries" are groups of such cells packed together in a single case (hence "AA cell" but "9 volt battery"), though in casual speech they are usually all called batteries. They are either single-use (disposable) or rechargeable.

Some cameras use standard batteries, such as AA cells. Others rely on proprietary rechargeables that are manufacturer-specific and often model-specific. Rechargeables may have a rating in milliamp hours (mAh), referring to the capacity or run time. A cell with, say, a 1,300 mAh rating puts out the same voltage as an 1,800 mAh cell; it just does so for longer given the same load.

Disposable

Zinc-carbon batteries are extremely cheap. Sometimes known under the anachronistic name "dry cell," these batteries have poor "energy density," and thus contain relatively little energy for their size.

Alkaline

Alkalines have better energy density, but high internal resistance means their output decreases under load. This makes them a poor choice for power-hungry *digital cameras*: the cells may contain plenty of remaining power but not enough to drive the camera. AA alkalines are commonly used with battery-powered flash units.

Lithium

Some AA cells and many photo batteries contain lithium. The 2CR5 and CR2 batteries used by most automated *35mm film cameras* sold in the 1990s are examples. They have very high energy density.

Rechargeable

Lead-acid

A very old and heavy battery technology, still used in modern automobiles. Some battery packs for larger portable flash units use sealed lead-acid batteries.

Nickel cadmium (NiCd)

An early rechargeable technology for small portable batteries. They have modest energy density, but can have a "memory effect," whereby they hold less charge than expected if recharged when only partially depleted. They also contain cadmium, a toxic heavy metal, and produce 1.2 volts per cell rather than 1.5.

Nickel-metal hydride (NiMH)

NiMH cells offer competitive energy densities and can be recharged hundreds of times. NiMH AA cells work well with flash units because they are reusable, contain no cadmium, and can recharge a flash rapidly because of low internal resistance. Like NiCds they produce 1.2 volts.

Lithium-ion or lithium polymer

Expensive lithium packs are popular with digital cameras and laptop computers, owing to high energy densities. However their manufacturer-specific designs means that obtaining replacements in the future to keep legacy products running may be a problem. They also pose a serious fire risk if shorted and are regulated by air safety agencies.

Control dial

An input device found on many contemporary cameras consisting of a small wheel operated by thumb or finger.

Older cameras, before the advent of automation, often had dials in which specific dial positions corresponded to specific settings or functions. For example, a camera might have a *shutter speed* dial containing commonly used shutter speeds. Such dials were permanently tied to controlling a specific function, and their position indicated a setting within that function's range.

With the arrival of digital automation, reprogrammable input dials became possible. These dials change their meaning on a contextual basis. For example, most *SLRs* include a small dial, located near the *shutter release* button, which is operated by the right index finger. This dial may be used to adjust the *aperture* when in aperture priority mode, the shutter speed when in shutter speed priority mode, and menu position if the camera has a digital menu.

Most better SLRs also have a rear-mounted control dial operated by the thumb, which allows for additional features, such as changing both aperture and shutter speed in manual mode in the case of cameras with electronic aperture control.

↓ *A ridged unmarked control dial, located immediately behind the shutter release button and designed to be operated by the photographer's index finger. (The dial to the left is the camera's mode dial, which specifies what shooting mode to use.) Some cameras position the control dial immediately in front of the shutter release button.*

Camera back

The section of a camera body, furthest from the *taking lens*, where film or an *image sensor* is positioned.

Most *35mm film cameras* have hinged backs which open outwards to expose the interior and allow for the loading of film. On consumer and amateur cameras these backs are typically not removable, but on more sophisticated cameras they generally are. This allows for backs to be interchanged. Medium-format cameras frequently have completely detachable backs to allow for a variety of media to be used.

For example, a regular film-camera back might be replaced with one containing a clock-calendar which prints the date on each picture. A handful of cameras also support sophisticated computerized data backs which record useful shooting information about each frame. Other cameras support the installation of Polaroid backs which allow for instant photos to be taken in order to test studio metering and so on.

Some cameras even supported high-capacity bulk film backs, which permitted very long rolls of film to be installed. These "magazine" backs were a boon for sports photographers in the days before digital, since shot after shot could be fired without changing film. Instead of the usual 36 frames per canister, magazine backs supplied 250 or even 750 frames at a time.

Digital cameras generally do not have removable backs. However, some medium-format cameras with removable backs allow the installation of digital backs which essentially convert a film camera into a digital camera. These digital backs are expensive high-end products typically used for studio and commercial photography.

↓ *The removable back from a medium-format camera.*

Hotshoe

A powered accessory shoe located on the top of a camera.

Accessory shoes are slide-in clips used to attach peripheral devices to cameras. Hotshoes contain one or more electrical connectors which allow the camera to control or communicate with a peripheral device. Hotshoes are almost always used to attach and control *flash* units, though unpowered devices such as *spirit levels* may be attached as well.

A simple hotshoe consists of a single metal contact in the center of the shoe. This is used to synchronize the flash by switching it on when required. More complex hotshoes found on contemporary cameras are manufacturer-proprietary

and often contain three or four additional contacts located around the central stud.

An accessory shoe with no power connectors is, of course, a cold shoe, but they are rarely seen today except on antique cameras.

Shutter release

The mechanical or electrical button which triggers the opening of a camera *shutter*.

In traditional all-mechanical cameras, the shutter was directly linked to the release button by a moving mechanism. Contemporary film-based cameras usually have a shutter powered by an electric motor, and the release button is a simple electric pushbutton. *Digital cameras* also use electric buttons to trigger the picture-taking process.

Most cameras today contain *autofocus* and autoexposure systems, and use two-position shutter releases. A half-press of the button will engage the automatic *focus* and *exposure*, and pressing the button all the way down takes the photo.

↑ *A shutter release button on a modern digital camera.*

Nearly all cameras are built for the convenience of right-handed users, and position the shutter release button on the right side of the camera body so that it can easily be pressed by the right index finger.

Self-timer

A countdown timer, typically built into a camera, which triggers the *shutter release* after a preset period of time.

Most cameras contain self-timers, usually indicated by the self-timer icon.

The details vary from camera to camera, but most bodies have a 10-second countdown, perhaps beeping or flashing rapidly at the 2-second mark. Ten seconds is usually enough time for a photographer to press the shutter release, then run hastily to join a group photograph when using the camera on a tripod. Self-timers are also useful for long *exposure* shots, such as *night photos*, when remote shutter releases aren't available. In such cases the photographer may use a self-timer to avoid bumping the camera accidentally when pressing the shutter release button.

Some cameras also support additional time-related features, such as *intervalometers*.

Intervalometer

An interval timer; a device for triggering a camera at user-specified time intervals.

Intervalometers are popular for demonstrating the passage of time, such as a *time-lapse* film of a flower opening or a building being constructed, and for some security applications. Individual stills can also be combined to form a sequence of photos or a movie. Intervalometers differ from regular countdown timers, which take just one photo following a certain period of time.

Intervalometers can also be combined with *multiple exposures* on some film cameras. For example, the image below left was shot on a single frame of film during a partial eclipse of the sun.

The first *exposure* was taken normally, with subsequent shots employing a solar filter. The result is a single photo, recording both the passage of the sun across the sky and the transit of the moon across the sun.

Some cameras have interval timers built in. Others require an external intervalometer to be plugged into a remote control socket. But *digital cameras* are perhaps the best choice, since most can be controlled by a *remote* computer. Photos can then be downloaded straight to a large *hard drive*.

Remote

Short for "remote *shutter release*," a wired or wireless device which lets a photographer trigger a camera without touching it.

Remotes allow for operation of the camera at varying distances. They also reduce the risk of blurring induced by physical contact with the camera.

Older mechanical cameras used a simple metal wire inside a flexible sleeve, like a bicycle's brake cable. These cable releases terminated in a tapered thread that could screw into a camera's shutter release. Rubber bulbs and air pressure were sometimes used, hence *bulb mode* for long *exposure* times.

Most cameras sold today use electric pushbuttons connected by wires. Wireless remotes are also available for some cameras, often relying on infrared signals like a TV set remote, and sometimes using radio waves. Most professional devices use radio since they do not require line of sight, can pass through walls, and have better range.

In sports and location photography, "remote" may also refer to a remotely-controlled camera. Such cameras are often installed in dangerous or inaccessible places.

↑ *Three remote controllers. The unit on the left is a typical wired shutter release remote which plugs into the camera body. The unit in the center is a small pocket infrared controller which sends invisible IR signals to compatible cameras. The unit on the right is a radio controller which sends digitally coded signals to a receiver (not shown) which connects to the camera.*

For example, a photographer covering a basketball game might position a camera directly over the basket, looking down. This is not somewhere where a photographer can conveniently perch, so the camera is fired by a radio remote control. Or a camera might be put underneath a snowy cliff, to capture dramatic shots of skiers leaping off.

← *The camera, fastened to the motorcycle, was triggered remotely.*

Light leak

Light entering a camera body through an opening other than the lens aperture.

Damaged or poorly constructed cameras can be vulnerable to light leaks, which typically manifest themselves as unexpected bright areas appearing on an image. There may be strange streaks or bright areas in corners. Leaks differ from *lens flare* in that light is entering from a location other than the front lens element.

Older cameras may have compressed felt seals around their backs and thus light leakage may be cured by replacing the felt. Bellows cameras can often have small cracks around the edges and corners of the bellows material. Other cameras, particularly inexpensive toy cameras, may have significant light leaks owing to low-quality design and construction.

Waterproof housings

Watertight enclosures that allow ordinary cameras to be used underwater without damage.

Waterproof housings can be very simple, such as the thick transparent plastic bags that allow a camera to be taken a short distance below the surface of the water. Or they can be very complex: hard plastic or metal shells with transparent lens ports and various O-ring-sealed levers to permit full operation of the camera.

Many compact cameras have waterproof housings available as accessories, so that people can take snorkeling snapshots on vacation. There are also midrange housings available for specific *SLR* cameras for scuba divers.

Prewind

A system whereby a *35mm camera* unspools the film from the film canister upon loading, then rewinds the film back into the canister as pictures are taken.

Traditionally 35mm cameras have pulled film out of the canister and onto a takeup spool as pictures are taken. Then when all frames are shot, the photographer either rewinds the film manually back into the canister or the camera senses tension on the roll and automatically rewinds.

Prewind, by contrast, works the other way around. When film is loaded and the back cover is closed, the automatic loading mechanism unwinds the film onto the internal takeup spool. The camera counts the exact number of frames available on the roll as it does this, which takes a minute or two. Then, as each picture is taken, the film is wound back into the canister frame by frame. Prewind has the advantage of winding exposed film back into the canister, making it less susceptible to accidental exposure.

Motor drive

A powered mechanism used with a roll film camera, which winds the film between shots and rewinds at the end of the roll.

The earliest roll film cameras were of course fully manual in operation, with simple winding levers to advance the film and knobs to rewind it. But sports and news photographers found that the need to wind the film and cock the *shutter* placed a limit on the number of frames of film that could be fired in a short period of time. Manufacturers devised add-on motor drives, or electrically-powered mechanisms that fasten to the camera and interface by means of a socket on the camera base.

By the 1980s manufacturers were building these mechanisms directly into the camera bodies themselves. The fastest film-based *SLRs* ever built could reach a top speed of about 10 frames per second (fps).

Motor drive technology also migrated its way to simple automated cameras, vastly improving their convenience.

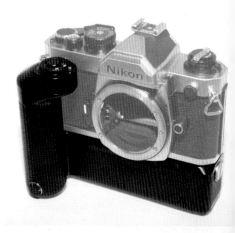

Camera supports

Various types of support systems used to reduce blur caused by camera motion relative to the subject.

One of the biggest causes of blurry photographs is camera shake, caused by poor technique or by *exposure* times that are simply too long for a person to hold the camera sufficiently steady. The usual solution to this problem is to fasten the camera to a solid object such as a tripod. This allows for a solid base for sharp exposure for nature photography, *night photography*, and so on. However, supports such as this cannot compensate for subject motion relative to the camera.

Tripods

From the Latin ("three foot"), tripods consist of three legs attached to a central mount. The mount can be fastened directly to a camera, or via an adjustable head.

The legs are usually hollow telescoping aluminum tubes, though other materials can be used. In the past wood was common, though today carbon fiber and other composite materials are valued for their rigidity and light weight. Most tripods have a central column that can be moved up for extra height, at the cost of reduced stability.

As with everything in photography, tripods involve compromises. Generally speaking, the larger and heavier the tripod, the more effective it is at eliminating camera motion as a cause of blurring by providing a stable and steady platform. However, the larger and heavier it is the more cumbersome and inconvenient it is. Nonetheless, tripods are essential for long *shutter speed* work, such as night photography. →

↑ Tiny desktop tripod with small ball head.

← Full-sized tripod with three-way head.

Camera supports

Monopods

Monopods are simply extendable poles, like the leg of a tripod. When used properly, the monopod acts as a third leg to the photographer's two. They are commonly used by sports photographers who need to support the weight of large and heavy *telephoto lenses* during games and by photographers who can't set up bulky tripods or can't justify the weight, such as wilderness photographers. Monopods prevent camera rotation and camera motion in the vertical axis, but do little to eliminate motion parallel to the ground (especially left/right and forward/back), and so are less generally useful than tripods. Some monopods also double as a hiker's pole or staff.

Clamps and brackets

All manner of clamp and bracket systems can be used to support a camera. For example, shown below is a photographer's clamp and articulating arm system. Such devices are used to fasten cameras to moving vehicles, to railings during sports events, and so on.

Studio stands

Extremely heavy bases are often used in studio settings to provide rock-steady supports for cameras, particularly large and heavy cameras such as 8x10in *view cameras*. Such stands typically consist of a vertical tube mounted to a solid base.

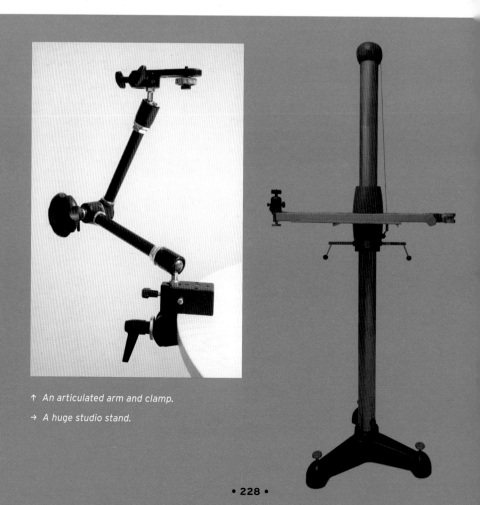

↑ *An articulated arm and clamp.*

→ *A huge studio stand.*

Tripod head

An attachment at the top of a tripod to which a camera can be fastened. Most tripods do not attach directly to a camera. Instead there is a movable device known as a tripod head which fits in between. The head allows for various types of camera movement without shifting the tripod itself. There are several common designs of tripod head.

Ball head

Ball heads are probably the most common head type used with still cameras. They consist of a spherical ball-and-socket arrangement, with a clamp mechanism to prevent the ball from rotating as required. Better ballheads also have a separate baseplate which allows for the head to be rotated without unlocking the ball.

Ball heads are very versatile, since they allow for freedom of movement in nearly every axis. However they can be a little too free for precise positioning, and the ball must be physically large enough to handle the weight of the camera and lens without drooping.

Three-way head

Heads which allow for rotation on three separate axes: rotation (pan), vertical tilt, and horizontal tilt. They usually have three separate handles or knobs to loosen or tighten each rotational plane. They are flexible but somewhat slow in operation.

Geared head

Similar to above, but each knob is attached to a geared mechanism. Turning the knob moves the camera smoothly and precisely; ideal for *macro* work.

↑ *A medium-sized ball head. The rectangular plate on the top is for a quick-release plate which allows the camera to be attached or detached with ease. The round knob to the left applies friction to the ball to prevent rotation. The lever to the right allows this particular ball head to be rotated on its axis independently of ball movement.*

Pan and tilt head

These allow for rotation (pan) and vertical tilting. They are more intended for video cameras, though they can be used with still cameras if necessary.

Panoramic head

A more complex category of head design which is used for taking multiple images to be stitched together in a *panorama*. Pan heads may include L-shaped brackets for setting the correct rotation point of a camera and lens, may be calibrated to allow for precise rotation, and may also support complex movements for multirow or spherical panoramas.

Gimbal head

A J-shaped mount used with very large and heavy *telephoto lenses*. The gimbal mount hangs the lens down from above rather than supporting it from below, making it very stable.

Tripod collar/mount

Aring-shaped clamp which allows a lens to be fastened directly to a tripod or tripod mount.

Large *telephoto lenses* are often much bigger and heavier than a camera. If a camera were to be attached to a tripod with such a heavy lens, then the whole rig might topple over from the weight. It could also place a good deal of strain on the *lens mount*.

The solution is to fasten the lens to the tripod and let the camera hang off the back of the lens, as shown below. Since add-on tripod collars are usually rings with adjustable clamps, they have an added benefit in that they make it easy to rotate the camera from portrait to landscape orientations

Some extremely large lenses have built-in tripod mounts and should never be used without them. Such integral mounts may or may not be designed to rotate.

Backwards compatible

A new technology, product, or standard which is compatible with, and can substitute for, older technology or standards. The reverse is not necessarily true.

Sometimes manufacturers will introduce a product that is completely incompatible with its predecessors. For example, in 1987 Canon introduced its EOS *SLR* line, and with it a new type of lens known as EF. Canon decided that its previous SLR *lens mount* design, FD, had technical and design issues which imposed limits on the future of its products, and thus took the risky decision to make a clean break with the past. EF lenses support advanced electronic functions but are completely incompatible with FD lenses and vice versa. The two systems are not "interoperable."

By contrast, Nikon has used the same mechanical lens mount, Nikon F, since the 1950s. With some exceptions most older Nikon lenses are compatible, at least mechanically, with newer camera bodies. This reverse compatibility has ensured that photographers are able to keep their investment in Nikon lenses, but arguably may have placed some technical limitations on what Nikon can do with future development.

↑ *Modern Nikon SLR cameras use a lens mount that is mechanically almost identical to this Nikon F from half a century ago.*

Lag time

The time that elapses between the photographer pressing the *shutter release* button and the camera taking a photo, also known as shutter lag.

Automated film and *digital cameras* have to do many things between the pressing of the release and opening of the shutter which can result in a noticeable delay. This problem is at its frustrating worst with inexpensive digital cameras and *camera phones*. There can be such a delay between the shutter press and the actual taking of the photo that spontaneous snapshots can be completely impossible. By the time the camera takes the photo, Uncle Charlie may well have already fallen into the pool, or little cousin Susie will have put on a self-conscious face.

There are a number of causes of lag time. They include:

- Achieving autoexposure metering. This usually is a negligible contributor.
- Achieving *autofocus*. This can be extremely significant with many *point and shoot* cameras. Even better *SLR* cameras can take a moment to achieve correct *focus* under challenging conditions, such as low light levels. Sometimes acquiring focus first (a half-press of the shutter release on most autofocus cameras) can make the picture-taking lag considerably less.
- *Flash*. Flash can take a moment to charge up, and cameras which emit prefire flashes (to serve as a *red-eye reduction* system, for example) can also take up additional time.
- General camera *CPU* slowness. Even with prefocused camera settings some cameras are simply very sluggish at processing information. This is particularly a problem if a digital camera is writing a previous photo to the *memory card* and the shutter release is pressed again. In such cases changing picture quality mode can sometimes help.

Beyond Economical Repair (BER)

A failed or damaged item for which the repair costs approach or exceed the replacement costs.

In the past, mechanical cameras were made of hundreds of small individual components, carefully hand-assembled. Individual component costs were often relatively low compared to the cost of replacing the entire product.

In an era of semi-automated mass-manufacturing, however, computers and cameras tend to be constructed from a smaller number of separate modules for which subcomponents are not available outside of a factory. The cost of each module can be quite high. Accordingly it may not take many modules to fail for the repair cost to exceed the cost of replacing the product with a brand new one.

Liquid damage is particularly problematic in this regard. Liquid, particularly highly corrosive fluids such as seawater or sugary drinks, can flow throughout the interior of a device, destroying multiple components within moments.

Grip

A feature which makes it easier to hold and operate a camera.

Camera grips are either part of the body or are accessories. Body-integrated grips are typically protrusions on the right side, often doubling as a battery compartment. They are frequently covered with anti-slip rubber, and make holding the camera more comfortable—at least for right-handed users.

Add-on grips typically screw to the base. They facilitate shooting in portrait orientation, and so are known as "portrait grips" or "vertical grips." Some are simple rubber blocks, but most grips sport a second shutter button and other controls. Many add-on grips contain supplementary batteries or even tiny fold-out tripods.

Bridge camera

A *digital camera* marketing category which fills the middle ground between *point and shoots*, and *SLRs*, combining features of both.

As digital SLRs continue to grow in complexity, and point and shoots have served primarily the needs of introductory users, some camera makers have seen a market for advanced amateur users. Such users may not want the size and bulk of a digital SLR, but want a camera more capable than a simple point and shoot. They want, in effect, a product which bridges the traditional gap. Here are some common hallmarks of a bridge camera.

- No interchangeable lenses. The camera will have a general-purpose *zoom lens*. Often this lens will be physically quite large compared to the body, giving the camera an L or T shape.
- Small sensor. Like point and shoots, bridge cameras have relatively small *image sensors* compared to a digital SLR.
- *Electronic viewfinder* screen with live preview. Bridge cameras do not have *pentaprism*/pentamirror assemblies with optical viewfinders.

Bulb mode

A manual *exposure* mode in which the *shutter* is held open for as long as the *shutter release* button is held down.

Bulb mode, often marked by "B" or "bulb" on camera dials and screens, is used for long exposure times. Most cameras capable of manual *metering* can be set to hold the shutter open for up to 30 seconds, but longer exposures normally require fully manual operation. Metering at such long exposures is typically a matter of trial and error, and remote shutter releases are normally used to avoid jarring the camera and blurring the shot.

The mode is known as "bulb" because older mechanical cameras sometimes used a rubber bulb as part of the shutter release cable, though today most cameras use wired electric remotes. Some older cameras also had a "T" or "time" mode, where one press of the shutter button opened the shutter and a second press closed it. This mode is replicated electronically in some modern cameras as well.

The photograph below was taken in bulb mode. The exposure required was almost two minutes, long enough for stars to record as short bars of light rather than points.

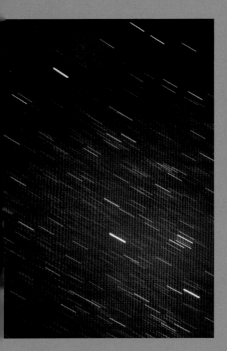

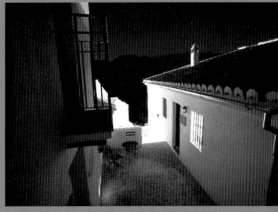

← *Longer exposures render stars as streaks of light circling the North Star.*

Camera bags and cases

Bags and cases specifically designed for storing and carrying camera equipment.

Bags

The traditional camera bag is a rectangular side-slung canvas or nylon bag worn over one shoulder. Subdivided into compartments, often with movable velcro panels, the bag can contain a camera or two, lenses, and a variety of accessories. The compartments are useful both for organizing the interior and for preventing items from bumping into each other when carried. The primary drawbacks are that they look like camera bags, which can attract the attention of thieves, and their one-strap design makes them inappropriate for long expeditions.

Backpacks

Photo backpacks are widely available for photographers who need to carry heavy loads for extended periods, such as wilderness photographers and outdoor sports photographers. Backpacks are also useful in urban environments, since they don't look like camera bags. For greater security some even have zips positioned on the inside edge, making them impossible to open while worn. Backpacks are generally less convenient to use than traditional bags, since they must typically be taken off to be opened fully.

Hardshell cases

Plastic cases with thick plastic walls. Such cases are often lockable and waterproof, making them ideal for professionals traveling under challenging conditions, such as wildlife photographers. They come in a variety of sizes, from smaller cases which can be carried aboard many commercial aircraft cabins to trunk-sized containers for large-scale professional teams. Many have handles and rolling wheels like airplane luggage.

Icons

Small pictogram symbols used to indicate preprogrammed picture-taking modes on a camera.

Most modern automatic consumer cameras have small pictograms adorning their *control switches* or *dials*. Many are predefined modes which the camera's designers have created to simplify picture taking. Each icon mode enables or disables certain features, and makes certain assumptions about the type of photography being done.

Most cameras with icons have a set similar to the list below, though of course the specifics will vary.

Landscape

Sets a narrow *aperture* to ensure a wide *depth of field*. It will likely put the camera into *focus priority*.

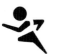

Sports

Sets a short *shutter speed* in order to freeze motion. It may use *release priority* and may engage continuous firing (i.e. the camera will shoot as long as the shutter button is pressed).

Portrait

Sets a large aperture in an attempt to get some *background* blur, though this may not succeed particularly well with inexpensive lenses with limited maximum apertures.

Macro

Stops the lens down to increase depth of field. In the case of *SLRs* with interchangeable lenses this mode cannot alter the optical capabilities of the lens and so does little to help with macro photography. However, some *point and shoot* cameras with integrated lenses do shift lens focusing to make closeup photography possible.

Night portrait

Engages a *slow shutter sync* with *flash*. Flash is fired to illuminate the *foreground* and the shutter is held open in order to expose the background with ambient light. Background blurring is likely to occur if the camera is not on a tripod.

Modern *digital cameras* support countless other modes, from party mode to beach/snow mode to sunset mode to dusk/dawn mode to underwater mode to fireworks mode, and so on. Nikon refers to icon modes as "Vari-Program," Canon calls them "Programmed Image Control/PIC" modes, and other makers use other names.

Spirit level

A transparent tube or container filled with liquid and a small air bubble, used for determining a level horizon.

It can be very easy, when taking a landscape or architectural photograph, to inadvertently shoot crooked horizons and tilted buildings. What appears to be level when peering through a tiny *viewfinder* may prove to be slightly out of alignment in the final image. This can prove particularly problematic for stitched panoramas.

Bubble or spirit levels are simple devices which assist in leveling a camera prior to a shot. They may be transparent cubes which fit in camera *hotshoes*, or they may be circular two-dimensional bubble levels installed in tripod heads. Regardless, they are a low-tech but effective means of keeping things on the level.

↑ Three bubble levels which fit into a camera's hotshoe. They contain one, two, and three bubbles respectively. The two and three bubble levels are useful for determining correct camera positioning in either portrait or landscape orientation without reorienting the bubble level.

Lens

In the context of photography, an optical device which alters light, usually through the principle of *refraction*, for the purpose of imaging.

The word "lens" can refer to a single piece of glass or plastic, such as the lenses used to make a magnifying glass or a pair of spectacles. These are known as "simple" lenses.

The term can also refer to a collection of transparent lenses, known individually as lens elements, assembled inside a light-tight frame or tube. Such a lens is known as a "compound" lens, and is the type used in a camera or *projector*. This of course is what most people think of when they think of a camera lens.

In the early days of photography, camera lenses would normally have only two or three lens elements. Modern lenses are considerably more complex, frequently

containing anywhere from five to 24 lens elements arranged in "groups."

The number of lens elements is no predictor of lens quality. *Prime lenses* have less complex optical requirements and so usually have fewer lens elements than *zoom lenses*. For example, a typical 50mm lens for a *35mm camera* will have only around six elements. But a complex zoom lens with a wide *focal length* range, a large maximum *aperture*, and *image stabilizing* might have 20 elements.

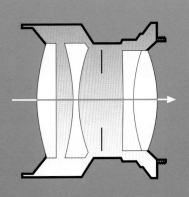

← A "block diagram" for a simple Tessar prime lens; a design which dates back to 1902. The lens consists of four separate lens elements, two of which are cemented together to form a doublet. The central line indicates the optical axis, or optical center of the lens. The dark lines indicate where the aperture diaphragm is positioned.

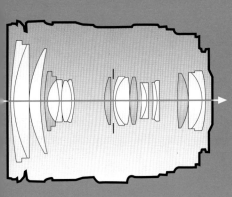

← A block diagram for a complex modern lens. This lens supports advanced features such as zooming and image stabilizing, and contains 16 lens elements in 13 groups. The elements in dark gray are notable in some way, such as being aspherical or made from low-dispersion glass.

Lens cap

A clip-on or screw-on cover, made of plastic or metal, which physically protects the end of a camera lens. Some *point and shoots* have sliding or motorized lens covers instead of lens caps. Cameras with interchangeable lenses have three types of cap: the lens cap, the rear lens cap (which is always the same size as the *lens mount*), and a body cap to protect the camera's internal mechanism when a lens is not attached.

→ *From left to right: a rear lens cap, a front lens cap, and a camera body cap.*

Lens hood

A open-ended tube which attaches to the end of a lens.

A hood, also known as a lens shade, serves two purposes. First, it prevents a great deal of unwanted light from entering the lens. Such light can cause flare and a reduction in *contrast*. Second, it can offer some protection of the lens glass against impact and scratching.

Lens hoods come in a variety of shapes and sizes. Lens hoods designed to fit one specific model of lens are known as "dedicated" hoods. Most lens hoods are flared cylinders, though many are cylinders with rounded cutout notches. Such petal-shaped "perfect" hoods are designed to reduce weight while providing the same amount of coverage as a cylinder. Some makers also make four-sided or even flexible rubber hoods. Hoods may attach via threaded screw mounts, clips, or turn-to-lock bayonet mounts.

The main drawbacks with hoods are the added expense and the fact that they can make lenses quite long. Nonetheless it's rare to see a professional shooting without a hood, as they make a tremendous difference to *image quality*.

Lens mount

A mechanical or electromechanical interface for connecting an interchangeable lens to a camera body.

Early 35mm lens mount designs, such as the Leica 39mm screwmount and the "universal" M42 lens screwmount popularized by Pentax, were purely mechanical systems. The lens mounts were simple threaded rings which screwed into the camera body. By the 1950s camera makers started introducing "bayonet" lens mounts which, while still rings, rotated a part-turn and click-locked into place.

The early all-mechanical mounts permitted the lenses to attach firmly to the camera but no form of communication between the lens and body was possible. Later, mechanical tabs began to be used which permitted the camera to stop down the aperture automatically. This allowed the camera to meter through the lens wide open but stop down the lens to the desired aperture upon taking a photograph. Other tab systems were used to transmit aperture information to camera meters, such as the Nikon AI "rabbit ears" system.

Today most lens mounts are a combination of mechanical lens mount designs and electronic interfaces for transmitting data between the lens and the camera. The most common lens systems include Canon EF and EF-S, Nikon F (DX and FX variants), Pentax K and KA, Sony Alpha (based on the Minolta A system), and the Four Thirds system designed by Olympus. These names represent both the physical mount and the economic ecology of products and accessories which develops around a specific lens mount design.

Sometimes lenses designed for one system can be adapted to another system through means of adapter rings. Automatic features, such as autofocus and automatic metering, are rarely preserved, but at least the lens can be attached in such cases.

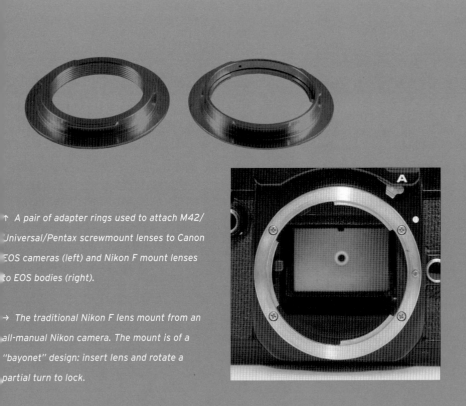

↑ A pair of adapter rings used to attach M42/Universal/Pentax screwmount lenses to Canon EOS cameras (left) and Nikon F mount lenses to EOS bodies (right).

→ The traditional Nikon F lens mount from an all-manual Nikon camera. The mount is of a "bayonet" design: insert lens and rotate a partial turn to lock.

Lens converter

A small supplementary lens which can be added to another in order to alter the latter's *focal length*.

Point and shoot cameras have permanently attached lenses which are not interchangeable. The photographer is therefore limited to whatever focal length or focal length range the camera manufacturer has built into the camera. This naturally limits the flexibility of the camera, particularly in the case of wide-angle views.

A solution is to attach a converter lens to the camera. Many cameras have threaded mounts (often concealed by plastic rings) around the camera lens to which a converter can be screwed, with 37mm being a common diameter. Other models have adapter kits available which allow converters to be fastened.

Converters are often described by the apparent focal length change they support. For example, a 0.42x converter makes the *field of view* much wider. A 50mm lens would have the field of view of a 21mm lens. A *telephoto lens*, in contrast, might be a 1.5x converter.

While convenient, lens converters invariably decrease *image quality*. They frequently cause blurring, flare, and color fringing, though there is a wide range in quality of these products, and better converters offer minimal quality loss. Some can also be rather ungainly.

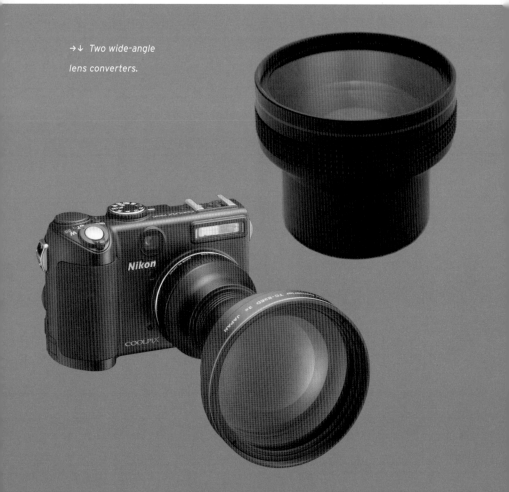

→↓ *Two wide-angle lens converters.*

_ens register distance

Flange distance, or the distance from the flange of the *lens mount* to the film or *image sensor* plane.

This distance varies from one lens mount design to another. *Rangefinders*, for example, typically have very short lens registers since the only thing that needs to fit between the back of the lens and the surface of the film or sensor is the *shutter* mechanism. *SLRs*, however, have moving *mirror* mechanisms that must fit inside the body as well, lengthening the necessary distance.

The lens register is important to photographers in two respects. First, long registers affect the design of lenses that can be used with the camera, particularly *wide-angle lenses*. A rangefinder lens with a short *focal length* can be positioned quite closely to the image plane, allowing for relatively simple, high-quality, and inexpensive wide-angle lenses. However SLRs have the mirror clearance problem, and so must have optically complex *retrofocus* designs.

Second, a camera with a short lens register can easily accept lenses designed for cameras with longer lens registers, but not the other way around.

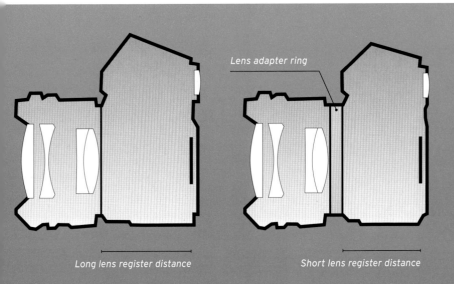

Lens adapter ring

Long lens register distance

Short lens register distance

↑ In order to get a lens designed for a camera system with a long lens register to fit a camera system with a short lens register, an adapter ring (see page 241) can often be used. Note that this allows physical connection of camera and lens; advanced features such as autofocus and metering are not likely to be supported.

Diaphragm

An adjustable iris-like mechanical barrier that controls the amount of light entering a camera.

A lens *aperture* is a hole in an opaque material that allows the passage of light. A lens with a fixed aperture (i.e.: a simple hole), while common enough, is not particularly flexible since the only way of adjusting the amount of light hitting the film or sensor is to adjust *exposure* time.

Most modern cameras employ a set of thin movable blades that can be adjusted to determine the size of the aperture. The diaphragms may be purely mechanical, and thus move in response to rotating a ring on the lens, or may be motorized and thus controlled by the camera's computer. Most advanced cameras have automatic diaphragms, which means they are in their widest position when the camera is being used to *focus*. When a picture is taken, a lever or motor stops down the diaphragm to the desired aperture setting a split-second before the photo is taken, then moves the diaphragm back to its open position.

Diaphragms vary in terms of the number and shape of the individual blades. Generally speaking, diaphragms with more blades achieve slightly rounder apertures than those with fewer, though this is very much dependent on the design. Rounder apertures are considered desirable since the shape of the aperture is one factor influencing the *bokeh* of a lens, or at least the shape of out-of-focus highlights.

→ *A motorized aperture diaphragm from a modern fully-automated lens. The device to the bottom of the unit is a computer-controlled stepping motor which instantly sets the aperture to the desired position. Note that the blades have been designed to create as circular an aperture as possible.*

Taking lens

The lens which is actually used to send light to the recording medium and thus take the photograph.

In the case of an *SLR* camera, the taking lens is the same one that the photographer looks through when peering in the *viewfinder*. However, in the case of *twin lens reflex (TLR)* and many compact cameras, there are two lenses on the body: a taking lens and separate viewfinder. *Digital cameras* with no optical viewfinder may have just a taking lens.

← *SLRs have a single taking lens for both picture-taking and the viewfinder, thanks to a reflecting mirror.*

← *Most point and shoots with optical viewfinders have separate lens systems.*

Prime lens

A lens with a fixed (nonadjustable) *focal length*. Unlike a *zoom lens*, which has an adjustable focal length to allow more or less of a scene to be taken in, a prime lens has a fixed *field of view*. The only way to adjust the view of a scene is to add a lens attachment such as a *teleconverter*, which alters the effective focal length, or physically move closer to or farther away from the subject. Sometimes physical movement is called "zooming with the feet," though it should be noted that this is misleading since moving will also alter the *perspective* of the scene; something that zooming (changing the focal length) does not do.

Prime lenses were the only type of lens available for many years after the invention of the camera, because zoom lenses are optically complex to construct. Although zoom lenses are the most popular type of lens used today, primes still have their place. A prime can be lighter in weight, can let in more light (i.e.: a "faster" lens), can offer better sharpness and *contrast*, and can be much cheaper than a zoom lens. Extremely long *telephoto lenses* (e.g.: longer than 300mm or so) are nearly always primes. Zooms are convenient, but for affordable optical quality a prime is often a good choice.

A lens with a single focal length in its description, such as "50mm" is a prime lens. A lens with focal length range, such as "24-105mm," is a zoom lens.

→ *A typical manual-focus wide-angle prime lens for a medium-format camera.*

Zoom lens

A lens with an adjustable (nonfixed) *focal length*.

Unlike a *prime lens*, which always takes in the same amount of a scene, a zoom lens has a range of coverage. For this reason, zooms are more versatile than primes, since they allow for a variety of different fields of view to be taken from the same physical position. (Though it should be noted that altering focal length does not alter *perspective*, which moving physically will do.)

This versatility explains why most amateur and semi-pro lenses sold since the late 1980s have been of a zoom design. However, the flexibility of adjustable focal length does come at a cost. Zoom lenses are usually optically slower and of lower *image quality* than a similarly priced prime lens. This is because zoom lenses are optically more complex to construct, and thus additional design compromises may be required to meet a desired sales price.

There is a wide range of cost and quality when it comes to zooms. It's quite common for lens manufacturers to sell different lens models with similar focal ranges at two or three price points, reflecting their maximum *apertures*, image quality (sharpness and *contrast*, particularly), and *build quality*.

A lens with a focal length range in its description, such as "70-200mm" is a zoom lens.

Note a common point of confusion: zoom lenses don't necessarily have long focal lengths. Such lenses with longer reach are *telephoto lenses*. It's quite possible, for example, for a zoom lens to cover a wide focal length range such as 17-40mm.

Constant and variable aperture zoom lenses

Z oom lenses in which the maximum aperture does not vary or varies across the *focal length* range.

Generally speaking, a constant or fixed maximum *aperture* is the hallmark of an expensive professional zoom lens. Most pro zooms have a maximum aperture of f/2.8 or f/4 across the entire focal length range. It doesn't matter if a 24-70mm f/2.8 lens is set to 24mm or 70mm; it will still be possible to reach f/2.8 as the widest aperture.

Lenses with variable apertures have a range as the maximum aperture. For example, a 28-105 f/3.5-4.5 lens will have a maximum aperture setting of f/3.5 at 28mm and a maximum setting of f/4.5 at 105mm. The focal lengths in between will have different maximum apertures depending on the design.

Note that there is no reason a professional quality lens won't have a variable aperture, just as there's no guarantee that a lens with a constant aperture value is necessarily of pro quality. It's just that constant apertures are a convenient feature which lens manufacturers generally attempt to achieve for the professional market.

Parfocal and varifocal

Z oom *lenses* which maintain, or do not maintain, *focus* across different *focal length* settings.

Most zoom lenses require refocusing when their focal length is changed. In other words, the photographer has to touch up focus after zooming in or out. These are known as varifocal lenses.

Some lenses, mainly more expensive professional lenses, maintain correct focus even when the zoom setting is changed. These are known as parfocal lenses.

Standard or normal lens

A *prime lens* with a *focal length* roughly equivalent to the length of the diagonal measurement of the film frame or *image sensor*.

Standard lenses take in a moderate amount of a scene—they can neither take in a broad sweep nor can they be used to isolate distant objects. On a *35mm camera* the diagonal of the film frame is about 42mm, but by convention a standard lens on such a camera is usually 50mm; sometimes 55mm. On a *sub-frame* digital *SLR* a standard lens might arguably have a focal length of about 35mm.

Because light doesn't have to be bent to one extreme or another, as is the case with a lens with a dramatically longer or shorter focal length, standard lenses are relatively easy and inexpensive to build. For this reason, standard lenses tend to be a rare thing in the world of photography: a high-quality bargain. They are inexpensive prime lenses which nonetheless take very sharp photos and which let in a lot of light.

↓ *A standard lens from a 35mm camera.*

Standard lenses are sometimes dismissed as boring because the *field of view* they offer is neither dramatically wide nor intensely narrow. However, a lightweight, sharp, fast, and affordable lens still has many advantages. A standard lens is always a prime lens, but sometimes *zoom lenses* with popular zoom ranges (e.g.: 28-90mm) are referred to as standard zoom lenses.

Telephoto lens

A lens which takes in a narrow portion of a scene owing to its relatively long *focal length*.

On a *35mm camera*, a telephoto lens is any lens with a focal length of about 85mm or more. Lenses of 300mm or so are sometimes called super telephoto lenses. Telephoto lenses are useful for taking photos of relatively distant objects, such as wildlife or players at a sports event.

Note a common point of confusion– telephoto lenses do not necessarily have adjustable *fields of view*. Such lenses are *zoom lenses*. Telephoto lenses can be either *prime* or zoom.

→↓ *Telephoto lenses were used to isolate small areas of these distant scenes.*

Teleconverter

An optical accessory which fits between an interchangeable lens and a camera body, allowing for a decrease in *field of view*.

Teleconverters or extenders contain lenses which essentially magnify the output of a lens projected onto the film or *image sensor*. They are commonly available in 1.4x, 2x, and even 3x versions which effectively multiply the *focal length* of the lens. For example, a 200mm lens used with a 1.4x extender will behave as if it were a 280mm lens.

While convenient, teleconverters have drawbacks. First, the additional optical elements in the light path invariably reduce image sharpness slightly, though the impact a teleconverter has varies depending on its optical quality. Second, a converter reduces the amount of light hitting the film or the sensor by one, two, or three stops depending on the magnification. This light loss can slow *autofocus* or cause it to fail. Third, not all teleconverters are compatible with all lenses: some physically do not mate. Finally, teleconverters are typically more useful with longer *telephoto lenses*. It isn't possible to, say, put an extender on a 20mm lens to get a 40mm lens.

↓ *A teleconverter for a 35mm lens.*

Wide-angle lens

A lens which takes in a great deal of a scene owing to its relatively short *focal length*.

On a *35mm camera* a wide-angle lens is pretty well any lens with a focal length of less than 35mm or so. A lens of 20mm or less might be considered extreme wide-angle. Wide-angle lenses are useful for taking in the entirety of a room or for sweeping landscape panoramas. Wide-angle lenses can be either *prime* or *zoom*.

→↓ *Two very different photos; both taken with 17mm lenses on 35mm cameras.*

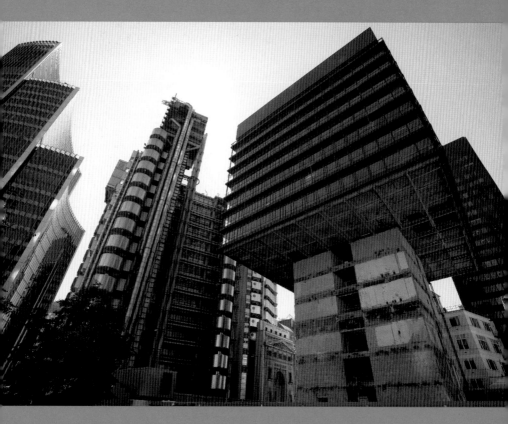

Retrofocus

A *wide-angle lens* design commonly used with *SLRs*.
The *field of view* of a lens is governed by its *focal
length*. Wide-angle lenses require short focal lengths, which
normally means that the end of the lens is positioned
quite closely to the film or *image sensor*. In the case of
cameras such as *rangefinders*, where the only physical
barrier between the back of the lens and the film or sensor
is a thin *focal plane* shutter, this is straightforward.

SLRs pose a problem, however. They have moving
mirror assemblies which sit between the back of the lens
and the *shutter*, occupying considerable space. There is
thus a limit as to how close the lens can be to the film or
sensor, unless the lens is to be used only when the mirror
is locked in an up position.

A solution to this problem is a clever optical trick
whereby the rear exit pupil of the lens, the imaginary
point where the rays leaving the lens seem to originate,
is moved backward inside the lens, allowing the lens to
clear the mirror. In effect a retrofocus lens is an inverted
telephoto design. Telephotos use complex optics to make
the lens physically shorter than the focal length, whereas
retrofocus lenses are designed to be physically longer than
the focal length.

Retrofocus designs make wide-angle lenses on SLRs
possible, but also add to the complexity and expense of
building a wide-angle lens. They were first made by French
designer Pierre Angénieux in the 1950s.

→ A 16mm retrofocus lens
on an SLR. The moving mirror
mechanism means that the
back of the lens can't get
very close to the film or
image sensor.

→ A 15mm lens on a rangefinder. The only
obstruction between the back of the lens and
the film or sensor is the shutter mechanism,
so a retrofocus design is not needed.

Kit lens

A lens included with a camera body as part of a complete sales package.

Most advanced and professional cameras which suppo interchangeable lenses are sold without lenses; body only This is because no one lens type fits all needs, and it is assumed that a person buying such a camera will purchas or will already have a stable of lenses to go with it to mee his or her needs.

However, low-end and consumer *SLR* cameras typically "bundle" or include lenses in the package, mainly because consumers expect a camera to be usable right out of the box. These "kit" lenses are optimized for affordability and are intended to be general purpose in nature, aimed at meeting the majority of a beginner's needs. Kit lenses are always *zoom lenses* these days, and typically cover a *focal length* range of about 28 to 90mm for *full-frame* and film cameras, and 18 to 55mm or 70mm for *sub-frame* digital SLRs.

↓ *An inexpensive "kit"
lens included with a digital
SLR camera.*

Kit lenses are optically very slow (f/4.5 to f/5.6 is typical wide open) and do not offer the best *image quality* possible. They also tend to be of lightweight plastic construction. While affordable and convenient, they do not represent the best image quality possible with a given camera.

Macro lens

A lens capable of focusing so closely that an object the size of the film frame or *image sensor* fills the entire frame.

The term "macro" is used fairly loosely by marketers, but the traditional definition of true macro is that of 1:1 magnification. In other words, if a standard *35mm* film or *full-frame* digital camera is used, then an object 36mm by 24mm wide would fill the entire frame. Similar conversions would apply to other image sizes, such as a cropped digital *SLR* or a medium-format camera.

Since macro lenses are often used for reproducing flat objects (e.g.: photographing postage stamps) they are also typically optimized for flatness of field. Most ordinary lenses are not, and can demonstrate loss of corner sharpness when photographing flat objects.

Macro lenses are almost always *prime lenses*, to avoid the quality tradeoffs inherent in *zoom lens* designs. The *focal length* of a macro lens varies, with the longer lenses (e.g.: 180-200mm) providing more working distances for shy subjects such as many insects, and the shorter

lenses (e.g.: 50-60mm) being more affordable. Most macro lenses fall midway, in the 90-105mm focal length range.

Macro lenses can usually also serve as regular lenses, albeit extremely sharp ones, and can achieve *infinity* focus. However, some specialized macro lenses, particularly those capable of magnifying images past 1:1, may not be able to reach infinity and are thus really useful only for macro shots.

Confusingly, most ordinary lenses have the word "macro" marked on them somewhere to indicate close focus distances, and *point and shoots* have macro modes which may be able to focus more closely than usual. Generally neither achieve true macro status, since they do not reach 1:1 magnification. Nikon refers to macro lenses as "micro" lenses.

Macro equipment

There are a number of tools for taking macro photographs without a true *macro lens*. Here are the most common.

Extension tubes

These are simple hollow tubes with *lens mounts* on each end. They allow the lens to be attached to the camera body at a greater distance from the film plane than normal. The ability to focus to *infinity* is lost, but the ability to focus closely is gained. Since they essentially work by enlarging the *image circle* projected on the film or sensor, tubes also cost light as the light is spread across a greater area. There is no reduction in *image quality* imposed by an extension tube, though *diffraction* effects may be amplified somewhat.

Bellows

An accordion-like bellows is essentially an extension tube which can be lengthened or shortened at will. Macro bellows tend to be mounted on sliding guide rails which allow for precise positioning and adjustment.

Closeup lenses/diopters

These are one or two element lenses which screw onto the filter mount at the end of the lens. They basically serve as magnifying glasses. They do not cost any light, but there is always some quality loss depending on the quality of the lens. Two-element diopters generally correct chromatic *aberration* a bit better. They must also be the size of the filter mount, which can be costly for larger lenses.

Reversing adapters

Some lenses, 50mm *standard lenses* being one common type, can focus more closely when mounted onto the camera backwards. There are reversing rings available which are simply a lens mount on one side of the ring and a filter mount on the other.

→ *An ordinary 50mm lens which has been mounted backwards using a simple adapter ring. The ring goes from the camera mount to the filter threads on the lens itself. This permits this particular lens to focus more closely than it normally would, allowing for macro photographs.*

Fisheye lens

An extremely wide *wide-angle lens* which does not attempt to render all straight lines in a scene as straight in the image.

Unlike a rectilinear lens, a fisheye exhibits a tremendous amount of barrel *distortion*. Fisheye lenses typically cover a *field of view* of either 180° vertically or diagonally. The former, with a *focal length* of 8mm on *35mm cameras*, are known as circular fisheyes and cast round images on a black ground. The latter, 15-16mm on 35mm cameras, fill the entire frame and have no blank areas.

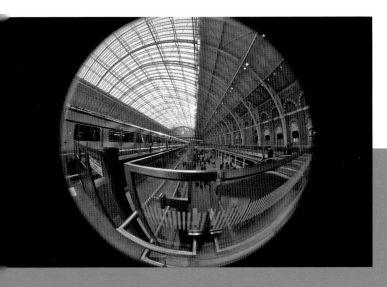

↑ *A picture taken with a circular 8mm fisheye. This lens, when used on a 35mm camera or digital equivalent, takes in almost 180° at the shorter dimension of the frame, thus casting a circular image. The only lines which appear straight are those which pass through the very center of the frame.*

→ *A photo taken with a full-frame 16mm fisheye. This lens has 180° of coverage on the diagonal when used on a 35mm camera or digital equivalent.*

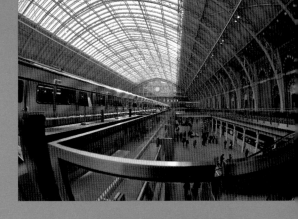

→ *By comparison, a photo taken with a 17mm wide-angle rectilinear lens, not a fisheye.*

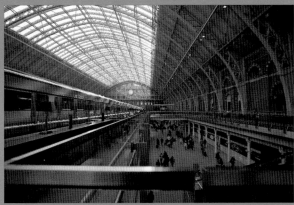

Catadioptric (mirror) lens

A lens that employs reflecting *mirrors* as part of the optical system.

Catadioptric lenses are hybrid designs, containing both refracting lens elements and two internal mirrors that shorten the physical length of the lens by effectively folding the light path in half. They are similar in design to Schmidt-Cassegrain telescopes, and are sometimes called "mirror" or "reflex" lenses.

The main advantage of the reflector design is that long *telephoto lenses* can be built quite cheaply, and mirrors are not subject to chromatic *aberration*. Inexpensive mirror lenses with 500mm *focal lengths* are very common, and the lenses are lightweight and highly portable.

The drawbacks are significant. First, most mirror lenses have weak *contrast* and sharpness. Second, the smaller mirror represents a physical obstruction at the center of the lens, creating distracting annular or doughnut-shaped *bokeh*. Third, most do not have adjustable *apertures*, and are fairly slow. Finally, few mirror lenses support *autofocus*.

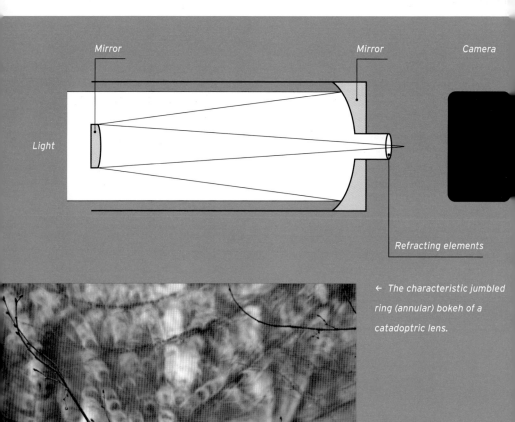

← *The characteristic jumbled ring (annular) bokeh of a catadoptric lens.*

Lens coating, multicoating

Antireflective coatings are surface treatments to a lens that reduce flare.

An ordinary piece of glass is almost as reflective as a mirror under certain conditions. Take a window, for example. When viewed from most angles its glass is transparent but, when viewed at the right angle, the sun or other bright objects can be reflected back.

Flare of this type is a problem for photographic lenses, especially when lenses consist of many individual pieces of glass. Multiple uncoated elements will mean all kinds of light will bounce around inside the lens, reflecting off each individual surface. This type of overall glare lowers the *contrast* considerably.

A lens coating is a material, such as magnesium fluoride, which is evaporated onto the surface of the lens. The coating reduces reflection through a process of optical interference, while still permitting the normal transmission of light through the glass. Coatings were key to making modern lenses possible. Until coatings were invented in the 1930s, lenses were typically limited to having three or four elements.

Coated glass is easy to distinguish from uncoated. Ordinary glass easily reflects the white light off a source like a light bulb. But coated glass has an odd sheen to it, often greenish or reddish. The less reflection seen, the more effective the coating. Generally multiple layers (multicoatings) work better than single coats.

Manufacturers have all kinds of proprietary formulas for lens coatings which they market under a variety of names and acronyms, such as MC and Super MC. Some makers also sell products which they claim have improved coatings for digital sensors. All kinds of optical glass benefits from coatings, including lens filters, binoculars, telescopes, and eyeglasses. The primary drawbacks to coatings, aside from cost, are that the coatings can be fairly easily scratched and can easily reveal any greasy or oily smudges.

Single-coated lens filter.

Multicoated lens filter.

Image stabilizing (IS)

A technology for reducing blur in photos through motion detection and compensation.

Camera motion during *exposure* is a common cause of unwanted blur, and the traditional solutions are to lock the camera down to a tripod or use *flash*. These are not always realistic options, and so image stabilizing was developed to reduce blur while shooting handheld.

Image stabilizing requires two things: a sensor gyroscope or other device to detect camera motion, and a motor or other system to compensate for that motion. Most systems can detect movement in two directions: horizontal and vertical. Some can also detect rotation, and in theory forward and back motion could be sensed also. There are two basic locations that the motion-compensating mechanism can be positioned: the lens and the camera body. Each has its pros and cons.

In-lens stabilizing

With in-lens stabilizing, a lens element or group of elements is attached to a motor. This moves the image cast by the lens, compensating for camera movement. In-lens stabilizing can work with either film or digital bodies. Proponents of lens-based IS argue that the mechanism for motion compensation can be tailored to match the specific *focal length* in use, thereby yielding better results than in-body IS.

↓ *This picture was taken under quite challenging photographic conditions: dusk, with a handheld lens set to f/4; 1/8 second at ISO 400. It was a busy street, which ruled out tripods. The magnified section on the left was taken with image stabilizing off, and the image on the right had stabilizing on. Note the considerable difference in sharpness.*

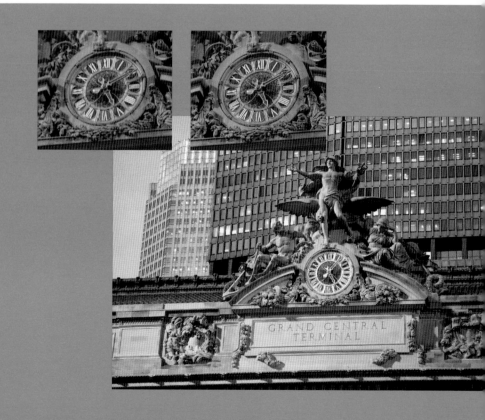

n-body stabilizing

n-body stabilizing involves either physically moving the *image sensor* to compensate for movement or simulating motion of a fixed sensor by remapping data digitally. The former is often referred to as "optical image stabilizing," much like the in-lens system. The latter, sometimes called "digital image stabilizing," is usually less effective, and is generally seen on less expensive cameras. Body stabilizing is not feasible with film cameras since it isn't realistic to move a single frame of roll film.

The advantage of in-body IS is obvious: it only needs to be bought once, and it works with all lenses.

Limitations of IS

Stabilizing is useful, but can only compensate for camera motion. Like a tripod it can't do anything about subject motion. So it can be of limited value for, say, photography of fast-moving objects under low-light conditions, as is the case with sports photography. There's no substitute for fast lenses in these situations. Many forms of IS also don't work with tripods, actually generating blur when locked down to firm platforms. Finally, IS draws more power from a camera battery.

IS doesn't move the camera or lens as a whole. Devices that do are known as gyroscopic mounts and are expensive professional tools, mainly used for *aerial photography*.

Image stabilizing is sold by a number of different names. Canon calls it "image stabilizing," Nikon "vibration reduction," Sigma "optical stabilizing," Panasonic "Mega Optical Image Stabilizing (OIS)," and Sony calls it "Super Steady Shot."

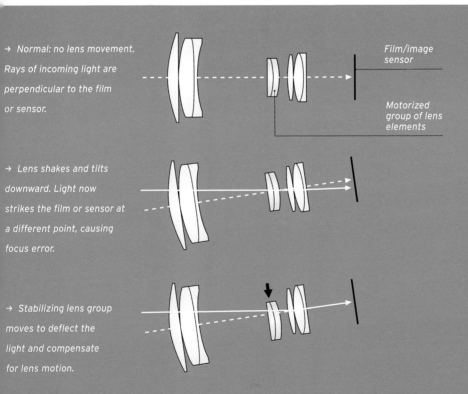

→ Normal: no lens movement. Rays of incoming light are perpendicular to the film or sensor.

Film/image sensor

Motorized group of lens elements

→ Lens shakes and tilts downward. Light now strikes the film or sensor at a different point, causing focus error.

→ Stabilizing lens group moves to deflect the light and compensate for lens motion.

Minimum focus distance

The closest point at which a given lens is capable of achieving *focus*.

Just as our eyes cannot focus on objects located too close to the face, camera lenses also have a minimum close focus distance, which varies from lens to lens. Generally speaking, *wide-angle lenses* have shorter close focus distances than *telephotos*.

The minimum focus distance is an inherent optical property of the design and construction of a given lens and can't be modified after the fact. However, additional devices such as extension tubes can be added to a lens to allow closer focusing.

The minimum focus distance is measured from the film plane or *image sensor*. The distance from the end of the lens to the closest object which can be kept in focus is the "working distance."

Minimum working distance

Minimum focus distance

Ultrasonic motor

An *autofocus* motor which uses ultrasonic vibrations to induce motion.

Traditional autofocus mechanisms use motors containing small magnetic coils, based inside the lens or inside the camera body. While inexpensive, they have three drawbacks: they generate noise, have speed limitations, and generally cannot be used in manual *focus* without disconnecting a geartrain of cogwheels from the focus ring.

Ultrasonic motors use piezoelectric elements to generate very high frequency vibrations which induce circular motion. The motors are extremely fast and, to human ears, almost silent. They come in two different forms: ring and geared micromotor.

Ring motors consist simply of two concentric rings. They can be the more desirable form since many implementations allow for manual focusing without having to disconnect the autofocus mechanism. This may be known as "full-time manual" and allows for quick and easy manual focus touchup. Geared motors substitute a small

ultrasonic motor for the magnetic motor in a traditional geartrain. They are reasonably quiet, but can't support full-time manual without a clutch mechanism.

Canon uses the marketing name "ultrasonic motor (USM)," Nikon uses the name "AF-S/Silent Wave motor (SWM)," Sony "SuperSonic Motor (SSM)," and Sigma "Hyper Sonic Motor (HSM)."

↑ *A pair of ring ultrasonic motors. The stationary ring is known as a stator and the rotating ring is the rotor. Remarkably enough, two rings of this type constitute the entire motor for many autofocus lenses.*

Modulation transfer function (MTF)

A method of measuring certain aspects of lens performance, typically indicated as a series of lines plotted on a chart.

MTF charts measure the variation in contrast from the center of the lens to the edge by projecting finely spaced pairs of high-contrast lines. Measurements are taken in a variety of ways, such as wide open and stopped down to f8. The contrast measurements may be made with widely spaced lines or narrowly spaced lines—low and high spatial frequencies. Some may take both sagittal (radial lines running from the center to the edge) readings and meridonial (tangential, or perpendicular to the sagittal) samples. Differences between the two readings indicate that the lens has astigmatism.

↑ This is a chart for a high-quality prime lens. The lines are clustered toward the top, indicating high contrast. They are also fairly level, indicating that contrast stays quite high toward the edges of the frame.

→↓ Four MTF charts. The vertical axis of each chart shows contrast or MTF. This is sometimes shown as running from 0 to 1 or from 0 to 100%. The horizontal axis shows lens data at an increasing distance in mm from the middle of the frame. When the sagittal and meriodional lines have similar shapes the lens is likely to have better bokeh.

↑ This, however, is a chart for a low-quality consumer zoom lens set to its maximum focal length. Contrast is poor, as shown by the lines clustering toward the middle of the chart. Contrast also falls off toward the edges of the frame.

↑ These two charts are for a high-quality professional zoom lens. Note the difference in performance when the lens is set to its wider position (70mm) than to its longer position (200mm).

Sweet spot

Informal name for the area of a lens which offers the sharpest and highest quality image. With virtually all lenses this will be the area close to the center of the lens.

Lenses, especially inexpensive ones, tend to lose sharpness toward the edges. They may also suffer from various forms of *aberration*, particularly spherical aberration (leading to softness) and chromatic aberration (leading to color fringing). Cameras with sub-frame *image sensors* will tend to use mostly the sweet spot of a lens, relatively speaking, compared to *full-frame* cameras. This is because the *sub-frame* camera, by effectively cropping off the edges, makes use mainly of the center of the lens.

↓ *Cathedral ceiling photographed with a very wide (17mm) lens on a full-frame camera. Note how the area toward the center of the frame is extremely crisp and sharp, but the upper right hand corner is very soft. Extreme wide-angles often are weak in corner sharpness, particularly retrofocus zoom lenses such as this.*

Fungus

A type of mold which can inhabit camera lenses in warm and humid climates.

Fungi attack the coatings used on camera lens surfaces, etching and destroying them. The telltale sign of fungus is a fine spiderweb-like pattern appearing on the inner surfaces of a lens.

It can be difficult or impossible to rid a lens of fungus once the infection has taken hold, so photographers in warm and humid areas are well advised to store cameras and lenses inside sealed plastic containers when the gear is not in use. The boxes should also contain water-absorbing silica gel material. Electric dryer cabinets can also be used.

When buying used lenses, always hold the lens to the light and examine the interior carefully for any evidence of fungus.

← *A lens bearing the hallmarks of a fungal infection: fine delicate traceries branching out from the inner edges of the glass.*

Photographer's vest

A light sleeveless jacket worn by a photographer for equipment storage purposes.

One of the challenges of being a photographer is quite simply gear management. Most photographers continually have to deal with a surfeit of equipment: lenses, batteries, *filters*, *memory cards*, film, *lens caps*, notepads, etc. The photographer's vest is one way of distributing this equipment across one's body in a convenient way.

Regulatory symbols

A wide variety of regulatory symbols are printed on most cameras sold today. Here are a number of common ones.

 CE. Conformité Européene. Product meets European Union regulations, typically those concerning radio interference.

 CSA. Canadian Standards Association. Product meets the safety standards of the Canadian standards agency.

 FCC. Federal Communications Commission. Product meets US government radio interference regulations.

 RoHS. Restriction of Hazardous Substances. A European Union directive aimed at reducing the amount of toxic materials, such as lead, mercury, and cadmium, in many products.

 Tickmark. Product meets the radio interference standards of the Australian Communication Authority.

 UL. Underwriters' Laboratories. Product meets the safety standards of the US standards agency.

 VCCI. Product meets the radio interference standards of the Japanese standards agency.

 Product contains materials which are considered hazardous and can't be disposed of with ordinary household waste under European Waste and Electronic Equipment (WEEE) regulations.

Filters

In general terms, optical material used to block certain wavelengths of light, or to otherwise modify that light.

The key point is that filters which alter a color balance will passively block certain wavelengths of light; they can't actively add color. As described earlier, white light consists of light across the color spectrum (see *color temperature*). If, say, some of the blue wavelengths of white light are prevented from entering a lens, the overall picture will have a slightly yellow cast to it. This isn't because yellow has been added: it's because some of the blue has been removed and this affects our perception of the light by altering the balance.

This has two important consequences. First, by definition all filters reduce some of the light entering the lens, which results in longer *exposure* times. The increase in time depends on the amount of light blocked, and is sometimes called the "filter factor." Second, filters are most useful with white or nearly white light. It is not possible to transform one wavelength of color into another.

This kind of color shifting is best done digitally in an image-editing program. In fact, optical filters are not as essential as they were in the days of film for the most part, simply because of the tremendous color flexibility afforded by digital editing.

Filters for Japanese cameras are usually circular metal rings with fine threads which screw onto the end of a lens. Some, often billed as "slim" filters, have low-profile rims to minimize the risk of vignetting with *wide-angle lenses*. Some filters are frameless rectangles which slide into special holders, and some European cameras employ locking bayonet filters. Most filters are made of glass, but some are made from plastic resin. Some lenses, particularly *telephotos* with large front elements or *fisheyes* with highly curved front elements, use internal or rear-mounted filters which are often squares of thin gel material.

UV filter

A visually transparent glass filter that absorbs *ultraviolet* energy.

Most films and *image sensors* can detect ultraviolet light, but the human eye cannot. Thus situations with high levels of ultraviolet, such as shooting outdoors at high altitudes, can result in unexpected loss of contrast since the UV is being recorded and becomes visible haze in the finished photo. One way to minimize the problem is to use a UV-absorbing filter, sometimes known as a "skylight" filter, on the camera.

Since UV filters are completely transparent to visible light they are also sold as "protective" filters. The theory behind this idea is that it's far better to scratch or crack a relatively inexpensive filter than it is to damage the actual lens itself.

The drawback is that a UV filter will always cause some degradation of the image. This may be minimal and impossible to detect in the case of clean, multicoated, and high-quality UV filters, or it may be significant in the case of cheap, badly coated filters. Some photographers refuse to use UV or protective filters for this reason, arguing that no degradation of *image quality* is acceptable.

Clearly it is foolish to put a low-quality protective filter on a high-quality lens, since increased risk of flare and decreased *contrast* are both likely possibilities. However, a well maintained and high-quality multicoated filter inflicts minimal image quality degradation. In fact some weather-sealed lenses require filters in order to be fully weatherproofed. Ultimately the choice to use or not use such filters depends on the photographer's personal priorities.

↑ *This photo illustrates the argument in favor of protective filters. The UV filter shown here valiantly gave its life to protect the quite expensive lens underneath, which was utterly unharmed.*

↑ *This photo demonstrates the argument against protective filters. What appear to be lights on the carpet are actually reflections of the ceiling lights caused by a poorly coated UV filter.*

Filters for black and white

Brightly colored *filters* which affect the final balance of grays in a black-and-white photograph.

Monochromatic photographs are not concerned with colors as such. Instead, the relative intensity of reflected light from each object is key. Different colors appear as different shades of gray in a monochrome photo. In fact, in the days of black-and-white movies, the sets and costumes were often rather strange colors so that they would look good on film.

Accordingly, when shooting black and white it is very common to use brightly colored filters to hold back certain colors. This allows for very different shades of gray in the final photograph.

For example, the brightness value of a cloud and the brightness value of a summer sky are often quite similar. The result is that skies often image as rather disappointing uniform shades of gray even though they may look quite contrasty in color. One way to tackle this problem is to

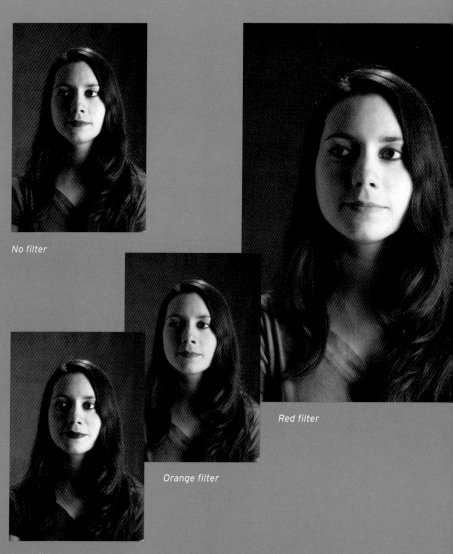

No filter

Red filter

Orange filter

Green filter

se a dark red filter. This blocks the assage of much blue light, thereby arkening the sky in the finished photo. he result is a dramatic dark gray sky with hite clouds.

The images below show the different esults achieved through the use of colored lters. For reference, the amusement park ide is bright red with orange letters and he sky is blue. The model is wearing a red hirt and red lipstick and is in front of a reen silk backdrop.

Note how the red filter is perhaps most generally useful, since it darkens the sky for improved contrast with the clouds, and also smooths out the model's skin tones, though the red of the lipstick is lost. The green filter is generally unflattering for the model, as it emphasizes skin texture, though it does show the lipstick well.

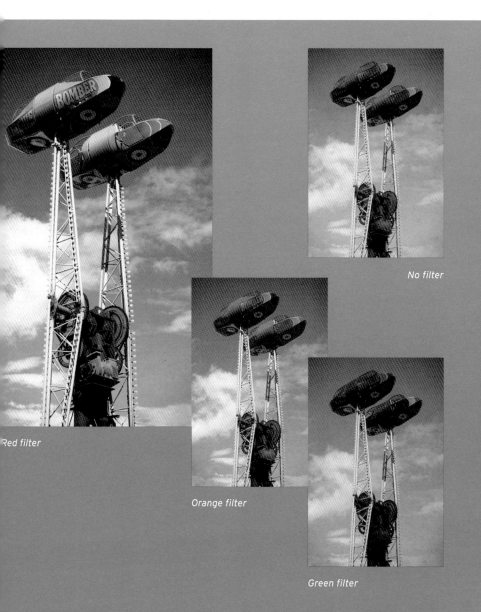

Red filter

No filter

Orange filter

Green filter

Polarizing filter

A filter that contains a thin layer of plastic material which can block light polarized in one plane.

Light has many wave-like properties. In fact, it is useful to visualize light as a child's jump rope. As the rope is moved it ripples in waves. If the act which causes the rippling is a simple up and down motion, the rope's wave will ripple in a single vertical plane.

Polarizing filters block the passage of light which has a waveform parallel to the axis of polarization of the filter material. Such filters are thus commonly used for reducing polarized reflections from many nonmetallic surfaces, such as glass and water. They can also darken blue skies, by partially polarizing sunlight.

There are two basic types of polarizing filter: linear and circular. Linear polarizers are less expensive, but can interfere with the operation of *autofocus* and autoexposure in modern cameras. Circular polarizers contain an additional element, a "quarter wave plate," which maintains compatibility with such devices by transforming the light's polarization into a circular or corkscrew form. Most polarizers are mounted in rotating metal rings, so that the angle of polarization of the filter can be adjusted simply by turning the ring

Since the polarization information is not recorded by film or *image sensors*, polarizers are one filter type which cannot be simulated in software. No program can accurately emulate the effect of a polarizing filter reducing reflection off the surface of water, for example.

↓ *Polarizing filters are extremely useful for darkening clear blue sky, increasing the contrast with the clouds. The amount of polarizing depends on the angle of the filter (most polarizers are built into a circular frame and can be rotated) and the position of the camera relative to the sun. When shooting near the sun the sky becomes very white and little polarizing is possible. The further one looks away from the sun the bluer the sky and the more polarization is possible.*

Other common filters

Other common types of filters include:

Color correction (CC)

CC filters are used for compensating for different types of light, such as when using tungsten lighting with daylight-balanced film or daylight lighting with tungsten-balanced film. The most common types are warming or cooling filters, and come in a variety of strengths. Correction filters for other color ranges are also available, as are magenta filters for reducing some of the green cast that can appear in fluorescent lighting. Color correction of this type is less critical for *digital cameras*, which have adjustable *white balance*, than for film.

Warming

A yellow or orange filter which blocks bluish light and "warms up" a scene by, counterintuitively enough, lowering the apparent *color temperature*. CTO (color temperature orange), German KR, and *Wratten* series 81 and 85 filters are used for warming purposes.

Cooling

A blue filter which blocks yellow-orange light and thus "cools down" a scene by raising its apparent color temperature. CTB (color temperature blue), German KB, and Wratten series 80 and 82 filters are used for cooling.

Color enhancing

Most commonly, filters containing didymium (a combination of rare earth elements neodymium and praseodymium) which perform a subtle boost to the reds in an image; particularly useful for nature photographers who photograph red rocks or autumn leaves. Such "intensifier" filters are quite expensive and can sometimes result in inadvertent *color casts*. They are also considerably less useful with digital than with film.

Soft or diffusion

A filter which slightly diffuses incoming light. Such filters may have treated surfaces or may be covered with small lenses or netting. The effect is to minimize the effect of wrinkles, spots, and skin blemishes. It can also lend a dreamy feel, but the soft filter look is generally considered dated today. →

→ *Cross or star filters are ordinary clear glass filters with grids of lines engraved on their surfaces. They create star effects around small highlight light sources, and are commonly available in square grid (four point), triangular grid (six point), and eight point versions. The images here were taken with four point and six point grids, respectively. The effect, while popular in the 1970s and 80s, can frankly be a little garish.*

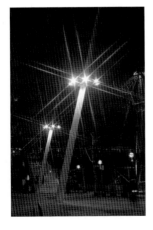

Other common filters

Infrared

Usually a filter which blocks visible light but which passes *infrared*. Such filters appear solid black to the human eye. Infrared filters are used for taking photographs with infrared film or digital cameras.

There are also filters which block infrared but which pass visible light. Such filters are not common, but can be used to correct reddish-magenta color casts which can occur with some digital cameras with poor infrared-blocking capabilities.

Neutral density

A grayish filter which blocks light equally across the spectrum. ND filters are useful for increasing the shutter time required to take a photo or allowing fast film to be used in bright light.

Graduated neutral density

Grad ND filters are usually clear on one end and darkened (neutral density) on the other. This is useful for darkening just one side of a picture. They're popular for taking sunset shots where the sky is very bright

but the ground is not: by "holding back" the bright area the darker section becomes visible as more than an underexposed black area. In a sense they are a simple way for *high dynamic range* photos to be taken. The dividing line can be sharp or blurry (hard or soft), though it is always straight, which limits the situations in which a grad ND can be used.

Split field

A closeup filter (diopter) which has been cut in half. This allows for a camera to focus on near objects in one half and far objects in the other.

Special effect

All manner of special effects filters, from subtle to cheesy, are available. They can enhance starbursts around highlights (cross-screens), add bright color tints, simulate *motion blur*, split an image into multiple images, and so on. These filters were very popular with hobbyists in the 1970s, but image-editing software has largely replaced them.

← *Some common filters. Clockwise from top left: an ultraviolet filter, a rectangular graduated neutral density filter, a polarizer, a multi-image filter (essentially four prisms surrounding a central square clear area), a cross filter for star effects, an 81A skylight (straw-colored warming filter), and a red 25 filter.*

← *A photo taken with a split-image filter, which is essentially a piece of glass cut into a prism.*

Step ring

A machined metal ring used to adapt a screwmount *filter* designed for one size of lens to a lens with a different filter diameter.

Step rings come in two forms: up and down.

A step up ring allows a larger filter to be attached to a smaller lens, such as a 77mm filter on a 72mm lens. This can be quite useful, since a photographer can carry just one filter size for two sizes of lens.

A step down ring allows a smaller filter to be attached to a larger lens, such as a 52mm filter on a 58mm lens. This is less useful, since there will probably be black areas around the edges caused by the smaller filter. However, it might work on a *sub-frame* digital *SLR* when used with a *full-frame* lens.

There are two other issues to be aware of when using step rings. First, the step ring will add a little height to the filter, causing it to project slightly further away from the lens. This may increase the chances of vignetting. Second, the step ring and filter combination may interfere with a *lens hood*.

↑ *A step ring allowing a 58mm skylight filter to be used with a lens with 52mm filter threads.*

↑ *Three step rings: two step up rings (large filter on small lens) and one smaller step down ring (small filter on large lens).*

Wratten numbers

A lphanumeric designations for colored *filters*, devised by the Wratten and Wainwright company.

The English photographic supply company founded by Frederick Wratten, later bought by Kodak, produced a series of filters from the early 1900s. These filters were given a fairly arbitrary series of alphanumeric codes.

Many of these codes are still informally used today in English-speaking countries. For example, one might speak of a "red 25" or a "1A" skylight filter.

Wratten number	Filter color	Uses
0	Clear	UV absorption
1A	Pale pink	Skylight filter for reducing UV
2A	Pale yellow	Blocks UV
25	Red	Black-and-white photography
29	Dark red	Tungsten tricolor
80A	Blue	Color correction, 5,500 K daylight film with 3,200 K tungsten bulbs
80B	Blue	CC, 5,500 K daylight film with 3,400 K tungsten bulbs
81A	Amber	CC, 3,200 K tungsten type B film with 3,400 K tungsten bulbs
81B	Amber	Warming filter -300 K
81C	Amber	Warming filter -400 K

Flash

A device which illuminates a scene for photographic purposes by emitting a brief but very bright pulse of light.

In Victorian times, powdered magnesium was often used as an effective, if dangerous, means for illuminating a scene. By the 1920s single-use electric flash bulbs, made of glass shells filled with fine metal wire, began to be used. These shrank over time from the large bulbs wielded by press photographers in black-and-white movies, to the disposable flash cube and flip flashes used by consumer cameras in the 1960s and 70s.

Electronic flash

Today such single-use flash bulbs have been replaced by electronic flash. Electronic flash units, commonly known as flashes and, in North America only, strobes, are built around small glass tubes containing xenon gas. Electricity is built up in a capacitor and then released through the tube, resulting in an intense split-second burst of light. Electronic flash units are more easily controllable than bulbs and, of course, can be used

repeatedly. And by the late 1970s and 80s electronic flash technology had become miniaturized enough to build a flash right into a portable camera.

Flash units come in two basic forms: battery-powered portable flash units and large studio units, which are powered by household AC current. Most consumer cameras have portable flash units built right into them, and others have clip mechanisms known as *hotshoes* to which separate flash units can be attached. Such hotshoe flash units can be self-metering "autoflash" units or can be dedicated flash units, controlled by a flash metering system proprietary to the manufacturer of the camera.

The maximum usable distance range of a flash unit is often provided by the manufacturer as a somewhat subjective guide number (GN). This is the distance multiplied by the f-stop used by the lens, so the higher the GN the more powerful the flash. Guide numbers are in either feet or meters, and usually assume ISO 100.

The term "flash" can also refer to "flash memory" in the context of digital photography.

← *A battery-powered flash unit.*

Flash bracket

A portable metal bracket, often hinged at one end, upon which both a camera and *flash* unit can be fastened and carried as one unit.

Flash brackets are a popular tool for wedding and news photographers, and others who rely on battery-powered portable flash units. They serve three main functions.

First, they reduce shadows cast by the subjects since raising the flash unit makes shadows tend to fall behind the subject. Second, they move the flash unit away from the lens axis, thereby reducing the likelihood of *red-eye*. And third, they generally hinge or rotate, making it possible to leave the flash unit mounted above the camera in both portrait and landscape modes. Flash units mounted directly to the camera will always be on the side when shooting in portrait mode.

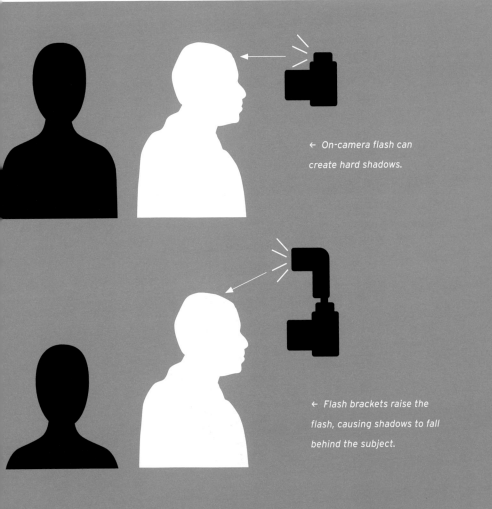

← On-camera flash can create hard shadows.

← Flash brackets raise the flash, causing shadows to fall behind the subject.

X-sync

The fastest *shutter speed* attainable with a *focal plane* shutter while employing *flash*.

Most modern *SLRs* contain focal plane shutters constructed of two separate moving sections known as "curtains." At slow shutter speeds the first curtain opens, exposing the *image area*, then the second curtain closes. But when a very brief shutter time is used, one of the curtains can be closing at the same time its counterpart is opening. The entire film surface or *image sensor* is not fully exposed to the light in such cases, instead, a narrow slit effectively travels across the image area.

This isn't a problem when a scene is lit by *continuous light*. But modern electronic flash units produce extremely brief pulses of light. If the shutter speed is too high and the shutter opening is reduced to a slit, then a flash-lit scene may not be exposed properly.

SLR cameras therefore generally have a top shutter speed that will work reliably with flash, known as X-sync. (Older cameras marked electronic flash connectors with the letter X). Older cameras often had an X-sync of 1/60 sec or so. Modern cameras typically vary from 1/90 sec to 1/250 sec and higher.

A flash-illuminated photo taken at a shutter speed higher than the camera's X-sync will result in partial flash coverage, as shown above right. However, this problem can only occur when using external flash units such as *studio flash*. Dedicated flash systems are programmed to know what a camera's X-sync value is, and are designed not to exceed it. This is why most cameras will not go higher than the X-sync when dedicated flash is enabled.

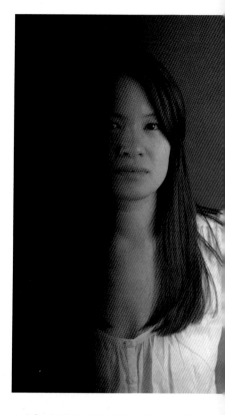

↑ *A flash photograph taken with a shutter speed that exceeds the X-sync flash synchronization limit of the focal-plane camera body. In this case the photo was taken at 1/250 sec, but the camera's X-sync is only 1/200 sec. The reason the area to the left is not completely black is because of ambient light in the room.*

Some cameras have a flash mode known as high-speed sync (HSS) or focal plane sync (FP mode) whereby the flash tube pulses during high-speed exposures. This reduces the output from the flash unit but permits the X-sync limit to be exceeded since the pulsed light simulates continuous light output.

TTL (through the lens)

Any form of *metering* which is done directly through the *taking lens* rather than through some sort of external sensor.

Most popular cameras today perform ambient light metering in this way. It's useful because the camera meters by viewing only that portion of the scene which will make up the final photograph. TTL metering is less likely to be fooled by, say, a bright object outside the frame.

Contemporary electronic *flash* systems typically work by metering through the lens, and variants of "TTL" are often incorporated in the marketing names. Common flash metering systems include Canon's E-TTL, Nikon's i-TTL, and Pentax's P-TTL. Such "dedicated" systems are proprietary to the manufacturer and are not compatible between brands.

Through-the-lens sensor built into the viewfinder housing.

TTL flash for film cameras records light bouncing off the surface of the film.

Slave flash

A *flash* unit which fires in response to an external command unit or when the firing of another flash unit is detected.

Slave flash units generally fall into one of two categories: simple optical and digital.

Optical slaves

Many electronic flash units contain small light sensors which can detect the firing of another flash. They thus sit idle until a master flash unit, which fires in synchronization with the camera, is set off. Such optical slaves can usually be triggered by *infrared*, so it's possible to use a master flash triggering system which outputs invisible infrared which does not record in the final picture. It is also possible to buy small optical slave sensors which can be attached to studio flash units via an external socket or to portable battery flash units via the *hotshoe*.

Optical slaves are an inexpensive way to fire multiple slave units together, but can be a liability in a public place. For example, a wedding photographer using an optical slave would probably find that it fires off in response to flash-equipped cameras used by wedding guests. Optical slaves also cannot really support any form of automated *metering*. They therefore require manual setup in advance except when using self-metering *autoflash* units.

↑ *A small light sensor which can be fastened to a flash unit's hotshoe. The optical sensor on the front detects when another flash fires and immediately triggers a slave flash to fire in turn*

Digital slaves

More sophisticated slave units can contain small computers which accept coded commands from a master flash unit. These slaves are controlled by pulses of infrared or radio waves. Since such slaves will only respond to digitally coded messages they will not fire inadvertently unless someone else happens to be using the same brand and code of unit nearby.

Digitally-controlled slave units can also support more advanced features, such as flash ratios, automated flash metering, *second-curtain synchronization*, and so on. Many popular *SLR* camera systems support wireless flash using proprietary systems of this type. However, since they are manufacturer-proprietary, digital slaves typically do not work with generic flash units or *studio flash* units.

← *A master transmitter which is attached to a camera's hotshoe. This device sends invisible infrared signals to slave units positioned around the scene. It can control two groups of slave flash units, and the brightness ratio between the two can be adjusted.*

Ring flash

An electronic *flash* unit equipped with a light-emitting tube which fits around the end of a lens in a complete circle.

Ring flash units provide a very direct form of lighting which seems to originate from the lens. They come in two basic types: small *macro* units and large studio units.

Small portable ring flash units are often used for macro photography. This is because the lens-mounted flash units can be positioned very close to the subject, which is important given the short working distances. They typically result in fairly flat and even lighting, though some allow for some shadowing by allowing the photographer to choose a ratio between one side of the ring and another.

In portraiture, large studio ring flash units offer a unique look popular with advertising and editorial photography. Ring flash results in a fairly flat cutout look to a subject. In particular any shadow cast by the subject will appear all the way around, like a kind of dark halo.

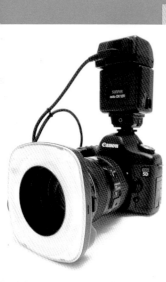

→ *The characteristic flat lighting and dark halo-like shadow caused by a ring flash.*

PC cord

A two-conductor coaxial plug and socket system used for carrying *flash synchronization* signals from cameras to flash units. Also known as a "sync cord."

PC cords have nothing to do with personal computers dating, as they do, from the 1950s. The name derives from Prontor/Compur, a popular in-lens *shutter* used with *view cameras*. For this reason PC sockets are also referred to as "German" connectors.

The system consists of a simple friction-fit plug and a 3mm socket used to trigger flash units, typically in *studio* situations. The voltage carried varies from flash unit to flash unit, and the cord carries flash sync signals only. No other information, such as flash metering or lens aperture, can be sent.

PC cables are notoriously unreliable despite their ubiquity. For this reason there are some variants on the basic design.

Some include tapered connectors and others include locking rings. Because the friction-fit sleeve of the PC plug itself is easily bent and damaged, resulting in unreliable connections, some makers sell "conditioning tools" which help reshape and tighten the plugs.

While PC sockets are very common on midrange to high-end cameras, not all *studio flash* units have PC sockets on them. Instead 3.5mm and ¼in audio connectors, of the type commonly used for headphones, are frequently used. Some studio flash manufacturers use their own proprietary plugs which are then used with cables with PC plugs on the end.

Because PC plugs are unreliable and long cables cumbersome, wireless flash triggers employing *infrared* or radio signals are popular in studio environments.

Popup flash

A normally concealed electronic *flash* unit built into a camera, which can be raised when required.

Most *SLR* cameras these days, except for those intended for professional photographers, contain small electronic flash units. These flash units are very low-powered, are vulnerable to *red-eye* owing to their proximity to the lens, and provide a fairly harsh direct form of lighting. However, they are very convenient for quick snapshots since they charge up almost instantly, are portable, and can never be lost.

Most SLRs store their internal flash heads at the top, by the pentaprism housing. The mechanisms vary. Some pop up automatically via motorized releases when activated, and some must be lifted by hand. Some even retract automatically when not required, though most need to be pushed down manually. Some also have extended flash arms to reduce the risk of red-eye very slightly.

Third party

A manufacturer which builds products designed for use with a camera system built by another company.

In a photographic context, the term typically refers to the maker of add-on accessories such as lenses and *flash* units. For example, a Tamron lens used on a Canon body or a Sigma flash unit used on a Nikon body would both be examples of third-party products.

If that's the third party, who are the other two? Generally, the maker of the camera system is considered to be the first party and the end user of the products (the customer or photographer) is the second party.

Gray market

A product which has been imported into a country or region by a company other than the official authorized distributor.

This practice is not technically illegal, but raises some issues. For example, the official distributor or importer often bears the cost of warranty repairs; not necessarily the parent company or manufacturer. Since the local importer isn't earning any income on products brought into the country by someone else, it may refuse to honor the warranty of another country or region. If the retailer also refuses to honor the warranty then the buyer may be stuck if the product fails. Some manufacturers may even refuse service on gray market products for a fee, irrespective of warranty.

Sometimes retailers will claim that gray market products are made to a cheaper technical specification than those officially imported. This is usually not the case with well-known brand names, but gray market products will definitely be localized for their market of origin. Power plugs may be designed for a different country's sockets, and manuals may be written in another language. For these reasons check carefully before buying a gray market (sometimes called "direct import") product.

The gray market exists because of currency exchange rates, local taxes, business costs for different regions, varying profit margins for local importers, and so on.

OEM

Original Equipment Manufacturer.

A somewhat confused term owing to its contradictory meanings, OEM refers generally to a situation in which one manufacturer produces a product which is rebranded and sold under a different manufacturer's brand name.

For example, a large chain store may sell an inexpensive camera under its store name. There have even been situations in which well-known camera makers have sold cameras and lenses built by other makers but sold under its name.

Traditionally OEM referred to the manufacturer which actually produced the product. More recently, the term has changed in meaning to refer to the company which resells the rebranded product. OEM can even refer to an unbranded or generic version of a product.

Loupe

A small handheld device, usually cylindrical or roughly cube-shaped with a flat base, and containing a magnifying lens or lenses.

Loupes are used for examining film and print samples, often with a lightbox. In effect, they're specialized magnifying glasses contained in convenient housings which keep the lens at the same distance from the film or paper surface.

Projector

A device which casts an enlarged image of a film *transparency* or digital photo onto a large surface such as a reflective screen or a wall, normally in low ambient lighting conditions.

In the case of a slide projector, a bright light is shone through the slide and a series of lenses. In the case of a digital projector, a light is shone through a transparent *LCD* (liquid crystal display) hooked up to a computer or other video output device.

In the 1970s and 80s rotary "carousel" slide projectors, which stored slides in a ring-shaped carrier, were popular for business and educational presentations. Sometimes two projectors were used, controlled by signals on an audiocassette, and some configurations even supported cross-fade effects. Today digital projectors are commonly used for business presentations.

← *A carousel slide projector.*

↓ *A digital video projector.*

Technique

General Technique

Flash Technique

Composition

The selection and arrangement of subjects or objects in a photograph or other visual work.

Many photographers advocate certain compositional guidelines, particularly to beginners. These are not rules to be followed blindly, but simply guidelines and tools that can be used when appropriate.

Another useful notion is to think of photography as a process of subtraction, not addition. With painting or drawing, an artist starts with a blank canvas and gradually adds information through the application of paint or ink or pencil lines. But with photography a photographer generally starts with a scene and then edits information out, through techniques such as in-camera cropping, selective *focus*, and *depth of field*, to emphasize the subject.

Simplification and ruthless editing

What appears an interesting scene to the eye may not work as a photograph. The mind simply ignores extraneous objects, but a photograph is a narrow two-dimensional slice of the world. Clutter rarely adds to the photograph: ruthless editing and selecting is recommended.

Lines and leading lines

The eye has a tendency to follow lines, and as such, lines in an image can help guide the viewer inward, toward, or through a subject.

Symmetry, asymmetry, and balance

Purely symmetrical images tend to have something of a static quality. Asymmetrical but balanced compositions can often be pleasing to the eye. See the *rule of thirds*.

Space

If simplifying an image to its raw subject can often lend power to that subject, so judicious use of space around it can concentrate viewer attention. The term "negative space" is often used to refer to empty areas.

Other directions

There are countless other aspects to creative composition that can be explored. Depth, shape, direction, size, patterns, perspective, texture, color, contrast, rhythm, proportion, convergence... all are theoretical concepts with direct practical applications to composition.

Rule of thirds

The compositional guideline that states that images generally have more visual impact when points of interest are positioned roughly one-third of the way in from the edge.

Novice photographers often tend to frame photographs such that the main subject of interest is situated right in the middle of the frame. This type of symmetrical framing may be beneficial for some subjects, such as classical Greek temples and the like. But for many subjects symmetrical composition can look static and lifeless. For this reason many photographers advocate for balanced but asymmetrical composition.

The rule of thirds divides the image into nine imaginary rectangles, and argues that the subject should be located at the intersection of one of these rectangles.

Like any so-called rule in an artistic field, the rule of thirds shouldn't be followed slavishly. But it can be a useful starting point for adding dynamism and visual tension to a picture. Note that the rule of thirds can also be thought of as a simplified form of the "golden spiral" or "golden ratio."

In summary, these guidelines aren't imbued with cabalistic powers, but are simply useful tools for creating attractive and interesting photos.

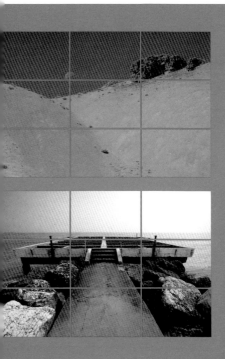

↑ These photographs, while quite different in subject matter and composition, nonetheless follow the rule of thirds quite closely. In both photos key subject items (the moon) or boundary lines (the top of the hill, the horizon) fall fairly closely to an imaginary grid drawn in thirds across the image.

↑ While claims that the golden spiral is a common natural feature are somewhat overstated, the rule of thirds can be seen as a kind of loose simplification of the concept. Here a Fibonacci logarithmic spiral, an approximation of the golden spiral, shows that the lamp is positioned roughly a third of the way down the image.

Focus and recompose

A technique whereby focus is locked on a subject, then the camera is moved to reframe the scene within the *viewfinder*.

Focus and recompose is commonly used with cameras which have either an *autofocus* point or manual focus assist aid which is centrally located in the viewfinder. When using such cameras it may be desirable to achieve focus using the available tool, but it may not be desirable to have the main point of focus be located in the middle of the frame. For example, portraits are rarely framed to have the eyes in the very middle.

While focus and recompose is a useful tool for *composition* it can introduce problems with multisegment computerized *metering* systems which bias the *exposure* to the currently selected focus point. If the camera is moved after focus is achieved, automated metering can be thrown off, particularly *flash metering*. For this reason it's generally best to select the nearest focus point in the case of cameras with multiple focus points, and not recompose the image.

Focus is locked.

Image is reframed, focus remains locked.

Selective focus

A technique for directing the viewer's eye to specific portions of an image by ensuring sharp focus on those areas.

When *depth of field* is narrow there is a great deal of creative potential in choosing areas of focus. This draws the viewer's attention to key sharp areas while causing other areas to fall away into a soft blur. It also allows for isolation of a subject from an uninteresting *background*, as is often the case with portraiture. Selective focus happens almost automatically with most *macro* photography, where the depth of field is usually razor thin.

Selective focus is not possible when there is great depth of field, such as with small lens apertures or very small *imaging areas*. Both of these factors are the case with most digital *point and shoot* cameras, which tend to keep everything in the scene in sharp focus.

In the images below a 50mm 1.8 lens was used on a *full-frame* (*35mm* sized) digital *SLR*. One shot emphasizes the subject's eyes whereas the other emphasizes the subject's hand on the violin's fingerboard. Which image is better depends really on the priorities of the photographer.

Selective focus is also possible when using lenses which cause blur for reasons other than depth of field. For example, a lens with tremendous spherical *aberration* around the edges may have a *sweet spot* at the middle of the lens. A photo taken with such a lens will be in focus at the center but not away from it.

↑ *Selective focus achieved by use of a tilt lens.*

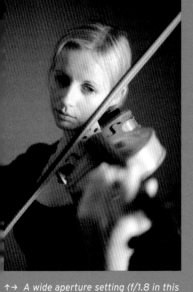

↑→ *A wide aperture setting (f/1.8 in this case) used to restrict depth of field to a narrow plane. This allows for selective focus to be employed.*

Metering

Determining correct *exposure* settings through the use of a light meter.

Light meters are electrical or electronic devices used to measure light levels or, in the case of color meters, *color temperature*. In the past, external handheld light meters were commonly used, but today such self-contained light meters are only used by professionals in certain situations. Instead most cameras contain light metering systems linked to automated computers, and calibrated to an average metering level of 12 to 18 percent, depending on the model. Light meters come in four basic types.

Reflected light meters

Reflected light meters measure the light reflecting back from a subject. They are available as separate handheld spot meter devices, and are also built into most automatic cameras sold today. Camera-internal light meters have different metering types or patterns.

- Averaging meters average the light measured across the entire *image area*. They are the simplest type but are easily fooled by high-contrast scenes. Many of these meters weight (give more importance to) the center of the scene.
- Spot meters take in a very small area of a scene, typically just 1 to 3 percent of the image area. They allow for great accuracy in selecting the area to be metered, but also require skill and experience to use reliably. Some advanced cameras allow the photographer to select multiple spot metering points.
- Partial meters take in a slightly larger area of a scene, typically 7 to 10 percent of the image area. They can be thought of as fat spot meters. They are less precise than spot meters, but generally easier to use. Some cameras tie the metering area to the focus point that's in use.

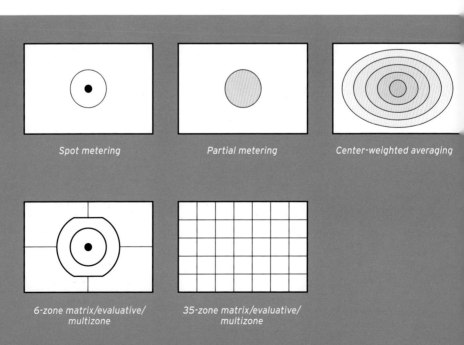

Spot metering *Partial metering* *Center-weighted averaging*

6-zone matrix/evaluative/
multizone

35-zone matrix/evaluative/
multizone

Matrix, multizone, or evaluative meters divide the scene up into a series of separate cells or zones. Each zone is metered independently, and then a computer program analyzes the overall pattern of bright and dark zones to determine a good exposure setting. Most automated and *digital cameras* use such meters today.

Since they are entirely computer-controlled, matrix meters afford few if any manual options, but are generally fairly accurate for most situations. The number of separate zones varies from model to model, ranging from five to thousands, but the sheer number of separate zones is not necessarily a guaranteed way of determining meter accuracy. Some advanced multizone meters also take color information into account, and many cameras link the currently active focus point to the metering.

Incident light meters

Incident or ambient light meters are the most common type of handheld meter, and generally have white domes which measure the ambient light that falls on the device. Since they measure the light falling on the subject they are not fooled by varying levels of reflectivity of the subject.

Flash meters

Flash meters are handheld ambient meters designed to measure the bright pulse of light from a flash unit, and are often used in professional *studio* situations. Many flash meters, such as the unit shown below, are combined incident/flash meters.

Color meter

A light meter that measures color temperature. These handheld devices were critical for commercial photographers who shot using film, as they are essential tools for determining color accuracy. They are less commonly used in the digital age.

Gray card

A flat surface which reflects a specific and calibrated percentage of the light which falls upon it.

Gray cards are used for two common functions: exposure *metering* and *white balance*.

Exposure

Cameras record reflected light and not the light which falls upon the surface of a subject directly (incident light). By using a gray card it's possible to record the amount of light bouncing back from a surface with known reflective properties. This allows the camera to meter correctly without it being misled by extremes of brightness or darkness.

By tradition most gray cards reflect 18 percent of the light which falls upon them. This corresponds to zone V in the *zone system*, though does not always match the assumed gray midpoint used by a camera's light meter. Gray cards are made of cardstock or textured plastic, since matte surfaces minimize the risk of spurious reflections. Some cards are divided into sections, such as white, black, or dark gray and medium gray areas.

White balance

Good quality gray cards are completely neutral, meaning they reflect all wavelengths of light equally and have no *color cast*. They can thus be used as a reference to determine correct *white balance* under complex or challenging mixed lighting conditions, or when a high level of color accuracy is required.

Most midrange and advanced *digital cameras* can set a custom white balance quite simply. A gray or white neutral card is positioned in front of the camera, filling the frame. A photo is taken, and the camera is instructed to set the white balance based on that image. Color balance can also be performed during *postprocessing* rather than in-camera. In this latter case the gray card does not need to fill the entire frame, as a sample of the image can be taken.

Bracketing

The process of taking multiple photographs of the same scene while varying one setting.

The term commonly refers to shooting a sequence of photos with different *exposure* settings. Bracketing is frequently used with slide or *infrared* film, since the narrow exposure latitude of these films can make it challenging to meter correctly. Bracketing is also used to produce a sequence of digital images of different brightnesses in order to assemble a *high dynamic range (HDR)* photograph.

Many cameras include autoexposure bracketing (AEB or ABC, for automatic bracketing control), which automates this process. Most shoot a sequence of three photos; typically one exposed normally, one underexposed by your specified number of stops, and one overexposed. The details vary, of course. Sometimes the order is under, normal, and over, and some cameras can produce an extended sequence containing more than three images.

The sequence below of three photos shows the same scene with three different exposure settings. The first is exposed under by one stop, the second is a normal exposure, and the third is exposed over by one stop.

It is also possible to bracket *focus* and *white balance* and other settings rather than exposure.

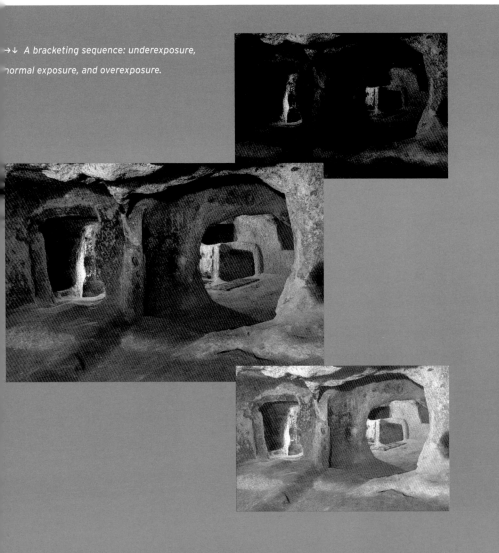

→↓ *A bracketing sequence: underexposure, normal exposure, and overexposure.*

Handholding rule

The reciprocal of the *focal length*; a rule of thumb for determining the slowest *shutter speed* that can be safely used when shooting a camera held by hand.

Also known as the camera shake rule, this rule is a simple way of determining the point at which blurring induced by camera motion relative to the subject is likely to become objectionable. To calculate it, take the current focal length and use that value as the denominator of a fraction with a numerator of 1. Thus a 90mm lens can be used safely with a shutter speed of 1/90 second or shorter. Many cameras with automatic camera shake warnings built-in follow this basic rule.

The basic take-home fact is that longer lenses require briefer *exposure* times to attain sharp images, since their reduced *field of view* essentially magnifies the effects of camera motion. Conversely it's possible to get away with longer exposure times when using a *wide-angle lens*.

This rule assumes a *35mm camera* with a nonimage-stabilized lens, and so must be adjusted by the *cropping factor* when used with *sub-frame* cameras. Note also that it is very much an approximate guide rather than a rule as such. The actual value varies depending on the sharpness that must be attained, on the steadiness of the photographer, and so on.

Multiple exposure

A series of images, superimposed one over the other in a semitransparent fashion.

With regular roll film cameras, multiple exposures are frames shot sequentially without advancing the film. Multiple exposures can be used to create the traditional Victorian ghost or "spirit" photograph, for example, which were taken by exposing the same glass plate more than once. A photographer takes a photo of an empty room and then gets someone to stand in the frame while a second shot is exposed; a double exposure. The result will be a normally exposed room with a spectral and transparent person seemingly standing in the same space.

Multiple exposures can also occur by mistake if film is reloaded into a camera more than once. Winding the film *leader* all the way back into the canister, in the case of *35mm* film, is a good way to avoid the risk of this happening.

Digital cameras can't take multiple exposures in this way, but some models simulate the effect in-camera by storing previous frames and then overlaying them in memory. However in-camera multiple exposures are considerably less flexible than the simple practice of layering (compositing) separate frames together in an image-editing program.

↑ *A Victorian-style "spirit" photo, consisting of a simple double-exposure to create the ghostly translucent effect.*

Sunny 16 rule

A simple rule of thumb for estimating correct daylight *exposure* settings without using a light meter.

The light reaching the Earth from the sun is, from a nonscientific point of view, fairly constant during daylight hours under clear skies. This fact can be used to make educated exposure setting guesses.

The sunny 16 rule states that, given a lens *aperture* of f/16, the *shutter speed* value should be the reciprocal of the ISO setting. For example, when using ISO 100, the aperture should be f/16 and the shutter speed should be 1/100 second. However, since most cameras don't have 1/100 as an option, the closest value should be used: probably 1/90 second.

This basic model can be adjusted for different aperture settings and, of course, will need to be adjusted for sunrise/sunset and different weather conditions such as cloudy days. But it makes a useful starting point for situations where no light meter is available. Since virtually all cameras sold today (except disposable film cameras and old-style *view cameras*) contain light meters, this rule is mostly useful for confirming light meter settings or for hobbyists with homemade cameras and the like.

Archival

Storage or printing technologies designed to resist the depredations of time.

The term "archival" is applied to various types of paper, printing materials, and storage media, and refers to qualities defined by the manufacturer. There is only broad consensus as to what a long time constitutes, and each manufacturer will publish data sheets for its products with extrapolated lifetimes based on its own internal testing methods.

For example, acid in paper will reduce its lifespan, causing it to turn yellow and brittle. Paper made from wood pulp typically contains lignin, a structural component of plant cell walls that has a detrimental effect on paper. Archival paper is often made from delignified wood pulp or cotton rag, has a fairly neutral pH balance, and may also contain some alkaline material, known as a buffer, to neutralize any acidic components.

Color imaging technology is another area where the need for archival materials is very apparent. Color slides and photographs taken in the 1960s and 70s, for example, are often very faded and discolored today. Massive color shifts caused by dye breakdown can turn an image magenta or green over a relatively short period of time. By comparison, a black-and-white photograph printed onto rag paper a century ago can look almost new, owing to the high stability of the materials used. The main artifact of aging of such photos is foxing, or small brown spots that appear on old papers.

Digital photography is also subject to archival issues. Regular ink-jet inks, for example, are frequently very vulnerable to the bleaching effects of light and *ultraviolet* energy, although archival fade-resistant inks are available. Ordinary writable CD and DVD discs are also susceptible to early failure, particularly those that use cyanine dyes and contain aluminum. Archival optical discs may contain gold or some other metal to avoid the oxidizing problem suffered by aluminum, use dyes such as phthalocyanine, metal-stabilized cyanine, and metal azo that are believed to be highly stable, have better environmental edge sealing, and may have tougher antiscratch coatings. Writable discs are also susceptible to moisture and light damage, and are best stored in cool, dry, and dark environments.

Catchlight

The *specular highlight* reflected from an eye.

The eye is probably the most important single point in just about every portrait. Ensuring correct *focus* of the eye is critical in most photography of people and animals. Getting that characteristic glint reflected back from a light source is also important to ensure a lively sparkle to the subject's eyes.

Flash is often used to create a catchlight. For example, wedding photographers may use flash units dialed down to intentionally low settings when shooting under even fairly bright ambient light conditions. They may also attach index cards to flash units pointing upward so that a tiny bit of light reflects forward while the bulk of the light goes upward. These techniques allow for a catchlight to appear in the eye, although the flash does not contribute much light to the final photograph.

Even nature photographers try to capture catchlights, often waiting until an animal turns its head to the right angle to get a natural catchlight. Sometimes flash is used for the same effect, perhaps with a Fresnel lens attachment to throw the light from the flash far enough to illuminate the animal's eyes.

Examination of catchlights is also a useful method for analyzing lighting techniques used in a given photograph. It may be possible to see the characteristic scalloped edge shape of an umbrella, for example, or the rectangle of a *softbox*. Sometimes photographers even put strips of black tape across their softboxes in a cross pattern so that the catchlight more closely resembles an actual window.

Chimping

Scrutinizing a *digital camera's* preview screen. Once upon a time, in the years BC (before computers) people would wander off after taking a photo. Today, in the years AD (after digital) people tend to stand rooted to the spot, gazing at the screen on their digital camera, after taking a photo. This universal practice is known as "chimping."

Chimping is generally mocked or frowned upon by professional photographers, many of whom started their careers in the days before digital cameras and their preview screens. However, it's clear that the ability to examine a shot or check its *histogram* immediately after shooting is one of the powerful advantages of digital photography.

Golden hour

The daylight periods close to sunrise and sunset, which frequently offer ideal conditions for many types of photography.

When the sun is close to the horizon its light has to travel a much greater distance through the Earth's atmosphere than when it's higher in the sky. The atmosphere is full of gases and dust which absorb a lot of the blues in sunlight, resulting in a yellow and eventually red color to the sun. The effect tends to be more pronounced in the evening, because a day's worth of dust has been kicked up into the air.

This is a favorite time for many photographers. The light is yellower (warmer in color, though lower in *color temperature*), which is often very flattering to human, natural, and architectural subjects. And since the sun is lower, shadows tend to be longer.

↑ *While the golden hues of sunset are not visible in this monochrome image, the long shadows cast by the setting sun are quite apparent.*

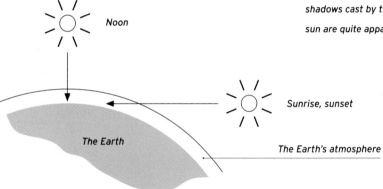

Noon

The Earth

Sunrise, sunset

The Earth's atmosphere

Hail Mary shot

A picture taken by a photographer with the camera held high above his or her head.

In the case of a digital compact camera with a fold-out vari-angle screen it may be possible to see the shot being taken, but in the case of an *SLR*, a "Hail Mary" is essentially taken blind.

The term arose in photojournalist circles, by analogy to sports slang. In American football a "Hail Mary" pass is one made in desperation with little chance of succeeding.

Motion blur

Blurring in an image, caused by motion of the subject relative to the camera during the *exposure* time.

To illustrate the cause of motion blur, tap a pencil onto a piece of a paper. The result is a single black dot on the page. However, if the pencil is held down for a longer period of time and either pencil or paper are moved, the result is a long line or ovoid. The same thing occurs during longer photographic exposures.

Motion blur comes in three basic types, all of which can mar a photo. These are subject motion, camera motion relative to the subject, and internal camera vibration.

Subject motion

In this case, the camera is stationary but the subject is moving, resulting in a sharp *background* but a blurry subject. This cannot be remedied by a tripod or *image stabilizing*, but by higher *shutter speeds*, *flash* (a brief pulse of light arrests motion), or asking the subject to slow down.

Camera motion

The camera is moving relative to the scene, perhaps because the camera is handheld and not on a tripod, or perhaps is being used on a moving vehicle. As a result the entire scene will be blurry. The problem is acute with long *focal lengths*, and can be minimized through use of tripods or image-stabilized lenses.

Internal camera vibration

The camera mechanism itself can also induce blur. Mirror slap (see *mirror lockup*) falls into this category.

Intentional motion blur

Motion blur can be induced deliberately to achieve a visual effect. Photos of fast-moving subjects may be exposed in such a fashion that blurring occurs in order to convey a sense of motion (see *panning*).

↓ *An example of deliberate subject motion. The camera was static while the model turned her head over a 4-second exposure.*

Panning

Tracking an object in motion for the duration of a photographic *exposure*. Turning a camera in order to track a moving object during an exposure does two things. First, it tends to keep the object itself relatively sharp, even at lower *shutter speeds*, since the object stays relatively constant in size and position in the frame. And second, it tends to blur the *background*, helping provide a sense of motion and dynamism to the photo. Sports photos are often taken while panning to track an athlete or moving vehicle.

↓ *By turning the camera to track the motion of the horse a relatively sharp image of the horse and rider is obtained, but the background becomes a blur of streaks. While not a realistic depiction of the subject, the panning shot creates a sense of motion and drama. Exposure time is about 1/10 second.*

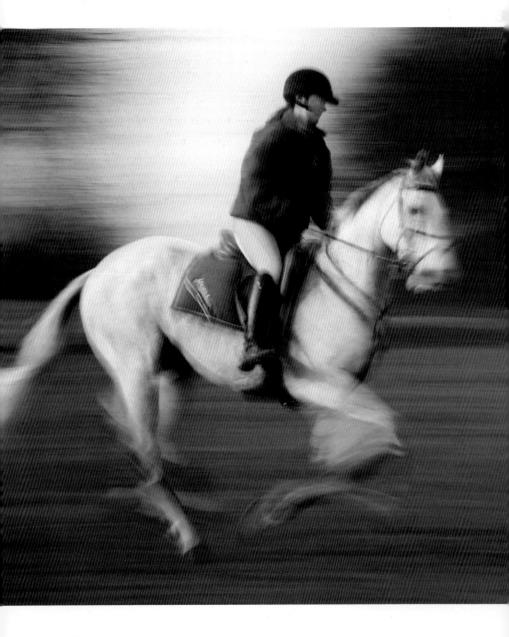

Postprocessing

Any work performed on an image outside of the camera.

A range of effects can be performed on an image in-camera. For example, different filters can be attached to the lens, different film types can be selected, or different *digital camera* settings used.

However, there are still many things that can be done to an image once the *shutter* button has been pressed. This is the realm of postprocessing, and varies depending on whether the image is film-based or digital.

Black and white

There are many different ways an image can be modified in the world of traditional *black-and-white photography*. Different processing methods can be used on the exposed film, affecting such characteristics as the *contrast* or *grain* of the image. Hollywood photographers of the 1930s and 40s would even physically retouch the glass plate negatives used to shoot movie stars of the day. Once film has been developed, a catalog of tools is available at the enlarging stage. It is very common for images to be dodged and burned and masked when enlarging a print by hand. Finally, different techniques are available during print processing which affect the final photo, such as changing development times.

Color film photography

Since color film processing is usually done with automated machines there is less scope for postprocessing work. Negatives are typically processed according to a standard formula, though they can be *cross processed* or pushed/pulled if required. Most automated machines support a good deal of global image alteration during the printing stage. Contrast, brightness, and color balance settings can all be altered. However, it is usually not possible to perform any localized alterations such as dodging and burning when making a machine print. This requires manual enlargement.

Digital photography

Digital photography offers unlimited potential for image alteration in post. Since digital photos are simply collections of numbers, all kinds of software tools are available to alter the images at will. This ranges from simple changes of brightness, contrast, and color balance in a traditional photographic sense, to complete alteration of the whole image.

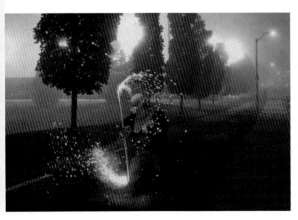

← *Two photos composited together in postprocessing.*

Soft focus

An image taken with correct *focus* but with softening or diffusing of the image; usually caused by spherical *aberration* of the lens or by diffusing *filters*.

The key point is that soft focus is not the same thing as out of focus. Rather, the image has a deliberate softening and reduction in local *contrast*. The effect is often used in portraiture, either to impart a dreamy or ethereal feeling, or to conceal the wrinkles of an older subject. The light glow from a soft focus image can also be used to lend a sense of timelessness to a photo.

The earliest camera lenses produced fairly soft images, particularly toward the edges and when larger *apertures* were used, because of tremendous amounts of uncorrected spherical aberration. Some modern camera lenses can be set to deliberately introduce spherical aberration simply by rotating a ring, and so can go from sharp to soft in an instant. Or a regular lens can be used, with a nylon stocking, petroleum jelly, or a special soft focus diffusion filter put over the end. The photo shown below was taken using a lens with deliberate spherical aberration toward the edges.

Soft focus can also be simulated digitally. There have even been film cameras which introduced a kind of automatic soft focus effect by taking two consecutive *exposures* without advancing the film, and defocusing the lens slightly on the second exposure.

Soft focus raises heated opinions. While it's still commonly used for wedding, boudoir, and romantic portrait photography, many photographers deride the effect as clichéd kitsch.

Specular highlight

A sharply defined reflection of a light source, which appears on a surface. Specular highlights are extremely noticeable on highly reflective objects when using light sources which are small relative to the object. In other words, a shiny object with *hard lighting* will result in very bright specular highlights.

Catchlights in eyes are essentially specular highlights reflecting from the surface of the eyeball.

Specular highlights can be an issue in portraiture as well. A photograph of a person with shiny skin (a bald man or a person who has been sweating, for example) will often have specular highlights. The effect is particularly noticeable with dark skinned subjects since the relative brightness between highlight and skin is greater than with light skinned subjects.

Since shiny spots on a person's face are generally considered undesirable, various means are used to control them. Applying makeup is one solution, as is ensuring that the model does not have an excessively sweaty or oily face. Using a large light source such as a *softbox* is another approach, since large light sources result in less obvious highlights. Consider the portrait below.

The picture was illuminated by two light sources, one to each side of the subject. The light source to camera right was a large softbox, but the light source to camera left was an undiffused bare bulb flash located further from the model. This difference in light type is very apparent in the difference in skin texture. Consider the crops.

The image to the left is from the side of the model illuminated by bare flash, and the high *contrast* reflections off the slightly shiny surface of the skin are highly apparent. By contrast, the image to the right shows how the softbox has resulted in smoother skin textures.

Bounce flash

A method of softening flash-originating light by reflecting it off a large surface, such as a wall or ceiling.

Light which originates from a battery-powered portable flash unit tends to be fairly harsh and high-contrast in nature. This *hard light* occurs because the light source is quite small relative to the subject. *Soft light* sources are generally large relative to the subject.

So, if the flash unit has a head that can be tilted or rotated independently of its body, bounce flash is a technique of reflecting or "bouncing" the light off a nearby large surface.

Bounce flash can be very effective, but has some drawbacks. First, the wall or ceiling must be white or cream colored to avoid the risk of *color casts* being

↑ *A flash unit with a built-in pull-out bounce card.*

introduced. A black wall would not be reflective enough and a red one would cast a reddish light over the scene. Second, by spreading the light over a larger area and lengthening the distance from light source to subject, the amount of light illuminating the subject will be greatly reduced. Small flash units may not be suitable for bounce flash for this reason. Third, light which originates mainly from the ceiling may result in dark shadows appearing under people's eyes.

Photographers often use a small "bounce card" to cast some light directly forward to help reduce this effect. This may be built into the flash unit or may be an index card held on with a rubber band.

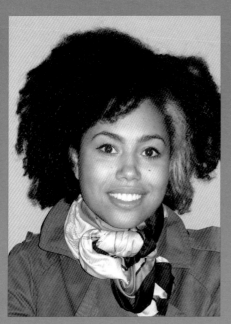

↑ *Direct flash is harsh and flat.*

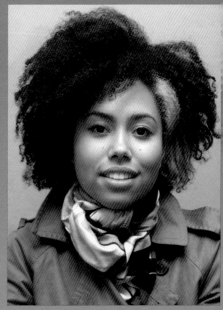

↑ *Flash bounced off the ceiling is softer and more flattering.*

Flash metering

Automated technologies used to meter and control the output of an electronic flash unit.

Exposing for ambient light involves control over both *aperture* and *shutter speed*. However, flash duration is extremely brief and thus not affected by shutter speed in most cases. It is also too brief for the human eye to measure. Accordingly, flash metering must be handled independently of ordinary ambient light metering. A number of different metering techniques have been developed over the years.

Manual flash metering

The simplest approach is to meter entirely manually. Each flash unit's output is set by hand, and correct metering is determined by use of a handheld flash meter and Polaroid test shots or, in the case of digital, examining a preview screen. This is the traditional approach for *studio flash* units, which rarely support automatic metering.

Autoflash metering

Many battery-powered portable flash units have self-contained flash metering. These "autoflash" units rely on small optical sensors that sense the amount of flash-originated light reflecting back from the scene. Since the duration of the flash pulse determines the total light output, the units turn off or "quench" the flash tube when the output is deemed to be adequate, using a switching device known as a thyristor.

Since autoflash units do their flash metering completely independently, they can be used on any camera: the only thing they require from the camera is a flash trigger signal for synchronization purposes.

Off-the-film through-the-lens metering

Many film cameras contain metering systems which record light passing directly through the *taking lens*. These *through-the-lens* or *"TTL"* metering systems can accurately meter from the actual portion of the scene that is being recorded and are not fooled by highly reflective objects located outside the frame. TTL flash metering systems sense the flash-originating light which reflects off the surface of the film itself during the course of the exposure, quenching the flash tube when appropriate. TTL flash metering is manufacturer-proprietary.

Preflash through-the-lens metering

Modern *digital cameras*, and some film-based cameras, use their ambient light sensors for flash metering as well. When a photo is taken, the camera instructs the flash unit to emit a low-power pulse of light of known intensity. The camera records the light reflecting back from this pulse, then sets the duration of the actual subject-illuminating flash accordingly. Preflash systems are manufacturer-proprietary.

Flash synchronization

Firing a *flash* unit in time with a camera's *shutter*, such that light from the flash properly exposes the film or *image sensor*.

Flash synchronization is automatic with the vast majority of cameras. Once the shutter is fully open a flash switch is triggered. This switch fires any internal or external flash unit in perfect synchrony.

If the flash unit were to be triggered by the camera's *shutter release* button, for example, then it would not synchronize properly since the flash would probably fire before the shutter is fully open. And synchronizing a flash unit by hand would be very difficult if a short shutter time is required.

There are different types of flash synchronization.

Open flash

Firing a flash in the dark with the shutter simply held wide open is the crudest way to time a flash firing with shutter opening. Prior to the development of flash sync technology, open flash was the only way to use flash lighting. Today open flash is primarily used for special effects photography, such as *high-speed photography* or cave photography.

M-sync

Old film cameras may have connectors labeled "M-sync" which were used for firing flash bulbs. Such bulbs took a split second to ramp up the light output as they burned. Accordingly the M-sync mode would fire the flash a fraction of a second before opening the shutter to allow the bulb to reach its maximum brightness.

X-sync

Electronic flash units produce light almost instantaneously, and thus no wait time is required. In *X-sync* mode the camera will fire the flash immediately after opening the shutter. Note that *focal plane* shutters cannot synchronize with flash at all speeds. There is an upper speed limit, also known as X-sync.

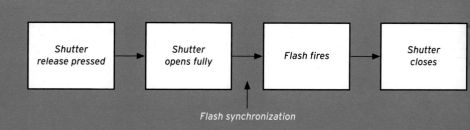

Shutter release pressed → Shutter opens fully → Flash fires → Shutter closes

Flash synchronization

Slow shutter sync

A photographic technique which uses a slow *shutter speed* in combination with *flash*.

A photo taken without flash under low ambient lighting conditions requires long *exposure* times. This results in blurred images in common social shooting situations, such as wedding receptions. A similar photo taken with flash can result in a "black hole" effect whereby the flash-illuminated subject is properly exposed but the *background* is too dark to register.

Image A was taken with an automatic camera, which illuminated the *foreground* with flash. In an attempt to achieve a handholdable shutter speed, it locked the shutter to 1/60 second at f/4. The result is a disappointing dark background.

One solution to this problem is to use a longer shutter time. Image B has an exposure of 1 second. The background now shows up well, but the subject is not illuminated well and the long exposure has resulted in blurring. The blur is caused both by camera motion (a tripod was not used but *image stabilizing* was) and the subject motion of passing vehicles. Image C combines flash with a slow shutter speed. The result is a good balance between the flash-lit subject and the ambient-lit background; in effect a double exposure on a single frame between the flash and the ambient light. This technique is known as "dragging the shutter" or "slow sync" and is normally used with *second curtain sync* flash. "Night" *icon* mode often uses this method.

Slow sync can result in a mixture of sharp (flash-lit) and blurred (ambient-lit) areas. This effect is often used deliberately to lend a sense of motion or dynamism to photos of wedding dances and rock concerts. In image D the *focal length* of a *zoom lens* was changed during the duration of the exposure, creating a hyperspace effect.

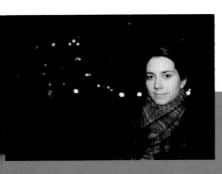

A

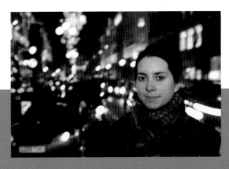

C

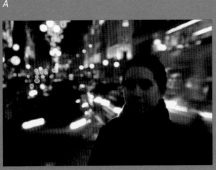

B

D

Second/rear curtain sync

Firing a *flash* immediately prior to the *shutter* closing, rather than upon the shutter opening.

Normally flash is fired as soon as both curtains (sections) of a *focal plane* shutter are fully open. The problem with this approach, known as first curtain or front curtain sync, is that motion trails may seem to project in front of the flash-illuminated subject when it is used in *slow shutter sync* mode.

In this first photo the flash fired, the model walked across the frame, and the candles exposed the digital *image sensor* as she moved. The result is a strange photo which looks like she was walking backwards.

The second photo uses second or rear curtain sync, whereby the flash was triggered just before the shutter closed. Thus the candle flames imaged first, then the flash fired, resulting in more realistic motion trails.

The main drawback to second/rear curtain sync is that it is more difficult to time the firing of the flash correctly. Also, less advanced cameras and flash units may not support the function.

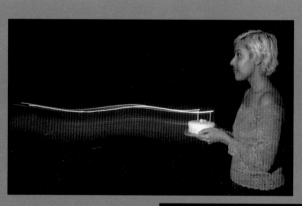

← *First-curtain*

↓ *Second-curtain*

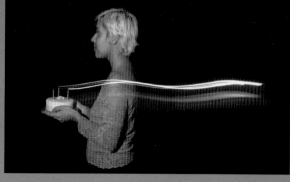

Red-eye

The glowing red-eye effect commonly seen in casual snapshot photography. Red-eye is not the result of supernatural forces but of the simple geometry of light. It is caused by light bouncing off the internal surface of the eye and reflecting back to the camera. It occurs when three main factors come together.

First, the likelihood of red-eye is greatest when the eye's pupil is large. This is why snapshots taken under low ambient lighting conditions (restaurants, parties, etc.) are likely to have red-eye.

Second, the light reflecting back from the eye's interior must be very bright relative to ambient lighting. *Flash photography as a light source fills this requirement neatly.*

Finally, the light entering the eye must originate as closely as possible to the center of the lens. An ordinary ceiling light isn't going to be a problem even if it were bright enough. But most small cameras have flash units built into the body of the camera. The light from the flash can thus bounce right off the interior of the eye back into the lens.

The effect is red in humans because the eye is lined with blood vessels. But some animals, such as cats, dogs, and deer, have blue or green reflections because their eyes contain an additional reflective layer. This structure, known as the tapetum lucidum, helps the animals see in low-light conditions.

Flash and lens almost on same axis: red-eye is likely.

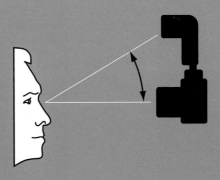

A larger angle between flash and lens lowers the chance of red-eye.

Red-eye reduction

Techniques to reduce or eliminate *red-eye* from occurring. There are a number of ways of eliminating this problem.

First, turn on a few lights. Anything to cause the subject's pupils to contract can help. Some cameras produce a bright white light or fire an unpleasant series of flash bursts in an attempt to make this happen, but this tends to result in rather stunned looking subjects.

Second, don't use *flash*. Red-eye won't happen with ambient lighting.

Third, move the flash as far away from the lens as possible. If the camera has a separate flash unit then swivel or tilt its head so that the light from the flash bounces off the wall or ceiling. Wedding and news photographers often mount a flash unit on a *flash bracket*, in part to reduce red-eye.

If these three methods aren't possible then it may be necessary to resort to some less graceful ways of eliminating red-eye. Most image-editing software has a red-eye removal function which paints out red-eye or eliminates the red color. And black pens are available to color over red-eye in a final print.

Stroboscopic

A lighting system which produces a rapid sequence of pulsed bursts of light.

Note one source of confusion. In North America, ordinary *flash* units are often called "strobes," particularly large flash units used in *studio* settings. Stroboscopy, however, refers to photography in which a series of photos is taken on a single frame of film or single digital exposure, normally using an electronic flash unit which is capable of firing multiple shots per second. Stroboscopic photographs can capture multiple views of a moving subject, making them ideal for motion studies. They are traditionally taken in dark spaces with the stroboscopic light the sole source of illumination. Some flash units are capable of stroboscopic effects, and the effects lights used for parties and nightclubs can also be used, albeit with less control.

↓ *A photograph taken in darkness with a flash unit strobing six times to capture the full motion of the aikido throw.*

Creative and Advanced

Three- and four-point lighting

A traditional form of portrait lighting involving three or four lights.

The most common form of lighting used for ordinary portraiture, cinematography, video interviews, and the like is three-point lighting. Very simply this technique uses three separate light sources to illuminate the subject. A classic example is shown on the left.

Here the three model-illuminating light sources are the *key light* to camera right, the *fill light* to camera left, and, in this case, a *hair light* above the model. Often the third light is a more general backlight rather than just a hair light. A fourth light was also used to illuminate the background for additional separation.

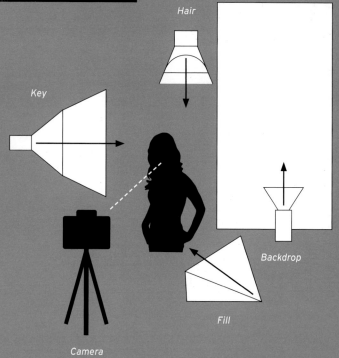

While sometimes dismissed as unimaginative "school yearbook" lighting, the technique is so popular because it offers solid and repeatable results, and forms the basis for more complex or visually unusual forms of lighting. The technique may seem artificial and unnatural since, after all, light in nature normally originates from one source (the sun) only. But nonetheless three-point lighting provides certain visual cues that we rely on when examining a portrait. The photo below was taken using three-point lighting. The back light was positioned to camera left.

High-key lighting

A lighting technique where the bulk of the image consists of brighter tones.

High-key photographs generally cast a cheerful or sunny mood. The lighting is bright, the *background* is often pure white, and shadows are typically avoided.

The effect is easily achieved by lighting a set with *soft lights* balanced equally from the sides (i.e.: *fill* and *key lights* produce the same or almost the same amount of light). Additional lights are often used on the background itself to achieve a bright effect.

Low-key lighting

A lighting technique which emphasizes the form and shape of shadows and which does not aim to fully illuminate the subject.

Typically a low-key lighting setup involves a dark *background* and lights which only partly illuminate the subject. There may be *key* from one side but little or no *fill*, for example. Shadows are pronounced and high *contrast*. Backgrounds are dark or only partially illuminated. The effect can be moody, foreboding, and mysterious.

Key light

The primary light source used to illuminate a subject.

Studio photography frequently involves a number of different light sources shining on a subject, but there is usually one main light source. In traditional *three- and four-point lighting* setups this key light is normally positioned at an angle to the subject in order to provide some dimensionality to the image.

In the photo on the right a key light in a *softbox* is positioned to the model's left (the camera's right). Very little light falls on the right side of the model's face.

Fill light

A light source, the second in a three-light studio setup, which is used to fill in darker areas and lighten shadows.

The fill light acts as a secondary light to the *key*. It lowers the *contrast* range of the image and reduces shadowing.

The photo on the right demonstrates the effect of the fill light alone. While in this example the fill is provided by a small *softbox* to the left of the camera, it could just as easily be a *reflector*. In fact, portable studio setups may well employ a folding reflector to serve as a fill source rather than dedicating an actual light to the job.

Hair light

A studio light positioned above a subject's head to illuminate the hair.

A common problem when shooting darker-haired subjects against dark *backgrounds* is that of the hair vanishing because of the loss of *contrast*. One way around the problem is to use a light background, but of course that may not be suitable for a *low-key* image.

Another technique to resolve the problem is to position a small light over the subject's head, usually from the same angle as the *key lighting*, to illuminate just the hair. *Light stands* with boom arms are often used for this purpose. The glow of the hair light provides a separation between the hair and backdrop. Tightly controlled light sources, such as lights with barn doors, *grids*, or snoots, are commonly used to reduce the amount of spill landing elsewhere on the subject.

While seemingly subtle, the light does outline the subject. Hair lights can also be used to provide a sense of dimensionality to the photograph, regardless of the background brightness. Traditional professional portrait photographers frequently use such lights, except for on bald subjects, for whom it would produce a lot of glare. Rim lighting and *backlighting* are also used for this purpose.

← *Though subtle, the hair light clearly helps delineate the model's dark hair from the background.*

Background light

A light in a studio setting positioned to illuminate a background or backdrop. To provide some additional separation between the model's hair and the dark background in the example below, the backdrop itself was illuminated by a small flash unit situated close to floor level. In order to provide a kind of glowing effect behind the model's head a snoot was used to restrict the light on the backdrop to the center.

In addition, the light was aimed more to camera left, the slightly shadowed side of the model's face, to provide additional modeling and depth.

Background lighting is common enough that specific accessories are made for the purpose. Very short *light stands* are available, to allow the positioning of lighting close to the floor, and scoop-shaped *reflectors* are also made, to create more of an oval patch of light on the backdrop.

→ Shining some light on a backdrop is one way to add a little more depth and dimensionality to a portrait.

Short lighting and broad lighting

Portrait-lighting techniques which appear to emphasize or minimize the breadth of the subject's face.

Both lighting techniques assume that the subject's face is turned slightly in profile rather than facing the camera directly. They also assume that the *key light* is brighter than the *fill*.

Short lighting

Short or narrow lighting involves using the key light to illuminate the side of the subject's face that is turned away from the camera. It tends to throw much of the near side of the face into shadow. It also tends to give a narrowing effect to the face, which can be useful if the subject has a rounder face and the desire is to deemphasize that fact. *Rembrandt lighting* is a form of short lighting.

Broad lighting

The opposite of short lighting: the key light illuminates the side of the face that is closer to the camera. This tends to make faces slightly wider, and tends to illuminate most of the surface of the face.

Butterfly lighting

A *high-key* portrait lighting technique in which the *key light* is positioned in front of, and slightly above, the subject's face.

Butterfly lighting, so called because of the shape of the shadow under the subject's nose, is a classic lighting technique that was commonly used for women in the so-called golden days of the big Hollywood studios. For that reason it is sometimes also called "glamour" or "Paramount" lighting.

Butterfly lighting typically uses a *fill light* or *reflector* positioned below the camera to prevent the appearance of dark shadows appearing on the face. This method is often not used on men because its symmetrical top-down lighting tends to highlight the ears.

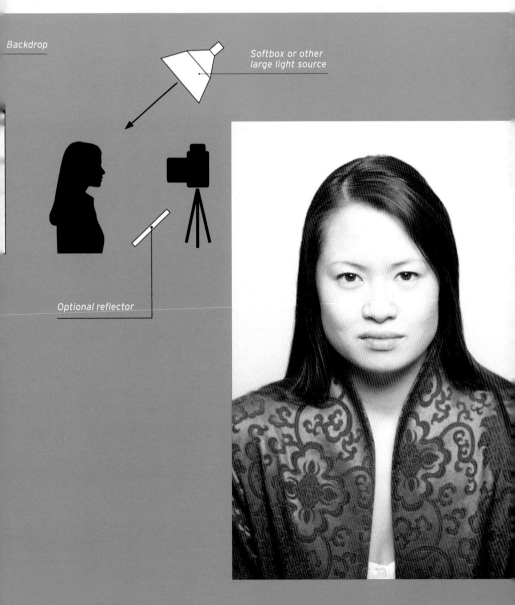

Backdrop

Softbox or other large light source

Optional reflector

Chiaroscuro

An artistic technique, derived from drawing and painting, which employs contrasts between light and dark to suggest dimensionality to a two-dimensional image.

In photography the term generally implies more of an emphasis on dramatic *low-key lighting* involving strong contrasts. It can be seen as the opposite of flat lighting, which tries to avoid shadows. In fact, careful use of shadows is employed to convey depth to the subject.

The term derives from the Italian for "clear" and "dark," and originates in painting and other prephotographic forms of visual art. Extremely dramatic chiaroscuro effects, used by painters such as Caravaggio, became known as "tenebrism."

Edge lighting

Backlighting which outlines a subject.

When employing *low-key lighting* a subject's clothing or hair can appear to vanish into the *background* if both are fairly dark. By projecting lighting from behind, the edges can appear outlined, thereby providing some separation between the subject and the background.

Sometimes the effect occurs naturally outside, particularly at sunset or sunrise, when the position of the sun can illuminate a subject at low angles.

→ *The model has been lit by two softboxes, one positioned to either side. This allows for an edge-lit silhouette effect, while providing enough light to illuminate his face. The low-key result is intended to convey a sense of mystery.*

Hard light

Ηigh-contrast lighting. Light which is projected from a very small light source, relative to the subject, casts sharply defined shadows. There is thus a high level of *contrast* between illuminated and nonilluminated areas. Hard light such as this can be unflattering to a human subject. *Specular highlights* tend to be revealed, as do slight imperfections in the skin. Nonetheless, hard light can be used effectively for dramatic or theatrical images.

Light from a battery-powered portable *flash* unit tends to be harsh and high contrast in this fashion, since flash heads are typically very small. One of the first techniques to improve the quality of flash-illuminated pictures is to enlarge this area. Adding an attachment to a flash head to spread the light can help a little. Bouncing the light off a wall, so that the surface reflecting onto the subject is quite large, is an effective technique.

Soft light

Low-contrast light from a large light source, relative to the subject, which casts soft-edged shadows.

Soft light is generally a more flattering form of light for portraiture than *hard light*. With soft light, human skin appears smoother and apparent textures are decreased. For that reason, large *light modifiers* are frequently used for portraits. These can be umbrellas, large fabric *softboxes*, and so on. Anything which spreads light across a larger area relative to the subject can work well.

Such light modifiers can be very large indeed. For example, cars are often photographed in studios using vast softboxes larger than the vehicle. Note that "relative to the subject" is a key point. A huge softbox, positioned a long way away from the subject, will suddenly become a small source of light relative to the subject.

↓ *A photograph taken with relatively soft lighting.*

Rembrandt lighting

A studio portrait lighting technique named for the artist who frequently employed it in his paintings. Seventeenth-century Dutch painter Rembrandt van Rijr is said to have painted his subjects as they sat in a studio illuminated by light from a north-facing window. The traditional hallmark of Rembrandt lighting is the appearance of a triangle of light on the subject's cheek, pointing downward from the eye. It is a form of *short lighting*, where the side of the face away from the camera is illuminated. The other side is left in partial shadow, creating a *chiaroscuro*-effect of dimensionality.

The technique involves positioning a *key light* at a 45-degree angle to the sitter, slightly above the face. A *reflector* or *fill light* may be used on the opposite side if desired.

↓ *The dramatic look of Rembrandt lighting. Note the characteristic triangle of light on the model's left cheek (camera right).*

Studio

At its simplest, a facility for taking photographs under controlled conditions.

The concept of a studio can vary in scope, from a simple room with the necessary equipment to take photographs, to a complete facility containing one or more such spaces, processing facilities, and offices to manage a business operation.

Most studios are generally windowless rooms with neutral walls and high ceilings to accommodate lights and backdrop equipment. Portrait studios require enough floor space to achieve a proper working distance from the subject, and may be equipped with ceiling tracks so that lights can be lowered and moved at will.

Backdrops or backcloths, often on adjustable rollers, are commonly used. They may be made of large rolls of seamless paper or various types of fabric, such as velvet or muslin. Commercial studios for set or product photography may require large cyclorama curtains or curved coving walls for photographing large objects such as cars. They may also have makeup and dressing facilities for models.

In the past, studios sometimes contained *darkroom* facilities. Today they are more likely to contain computer equipment for a *digital workflow*, since much *postprocessing* work is done internally rather than being farmed out to a lab.

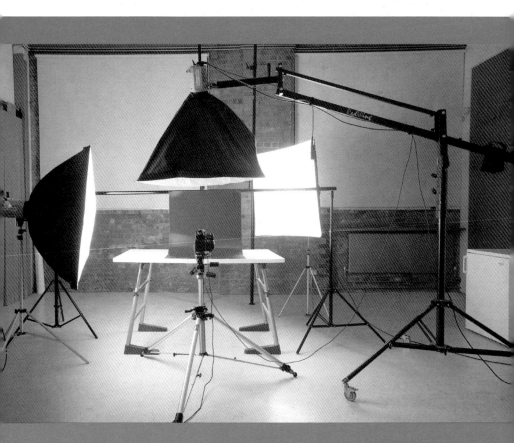

↑ *A professional photographic studio being used for a still-life product shoot. Three softboxes are being used, one of which is suspended from an overhead boom.*

Continuous lighting

An artificial light source which appears to produce steady and constant lighting to the human eye rather than a *flash*.

Tungsten incandescent

Ordinary incandescent bulbs are what most people think of as light bulbs: rounded glass shells containing slender wires of tungsten metal. Electricity passes through the wires, heating them until they glow.

While inexpensive, tungsten bulbs pose four basic problems for photography. First, although tungsten appears white to the human eye, it actually has a yellow-orange cast (a lower *color temperature*) compared to daylight. This causes color balance problems, and requires color-compensating *filters*, special film emulsions, or digital *white balance* adjustments. Second, tungsten bulbs generate a lot of heat. They are thus called "hot lamps" in studio parlance, owing to their tendency to cause models to wilt and sets to overheat. Third, tungsten lamps consume a lot of electricity because so much is wasted as heat. In fact, they are banned in some areas because of their huge energy consumption. Finally, they are difficult to control since many *light modifiers* can't cope with high heat. Incandescents also drop radically in color temperature if dimmed.

Photoflood

Photofloods are simply regular tungsten bulbs which operate at high temperatures. They produce a slightly bluer light than ordinary tungsten, at the cost of significantly reduced useful lifespan. Some photofloods have light blue coatings to shift their color temperature slightly to the cool end of the spectrum. Because of their low cost they are popular with amateur photographers, particularly digital users who can easily change white balance settings, but they have the same heat and power drawbacks of ordinary incandescents.

Quartz halogen

Another incandescent variant, halogen lamps also drive tungsten at very high temperatures. However, halogen gases inside the bulbs extend the life of the filament. Although halogen light is a bit whiter than normal tungsten, it still has a yellow cast.

Halogen work lights on stands are readily available from home improvement stores, and are popular light sources for amateurs. However, halogens carry an increased risk of fire owing to their tremendous heat output. In fact, the bulbs run so hot that quartz is used in place of ordinary glass.

Fluorescent

Fluorescent lamps range from long harsh office tube lights to compact bulbs which simulate tungsten. The lamps contain mercury vapors which produce *ultraviolet* energy when electricity flows through them, and their interior surfaces are coated with a phosphorescent material which glows white when exposed to UV energy. Since fluorescent bulbs do not incandesce they generate less heat than tungsten bulbs, and are therefore much more energy efficient.

Banks of fluorescents, often adapted from film and video applications, are sometimes used in studios. Such photographic applications require daylight-balanced tubes, since standard office tubes lend a sickly greenish cast. Fluorescent technology is also used in lightboxes and the backlights of many *LCD* screens.

HMI

Hydragyrum (an archaic word for "mercury") medium arc-length iodide lights are high-intensity bulbs used for professional cinematography and videography. HMI lamps produce near daylight-balanced light with less waste heat than tungsten lighting, but are also very expensive. The bulbs operate at high temperatures and can shatter dangerously if mishandled.

Gas discharge

This type of lighting includes mercury vapor lamps and sodium vapor lamps. These are the high output bulbs used in street lighting, industrial applications, sports arenas, gymnasiums, and so on. Such lamps, especially orange sodium vapor, do not produce a continuous spectrum of light but have spikes at certain points, resulting in strange color casts. This, combined with their harshness, makes them challenging lights to photograph under. The *color casts* make them particularly difficult for film photographers, since it's not possible to compensate for their white balance through use of filters. Digital photographers have an easier time of adjusting images in a computer to correct for the color casts.

LEDs

Light emitting diodes are small electronic components which produce light but little heat. White LEDs are sometimes used as flash in small *camera phones* and also the backlights of some LCD screens, though they tend to have a bluish cast.

Studio flash

High-powered *flash* unit, powered by wall current or a large battery pack, typically used in *studio* situations.

Small battery-powered flash units are always limited in power and flexibility, since they are built primarily with portability in mind. Studio photographers, by contrast, are not so concerned with portability. Instead raw power output and control over the characteristics of light are more important.

Most studio flash units have small circular xenon-filled flash tubes surrounding an incandescent modeling light. They come in two basic designs: pack and head, and monolights.

Pack and head

Large studio lights tend to have large floor-mounted power supplies, sometimes known as "packs" or "generators." These are linked to small flash heads by heavy cables. The advantage of the pack and head design is that the output of multiple flash heads can be controlled from one location. For example, to adjust the ratio between heads one and two the photographer need only adjust a knob or slider or two on the pack. Some high-end systems are quite sophisticated, and include USB interfaces to personal computers.

↑ *The back end of a monolight, showing the various controls. This unit has a built-in optical slave (the white dome in the upper right corner) and can also be used with two types of sync cables. The modeling light can be at full brightness or can be proportional to the output of the flash, which is set by the vertical slider. The device also has a standard IEC power socket for an AC cable.*

Monolights/monoblocs

Monolights or monoblocs are independent stand-alone AC-powered flash units. Each monolight contains a flash tube and all necessary circuitry to make it work, housed in a heavy metal or plastic shell.

Monolights are generally fairly affordable, but adjusting *light ratios* between multiple flash units involves walking over and adjusting each one separately. Monolights also tend to be more top-heavy than pack and head lights, since more weight is positioned at the top of each light stand.

Speedrings

Most studio flash units have a circular mounting ring at the business end to which *light modifiers* can be added. These may be simple dish-shaped *reflectors* for use with umbrellas, may be multiple-layer diffusing *softboxes*, and so on. Generally the speedrings for one brand's lights are not compatible with those made by another firm, except when a company has deliberately adopted another's design.

↑ *A large pack which can power up to three flash heads.*

Studio lighting equipment

Artificial lighting, mainly used in a controlled *studio* setting.

The primary advantage of photography in a studio is control over the finished image, and studio lighting is key to reproducible photographic work. All manner of electrically-powered lighting equipment is available to give the studio photographer total control over the scene. The equipment generally falls into one of two categories: *flash* or *continuous*.

Such equipment is most easily used in a studio environment, but of course can be used elsewhere. For example, equipment optimized for portability, such as battery-powered flash gear, is commonly used for location shoots. Nonetheless, the common denominator for studio lighting in the modern studio is reliance on domestic AC power.

↑ *The front end of a typical monolight, showing the removable "spill-kill" reflector, the circular flash tube, and the cylindrical modeling lamp. The small hole to the bottom of the dish can accommodate the shaft of an umbrella.*

Lighting ratio

The ratio of lighting intensity between two light sources.

The term is most commonly used in *studio* situations, where multiple artificial light sources are commonly used, and usually in the context of the difference in brightness between *key* and *fill*.

If the key and fill lights have the same brightness, then they will have a ratio of 1:1. A ratio of 2:1 means that the key is twice as bright, or one stop over, the fill. A ratio of 4:1 means that the key is four times as bright, or two stops over, the fill. Ratios are most easily determined with a light meter, particularly in the case of flash.

Light stand

A stand, usually telescoping, designed to support lighting equipment.

Studio lighting gear, whether *flash* or hot lamps, typically needs to be at or above eye level in a *studio* environment. Light stands are simple telescoping stands, often vertical aluminum poles with three fold-out legs, designed to hold such equipment. They differ from tripods in that rock-steady stability is less of an issue, and so the leg sections tend to be attached close to the base of the pole. Such a design would be inappropriate for tripods as the upper unsupported pole sections tend to sway somewhat. Heavier duty stands with rotating legs, rather than fold-out legs, are known as "C-stands" or "Century" stands.

Most light stands have ⅝in mounting studs at the top, to which lighting equipment is clamped. Some stands also have ¼in or ⅜in threaded posts to which cameras, portable *flash* units, and other devices can be attached if desired. Light stands are often painted black to reduce reflections, and professional stands are usually air-cushioned. Air-cushioning slows the movement of the telescoping tubes through a simple system of internal pistons, thereby preventing delicate lamps from slamming down vertically if the clamps which hold the tubes are released inadvertently.

Some light stands have additional poles or arms which can extend horizontally. These arms, known as booms, are commonly used for supporting *hair lights* over a model's head, or indeed any application where light needs to be directed downward. The light stand shown below left has a boom with a weighted sandbag to counterbalance a flash unit and *softbox* being used as a hair light. Such sandbags are also used to weigh down light stand legs to reduce the risk of a tall stand toppling over, particularly when working outdoors.

As noted, light stands are not ideally suited as camera supports owing to their lower stability. However, they are available in a wide range of heights and can be used as an impromptu tripod, particularly when a fair vertical reach is required.

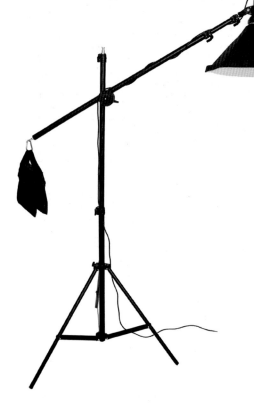

Light barriers

A variety of devices used to control light and prevent unwanted spill.

Snoot

A conical attachment, often stepped rather than smooth sided, which narrows down light to a soft-edged beam.

Barn doors

Adjustable metal flaps, either two or four, which attach to a light. The traditional old-school Hollywood or stage light devices.

Flag

A flat square or rectangular panel on a movable or bendy arm, used to control spill and reflections for specific small areas. Flags are also used to prevent *lens flare* by blocking direct light from the surface of the lens.

Gobo

Probably taking its name from "go-between," a metal or glass plate which fits inside a lamp assembly. The plate has a pattern cut into it so that the light, often a hot spotlight, projects light in the shape of that pattern. Detailed gobos can be produced which project words, images, corporate logos, or even moving shapes such as the hands of a clock, onto a surface.

Cookie

From "cucoloris," a sheet of flat material with holes cut in it. This device is positioned in front of a lamp so that specific shadows are cast. For example, a cookie may be cut out with holes resembling leaves or branches. When put in front of a spotlight the appearance of shadows from a leafy glade is created. Cookies are often used for casting textured light on a background in a theatrical fashion.

Light modifiers

A variety of light-modifying devices which are used to diffuse the light produced by a light source. They are typically add-on attachments.

Umbrella

The folding umbrella is a classic light-modifying tool, providing a wide coverage of light. At its simplest, it is a white fabric umbrella which folds down conveniently for storage. When in use its shaft is inserted into a fixture in the lighting head. Light bounces off the umbrella and reflects back to the subject (i.e.: the light source is pointed away from the subject). Umbrellas commonly use silver, gold, white, and translucent fabrics for different effects. Brollies are inexpensive and convenient, but can result in a lot of spill light scattering around uncontrollably.

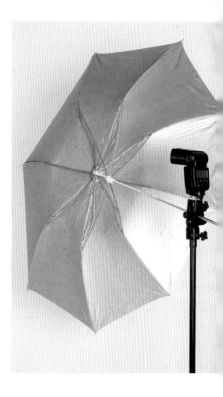

↑ *A wireless battery-powered flash unit with collapsible umbrella and light stand. A highly portable combination used by photojournalists and hobbyists alike.*

Beauty dish

A circular metal or plastic dish with a central *reflector*. The light is mounted at the base of the dish, and points outward. Light reflects off the central reflector onto the large dish, then reflects outward again from the dish. The result is evenly spread light, often with a "wraparound" effect if used close to the subject. Sometimes a fabric diffuser is stretched across the diameter of the dish.

Light bank

A combination of an umbrella and a *softbox*. These modifiers are often octagonal in shape for near-circular *catchlights*, and feature a *flash* head which shoots away from the subject. The light strikes the internal surface of the fabric bank and reflects back out past layers of diffusing fabric like a softbox. The banks are carefully designed to offer virtually no light falloff across the surface of the diffusing material.

Diffusion screen

A large translucent fabric screen, stretched out on a frame, used to diffuse light shone through it. Such screens are often used in conjunction with large hot lamps in filmmaking and videography.

Modeling light

A *continuous light* positioned alongside a *flash* tube for the purposes of previsualizing lighting arrangements.

One of the more difficult aspects of flash photography is understanding where light and shadows will fall in the final image. Flash photography involves extremely brief pulses of light that human brains cannot really interpret and analyze.

For this reason most *studio flash* units contain incandescent light bulbs to serve as a preview. These modeling lights are typically small tungsten or halogen bulbs located within the circular ring of the flash tube itself. They don't produce enough light to affect the scene significantly, but produce enough to help determine relative lighting placement for multiple light setups.

Some flash units switch off the modeling lamps while the flash unit is recharging and unavailable for use, thereby serving as a visual indication that the flash isn't ready to fire yet. This also reduces the electrical load of the unit. Some units also have an option whereby the modeling light "tracks" the output of the flash proportionately. In other words, as the output setting for the flash tube is decreased, the modeling light will decrease in brightness accordingly. This can be useful for comparing output ratios when using multiple flash units of the same output. (Obviously it's of limited utility between flash units or if the modeling lamps have different wattages.)

The main problem with modeling lights is that the heat they generate can be a problem for some *light modifiers*, particularly enclosed fabric devices such as *softboxes*. They also don't show what the scene will look like exactly: for that, test shots are needed.

Battery-powered flash units do not have modeling lights, but some simulate them through modeling flash, which is simply a steady pulsed output of light.

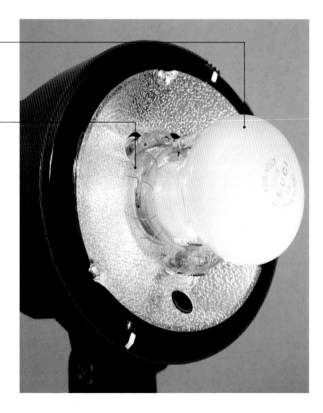

Modeling light

Flash tube

Softbox

A collapsible *lighting modifier* designed to spread light from a lamp or a *flash* unit across a large surface area.

Softboxes are typically rectangular or octagonal in shape, and have internal reflective surfaces and diffusers to ensure that the light produced is smooth and even across the whole light-producing surface. Many contain secondary internal baffles to further smooth the light, at the cost of reduced output. They are usually constructed of fabric, held together by an internal metal frame.

By enlarging the area of the light relative to the subject, softboxes help produce very soft-edge shadows. This type of lighting is usually considered fairly flattering to a human subject.

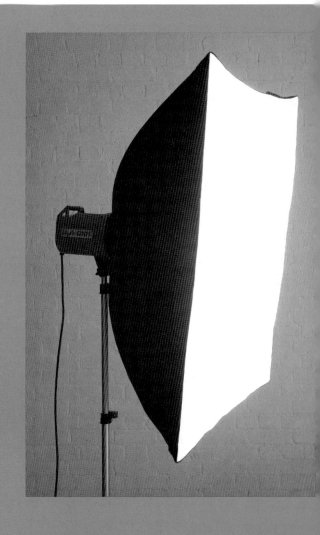

Reflector

In varying contexts, a device used to reflect light.

A reflector is quite simply anything reflective. It may be a metal frame with white fabric stretched across it, it may be a collapsible circular frame equipped with silver or gold metallic fabric surfaces, it may be a piece of white foamcore. Anything which reflects light can be used. Large mirrored surfaces are typically avoided in favor of smooth surfaces which provide softer light, but tiny dental mirrors are often used to reflect light for jewelry and wristwatch product shoots.

Reflectors are useful tools for altering patterns of light and filling in shadows. In many cases, such as *fill lighting*, a reflector can be used in place of an actual light source.

↑ *A versatile reflector: a collapsible fabric disc with a number of different fabric types (translucent white, opaque black, metallic silver, metallic gold) which can be zipped in as required.*

Grid

A raised grid, attached to a light fixture, which reduces off-axis spill.

One of the difficulties with control over lighting, particularly large *soft light* producing devices, is that of direction. Many fixtures, such as umbrellas, tend to send light outward in a wide angle. This can be a problem if a backdrop receives more illumination than it should or if stray light striking a lens causes flare.

One way of reducing these problems is to attach a grid to the fixture. This is a simple frame which blocks light spilling from the sides and lends a directional quality to the light.

Grids can be made of various types of material, usually stitched fabric or metal. Larger grids are often known as "egg crate grids." When the light-blocking barriers run in only one direction they are normally referred to as "louvers." The narrower the grid the narrower the beam, and grids are sometimes specified in terms of their beam angle: perhaps 40 degrees or 50 degrees.

→ While seemingly crude looking, this collapsible fabric grid is nonetheless quite effective. Attached to the front of the softbox with velcro strips, the grid reduces the amount of spill. This particular strip light also has a recessed front panel, reducing spill still further.

↓ This clip-on metal "honeycomb grid" is used to restrict the spill from a spotlight or flash unit with reflector.

Light tent

An enclosure, typically made of translucent fabric stretched over a frame, used for photographing objects.

It is often desirable for product and advertising photography to show an object in isolation. An advert, for example, might show an item against a pure white field to emphasize the product, free of clutter. Light tents allow for such simple and smooth lighting, particularly for reflective objects.

Below, an inexpensive light tent is used to photograph a teapot and cup. Since the items being photographed are so reflective, the tent could also be fully enclosed by installing a fabric panel to avoid reflections from the front. This panel would have a small slit in it to admit the camera lens. The panel is removed in this example to show the setup.

Such light tents are ideal for photographing objects to be sold on auction sites, and the like. They are often conveniently collapsible, folding down to round packages the size of a large dinner plate. Since color balance can easily be compensated for by *digital cameras*, they can also be used with ordinary tungsten lighting, as shown here.

Lens movements

ovement of the lens independently of the camera body.

Most cameras sold today have lenses which are fixed relative to the body. It's only possible to adjust the *focal length* and the focusing, even if the lens can be detached from the body.

This is not the case with cameras which link body to lens with a flexible fabric or leather accordion-like bellows. Such cameras often offer complex lens and body movements, allowing a variety of effects to be achieved. These movements are known as shifting (or rising/falling) and tilting.

Some special-purpose lenses exist which support lens movements on rigid bodied cameras. These may support shift, tilt, or both. The lens shown below is quite complex, and has no fewer than five concentric rotating rings. From top to bottom these are *focus*, *aperture*, shift (up to 10mm), tilt (up to 8 degrees), and detented rotate.

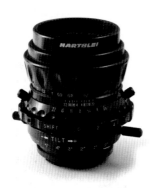

↑ *A Lensbaby 3G, an unusual lens consisting of a series of lens elements attached to a flexible plastic hose. This allows the lens to tilt in any arbitrary direction. The threaded metal posts allow the lens to be locked into position.*

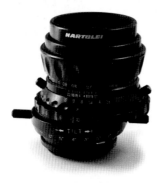

← *An extremely flexible lens capable of tilt, shift, and rotate movements. This shot demonstrates how the lens can be shifted across by up to 10mm.*

Lens movements: shifting (perspective correction)

Movement of a lens in a plane such that its optical axis (center) no longer coincides with the center of the *image area*.

Most lenses project an *image circle* which is centered over the film or *image sensor* area. The coverage area of this circle is designed to cover the imaging area and no more. Shift lenses, however, have large image circles which cover much larger areas, allowing for the image area to be moved within the image circle by shifting the lens itself. This allows for useful *perspective* correction effects.

A common photographic problem with architecture is that of the falling building effect. When a camera is pointed up at a tall building, the resulting photo often looks like the building is falling backward. Rectangles become trapezoids; an effect known as converging parallels. This is because of the simple geometry of perspective—the lens is closer to the base of the building than the top of the building.

The ideal way to solve this problem is to move the camera to a higher position so that the distances between base and top are equidistant to the lens, but this is obviously not always possible. Another solution is to step further away from the building so that the relative differences in distance are less. Such a photo, when cropped, can have a building with parallel sides. Another approach, when making traditional photographic prints, is to tilt the photographic paper relative to the *enlarger*. Still another approach is to warp the image digitally.

The perspective problem can also be solved optically by using a shift lens to move the image area within the image circle. This is why shift-capable lenses are often known as "perspective correction" or "PC" lenses.

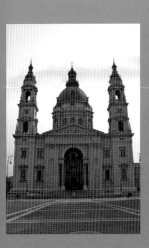
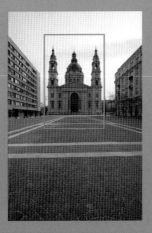
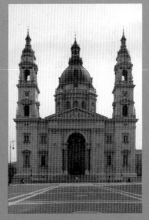

↑ A photo taken with a regular 35mm lens. Keystoning is apparent.

↑ If the photo is taken with an extremely wide (17mm in this case) lens and kept level with the horizon, the building no longer appears to be falling back. But now the ground dominates the image.

↑ This 17mm photo could be cropped to yield a building with correct perspective. A shift (PC) lens can be used to create a similar result without cropping.

Lens movements: tilting

Altering the angle of the lens plane relative to the imaging plane.

Most cameras maintain precisely parallel planes between the film or *image sensor* and the lens, simply because the lens barrel is fixed in place. But when a camera supports lens movements then these planes can be tilted at angles relative to each other and to the subject plane, to useful photographic effect. This phenomenon relies on the "Scheimpflug" (pronounced SHIME-fluke) principle, named for Theodor Scheimpflug, who described it in 1904.

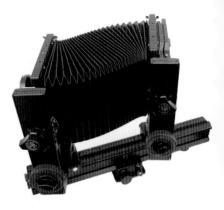

↑ *The rather extreme tilt motions of which a view camera can be capable. The front and rear standards are nearly parallel in this case, but do not have to be.*

Lens tilting is commonly used for two purposes. First, tilt lenses can be used for vastly expanding the apparent *depth of field* of an image without stopping down. This is popular for nature photographers, who can tilt a lens such that a *foreground* flower can be just as sharp as a distant mountain range.

Second, tilting the lens results in interesting and dramatic bands of sharp *focus* to cut across an image. This can be used for striking portraiture, and it can also be used to take photos of scenes that look like tiny models. Somehow the eye is fooled by the effect, such that a tilt image of a real city street suddenly looks like a photo of a model train layout.

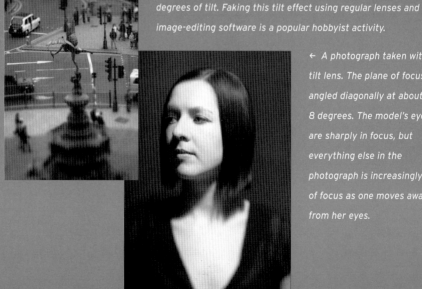

← *A "model world" shot taken with a lens capable of up to 8 degrees of tilt. Faking this tilt effect using regular lenses and image-editing software is a popular hobbyist activity.*

← *A photograph taken with a tilt lens. The plane of focus is angled diagonally at about 8 degrees. The model's eyes are sharply in focus, but everything else in the photograph is increasingly out of focus as one moves away from her eyes.*

Retouching

Alteration of an image after the photo has been taken. Retouching can mean different things, but generally applies to localized alteration of an image rather than general changes to the whole picture, such as changing brightness or *contrast*. It also implies more elaborate changes than simply dodging or burning, (brightening or darkening an image) but removal of blemishes or actual editorial alterations.

In the days of film, retouching was a complex process which could be used to remove the blemishes from the face of a Hollywood star or remove an unwanted political figure after the latest purge. It may have involved retouching the negative itself—common in the case of large glass plate negatives—or of a print, which would then be rephotographed. The process was essentially a painting process, though in some cases negatives were also scraped. Advertising photographs were routinely airbrushed for decades to minimize flaws.

With the rise of digital, retouching took on an entirely new life. It is now possible to make sweeping alterations to a photograph quite easily using an image-editing program.

↑→ *Cosmetic retouching*

Panoramic

Photographic techniques used to capture wide *fields of view*.

For centuries large paintings have been used to simulate the experience of viewing a scene. For example, in the nineteenth century it was a popular fad to construct large circular rooms containing painted dioramas for an immersive experience. Photographically, various techniques have been invented to create panoramic images.

↑ *A swing-lens camera.*

Wide-angle lenses

The simplest approach is to use a *wide-angle lens* to capture a large area of a scene. Such pictures may be cropped at the top and bottom to create a wide *aspect ratio*.

Segmented panoramas

Another technique is to take multiple shots of a scene, rotating the camera between each shot. The finished prints are then lined up in a row. This simple and inexpensive technique has the drawback of gaps and lines appearing between each image.

Rotating lenses

Some rare film cameras use a moderately wide lens which physically rotates during an exposure. *35mm* swing cameras, for example, may capture a frame 24mm tall by 60mm wide, rather than 36mm wide. This requires special manual printing of images, as most commercial minilabs cannot cope with unusual frame sizes.

The rotation mechanism must be extremely precise, since any speed variation will cause *banding* to occur. As the photo is not captured at a single instant, any moving objects will record as strange elongated shapes.

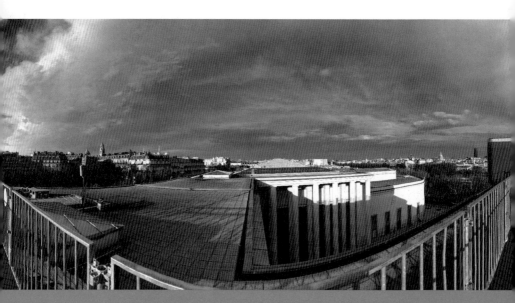

↑ *A full 360 degree panorama using separate exposures taken at 10 degree increments. This is actually an HDR (high dynamic range) pano, and so three shots were taken for each of the 36 positions. 108 photos were thus seamlessly blended together to form the final picture.*

asked (fake panoramas)

Some consumer film cameras simulate a panoramic effect by installing masks which simply alter the aspect ratio of the finished picture. Such fake panoramas do not increase the width of the visible scene. In fact, since they just crop off the top and bottom of the image, *image quality* ends up decreasing. *APS* "P" mode operates in this fashion.

Digital stitching

The most common way to achieve panoramic effects today is to shoot a series of separate digital images and combine the frames later in a computer. Such pictures are similar to segmented panos, but good software can smooth and hide the seams. Some cameras have a "stitch" mode to simplify the process of lining up images by showing a ghost image of the previous shot on the preview screen.

If the camera is not rotated around the lens entrance pupil (usually near where the aperture diaphragm is located) then *parallax* error will occur. This prevents the segments from lining up correctly; a particular problem when photographing straight lines, such as buildings or fences.

Complex immersive digital environments can also be made from multiple stitched rows or from spherical projections. Panos can be animated on-screen for a "virtual reality" effect, and linked clickable nodes can let the viewer jump from location to location. Software can also be used to "unwrap" *fisheye* photos into flat panoramas.

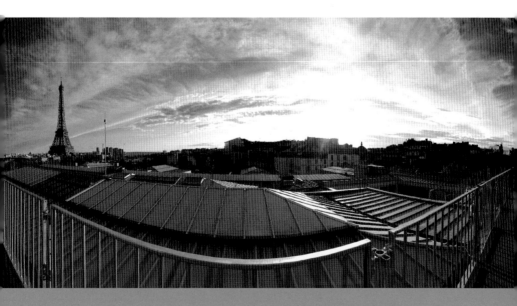

Aerial photography

Photographs taken from an airborne vehicle or aircraft.

From the earliest days of photography people have sought unique airborne perspectives by taking cameras up into the sky. As early as 1858 French photographer Nadar was taking aerial photos of Paris from a hot air balloon. Today all kinds of aircraft are used for photographing the ground from above, as well as photographing other aircraft. Aerial photography is used for mapping, environmental surveys, art, advertising, and of course, espionage.

Balloons

Hot air balloons are still a very good platform for aerial photography. They move slowly, reach interesting altitudes, and are fully open to the air, so window reflections are not a problem. However they only drift where the wind carries them, are vulnerable to weather conditions, and are generally limited to areas away from buildings unless they're tethered to the ground.

↓ *A balloon seen from a balloon.*

Airplanes

The majority of professional aerial photographs are taken from small single-engine aircraft. Planes such as Cessnas with high wing mounts are popular, since the chance of a shot being blocked by a wing is lower. Many photographers fly in craft with the doors removed to avoid window reflections, though this of course does make shooting windy and cold. To minimize blurring caused by engine vibration, gyroscopic mounts or *image-stabilizing* systems are often employed.

It is also possible to take photographs from commercial jet aircraft, though they fly at extremely high altitudes and thus small details can be difficult to discern. The photo below was taken from an airliner flying over the Swiss Alps. It has the classic blurring and *distortion* caused by the airplane's scratched plastic windows.

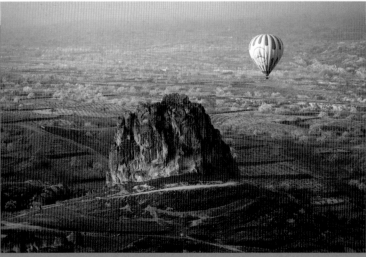

Helicopters

Helicopters are often used for aerial shots, since they are very versatile craft. Shortly after the photograph on the right was taken, for example, the helicopter landed inside the volcano's crater; something that would be impossible with a plane. Helicopters are expensive to rent, however.

Model aircraft

Small model planes carrying cameras, controlled from the ground by radios, are popular for low-level aerial photography in residential areas where full-size craft may not fly. Such devices are sometimes used for real estate and commercial photography.

Kite aerial photography (KAP)

Aerial photographs taken using cameras suspended from kite lines.

Kite-borne cameras were occasionally used in Victorian times for aerial pictures, but the development of powered aircraft soon relegated kite photography to the history books. In the 1990s, however, the development of lightweight portable cameras and affordable radio control systems meant the rediscovery of this photographic technique, this time as an engrossing hobby. Large kites with sufficient lifting power to carry a camera rig are used. The camera rig hangs down from the kite line and not the kite itself. Computer-controlled radios are used to tilt and fire the cameras remotely, and sometimes even video transmitters are used to send live *viewfinder* previews.

Unlike ordinary aerial photographs, which tend to result in fairly abstract views of the world below, kites fly at relatively low altitudes. The result is a bird's eye view of the world; higher than a ladder and lower than a plane. The technique has even been used by researchers documenting landscapes.

While engaging, KAP does have its drawbacks. Kites require steady wind conditions to operate, and adequate clearance from buildings and trees is also needed.

↑ *A homemade radio-controlled kite camera rig.*

Astrophotography

Photography of celestial bodies.
Photographing the sky involves
a number of unique challenges. Celestial
objects are extremely tiny when seen from
the ground, are mostly extremely dim (with
two notable exceptions), and move
continuously across the sky.

The moon

The moon is the easiest celestial object to
photograph. Its light, reflected from the
sun, is recorded easily by a camera, and it
is a relatively large object in the sky. Even
so, it takes an extremely long lens to have
the moon come even close to filling the
frame. In fact, it's quite disappointing how
tiny the moon looks in a photograph with
an ordinary lens, even though it may look
spectacularly large to the naked eye.

The best way to photograph the moon
itself is to attach a telescope directly to an
SLR camera in lieu of a lens, a technique
known as "prime focus." Most decent
telescopes have optional T-mount lens
adapters available for this purpose.

↑ *A telescope with a fully computerized
automated mount.*

↓ *Lunar eclipses are quite frequent and provide
excellent opportunities to combine the moon
with foreground interest. This photograph was
taken with a 300mm lens on a 35mm camera.*

Acceptable results can also be achieved by simply holding a camera to a telescope's viewfinder, a technique known as "afocal" photography.

The sun

The sun is very challenging to photograph because it's so bright. In fact, gazing at the sun through an unshielded camera viewfinder or telescope is a surefire way to suffer immediate and permanent eye damage. Special solar filters must be used for any solar observation or photography; simple welder's goggles are not safe enough. Alternatively, one can project an image of the sun onto a sheet of paper using a telescope or pair of binoculars.

Stars and other objects

The most difficult celestial objects to photograph—stars, planets, galaxies, and nebulae—are of course enormous but appear miniscule when viewed from Earth. The traditional approach taken by amateur astrophotographers has involved all-manual film-based cameras in *bulb mode*, attached directly to motorized telescopes. These motorized "equatorial mounts" are capable of tracking apparent stellar motion caused by the rotation of the Earth. Without such mounts stars would record as curved arcs rather than bright points.

Since the law of *reciprocity* fails badly at the extremely long (often multiple hour) *exposures* required for *night photography*, some dedicated photographers bake films in small ovens filled with hydrogen/nitrogen gas, a process known as "gas hypersensitization" or "hypering," to improve film sensitivity.

Digital photography has brought a different set of demands. *Noise* can be a problem, and so some astrophotographers take multiple shots in sequence and composite them together ("stacking") to average out the noise. More modern *digital cameras* have greatly improved *noise reduction* which make longer exposures possible.

↑ *Total solar eclipse taken with an effective focal length of 670mm on a 35mm camera.*

High dynamic range (HDR)

Techniques for expanding the brightness range in a photograph.

One of the drawbacks of most *digital cameras* is that their dynamic range or brightness range, which is the maximum difference between a bright area and a dark area, is not very wide. By contrast, human vision is capable of detecting a very wide range of brightnesses, since our eyes can adjust automatically to different light levels.

This means that it is often rather difficult to take a photograph of a scene with a wide *contrast* range. An outdoor photograph containing both sky and ground is a typical example. Either the sky is correctly exposed and the ground is too dark, or the sky is overexposed and blown out and the ground is correctly exposed.

Compounding the problem is the fact that highly overexposed areas of a digital camera will record no detail whatsoever—they will be pure white.

The traditional approach to the dynamic range problem has been to use a graduated neutral density filter. This works where there is a clear delineation between light and dark, as with a shot of a sunset over an ocean, for example. But GNDs cannot be used where there are complex patterns of light and dark areas.

Another approach to the problem, until such time that camera makers solve the issue through improved *image sensors*, is to shoot multiple shots of the same scene. These photographs can then be composited together digitally. Areas correctly exposed for bright spots can

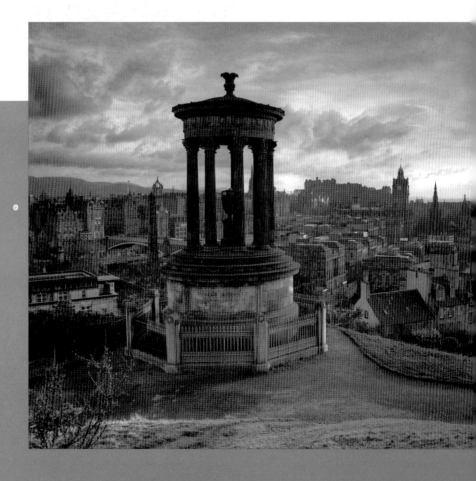

e used in one section and areas exposed or dark in another. The result is a single image with an expanded brightness range, or high dynamic range.

There are a number of drawbacks. The most significant is that the technique is not very useful for photographs containing moving subjects. Static shots of buildings or landscapes can be a problem if people walk by or if leaves stir in the wind. These moving sections of a photo mean that the component frames have differences other than mere brightness. Walking people can turn into blurred apparitions, even when using custom HDR software with antighosting controls. Another drawback is that the technique is quite time-consuming, both during the shoot and in postproduction.

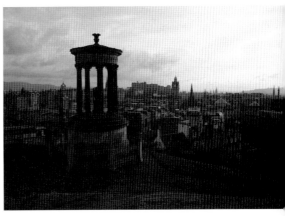

Medium

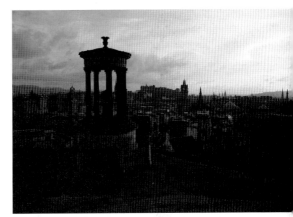

Dark

Light

← *A high dynamic range image consisting of three photographs, with 1²/₃ stops between them. The final composite image covers a wide range of brightness values. This particular image has also had local contrast increased for a deliberately unreal effect. Of course, HDR images can be considerably more subtle than this.*

Infrared (IR) and ultraviolet (UV)

Electromagnetic radiation (EMR) of a wavelength that lies immediately outside the range of human perception.

Visible light is just one form of a complex phenomenon known as electromagnetic radiation. The difference between light, which we can see, and radio or microwave or X-ray energy, which we can't, is the wavelength of that energy.

EMR that lies just past the visible range on the red side of the spectrum is known as infrared (IR) and on the blue/violet end, ultraviolet (UV). This is relevant to photography because the wavelengths of IR and UV closest to the visible spectrum, known as near IR and near UV, can be altered optically by lenses and can be recorded by certain types of film and *image sensors*.

Infrared

IR photography records IR energy that's reflected from IR-producing sources, such as incandescent bulbs and the sun. By loading a camera with IR-sensitive film and using a *filter* that blocks incoming visible light but passes IR, it's possible to take a photograph of a scene that looks very different from how our eyes would see it. Grass and deciduous leaves can glow pure white since they reflect a good deal of IR, a phenomenon known as the "Wood effect" after its discoverer, Robert Wood. Human skin has an ethereal quality to it, and clear blue skies can appear pitch black.

It's possible to take IR photos digitally, though most digicams have *IR-blocking*

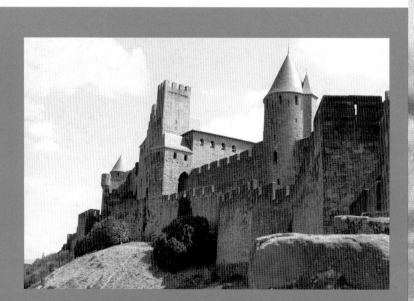

↑ A photograph which records visible light.

→ Dark skies and glowing white foliage: the strange world of black-and-white infrared photography.

ilters integrated into the image sensor. Modified cameras with the filters removed, or *digital cameras* designed specifically with these filters absent, make excellent R tools, since it's possible to see instantly f a photo worked or not.

Cameras are designed for visible light ocusing only, some *SLR* lenses have small ed dots on their manual focus scales which ndicate the amount of compensation equired to focus at IR wavelengths. R photography does not record heat patterns, contrary to popular belief. This atter is known as "thermal imaging" and can't be done using ordinary cameras.

Ultraviolet

Reflected UV photography is more difficult to achieve as it tends to require more specialized equipment, and is often used for scientific and forensic applications. For instance, UV photography of flowers often reveals fascinating patterns, invisible to humans but as obvious as an airport runway to flying insects which can see UV energy. UV photography can also be used to reveal hidden bloodstains, which can be very important for criminal investigations.

Technical note: UV and IR are referred to here as "energy" to distinguish them from visible light, though strictly speaking they are forms of electromagnetic radiation which can carry energy, which is not quite the same thing to a physicist.

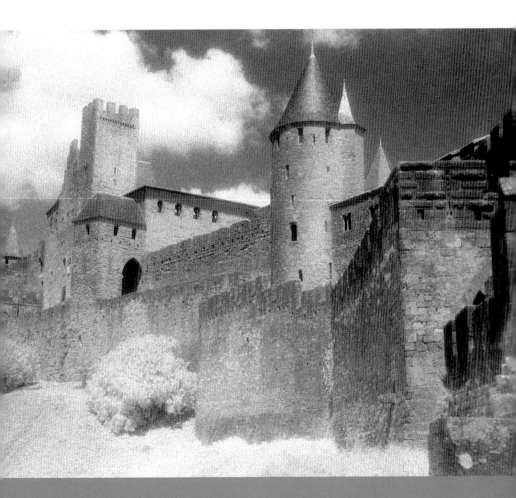

Backlighting

A scene in which the predominant (*key*) light source is positioned behind the subject and shines toward the lens.

Backlighting a subject is a useful way of producing dramatic images. The result can be an outlined subject or even a silhouette. It's sometimes called "contre jour," which is French for "against the day;" though often translated as "against the light."

Take image A, for example. Shot with direct sunlight, it's a fairly ordinary looking snapshot. It shows the statues quite well, but is otherwise uninspiring.

However, just by moving around the side of the fountain (B), a more dramatic image can be had by shooting into the sun. This position results in a loss of detail and information about the sculptures, but highlights the silhouetted shapes and the droplets of falling water. This shot also benefits from a slightly wider *field of view*, as shown in image C .

Backlighting is also used as a *studio lighting* tool, particularly in combination with other forms of lighting.

A

B

C

Night photography

Photographs taken under low-light conditions, such as at night.

While it may not seem immediately obvious, fascinating images can be taken with long *exposure* times under low-light conditions. Rather than snapping an image in a fraction of a second, night photos are built up slowly over seconds and minutes. The result can be a surreal view of the night, capturing aspects not visible to human sight. Colors can seem particularly vivid, since human color acuity is low in dim light.

The basic tools required are a solid tripod, a *remote* release or timer, and a camera with manual exposure controls. Film cameras yield excellent results, since they have no digital noise. However, camera light meters are often of little benefit for long exposures, so extensive tests and careful notes are needed to get a hang of the exposure times required for a successful night shot. Color film also suffers from color shifts caused by *reciprocity failure*.

Digital cameras have the advantage of immediate preview screens and *histograms*, but many cameras (particularly older models and *point and shoots*) tend to have significant problems with noise and hot pixels at long exposures. *HDR* techniques can also be used to reveal details in darker areas and compensate for bright light sources.

While careful use of manual off-camera flash can be a useful *"painting with light"* technique, simply firing off an on-camera flash is unlikely to make for an interesting night shot. Disabling automatic flash is thus very important.

Finally, in these paranoid times a relaxed and accommodating attitude, proper photo ID, and a portfolio of night photos are all valuable tools for dealing with police and security guards, who may be suspicious of a person lingering in the shadows with strange-looking equipment.

Painting with light

A photographic technique whereby a subject is positioned in a dark room, the camera *shutter* opened, and the subject illuminated by handheld lamps.

Most photography is performed with extremely brief *exposure* times; usually a fraction of a second. But it is of course possible to take photographs with much longer time periods. This may be a static subject illuminated at night, or it may be a more complex studio shot.

"Painting with light" is essentially the process of directing light on a subject by hand over a period of seconds or minutes. It may be as simple as posing a model in a dark room and then shining battery-powered handheld lights over him or her, moving the lights continuously to avoid "hotspots." An effect almost like a classic *chiaroscuro* oil painting can be achieved this way. Blinking LED light toys are also a popular tool for this sort of photography, since they leave a firefly-like trail of moving dots or lines.

More sophisticated applications of the technique include using high-powered lamps at night to illuminate structures, using pops of light from a handheld *flash* unit to illuminate a subject, and using professional *studio* tools such as fiber-optic lights. The latter, sometimes known as light hoses since they use flexible fiber-optic lines to direct light from a central source to a handheld wand, were popular for product photography shots. The rise of digital has meant that some of these effects can now easily be simulated in a computer.

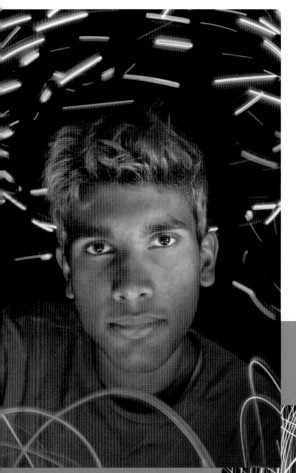

↑ *An open shutter photo with blinking light toys.*

→ *This photo was taken by simply tossing a camera in the air. The shutter was open for the duration of the toss.*

High-speed photography

A photograph with an extremely brief *exposure* duration.

High-speed photography is designed to freeze or capture motion, and is typically achieved through one of two methods. Either a very brief *shutter speed* is used or the photo is taken using electronic *flash* as its primary light source.

Consumer cameras are commonly available which can reach shutter times as brief as 1/2,000 to 1/4,000 second, which is often short enough to freeze even fairly rapid motion. For example, water cascading down a fountain can be frozen into little diamond-like beads by using a high shutter speed in bright daylight.

Mechanical shutters may not be fast enough to capture very brief events, such as a drop of water splashing into a dish, for which flash-based high-speed photography is often employed. This technique takes advantage of the fact that the pulse of light from an electronic flash unit is extremely brief in duration, sometimes in the milliseconds.

High-speed flash photos are frequently taken in darkened rooms with the camera's shutter held open. A brief pulse of flash light is then timed, often with an audio trigger, to a specific event such as a pin popping a balloon. The creation of sound-triggered high-speed flash photos is a popular pastime with hobbyists.

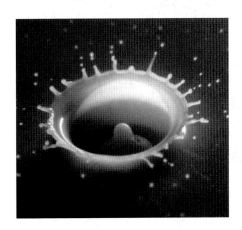

→ *Much like Harold Edgerton's famous "milk drop coronet" photo of 1957, this image was taken in darkness with an open shutter. A carefully timed burst of light from a flash unit was used to freeze the moment, capturing the crown-like splash of a droplet of milk.*

Time lapse photography

A series of photographs of the same scene taken sequentially over a period of time.

Time lapse photography is a technique for showing the passage of time photographically, especially for something that occurs more slowly than the human eye can easily perceive. It's a common tool for nature documentaries, for example, which want to show the slow opening of a flower or the growth of forest fungus on a log. Time lapse sequences are also often used for building construction photography.

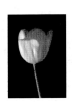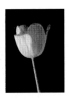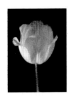

Intellectual property

Any creation of the human mind as considered by the legal framework of property ownership.

The most important form of intellectual property for a photographer is copyright, which governs artistic creations. Other forms of intellectual property include trademarks, which cover names and symbols used for commercial marketing, and patents, which cover inventions. The three fields are extremely disparate and serve different social and economic purposes, but are often grouped together since they all involve intellectual creations rather than physical objects such as land.

Copyright is a complex and frequently misunderstood topic. Essentially it is an area of law covering artistic creations which have been fixed in some tangible form. Copyright does not extend to words or names: those can only be trademarked.

When an artistic creation, such as a photograph, poem, or song is created, the work is normally owned automatically by its creator. The copyright owner can then determine who has the right to make further copies of the work, or can sell or transfer those rights to someone else. Other rights include the right to be identified as the work's creator, or have control over who can use the material to create derivative works. Work produced by an employee may be owned by his or her employer as it would be considered "work for hire."

Copyrighted works may be identified by the copyright symbol (©), but the Berne Convention does not require registration or identification for copyright to be valid. Photographers wanting to learn more about the ramifications of copyright law to his or her work are advised to research the topic carefully and consider obtaining legal advice.

Model release

A written statement, signed by an identifiable person in a photograph or a minor's legal guardian, giving permission to the photographer to use the likeness.

Model releases, which are essentially contracts ensuring that a subject consents to the use of his or her photographic likeness, can be very important in terms of publishing an image. They may or may not cover issues such as remuneration and the circumstances under which the photo may be used, though in some jurisdictions they may not be a valid contract without some form of "consideration" included (e.g.: a token payment or promise of a print). They can be a few sentences long or several paragraphs.

Photojournalism

Photography for newsgathering or general editorial purposes.

Photojournalism covers a very wide field. It ranges from war photography to social documentary to celebrity portraits to corporate news. A photojournalist (PJ) for a small newspaper might cover the opening of a new school in the morning, take a picture of a local hero at lunchtime, and cover an amateur sports game in the afternoon. In many cases the photographs are taken to illustrate a written story, though the photos themselves may serve

a primary role. Either way, the PJ attempts to tell a newsworthy story through photography. They must capture action of some sort rather than, say, a static object such as a landscape or a commercial product. A photojournalist may be a salaried employee of a newspaper, magazine, or news agency, or may be a freelance "stringer" who is paid by the photograph.

The decisive moment

A carefully chosen still frame that represents a frozen transitory moment and perhaps encapsulates a story.

The term is derived from the preface of pioneering photojournalist Henri Cartier-Bresson's 1952 book *Images à la sauvette*, (images snapped hastily or on the run) which was titled *The Decisive Moment* by his US publisher.

Cartier-Bresson expounds on his photographic philosophy in this preface, arguing that, while the world is in constant motion, every sequence of events can be distilled to a decisive moment. Photography is a matter of intuitively recognizing this instant and capturing the unique visual *composition* which expresses its humanistic and emotional essence. Indeed, photography is perhaps unique in the arts in its ability to freeze such a moment in time.

"...If the shutter (is) released at the decisive moment you have instinctively fixed a geometric pattern without which the photograph would have been both formless and lifeless."

Photo essay

A collection of photographs intended to convey a narrative or inspire an emotional response in the viewer.

Photo essays can be structured in countless ways. They are commonly built in a linear and chronological fashion, telling a basic story. Or they can be a series of disconnected shots which cumulatively describe a whole event or chain of events. They are often used in *photojournalism*, covering the events of a war or national disaster, for example. They may be personal and reflective, documenting the effects on a family of a person's illness, or the rise to power of a politician, or of last year's family road trip across the country.

In short, photo essays cover extremely wide ground, with the main common point being that a series of photos are used to convey a message greater than the sum of the individual shots.

→ *A team of volunteers assemble a huge art installation in the middle of an alkaline desert, despite a dust storm.*

Stock photography

Photographic images licensed for commercial use. Stock photography collections are maintained by large companies, often known as stock agencies. These companies license images to clients on behalf of photographers using different economic models.

Rights-managed

A fee must be paid each time the image is used, and there usually is a time frame in which the image may be used exclusively by the buyer.

Royalty-free

One-time fee to purchase a license for a photo. The photo can then be used as many times as the buyer wishes. There may be some restrictions on the kind of use to which the image is put, and the number of copies printed. There is no guarantee of exclusivity, and the buyer is purchasing permission to use the image, not buying the copyright. Royalty-free images are often sold in large CD or DVD collections and tend to be somewhat generic in nature in order to appeal to a mass-market.

Agencies

Agencies take a percentage or may charge additional fees. Traditionally agencies acted as a go-between or marketer for the photographer. Some agencies may still perform an agent role, but many now purchase images and broker their sales independently of the photographer. While traditional stock companies work with established professional photographers, "microstock" companies sell downloadable images over the internet at extremely low prices, often soliciting and accepting work from amateurs.

Stock photography is popular with commercial clients who need photos to illustrate their work or for advertising, but do not wish to go to the expense of hiring a photographer to acquire specific images on a shoot.

↓ *Stock photographs tend to be highly marketable images, such as business-oriented images or photos of iconic symbols.*

Acknowledgments

Special thanks to:

Jennifer Savage and John, Sanae, and Naomi Guy.

Fiona Haser and Piers Bizony.

Christoffer and Shoko Rudquist. c-h-r-i-s-t-o-f-f-e-r.com

Steve Double. double-whammy.com

Nick Montfort.

Paul van Walree. vanwalree.com

Richard Damery, Aperture Photographic. London UK. apertureuk.com

Claire Nash, Diana Nash, Beckie Bonfield, and Orinoco Flow, Kemnal Manor Stables. Chislehurst, UK.

Linda McQuillan and Ken Gannon. North London Aikido, London UK. thewellbeingcentre.org

Hotel Everland Paris (2007-2009) appears courtesy Lang/Baumann. Burgdorf, Switzerland. everland.ch

IT (page 365) appears courtesy Michael Christian and company. Berkeley, USA. michaelchristian.com

The Temples (pages 48, 80) appear courtesy David Best and company. Petaluma, USA.

Burning Man images courtesy Black Rock City LLC. San Francisco, USA. burningman.com

Jussi Hokkanen and Paul Duxfield, Cameras Underwater. London, UK. camerasunderwater.co.uk

Martin Reed, Silverprint. London, UK. silverprint.co.uk

Henry Posner, B&H Photo Video. New York, USA. bhphotovideo.com

Chuck Westfall, Canon USA. Lake Success, USA.

April Sankey, Jane Roe, Liz Farrelly, Tony Seddon, and all at RotoVision for making this project happen.

Additional thanks to George and Sally Low, Dan Shiovitz, Stephen Granade, Emily Short, Gunther Schmidl, Robin Lingwood, Taz Alexander, Barbara Harrison and the Barge St Bride, John Cater and Fahmida Rashid.

Models:

Borge Boakye, Beckie Bonfield, Alicia Colvin, Aran Dasan, Mel Dasan, Kiran Double, Emma, Catherine Francey, Ken Gannon, Santiago Genochio, Hanna from the Prada-Meinhof Gang, Alma Haser, Nicholas Immaculate, Kathy, Nadia Lala, Linda McQuillan, Susan Mokogwu, Mona, Fahmida Rashid, Jennifer Savage, Joel Stanley, Floyd Taylor, Martina Ziewe.

Additional photography:

All photographs by NK Guy except:

288 (right) courtesy John Guy.

200 courtesy Fiona Haser.

225 courtesy Jussi Hokkanen.

199 courtesy Richard Wheatley.

156 Gertrude and Mabel Hubbard, ca. 1858. Image courtesy the Daguerreotype Collection, United States Library of Congress Prints and Photographs Division, cph 3d02008.

137, 138, 189 (bottom left), 202, 239, 244, 255 (top), 262, courtesy Canon Inc.

192 (top) courtesy Casio Computer Co.

284 (lower), courtesy Seiko Epson Corp.

84 (left), 100, 175, 201, 217 courtesy Fuji Film Corporation.

121, 122 courtesy Intel Corporation.

100 courtesy Lexar Media, Inc.

247 (bottom) courtesy Olympus Corporation.

190 (top) courtesy Panasonic Corporation.

188 (bottom), courtesy Pentax Imaging Company.

100 courtesy SanDisk Corporation.

293 courtesy Sekonic Corporation.

100, 234, 245 (bottom), 247 (top), 281, courtesy Sony Corporation.

78, 84 (right), 138 (bottom), 189 (bottom right), 190 (bottom), 242 (bottom), 245 (top), 250 (top), 274 (bottom) courtesy Nikon Corporation.

282 Tamron Co. Ltd.

All trademarks mentioned herein belong to their respective owners.